A
CONCISE
HISTORY
OF
JAPANESE
ART

A
CONCISE
HISTORY
OF
JAPANESE
ART

Peter C. Swann

KODANSHA INTERNATIONAL

Tokyo • New York • London

This book was first published as *An Introduction to the Arts of Japan* by Bruno Cassirer, Oxford, England (1958).

Distributed in the United States by Kodansha America, Inc., 114 Fifth Avenue, New York, N.Y. 10011, and in the United Kingdom and continental Europe by Kodansha Europe Ltd., Gillingham House, 38-44 Gillingham Street, London SW1V 1HU. Published by Kodansha International Ltd., 17-14 Otowa 1-chome, Bunkyo-ku, Tokyo 112, and Kodansha America Inc. Copyright © 1979 by Kodansha International Ltd. All rights reserved. Printed in Japan.

LCC 78-71254
ISBN 0-87011-377-1
ISBN 4-7700-0714-0 *(in Japan)*

First edition, 1979
91 92 93 10 9 8 7 6

CONTENTS

CONTENTS

PREFACE

In the introduction to this book's First Edition, published some twenty years ago under the title *An Introduction to the Arts of Japan*, I described the position of Japanese art in the West as follows: "Familiarity with Japanese art in the West generally begins and ends with colour-prints. . . . The general art-loving public may also have seen a Japanese ivory carving, a late (and generally bad) piece of export porcelain or a charming lacquer object. Little else has reached Europe."

At the time I wrote it, my description was accurate. Interest in Japanese art was increasing, of course, but few up-to-date popular introductions to the subject were available. There were two main reasons for this unfortunate state of affairs—a flood of Chinese art and the political unpopularity of Japan that had culminated in the Second World War.

The first exhibition of Japanese art in London was held in 1854. It aroused little interest, but by the 1880s, through appreciation of the color print, Japanese art was the rage of Europe. Some years later, in this century, a flood of fine Chinese art overwhelmed the West, and many Westerners were shocked to find that what they had eulogized in Japanese art had been influenced by and even directly inspired by earlier, though not necessarily finer, Chinese models. This produced a reaction born of disillusion in which *all* of Japan's artistic achievements were decried as pale reflections of earlier Chinese masterpieces. Western critics, in discovering and exploring the monumental art of China, began to ignore the very real and

often unique contributions of Japanese art. This situation persisted through the 1950s.

As for the effect of the war, it is sad when the appreciation of an art is influenced by political considerations, but sometimes this happens. Happily, in the last twenty years Japan and the West have developed a strong bond of friendship, and that same period has seen the publication of many books on Japanese art, not a few of them specialized and the outcome of outstanding research by Japanese and Western scholars.

Numerous also are the well-illustrated and somewhat unwieldy volumes of the coffee-table genre. Certainly, knowledge of Japanese art is no longer restricted to the color print. Museums in the West have greatly expanded their collections and Japanese taste has penetrated Europe and America in many and subtle ways. It is a tribute to United States museums and collectors that it would now be possible to replace a large proportion of the illustrations in this introduction with examples in their collections.

In this completely revised edition I have attempted to correct a number of errors in the original—a depressing experience for any author—and to incorporate new information for which I am indebted to many scholars. The hope is that it will meet a continuing need for a general survey of a rich subject and serve the growing numbers of both students of Far Eastern art and visitors to Japan. There, and in the West, so much has been carefully preserved and has become so accessible that the subject is no longer, as it was twenty years ago, the esoteric preserve of the few.

Acknowledgments

A book of this nature is the outcome of so many experiences, opportunities, and so much help that it is impossible to make a comprehensive acknowledgment. However, certain people and institutions played a particularly large part. Dr. William Cohn initiated me into Eastern art and guided my first steps. A scholarship from the Scarborough Committee enabled me to study in America and Japan. In Japan itself, many scholars helped and guided me: Professors S. Mizuno and T. Nagahiro, Dr. S. Shimada, Messrs. S. Noma, R. Kaneko, Y. Yamanobe, and above all, Shinji Nishikawa, a good friend and my frequent companion on many journeys to see Japanese sculpture. Without his help, wide knowledge, and sympathy to a trouble-

some foreigner I should have missed many of the opportunities which can make a stay in Japan memorable.

I am extremely grateful to all museums and collectors who made available illustrations of objects in their collections, and especially to Mr. M. Ishizawa, who was particularly helpful in producing the First Edition.

Finally are due my thanks to Mr. and Mrs. Myron S. Falk, not only for their well-known generosity to students, but also for their insistence over many years that I undertake this revision.

NOTE TO THE READER

All spellings of Japanese words and names follow the standard Hepburn system of romanization, except those of words commonly anglicized, where the macron has been dropped. This is a lucid system and will present the reader with few pronunciation problems. Japanese names in the text are presented in customary Japanese order—family name first—and major figures are thereafter referred to by their personal or adopted names; the painter Yosa Buson, for example, is simply called Buson. Names of all contemporary Japanese writers whose works have been published in English, however, are given in Western order in the text, for this is generally how these authors choose to be known outside of Japan.

The suffixes *-ji*, *-dera*, and *-in* are used to indicate that the proper names to which they are attached are those of Buddhist temples or of structures within the temple grounds. Such suffixes always form an intrinsic part of the proper name in Japanese, and it has been thought better to include them in the text.

Substantive footnotes and suggestions to the reader appear at the bottom of the text pages. Source references are collected in a Notes section in the back of the book and are indicated by superscript numbers that run consecutively in each chapter.

A Concise History of Japanese Art

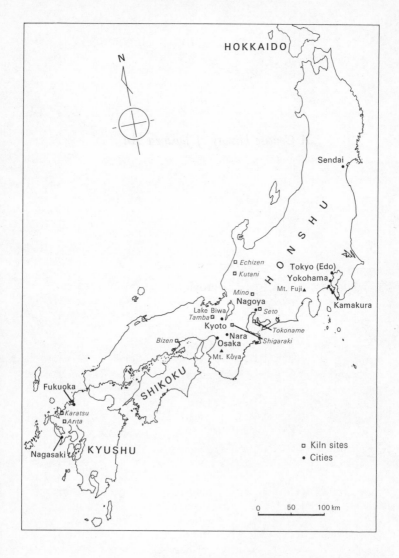

MAP OF JAPAN
SHOWING PRINCIPAL PLACES MENTIONED IN THE TEXT

INTRODUCTION

Laurence Binyon in 1923 said that the Japanese artists "certainly . . . have added new elements, and in some particular respects have surpassed the older nation [i.e., China], though in other respects they have never attained the same level."[1] Is this a fair summing up? No answer to the question can be provided without a consideration of the ceramics, textiles, metalwork, and lacquer of Japan as well as its painting and sculpture. In the same way, no book on Chinese art would be complete if it ignored the bronzes and ceramics of that country. All visual arts are deeply rooted in the crafts, and Japanese artistic taste often found in them its most characteristic forms of expression. The distinction between art and craft has nowhere been finer than in Japan. Unlike China, in Japan the crafts were never scorned or considered inferior. Many famous painters worked also as potters or as designers of lacquerware. Indeed, this freely accepted attitude that all art is one is a most refreshing feature of Japanese art in general.

There have been many books which have tried to interpret a nation's art in terms of its psychology, not always successfully. Yet the survey of the art leads naturally to interest in the characteristics of the people. The Japanese have very mixed qualities. Tender and romantic, kind and sensitive, they can also be brutal, impetuous, cynical, and treacherous. Convinced of the superiority of their own traditional way of life, they have never hesitated to adopt and to try to adapt whatever they think advantageous and "successful" in that of other nations. This instinct has often, as at the present time, led them

into difficulties which spring from a lack of understanding of the foundations upon which others have built their achievements. Their facility in the mastering of new techniques, whether Chinese or Western, has led to frequent crises in which often only their innate aesthetic taste has saved them. Facility so easily produces superficiality, and the Japanese have not always avoided the trap which their ready skill laid for them.

The Japanese have a word *shibui* which can only be inadequately translated as "good taste." It has come to mean "quiet," "refined," "restrained," "tasteful," "subdued," "cultivated," and it conveys the Japanese ideal of taste. It is easy for the art historian, dwelling among the beauties of the past, to be appalled by the products of twentieth-century Western life in Japan where they contrast so hideously with what is left of the old Japan. But to dwell upon this ugliness is as false as it is to represent Japan in the rosy terms of the tourist poster, as a land of fanciful scenes of cherry blossoms, gaily kimono-clad ladies, and the haunting sadness of Madame Butterfly. The whole world has moved on and we have all suffered the same misfortunes.

Painting and sculpture must form the basis of any appreciation of Japanese art, but the real taste of the Japanese is equally found in many an unexpected corner—in the minute garden whose apparently careless natural charm is in fact the product of the most careful thought, in the arrangement of a bowl of flowers, in the faultless architectural balance of a room, in the vigor expressed by a few lines of calligraphy, in the sensitivity of an evocative line of poetry. Above all, it is to be found in the shrines and temples carefully preserved through the centuries. These much-visited treasure houses of ancient art provide a constant reminder of past glories. Their beauty and their contents are deeply ingrained in the popular artistic sense.

The Japanese know the history of their art better than any other Asian people: museums are excellent and intensively active; more records have been preserved than in other lands; Japanese scholars have been more industrious than those of other Eastern nations and their attributions are usually accurate. The Japanese people have a genius, almost a mania, for conservation. Art objects from the very earliest times which in China have long since disappeared have in Japan been carefully protected, occasionally—as the student anxious to see them will have found—with almost maddening caution.

Japanese standards of beauty may differ from ours—therein lies much of their interest; their approach may be quite different, which gives the Westerner an opportunity to open his mind and form his own judgments. And it is for the Westerner that this book, only an introduction in every sense, is intended.

No introduction to a nation's art can ever be satisfactory. It must ignore many vexed questions, leave doubts unvoiced, simplify or avoid many problems. It must perforce leave out more than it includes. This book will share in full measure all these failings—and add some of its own. Long lists of artists, genealogies of schools, and chronologies of works are not included. It attempts merely to fill in the broad outlines of Japanese art by reference to a number of representative and outstanding works almost all of which are illustrated. The hope is only to stimulate an interest and fill a gap.

The history of Japanese art is a very long one. At the very beginnings of Japanese civilization there were made superb examples of neolithic art, long before the first great cultural impact on Japan—that of China. Such influences have sometimes obscured the native Japanese artistic spirit but they never entirely obliterated it. As N. G. Munro said, "the artistic talent of later Japan was rooted in the prehistoric past." To this very distant past we must now turn.

PAGE 17. Daibutsu ("Great Buddha"). Nara period. Height: 48 ft. Tōdai-ji, Nara.

PAGES 18–19. Section from the Take-kawa chapter of the scroll painting *The Tale of Genji*. Twelfth century. Ink on paper. Height: 8½ in. Tokugawa Reimei-kai Foundation.

PAGE 20. View of Mt. Kōya, site of the temple founded by Kōbō Daishi in the ninth century. Wakayama Prefecture.

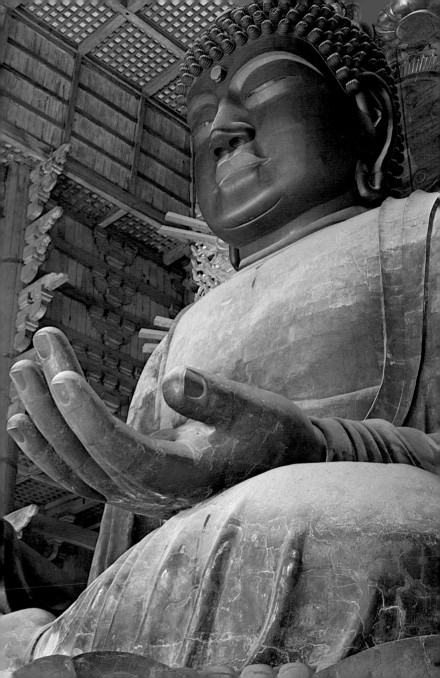

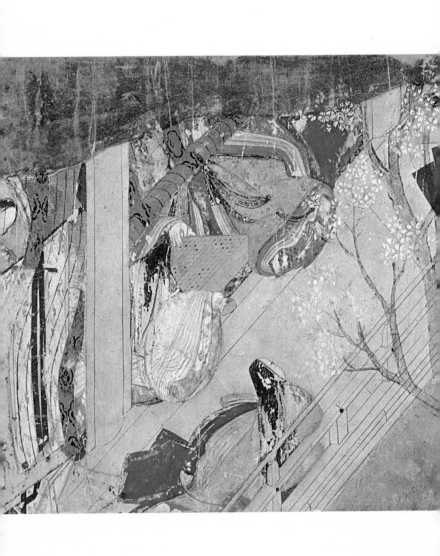

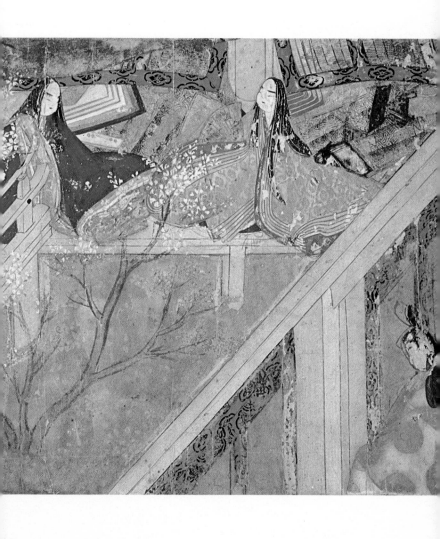

1

JAPANESE ART TO THE SIXTH CENTURY

The art of stone-age man is perhaps the most difficult of all arts to appreciate and judge. Our reconstructions and interpretations seldom help to elucidate much of its meaning. The obvious danger is that of modern man overintellectualizing the motives of his stone-age ancestors, of reading into them his own more complicated or, rather, more sophisticated outlook. But the pattern of the development of neolithic art in Japan is fairly clear and, in the light of increasing archaeological discovery, becoming clearer every year.

Before considering Japan's earliest art, however, it is important to understand a little of the native Japanese religion which has come to be known as Shinto, "the Way of the Gods." Its origins and development are so vague that adequate summary is difficult. First it is essential to distinguish the elaborate state cult which was built up for political reasons and the deep-rooted ritualism which springs from a simple animistic creed. The former had comparatively little influence on art while the latter has deeply affected the Japanese character and thus has colored the whole Japanese approach to art.

The very vagueness of Shinto has been a source of its power. It has given it a resilience which has enabled the native beliefs to survive the impact of more advanced, compelling religions such as Buddhism. Through the centuries its influence has waxed and waned but the native gods have never been completely neglected. To this day its most important ceremonies and festivals are scrupulously observed. The main Shinto shrine at Ise, for example, was founded in A.D. 478. Since the seventh century it has been completely and

exactly rebuilt on an adjacent site every twenty years, the present set of buildings being no less than the sixtieth reconstruction.

Shinto is rooted in the rich Japanese mythology. According to this, the race is descended from the gods. Such mythological origins are, for instance, related in the *Kojiki* and *Nihongi*, eighth-century compilations which, though under strong Chinese influence, include much indigenous material. They command as much respect nowadays in Japan as does the Book of Genesis in the West. But the more simple and fundamental beliefs of the cult, such as ritual purity, have influenced the Japanese spirit very deeply. Sir George Sansom defines Shinto as "a religion founded upon a conception, a vague and unformulated conception, of the universe as composed of a myriad sentient parts."[1] Thus everything in nature, from the sun goddess downward, the awesome as well as the friendly, the beautiful, the unusual, and even the everyday things have their divinities and share the quality of being *kami*. This word originally meant "superior" but has come to mean "divine." The emperor derives much of the respect which he commands, and which he has preserved through many difficult times, from the belief that he is the chief intermediary between the spirits and his people. In times of strain the Japanese people have repeatedly returned to their native gods—and thus also to the emperor.

Japan is a rich and fertile country, and Leigh Ashton points out that Shinto is a religion of love and gratitude rather than of fear—in particular, gratitude for the bountiful gifts of a kindly nature. It is the awareness of the myriad spirits in nature combined with an appreciation of nature's kindness which has given the Japanese a sense of the beauty and friendliness of their picturesque islands. This has affected the artist as well as the peasant. Although one can exaggerate the influence of Shinto, it is safe to say that it has left a deep and distinguishing mark on the innermost sensitivities of the Japanese people. It finds its earliest expression at the very beginnings of Japanese art in the neolithic period.

The Early Neolithic Cultures

Archaeological excavations of neolithic sites in Japan have revealed two types of culture fairly evenly distributed. They are distinguished by their different techniques of pottery making. In the one type (fig. 1) called Jōmon ("coiled rope"), the heavy, earthen-

1. Pottery vessel. Jōmon period. Height: 1 ft. 2¾ in. Tokyo National Museum.

ware pots were made with coils of clay. They were probably used for storage and are distinguished by a profusion and invention of decoration not found in any other stone-age culture. This decoration may have its origin in basketwork. As J. Edward Kidder comments, these pots are "the expression of a dynamic and robust society."[2]

Other scholars point out the delight the early Japanese potters had in working unwashed clay so that pebbles and shell fragments appear in it. Roy Andrew Miller comments: "In a sense, there is a continuity of problem here which runs through much of Japanese art, and one from which ceramic art in particular has never been divorced. It can be expressed as the conflict between the medium and the method, and in its resolution were evolved most of Japan's important contributions to world art. This conflict, which is one that every Japanese artist has been concerned with, revolves about the question of whether the natural qualities, textures and surfaces of materials should be sacrificed to the demands of his own particular technique and if so to what extent. . . . the Japanese potter . . . can be said to have been at his best when, as in [the] prehistoric Jomon wares, he gave his material full recognition and did not attempt totally to transform it."[3]

During the period in which this type of pottery was produced, the inhabitants of Japan began to change from a nomadic, hunting and fishing culture to a more settled type of civilization. The early peoples in Japan occupied the more hospitable areas such as the east coast of the mainland and Kyushu with their abundant supplies of fish—as is attested by some two thousand shell mounds, the remains of their staple diet.

In the second type, called the Yayoi, after a neolithic site of that name, the pottery is of a much more advanced technique. Where the two types occur together, the Jōmon is found on a lower level and therefore is earlier. Some scholars claim that the remnants of the Ainu people living today in Hokkaido belong to the same stock as those who produced the Jōmon culture (sometimes called "proto-Japanese") and are the descendants of the first Caucasian immigrants who were then driven north by later arrivals of Manchu-Korean and then Mongol types, while the Yayoi people, who came later, certainly had more recent and closer contacts with the mainland. Other scholars, basing their conclusions on skeletal remains, claim that the two peoples are the same and that the differences are simply due to evolution.

In any event, the origins of the Japanese people are very obscure. Like Great Britain, Japan forms the farthest extension of a great land mass with access from north, south, and west, so that migrant peoples, on reaching Japan, could go no further and were forced to merge there. A number of different ethnic elements can be seen in what is now, of course, a well-consolidated population. Man came to Japan quite early, but civilization, relatively late in the Far Eastern time scale. Less importance is now given to influences from the Malay-Pacific areas except where these influences came through China.

It seems that the Yayoi, from about the first or second century A.D., introduced more advanced agricultural techniques and a knowledge of bronze—and soon afterward, iron—casting and evolved a more intricate tribal organization. The union of the Jōmon and Yayoi stocks produced the Japanese people. Archaeologists are cautious about dating either of these cultures, but modern researches have pushed back the beginning of the stone age to the eighth millennium B.C. and its end at the beginning of the Christian era.[4] Local differences in the state of development and the dispersion of

these two cultures create many perplexities for the investigator.

Recent discoveries of Jōmon-type pottery have enabled Japanese scholars to divide the first long period into three or more subperiods according to the degree of skill revealed in the manufacture of their pottery. Some two hundred small clay figurines have been discovered which, in their most developed forms, belong to the two latest subperiods. The imagination which inspired them, the workmanship and the variety of decoration, place many of these, without doubt, among the most outstanding examples of neolithic art yet discovered anywhere in the world (fig. 2). Scholars see in the pottery a development, from about 5000 B.C. and accelerating from about 2600 B.C., during which its style gradually becomes more conventionalized and, in the last period, more and more imaginative and ornate. The geographic dispersion of pots shows that they were first made in the central part of Japan and spread northward. Phallic symbols occur, but, generally speaking, the sexual organs are not particularly emphasized. Nevertheless, examples of fertility symbols of the mother-goddess type are found resembling neolithic figurines unearthed throughout the world at a similar stage in man's development. In Japan, the desire seems to have been not only for human fertility but also for the increase of all life, which may explain why

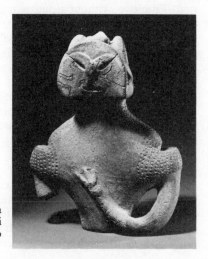

2. Clay figurine. Middle Jōmon period. Excavated in Yamanashi Prefecture. Height: 9⅞ in. Tokyo National Museum.

so many of these figurines do not show the usual features of pregnancy.

There is no reason for thinking that the example reproduced in figure 2 is a fertility symbol. It comes from the earlier period and, measuring ten inches in its truncated form, is among the largest yet found. The flat figure is burnt brown, its blackish shoulders decorated with an impressed pattern. Its symbolism or meaning can hardly be surmised, but the powerful modeling, tense attitude, and striking facial expression reflect the haunted imagination of a primitive people. Probably the animallike figure, as in many other examples, a portable and well-handled cult object, was made to propitiate some important spirit of the kind which abounded in the life of neolithic man. Some Japanese experts say that the fantasy seen in these figures springs from man's joy in creation, but there can have been little joy in the spirit which animated the creator of this figure. Terror or, at best, magic would perhaps better describe the force which moved its maker. It requires no great stretch of the imagination to see even in this early figurine a deep-seated Japanese taste for the fantastic and horrific which repeatedly appears in the art of subsequent ages—and which is seen in a very developed stage in the masks of later periods (see figs. 20, 40). Nevertheless, the immense variety and the fact that no two alike have been found attest to a most fertile artistic imagination. Primitive without being naive, their explosive and restless qualities have survived in the Japanese taste for ceramics. Later Shinto may well have become a friendly religion but there is much that is terrifying in its earliest manifestations. It is interesting to see, even in such primitive Japanese art, a relatively polished technique and a decorative sense which is highly developed in comparison with those of the arts of other parts of the world at a similar stage in the development of their inhabitants. This skill and style remain features of Japanese art throughout nearly two thousand years, and presage a most original culture.

The Old Tomb Period

From about the third to the sixth centuries A.D. the picture of early Japan becomes clearer. The introduction of rice cultivation to northern Kyushu via southern Korea led to a more settled culture able to exploit the richness of the country. It developed very rapidly, especially in the Kansai area around modern Kyoto in the first and second

centuries A.D. This phase is called the protohistoric or Old Tomb period (*kofun jidai*) from the man-made earth mounds covering the stone burial chambers of important people. Some of these are of gigantic proportions; that of the emperor Nintoku, who died ca. A.D. 427, is ninety feet high (fig. 3) and, with its moats, covers an area of 458 acres near Osaka. The size of these tombs indicates that the social organization of the tribes had developed from a patriarchal family system to a system of small communal states, of which hereditary tribal system the head clan was the Yamato. The power of this clan had reached as far as parts of Korea. Many of these burial mounds have remained untouched owing to the sanctity which surrounds all things imperial; this understandable respect is a great obstacle to the archaeologist. The mounds are magnificent sights rising in quiet, undisturbed majesty from the small, flat, cultivated

3. Aerial view of the tomb of Emperor Nintoku (ca. 395–427) near Osaka. Overall area: approx. 458 a.

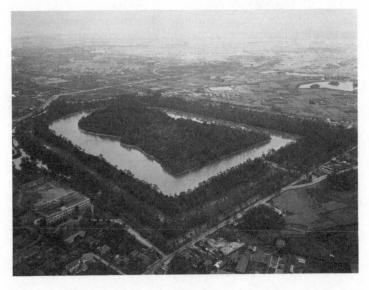

fields which surround them—the still water of their moats adding to the atmosphere of inviolability they radiate. What treasures do they contain? Early Japanese and imported Korean and Chinese art? Bronzes, jades, and even gold jewelry would probably be found in them. Certainly, by this time, the crafts flourished for there are later records from which we can surmise that considerable trade guilds existed. But, though the impossibility of excavation at present may be tantalizing, it is just this reverence for the past which has preserved these mounds intact, like so much else of Japan's cultural heritage. How much the poorer we should be if this spirit had never existed!

In the late fifth and early sixth centuries a new kind of hard-bodied, nonporous pottery made its appearance. This Sue ware is due to immigrant Korean potters, though it tends to be less accomplished than the Korean wares themselves. It often has a dark green glaze which is the result of the presence of wood ash in the kiln. It is from this Sue ware that much of the later Japanese pottery springs (see fig. 24).

Late Yayoi Culture: Metalwork, Pottery, and Haniwa

The Old Tomb period coincides with the later part of the Yayoi-type culture. As contacts with the mainland increased, so more items such as bronze mirrors and jade objects entered Japan where they were admired and treasured. Koreans immigrated to the islands, bringing with them a deeper knowledge of Chinese culture. It must be remembered that the Chinese had occupied part of Korea and that one Chinese outpost survived there into the fourth century A.D. Japan, unlike China, had a very short and undistinguished bronze age. Close and easy cultural contacts with the mainland only developed toward the end of China's great bronze age (end of first millennium B.C.) at a time when the finest bronze work was already forgotten and China was moving into the iron age. The contacts came through southern Korea, with which area Japan had extensive military and diplomatic contacts. One must remember that the Chinese during the Han dynasty (and until the early third century A.D.) had four colonies in northern Korea through which knowledge of iron could be transmitted. A number of bronze implements such as spearheads and bells (fig. 4) are found in Japan, but they do not compare in quality or in quantity with the Chinese products of the

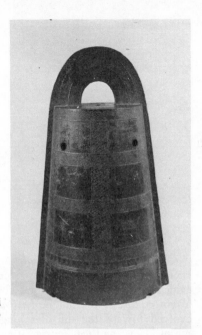

4. Bronze bell (*dōtaku*). Yayoi period. Height: 1 ft. 4¾ in. Tokyo National Museum.

Shang and Chou periods (ca. thirteenth to third century B.C.).

The bells (*dōtaku*) are of particular interest since it is supposed that they were used in ceremonies concerned with the fertility of the soil and that they were buried to encourage it. Bronze mirrors with decorated backs of Chinese origin and Japanese copies are also found. Some of the latter are of fine quality and show how quickly the Japanese mastered continental techniques.*

Yayoi pottery makes a complete break with the Jōmon wares. The clay is more refined, the shapes are more symmetrical, and some kind of potter's wheel was used (fig. 5). It is simpler and less elaborate in decoration and certainly less imaginative. Designs, when they occur, are geometric and somewhat sophisticated. Simple painted designs sometimes occur. Shapes appear which persist in

* For a detailed survey of early Japanese art see J. Edward Kidder, Jr., *Early Japanese Art* (in Bibliography).

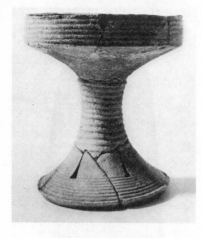

5. Stemmed cup. Yayoi period. Earthenware. Height: 8¾ in. Hiroshima University Literature Department.

later times and certainly ideas from the mainland become more evident than hitherto. The most characteristic product of the late Yayoi culture is the unique *haniwa* figures which seem to have evolved toward the end of a long tradition (figs. 6, 7, 8). *Hani* means "clay" and *wa*, "circle" (i.e., "clay objects arranged in circles"), and the individual pieces vary in size from twenty to forty inches. The Japanese set them in circles round the foot of the earthen burial mounds to retain the earth or form a kind of fence which was intended to be seen from a distance, perhaps as a deterrent to trespass. They may have evolved from the libation vases placed on top of the tomb into cylinders and then figures. They may be intended as a kind of spirit or magical fence. Many are only simple, undecorated cylinders which, for all their simplicity, give evidence of considerable ceramic skill. But by far, the most interesting are models of human figures, animals, houses, and so on. The ultimate inspiration for these models of human figures, but many steps removed, may well have come from China, and some writers have suggested that, as in China, figures were made as substitutes for the human sacrifices which in very early times accompanied the burial of important people. However, the Japanese did not begin to make models of human beings until the beginning of the fifth century A.D., many centuries after the Chinese had discontinued the custom,

and any connection with human sacrifice is conjectural. One interesting artistic comparison can be made with two rare neolithic pots now in the Museum of Far Eastern Antiquities, Stockholm (fig. 9), which come from the Kansu area in China and probably date to almost two thousand years before the *haniwa* figures. It is impossible to prove any direct influence but the modeling is strikingly similar.

The interest of *haniwa* lies in their effective modeling, which owes something to their technique of manufacture. They are made in a shape which is basically a hollow cylinder. This allowed the fire to reach all parts more evenly, while the perforations for the eyes and mouth allowed gases to escape and thus avoided cracking. These technical expedients contributed to the plastic effect. Above all the *haniwa* were the products of simple craftsmen working in haste on the occasion of the death of an important individual. This speed resulted in rapid, sure modeling and an extreme economy of means. The two dancers illustrated in figure 10—perhaps intended to represent a man and a woman—seem to be singing as they dance, and the treatment of the arms as well as the haunted expressions are reminiscent of some of the Jōmon figurines. Certainly they belong to the same spirit-fraught world of magic and superstition. The impression of arrested movement, so fitting to an art of the grave, imparts a ghostly quality to many of these figures. The expressions created by the empty eyes and open mouths would have deterred at least a timid grave-robber—if such a man existed. The wistful monkey's head (fig. 11) with its appealing look and eloquent, watchful twist, must rank among the world's masterpieces of animal sculpture of any age.

Kidder summarizes his conclusion: "The cylinders outlined the sacred precinct and acted as a magical barrier to safeguard the living from the dead. The inanimate objects got their start as simple symbols of the house of the dead, but caught on in the Kantō (Tokyo) plain area as symbols of wealth and status. Tomb protection was afforded by arms and armour, and these and other objects served as marks of prestige. Ultimately, from the Middle Tomb period onward, the human figures dominated the scene. Could they have come in about the time human beings were no longer being sacrificed, assuming for the sake of argument that they were? If so, they would be almost literally funerary substitutes, and provided for service in the next world. It is possible. Horse sacrifice was finally banned;

6. *Haniwa* figure of a warrior with falcon. Old Tomb period. Excavated in Gumma Prefecture. Height: 2 ft. 6 in. Tokyo National Museum.

7. *Haniwa* figure of a horse. Old Tomb period. Excavated in Saitama Prefecture. Height: 2 ft. 9 in. Tokyo National Museum.

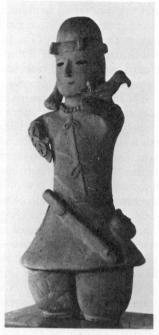

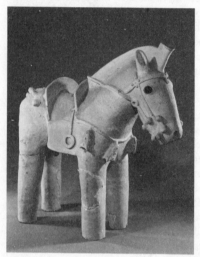

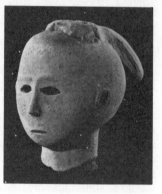

8. *Haniwa* figure of a woman's head. Old Tomb period. From Ichinomoto, Tenri City, Nara Prefecture. Height: 6½ in. Imperial Household Collection.

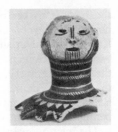

9. Fragment of a neolithic pot from western China. Second millennium B.C. Size: approx. 8 in. Museum of Far Eastern Antiquities, Stockholm.

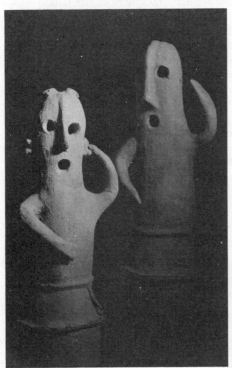

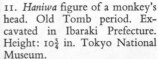

11. *Haniwa* figure of a monkey's head. Old Tomb period. Excavated in Ibaraki Prefecture. Height: 10¾ in. Tokyo National Museum.

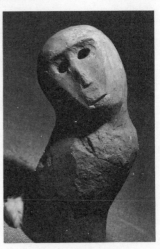

10. *Haniwa* figures of dancers. Old Tomb period. Excavated in Saitama Prefecture. Heights: 1 ft. 6 in. and 11 in. Tokyo National Museum.

the records make for a stronger case for live burials of human beings. But finally, in the rows of human figures and animals in the Kantō there materializes the appearance of a full funeral procession —soldiers, retainers, bodyguards, workers, animals and all. It is theatrical pageantry, a display for the living to gratify the spirit of the dead."[5] The magical, almost sinister atmosphere of the Jōmon has yielded to an optimistic cheerful world in which the gods seem benificent and man is in control of his fate.

The men, women, houses, ships, and animals represented in these terra-cotta models belong to a world increasingly conscious of China, but as yet hardly touched by it. Here, in these early centuries A.D., the original Japanese artistic talent speaks clearly and directly— perhaps more understandably to us in the twentieth century than at any other time since it first expressed itself some fifteen hundred years ago. It was to be many centuries before this Japanese spirit in the arts was able to break once more through the heavy overlay of a more sophisticated, alien Chinese world. Perhaps it never again appeared with such pure, naive charm and such eloquent simplicity.

2

THE ASUKA OR SUIKO PERIOD

552–646

The introduction of Buddhism to Japan in the middle of the sixth century brought about an almost unbelievable change in the life of the Japanese tribes—a change even more revolutionary than the introduction of Western culture and techniques in the nineteenth century. The Japanese, until then a comparatively primitive people with only tenuous contacts with China through Korea, adopted in a remarkably short time the religion, and with it the complete culture, of a nation infinitely more advanced than themselves. The will and imagination which enabled them to do this are admirable. Nevertheless, in their admiring, unquestioning adoption of things Chinese they sometimes overlooked the fundamentals of Chinese achievements to grasp only the glittering externals. From this momentous introduction of Chinese Buddhism and its effect on Japanese life springs the too-often repeated criticism that the Japanese only reflect other cultures and somewhat palely at that. The judgment is by no means altogether sound.

The Chinese themselves had taken their Buddhism in the first centuries A.D. via central Asia from its birthplace in India. From China it spread to Korea which, from about the first century onward, had cultural contacts with Japan, and it was from there that the Japanese obtained their introduction to this profound and stim-

Asuka is the name of the place in which the capital was situated during these years. The whole period is alternatively often called Suiko from the name of Empress Suiko (593–628), whose reign was the most brilliant of the period.

ulating religion. In this way the Japanese acquired their Buddhism third- or even fourth-hand. It is a tribute to their native intelligence and energy that they both desired it and could grasp it so rapidly. The masterpieces that China, even with its long artistic tradition, was inspired to create under the influence of the Buddhist faith are a matter for wonder; the achievements of the Japanese, building only on a genuine enthusiasm, vigor, and taste, are even more surprising.

The Life of the Buddha

Like all religious art, Buddhist art cannot be understood without some knowledge of the religion and its founder. As with the life of Christ, that of the Buddha is full of events which have inspired centuries of artists both in his home country and across the vast areas of the Far East into which Buddhism penetrated. It should be remembered that, in its finest hour, Buddhism had more adherents than any of the world's religions has ever claimed. Its art from India to China, Southeast Asia to Japan, is one of the glories of man.

Like Christ, the Buddha was a historical figure but born nearly six centuries before Him. The story of his life is permeated with mythology. His father, Suddhodana, was a wealthy chief of a small Aryan tribe called the Sākyas in the city of Kapilavastu, northern India. His family name was Gautama but the son is usually known by the name Sākyamuni. Tradition tells of his great physical beauty and high intelligence and many other signs of his destined greatness. In spite of the advantages of birth and wealth, being surrounded with every form of luxury, his spirit was troubled and inner happiness seemed to elude him. Even a beautiful wife and a handsome young son failed to bring him contentment. On three occasions when he happened to ride out of his castle, he met in the form of human beings three of the principal reasons for sorrow—old age, sickness, and death. According to the scriptures, the gods sent these apparitions to remind him of the purpose for which he was born. They awoke his determination to learn why living beings suffered and thence how to escape the pain on which the world seemed to be built. During his meditations on these problems, on the fourth occasion when he left his castle, he met a homeless ascetic. The calm features of this man showed that here, at least, was one seeking a solution to the problem of pain inherent in the transience of all things. Determined that he too would seek in similar solitude de-

liverance for himself and all mankind, the prince slipped quietly away from his castle in the middle of the night.

The stories of what is called the Great Renunciation and the events leading up to it such as his four exits from the palace are often depicted in Buddhist art. The life of pleasure which he formerly led and his birth in the Lumbini Garden are frequently shown. He is said to have been delivered from his mother's side while she supported herself by holding on to the branch of a tree. One of the most frequent representations is the scene of his departure from the palace in which heavenly beings support his horse's hooves in order to prevent any sound reaching the sleeping household. Another popular scene shows him in the forest bidding farewell to his white horse which kneels before him and to his lamenting groom. His victories over the forces of evil inspired countless artists and, of course, his death, as he lay surrounded by mourning disciples, is as often represented as that of Christ on the cross.

The prince, after leaving his home, set out on the second great period of his life in which he sought truth in the traditional Indian way as a homeless ascetic. The stories of his temptations in the wilderness have something in common with those of Christ. After some years of study he decided that he could not find the solution to his problems in any of the Brahmanical teachings which emphasized the need for man to spiritualize his inner self. This, he felt, was only a balm and not a radical cure of man's sorrows. Man was still bound by the chain of birth and rebirth from which escape was impossible.

He then decided to win salvation through the traditional method of austerities, hoping thereby to free his soul from his body. Reducing his food almost to nothing, the prince wasted away nearly to the point of death. But this means, too, failed him and he took food to regain strength before entering into his last trial—that of the most profound meditation. Under the Bodhi tree at Bodh Gayā he sat during one final night of the most testing temptations, enduring and repulsing the repeated onslaughts of Māra and his evil company of demons. As dawn broke, he achieved enlightenment, saw the innermost secrets of birth, death, and rebirth and the final way of escape. At this moment he became the Buddha, "the Enlightened One."

The third period of his life was spent in spreading his teachings throughout the northeast of India. His following grew rapidly, mir-

acles as astounding as Christ's were recounted, and he was recognized as the founder of a new sect within the old Hindu tradition.

At the age of eighty his end drew near. With his sorrowing disciples around him he entered into his final ecstasy and passed into *parinirvāna,* the final release, "the complete extinction of selfhood as well as the material on which it is built." His body was burned and the relics divided—their fate over the centuries was as checkered as that of the fragments of the true cross. In 1956, the twenty-five hundredth anniversary of this event was celebrated throughout the world.

The Spread of Buddhist Teachings

After the death of the Buddha, through the efforts of dedicated disciples and evangelists his teachings spread still further. Certain of them have had the most far-reaching importance in the history of Asia. Their subsequent development as a religion, especially in the forms accepted in China and Japan, deeply influenced, in fact totally permeated, the arts of these countries. Buddhism flourished in India over fifteen hundred years till the coming of Islam (tenth to twelfth century) and it survives to this day in Sri Lanka, Burma, Thailand, Tibet, and Nepal, not to mention the countries of the Far East. It spread like fire through central Asia and to China and Japan, where it set alight the imagination of a people ripe for a spiritual awakening.

The Buddha's doctrine evolved in various schools which, about five hundred years after his death, formed two main divisions, the Hīnayāna, or "Lesser Vehicle," and the Mahāyāna, or "Greater Vehicle." In Hīnayāna, although the laity also shared in the benefits of Buddhism, the tendency was to stress the life of the secluded monk as the way to salvation. The great difference between this and the Mahāyāna was the elaboration in the latter of the concept of celestial *bodhisattvas.* These were mortals who, because of merit gained in past lives, were entitled to become Buddhas and enter *nirvāna* but, through compassion for suffering humanity, delayed the final consummation. Thus the Mahāyāna greatly increased the numerous assembly of heavenly and ghostly beings. It was mainly the Mahāyāna form which reached China and Japan and the bodhisattva concept which appealed to their peoples. They eagerly adopted and developed Buddhas of the past and future, guardians, demons, angels, bodhisattvas in particular, and all the visual aids to belief so

attractive to the lay mind. One of the strong points of this Mahāyāna Buddhism was an extremely accommodating outlook which enabled it to absorb, often without conflict, the native beliefs of the countries which it reached. Thus Chinese Taoism and Japanese Shinto colored the Buddhism of China and Japan respectively. Just as the native doctrines of these foreign countries were accepted into Buddhist beliefs, so the native gods also found themselves placed among the ranks of the Buddhist divinities. All this was achieved by peaceful means for, of all the world's great religions, Buddhism must rank among the most unwarlike. The pacifist outlook of the religion made it attractive to rulers anxious to have a quiet, easily manageable population. This same aspect of Buddhism worked against the faith when a king had military aspirations and resulted in occasional but serious persecutions of the believers.*

The time of the official introduction of Buddhism into Japan is given as A.D. 532, the year in which the king of a Korean kingdom presented the Japanese emperor with a number of Buddhist ritual objects, including a statue of Prince Sākyamuni. This, of course, is nothing more than a convenient date, for Buddhism must have been known in Japan prior to that year through the numerous cultural contacts with Korea which had started as early as the first century A.D. Buddhism is said to have been introduced into Korea by two Chinese priests in A.D. 372, and already in A.D. 405 a Korean had come to the Japanese court to teach the Chinese language. The transition through Korea must have been very rapid, though the religion was already over a thousand years old when it reached Japan.

In spite of a desperate semireligious, semipolitical opposition, it took less than fifty years for Buddhism to establish itself even more firmly in Japan than in China. The progress of the faith was particularly fast after Prince Shōtoku, sometimes called the Buddhist Constantine, acting as regent for his widowed mother, encouraged the spread of the faith by official edict in about A.D. 587. From then, many monasteries were built, manned with priests and furnished with all the trappings of the faith. In 577 the King of Paekche in what is now South Korea sent to Japan a group of monks, nuns, and craftsmen skilled in building temples and in making Buddhist stat-

* The best short summary of Buddhism and its influences on Japanese art is given in John M. Rosenfield and Shūjirō Shimada, *Traditions of Japanese Art*, pp. 9–11 (in Bibliography).

uary. A large official embassy was sent to China in A.D. 607. Sansom notes that forty-six temples were built by the year 640. No conversion, except perhaps that of Java by Islam, can ever have been more rapid, more complete, and more sincere. Almost overnight the Japanese accepted from the missionaries of the Greater Vehicle a spiritual revolution which had swept through India, central Asia, China, and Korea. In art this revolution found expression in a mixture of elements from the plastic art of the Hellenic world, Iranian elegance, and the sensuous sweetness of Indian Gupta art.[1]

It is worth quoting Rosenfield and Shimada: "Throughout their long existence, Buddhist arts were motivated by an awareness of the inconceivable and invisible sources of all being in Buddhist metaphysics, a fact we should never ignore. This awareness is present in the atmosphere of mystery and inchoate darkness in the interior of temples; and it is present in the sense of an even grander and more inexpressible majesty that lies beyond the most splendid altar groups, the most exquisitely wrought mandalas. It is part of the rationale of the 'imperfect' image in Zen painting. It is, in a sense, the root of aesthetic inspiration of all Buddhist art."[2]

The Cave-Temples at Yün-kang and Lung-mên

Japanese scholars do not agree on many of the details of the earliest sculptures which, despite their delicate materials, have escaped destruction. Although early Buddhism in Japan was comparatively simple with few divinities and little of the complicated iconography which makes statues of later periods more difficult to understand, their diversity of type and the disappearance of most of their mainland prototypes have created considerable problems. There is no doubt, however, about the origin of their inspiration.

In the fifth and sixth centuries in China there were created the vast cave-temples at Yün-kang and Lung-mên. This happened under the devout rulers of the NorthernWei dynasty (A.D. 386–532) who had been completely won over to Buddhism. The Wei were a northern tribe which had conquered a large area of inner China, and under their patronage hundreds of cave-temples were carved from the living rock with myriads of statues, both large and small. They are one of the artistic wonders of the world. The work of literally thousands of skilled sculptors over a long period went into them—a vast monument to a burning faith. Almost certainly, sculptors who had

worked or been trained there found their way to Korea and to some of the southern Chinese states such as the Liang (A.D. 502–56), thus spreading Buddhist art far and wide. In the south the absence of good rock cliffs made cave-temples a rarity, and the talents of the artists were directed into bronze casting. Bronzes are portable, and such works were exported over the rest of the Far East, into Korea and eventually into Japan. In Japan, likewise, there are no caves suitable for temple carving and even good stone is rare, whereas wood is plentiful. So, as well as bronzes, many fine wood sculptures have survived in Japan, whereas in China such work has largely disappeared. The Japanese products do not suffer in any way in comparison with what has survived on the mainland.

Works of the Tori School

Among the earliest sculptors known by name in Japan is a Korean-Chinese immigrant, Tori, whose family came to Japan in A.D. 532. He gave his name to the earliest school of Japanese sculpture, the Tori school. A number of figures in this style have been preserved, the most important being his famous bronze Sākyamuni Triad dated A.D. 623, which can still be seen in the Hōryū-ji monastery near Nara.

Prince Shōtoku, the great protector of the faith, was at this time ill and his consort offered prayers for his recovery and ordered the triad to be cast in bronze. The dominant influence of late Northern Wei sculptural styles (fig. 12) is clearly seen in this work, the most easterly manifestation of types formed at Yün-kang and Lung-mên(fig. 13). Seiichi Mizuno, the Japanese expert on Chinese cave-temples, pointed out that the Shaka (Sākyamuni) Buddha in the P'ing Yang cave at Lung-mên, made in 523, is the closest surviving counterpart.[3] A time lag of a century or so in styles is understandable at this early period. The Japanese soon closed this gap. The drapery is symmetrically arranged in clear-cut folds which fall richly but very formally over the pedestal; there is a certain lack of proportion in the limbs; the so-called archaic smile on the lips brings a little animation to an otherwise impassive face. The body is heavily swathed in robes and there is a high degree of stylization in the whole composition. But, in addition to the strong Chinese influence, one can already recognize in this triad a sense of rhythmical design which was to become one of the characteristics of Japanese art. The faces are heavy and full with a high bridge to the nose, a long cylindrical neck, and

12. Seated figure from a Chinese cave-temple. Northern Wei period (early sixth century). Stone. Courtesy Seiichi Mizuno.

13. Sākyamuni Triad, by Tori Busshi. Dated equivalent of 623. Bronze. Heights: seated figure, 2 ft. 10 in.; attendants, 2 ft. 11¾ in. Hōryū-ji, Nara.

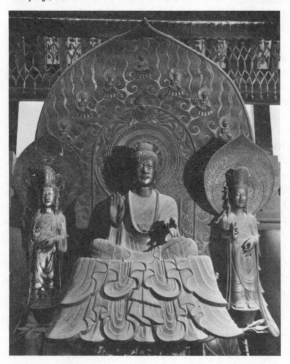

generally well-proportioned features. Such figures, like those in the caves, are obviously intended to be seen only from the front. The expressions are calm, highly stylized, and convey both dignity and mystery. The superb casting matches the majesty of the concept. The regularly arranged drapery seems to have absorbed much of the sculptor's energy. But it is in the elegant background motifs that its maker felt really at his ease and free to escape from the strict canons laid down for the central figures. There is a high degree of spiritual detachment and otherworldliness in the work, especially in the faces. The artist's concept of the gods is still that of suprahuman beings. It is unfortunate that the angels which originally surrounded the halo are now lost.

Another early work, the Guze Kannon (fig. 14) in the Yumedono ("Dream Hall") of the Hōryū-ji, the little building in which Prince Shōtoku is said to have carried out his meditations, is attributed by some Japanese scholars to the same Tori school. But, although late Northern Wei style is predominant, there are notable differences. It has the appearance of a bronze statue, but it was in fact carved from a single piece of camphor wood and then covered with gold leaf. Its magnificent state of preservation is due to its having been treated through the ages as a "secret statue" visible to the worshiping public

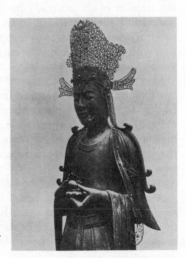

14. Guze Kannon. Asuka period. Wood. Height: 6 ft. 5½ in. Yume-dono, Hōryū-ji, Nara.

only on very rare occasions. The face, which is infused with a new warmth and tenderness, shows a most striking development. The modeling in general is more plastic and the whole figure somewhat less stylized, though the full possibilities of wood as a sculptural medium have hardly yet been realized. Sherman Lee considers this statue of the "compassionate" Buddha to be "perhaps the supreme example of the early Six Dynasties style in either China or Japan."[4]

The attendant figures of this image have a similarity to the Tori Triad but the whole conception is lighter, more graceful, and certainly more sympathetic. The figure is taller, more humanly proportioned, and the face begins to show more personality. Some historians have suggested that it is a portrait of the great Prince Shōtoku whose support for Buddhism in early times was so momentous. One might say that in the Tori Triad the artists seem to stand at the end of a tradition while in the Guze Kannon they are at the beginning of a new one. An interesting and oft-quoted sidelight on the Japanese preservation of early treasures tells how the pioneer American scholar Fenollosa in 1878 was the first to see this sculpture, perhaps for many centuries. He found it to be in perfect condition, swathed in wrappings and covered with many years of dust.

The technique and workmanship in both works are of the highest quality. Throughout Japanese art there are seldom signs of first halting steps or of the unsteady hand of the beginner. Japan was presented with the spectacle of an art completely formed in China; and its great achievement was to recognize that art, to join in its production with tremendous creative energy, and to develop it in new ways which China never surpassed.

Korea was not the only source of Japanese knowledge of Chinese art. Different influences spread from different centers on the mainland to satisfy the inquiring mind of the Japanese. Thus, from the earliest days in Japan, there were at least three different schools. To distinguish among them is often hard, and opinions differ among the Japanese about the attributions of surviving works.

Simple Austerity: The Kudara Kannon
A well-marked style, different from those of the Tori school and the Guze Kannon, is seen in the Kudara Kannon (fig. 15). *Kudara* is the Japanese name for the Korean kingdom of Paekche from where the figure or its creator is said to have come to Japan. Some Japanese

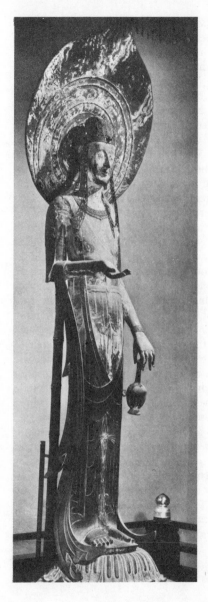

15. Kudara Kannon. Asuka period. Wood. Height: 6 ft. 10½ in. Hōryū-ji, Nara.

see in it a relationship with the Guze Kannon. But the statue has such individual qualities that it is best considered as a unique work. Ultimately its inspiration may have come from a different part of China, perhaps from the south rather than the north, and from a period slightly later than the Northern Wei. In this long, slender figure the limbs are again out of proportion but in exactly the opposite way to that of the Tori bronze. The elongation gives a grace and lightness to the whole concept. The figure is conceived far more in the round, and the drapery which curls forward instead of sideways produces an effect very different from the frontality of the Tori bronze. The three-dimensional impression is much stronger. There is a far greater feeling of movement in this tall figure than in the squat Tori bronze. The lateral movement of the body gives it a most pleasing grace. The drapery is lighter and the figure less heavily swathed—in fact the sculptors have transformed all the heaviness of the bronze into lithe, willowy elegance. Instead of the thick, stylized expression of the Tori image, we have here a calm, inward, almost mysterious spiritual look of contemplation. The Tori bronze is an imitation of stone originals which were meant to be seen from below in dimly lit caves. Translated into bronze and brought down from their niches, they lose much of their power. In the Kudara Kannon the sculptor, a Korean whether working in Korea itself or in Japan, has found in camphor wood the material best suited to his talents and he has responded to its possibilities. In support of its Japanese origin some Japanese scholars have pointed out that the camphor tree did not grow in Korea when this statue was made, and Yukio Yashiro sees in its features "the combination of beauty and sadness . . . which are typical Japanese artistic qualities."[5]*

The spectator still looks up at the figure, but it no longer stands high in a niche on a wall. It has been brought down almost to ground level, and it remains elevated above humanity solely by virtue of its proportions, which keep it, as it were, at a mysterious distance. The sculptural idiom of this statue forms a complete contrast to that of the Tori style. The harmoniously flowing drapery is in very low relief with large undecorated areas; the artist is discreetly conscious of the body beneath the robes though not yet com-

* An excellent facsimile copy of this statue in the British Museum was ordered by Laurence Binyon when he was in Japan.

pelled by any desire to model it in detail. In all respects the figure reflects a new simplicity and austerity in Buddhist religious feeling. This extraordinary image, unique in Far Eastern sculpture, exercised little influence on subsequent work. From this time onward a different trend in Buddhist artistic thought took the sculptors in the direction of a more solid representation of the body. The Kudara Kannon represents a noble but isolated vision.

A New Sense of Physical Beauty

On the latest style of the Asuka period, the authorities again differ. It is represented by two superb works of deep religious inspiration. Their subject is Miroku, the Buddha of the future. One is in the Chūgū-ji monastery near the Hōryū-ji (fig. 16) and the other in the Kōryū-ji near Kyoto (fig. 17). The former is sometimes described either as a Kannon or as a portrait of Prince Sākyamuni while the latter is sometimes called the Kudara Miroku to suggest that this, too, is of Korean origin. These statues raise problems which will probably never be solved. Both are wooden figures seated in medita-

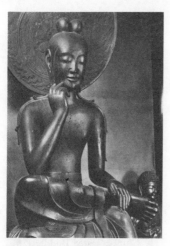

16. Miroku. Mid-seventh century. Wood. Height: 4 ft. 4½ in. Chūgū-ji, Nara.

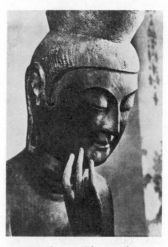

17. Miroku. Mid-seventh century. Wood. Height: 4 ft. 1 in. Kōryū-ji, Kyoto.

tion expressed in terms of calm and repose with one leg crossed over the other in the half-lotus position, hand to chin and upper body uncovered.

What immediately distinguishes them is a new sense of physical beauty which nothing else in the art of the time leads us to anticipate. It is difficult to imagine a more complete mastery of the simple wood which the artists chose for their medium. The warmth and mellowness of the material as well as its sculptural possibilities have been fully exploited to infuse not only the faces but the whole bodies with tenderness and an appeal to the sentiments. In the Kōryū-ji figure even the grain of the wood itself has been skillfully brought out to give an added elegance to the face. Sculpture is here raised to a level of intimacy rare in the early art of the East. Any tendency to oversoften the features has been counteracted by giving sharp edges to the nose and a strong cleft to the chin. The bottom half of a strikingly similar sixth-century stone statue was found in Kyungju, Korea. Small bronze statues of similar pose and feeling are also well known, notably some statuettes which formerly belonged to the Hōryū-ji but were given to the emperor (fig. 18). Saburo Matsu-

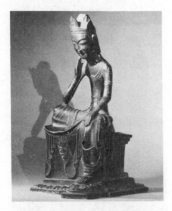

18. Miroku. Probably made in 666. Bronze. Height: 11⅛ in. Formerly in the Hōryū-ji, Nara; presented to the emperor and now in Tokyo National Museum.

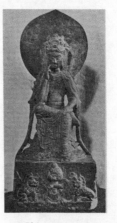

19. Chinese seated Buddhist figure. Dated 544. White marble. Height: 1 ft. 9¼ in. Shodō Museum, Tokyo.

bara has pointed out the significance of some fine white marble examples from sixth-century China (fig. 19), but none of them has the refinement of these works in which their carvers have followed Chinese or Korean prototypes but infused them with a sensitive, melting quality which is tender without being weak, lyrical without being sentimental. They show Japanese religious art and craftsmanship at its purest, neither completely overwhelmed by foreign influences nor carried away by the realism and virtuosity which in later periods so often diluted the strength of the artists' vision.

These Miroku statues differ from both the Kudara Kannon and the Tori-school works. Although the Kōryū-ji Miroku, from its similarity to Korean works, is often said to be of Korean origin, the Japanese spirit reveals itself in a degree of sensitivity and warmth which the Koreans never reached. The sculptor has liberated himself from the conventions of the other styles. The heaviness of the features has gone and the Japanese have given free play to their appreciation of surface textures and facial expression. The human intimacy found in these statues is absent from similar works of the mainland. The delicate gesture of the slender finger lightly poised near the chin, the low, simplified crown, the lack of ornaments, and the detached contemplation of its dreamy, half-closed eyes contribute to a figure of sustained lyrical and spiritual inspiration. Very early the Japanese learned the fundamental artistic truth that nobility can often best be expressed through restraint. Yashiro observes that "the whole sculptural approach of this statue, notably in the face and drapery, seems to presage the arrival of an age with a new artistic spirit."[6] This was to be the Nara period discussed in the next chapter.

Gigaku Masks

From this early period, too, date some of the carved masks for use in the *gigaku* performances held in the temples (fig. 20). These were ceremonial posturings accompanied by music. The masks, which seem to belong to another world with an imagination quite different from that which the previous art of China and Japan would lead us to expect, may originally have been copied from Chinese prototypes, but none of these has survived. They are said to have their origins in the far west of central Asia and for this reason may represent strong echoes of Western facial types. The Japanese examples are thus unique in Eastern art. The earliest of these masks formerly belonged

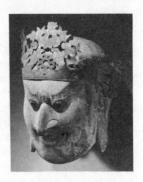

20. Mask for *gigaku* dance. Asuka period. Wood. Height: 9 in. Tōdai-ji, Nara.

to the Hōryū-ji, that treasure house of early Buddhist art, but the temple presented them to the imperial collection in the nineteenth century and they are now kept in the Tokyo National Museum. They show the same imaginative sense which inspired some of the prehistoric art of Japan, immensely enriched by the new worlds of Buddhism and Chinese culture. This love of fantasy, seen so clearly here, combined with a genius for the expression of personality are two of the most powerful and individual features of Japanese art. They show themselves constantly throughout its history and distinguish it from that of the Chinese in which personality is generally overpowered by the grandeur of their conceptions. The Chinese have produced a few notable portraits over the centuries but the genre does not seem to have engaged their interest as much as it has the Japanese, who seem always to have been attracted by what is individual. They have resisted the Chinese impulse to create types. Each age produced its portrait masterpieces. Sometimes they have carried them to a point where quick fantasy leads them into an eccentricity bordering on the grotesque. The Japanese sense of humor is a welcome aid for the uninitiated Westerner in his attempt to appreciate this Far Eastern art. In these masks the carvers of religious icons seem to have found a welcome freedom from the usual canonical types.

Aspects of Japanese Painting

Though this period is chiefly notable for its sculpture, a few specimens of its paintings have also survived. From the earliest times Ja-

panese painting has differed from that of the Chinese, although there are many obvious similarities. In both countries the painters use the same materials—paper or silk to paint on and a very sensitive brush, with black ink in all its nuances and water colors. They are influenced by the art of calligraphy, which uses the same brush and ink and tends to emphasize line and outline at the expense of shading. Shading, as we know it, is hardly ever used in the East. The coloring is flat and generally even. The subjects, too, are often the same—landscapes, flowers, figures, animals, religious and genre scenes, and so forth. Wherein, then, lies the difference between the painting of China and Japan?

Without any doubt the Japanese artist, even when painting as close as he can to the Chinese style, generally imposes his personality on the pictorial arts. The Japanese tend to see painting much more as decoration than the Chinese. For the latter it is one of the most exalted means whereby a man can express his spirit. The Japanese appreciation of decorative values comes not only from a love of color and an eye for a beautiful surface but also from a fundamentally less philosophical approach to painting. From very early times the Chinese have accumulated a vast literature on the theory and philosophy of painting while the Japanese have been comparatively little concerned with such problems. Where the Japanese break away from their Chinese teachers they can rise to great heights. Where they try to ape them too closely they often justify the criticism of being shallow copyists. When borrowing directly from the Chinese they are inclined either to oversweeten or to overemphasize. They tend to empty Chinese painting of just those qualities which make it sublime. What the Japanese lose in depth of artistic inspiration they sometimes try to gain by a sensationalism in composition in which virtuosity takes the place of sensibility. In the decorative arts the Japanese have produced some of the most original work the world has ever seen but—with a few notable exceptions—subtlety in painting is not their strong point.

The nature of Japanese writing as opposed to the Chinese also had its influence on the painting of the two peoples. The brushstroke as used in calligraphy is the basis of all Eastern ink painting. The Japanese script, especially where it uses the native syllabary rather than Chinese characters, is smoother, softer, and far more cursive than the firm Chinese characters (fig. 21). The abbreviated native *hiragana*

21. Calligraphy in Japanese *(right)*
and Chinese *(left)* styles.

syllabary characters with their rounded forms and running lines have influenced Japanese painting in the direction of a softer, more flowing line. The ink, too, tends to have less power, less depth and resonance than in a Chinese ink painting. Even today if a painter in Japan wants good ink he tries to find the Chinese product.

The study and appreciation of Eastern calligraphy and brushwork has hardly begun in the West but generally it is possible for a Westerner, after a little experience, to tell the difference between the softer or the consciously exaggerated brush of the Japanese and the more powerful, inwardly comprehended stroke of the Chinese. The media of Far Eastern painting express spiritual values so sensitively that it takes a very skilled Japanese to be able to pass himself off as a Chinese painter. To our confusion, however, some have succeeded. And in any case it can rightly be claimed for the Japanese that, in their own way, they are just as original in painting as the Chinese although this originality is expressed in spiritually less exalted terms.

There is an additional reason for this. In Japan, painting never became the exclusive domain of the scholar as so often it did in China. In this sense it has a broader base than in China. The influence exerted by the accomplished craftsman, very conscious of his individuality, on Japanese painting gives it a resilience not always found in Chinese painting. The artisan-painter in Japan is less fettered by tradition and therefore often more vigorous than the scholar-painter in China. The Japanese, it is true, are at times tempted to sacrifice too

22. Detail of bronze bell (*dōtaku*) in figure 4. Tokyo National Museum.

much to the ultimate decorative effect, but they are often saved by a sense of design which in all periods shows itself as perhaps the most highly developed in the world. When not trying to follow Chinese modes too slavishly, the Japanese painter can be completely individual and spontaneous.

In trying to trace the beginnings of the pictorial arts in China, scholars often produce as evidence the animated hunting scenes cast in low relief or incised on bronze vessels. Similar artifacts can be quoted for the early painting of Japan, where metal mirrors or early bronze bells called *dōtaku* (fig. 22) in a similar way show simple pictures of everyday scenes. These lively matchstick figures, even though they bear little relationship to later Japanese painting, place the emphasis on that line and movement which are the foundations of all Far Eastern painting.

The Tamamushi Shrine

The treasury of the Hōryū-ji owns the earliest extant paintings of the Asuka period. Here, near the bronze Tori Triad, is kept the small sanctuary known as the Tamamushi Shrine or "Beetle Wing" Shrine, so called from the use of iridescent beetle wings under metal openwork to decorate the edges. On the pedestal of this most important early artifact are painted scenes from the lives of the Buddha in his various incarnations. The one illustrated (fig. 23), perhaps the most famous of all, is that in which he is shown giving his own body to feed a

starving tigress and her cubs—a scene which illustrates his great compassion for all living creatures, animal as well as human.

These paintings are in red, green, and yellow lacquer on a black background—a technique unusual in the East and one which comes nearest to Western oil painting. The archaic method of depicting successive phases of an action on a single surface has its advantages; by showing in a semicircle the Buddha's disrobing, his fall into the pit, and his death, the artist was able to produce an impression of vivid action and to satisfy his unschooled public by completing his story. This liking for continuous narrative appears frequently in later periods. The absence of comparable contemporary Chinese works makes it very difficult to date the painting with any certainty, but the very beginning of the seventh century might not be a rash estimate. The schematic rocks and bamboos recall Chinese Northern Wei, Six Dynasties, or T'ang engravings and suggest an already well-developed landscape tradition going back perhaps as far as the Han dynasty in China. Certainly, in this simple but exquisite scene there is a combination of lyricism and drama which the Japanese enjoy to the full.

Pottery, Metalwork, and Textiles

What pottery of the period has survived shows that this craft was little more than a continuation and development of the Sue wares which originated in the late Yayoi period (fifth to sixth century A.D.) and were used for ceremonial offerings. Many are directly influenced by Korean wares. The powerfully shaped jar shown in figure 24 was thrown on the potter's wheel; the neck is quite skillfully made but the body is heavy and clumsy. Its main attraction is the dark green natural ash glaze produced by particles of the burnt fuel falling on the clay vessels creating a glaze which then runs naturally down the body. We cannot date the vessel accurately, but similarities with Korean wares have led Japanese scholars to place it in the period just before Nara. It was fired in a high-fired kiln, a technical innovation from Korea which led to a rapid development in the craft. The craft of pottery making was unfortunately slow to react to Chinese models and there is little to suggest that the Japanese were keeping up with the progress being made on the mainland of China. There was nothing in Japan as yet to compare with the Yüeh-type pottery or the pre-seventh-century tomb figures of China.

23. Painting on a panel of the Tamamushi Shrine depicting a scene from the life of Buddha. Early seventh century. Lacquer on wood. Dimensions: 2 ft. 1½ in. × 1 ft. 2 in. Hōryū-ji, Nara.

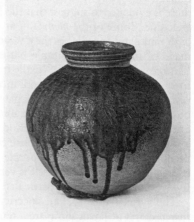

24. Jar of Sue ware. Ca. 600. Dark green natural ash glaze. Diameter at mouth: 5 in. Tokyo National Museum.

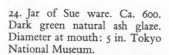

A specimen of metalwork of the Asuka period deserves particular mention. This is a gilt-bronze banner—a detail of which is shown in figure 25. The whole object, which again belonged to the Hōryū-ji, is over fifteen feet in length and the detail is from a section where heavenly beings or *apsarases* are playing musical instruments or making offerings. A band of arabesques of honeysuckle whose origin scholars have traced to ancient Greece surrounds the lively figures. This very large work was produced by piercing sheets of bronze and then incising designs on one side. The style of the figures is pre-T'ang and reflects the elegance of some of the Chinese cave-temple carvings (fig. 26). The design of the billowing robes is particularly effective; its asymmetrical arrangement contrasts with the regular arabesques to make a lively, free pattern. The workmanship recalls that of the paintings and metalwork on the Tamamushi Shrine.

As a result of the damp climate in Japan, most of the earliest textiles have disappeared without a trace. In parts of China where the climate is very dry, fragments of textiles have survived from the two centuries before and after Christ. We can only gain some idea of early Japanese textiles from more durable materials such as pottery or sculpture. We know little about the work of the earliest times other than that knowledge of weaving probably came from China in the Yayoi period together with other cultural improvements. The Korean craftsmen who reached Japan in the fourth and fifth centuries must have included some who were skilled in the craft, and there is evidence to suggest that the Japanese court made them very welcome. Some of the *haniwa* figures evidently represent people of high rank, and the clothes they wear are of a complicated style and made of material with simple but elegant designs.

A remarkable number of textile fragments have survived in Japan from the Asuka and Nara periods in a variety of techniques—figured silk, brocades of many types, silk gauze, embroidery, dyeing by various methods. In the Chūgū-ji, a nunnery adjacent to the Hōryū-ji, are fragments of two Asuka-period banners made in A.D. 622 (fig. 27) depicting the rebirth of Prince Shōtoku in paradise. The colors of the embroidery done on purple silk gauze are still remarkably fresh and the needlework itself is very fine. The designs are free and lively, and the figures in particular have a remarkable vitality.

The variety, quality, and sincerity which these earliest Buddhist-inspired arts of Japan show are a remarkable illustration of the way

the Japanese could master and absorb this rich, new culture despite the fact that they were far removed from its center of dissemination. In the Nara period which follows, the Japanese were to be exposed to the full force of Chinese civilization.

25. Detail of a banner depicting heavenly beings playing musical instruments. Asuka period. Gilt bronze. Length of whole banner: approx. 15 ft. Hōryū-ji, Nara.

26. Chinese cave-temple carving showing flying angel. Northern Wei period (early sixth century). Width: 2 ft. Possibly from Lung-mên caves; now in Victoria and Albert Museum, London.

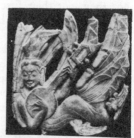

27. Detail of a banner depicting the rebirth of Prince Shōtoku in paradise. Dated 622. Embroidered silk. Overall size of banner: 3 ft. 11 in. × 3 ft. 8½ in. Chūgū-ji, Nara.

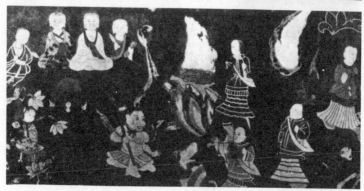

3

THE NARA PERIOD

646–794

The Japanese were not content for long to accept their knowledge of China secondhand through Korea and Korean immigrants. In A.D. 607 they sent their first national embassy with cultural objectives to the Sui court of China itself. From then until 894 not less than seventeen others followed. Many young scholars accompanied these expeditions on what Edwin O. Reischauer calls "the first organized program of foreign study in the world."[1] What the visitors saw there must have impressed them even more than the rumors of China's greatness and the reports of the Koreans. In these embassies the Japanese accepted treatment as a subordinate nation. The cultural domination of Japan by China culminated in what is known as the Taika Reform of A.D. 645 when Japan instituted far-reaching administrative changes in an attempt to adopt the complete administrative and social system of the T'ang dynasty, which had succeeded the short-lived Sui in A.D. 618. Unfortunately, the country, though spiritually willing, was not ready socially, economically, or politically to support such a long-term, wholesale emulation of a country with vastly greater resources and older traditions. It is remarkable that the changes achieved as much as they did. In addition to the dazzling grandeur of the T'ang political and cultural scene, the Chinese ideal of a centralized monarchy controlling a vast and obedient empire made a strong practical appeal to the rulers of Japan. It held out

The Nara period may also be divided into the early Nara or Hakuhō period (646–712) and the late Nara or Tempyō period (712–94).

the tempting possibility of controlling some of the more independent clans outside the capital area. But this was a problem which the Japanese could not solve simply by adopting an alien code. It would be possible to write the history of the next thousand years in terms of the various efforts the central authority made to overcome the independence of the local lords.

The Establishment of the Capital

In 710, the Japanese established their capital city at Nara. They modeled it as closely as possible on the Chinese metropolis of Ch'ang-an, one of the wonders of that and any age. Such a large-scale imitation can have but few parallels in world history. Individual palaces like Versailles have been copied but seldom a whole city. Modern Nara does not resemble the ancient city very closely, but to walk round parts of it is to recapture some of the atmosphere of seventh-century China. Old temples still stand in their open spaces, discreetly separated yet near enough to create the solemn impression of a compact holy city untouched by the centuries. Many of the ancient sculptures are preserved in their original homes, having withstood the passing of more than a thousand years with unbelievably little damage.

In its finest hour the city must have presented a glorious spectacle: four miles square with wide if muddy streets, great monasteries set in their parks, and palace buildings between them all tiled and brightly painted. But this glittering façade hid a more sordid reality. The countryside had been stripped of wood for the temple buildings. In the scattered villages the inhabitants had much to fear from the sullen aboriginals and even more from bands of armed robbers. The peasantry were badly housed, scantily clad, and poorly fed. By comparison, the brocade-clad nobility lived like gods. In China, in theory if not always in practice, the lowest in the land could through diligence reach the highest rank; but Japan ignored this important feature of their Chinese model. In Japan few scholars of humble origin obtained positions of authority or responsibility. Locally, aristocrats with mandates from the central authority filled the positions. In the capital, hereditary nobility performed all except the lowest clerical duties. The result was an inefficient system of tax gathering since there was no strong civil service to protect the central power. The peasants suffered in this centrifugal economy. More and more

power passed into the hands of large court families or religious institutions which managed to achieve tax-exempt status. Education was for the more exalted classes and the lot of the poor was hard.

Chinese Influence

Culturally the main effort was spent in a sincere struggle to understand and absorb Chinese Buddhism and, to a lesser degree, Confucianism. It is important to appreciate that by the time Buddhism arrived in China in the first centuries A.D., Confucianism had already had centuries in which to establish itself. In Japan, however, the two arrived together and, although the Japanese paid lip service to the admirable tenets of Confucianism, it was Buddhism which fired their imagination. In this they were only following the Chinese tendency of the time. Buddhism was then the more vital force. It appealed to the spirit rather than to the intellect and to the common man as much as to the upper classes. Confucianism was a somewhat dry, ethical code more attractive to the scholar and the ruling classes. It only began to influence Japanese society deeply in the Tokugawa period (see later).* The egalitarian aspect of Confucianism and the concept of the "mandate of heaven," whereby an evil ruler forfeited his right to the throne and could be supplanted by a popular uprising, made no appeal to the Japanese aristocracy. They believed not only in the divine right but in the divine origin of the emperor. There could be little flexibility in such a fundamental concept which combined in the Japanese emperor the powers of both a high priest and a secular ruler.

Whereas in China there was room for the rise of great dynasties popularly supported and universally esteemed, in Japan the imperial power was generally only delegated to whoever happened to be strong enough to force his will on the emperor. This tended to rob the *de facto* ruler of that sense of ultimate responsibility without which government becomes at its best bare opportunism and at its worst ruthless exploitation. The ruler's aim was often only to maintain his power, and politics easily degenerated into a merciless struggle for power. The hope that the quietist tenets of Buddhism might calm the leaders of unruly clans was not realized. In subsequent cen-

* For a good short summary of the influence of native and imported religious beliefs see Edwin O. Reischauer, *The Japanese*, pp. 213–24 (in Bibliography).

turies Japan suffered badly for its failure to reach the more subtle Confucian springs of Chinese culture. In the realm of art it is possible to attribute the Japanese weakness in Chinese-style landscape painting partly to a lack of Confucian training which, like Taoism, urged man to seek unison with nature. This is the philosophical root of much Chinese painting and its absence in Japan contributed toward the fundamental differences between their two arts.

Nevertheless, what the Japanese lacked in depth of understanding was balanced by their energy and enthusiasm. A sign of the tremendous vitality of this early age is clearly seen in the rapid creation by a comparatively undeveloped society of a large and skilled class of artisans capable of producing works of art on a scale and of a quality which compare well with those of China. Many foreign craftsmen had come to Japan, taught the Japanese, and intermarried with them, thus becoming an integral part of their thriving society. As the Japanese craftsmen came to age and independence so, by selection and emphasis, they began to put their stamp on Japanese art.

In its direct contact with T'ang China, Japan not only came a step closer to the ultimate source of Buddhism but it also took this step at a time when China itself was closer to India. China, we must remember, was as anxious to have intimate contacts with the Indian wellspring of Buddhism as were the Japanese to learn from China. Many Chinese pilgrims from the fifth century onward overcame great hardships in their travels across central Asia to India where they studied at the fount of Buddhist learning. There and on route they saw examples of Buddhist art in the full flood of late Gandharan and Gupta styles.

The origin of the styles of Buddhist sculpture introduced into China and developed there presents a very complicated problem to which no easy answer can be offered. Some scholars claim that they came from the northwest Indian Gandharan styles which contained a great deal of Hellenistic influence. Others have suggested a central Indian origin from the great Gupta dynasty which reached its height ca. 375–490. Discoveries in central Asia, on the other hand, have shown that along the northern and southern routes to India which skirt the Tarim basin considerable Buddhist colonies flourished in Khotan, at Karashahr, Kucha, and Kashgar. Chinese contacts with these central Asian kingdoms and settlements were frequent. The military power of the Northern Wei state compelled these colonies

to pay tribute and even to send Buddhist teachers with all their religious equipment.

As far as Gandharan art is concerned, it appears that there were two marked styles—an earlier Gandharan style influenced by Hellenistic modes and a later Gandharan style which was strongly oriental in its approach. A characteristic of the later style is the use of stucco and clay which enabled the sculptors to model far more freely than is possible in stone (fig. 28).

It may be possible in time to establish the existence of a central Asian style which received strong influences from later Gandharan sculpture, from central India (especially in painting), and from Iran. The basically sensual forms came from India, the complicated crowns and floating ribbons are probably of Iranian origin, while the drapery owes much to Gandharan prototypes. In central Asia these styles merged and were then probably introduced into China. All we can say is that the Chinese styles were the result of mixed influences brought to China by a complicated route and there developed along individual lines.

Early Works in the Chinese Style

The most typical expression of the tradition brought from India and central Asia as interpreted by the Chinese and taken over by the Japanese is the gilt bronze Kannon Bosatsu or Shō Kannon (fig. 29) in the Yakushi-ji (Yakushi is the Buddha of healing, one of the Buddhas of the Four Directions) in Nara. No records exist to help in dating this statue accurately. On stylistic grounds it could be placed in the early Nara period. The body beneath the robe is more evident and at the same time more graceful than in works of the preceding period. It begins, but only just begins, to have the warm living quality which we associate with Chinese T'ang sculpture. The curves and lines of the flesh are still smoothed over in a tentative manner; the pose is still rigid. The constricted waist, full chest, and transparent "wet" clothing reflect faithfully the Far Eastern interpretation of Indian or central Asian modes. Traces of the Yün-kang and Lungmên styles persist in the flaring skirts, but these suggest a lifeless, almost automatic anachronism. Japanese scholars find in it an air of gentleness and serenity not found in its continental prototypes.

The Gakkō ("Moonlight") Bodhisattva in figure 30, sometimes called the finest T'ang sculpture to survive, shows this style as fully

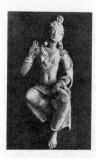

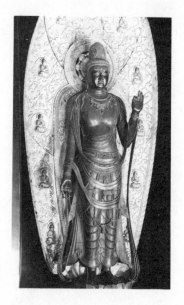

28. Bodhisattva from Fondu-kistan (Afghanistan). Ca. seventh century. Stucco. Height: 2 ft. 3 in. Kabul Museum. Photograph courtesy George Butcher.

29. Kannon Bosatsu or Shō Kannon. Early Nara period. Bronze. Height: 6 ft. 3 in. Yakushi-ji, Nara.

developed some forty or fifty years later, ca. 720. It belongs to the same temple, the Yakushi-ji, and is one figure of a triad with a seated Yakushi Buddha in the center. These figures, over ten feet in height, are of a scale that no longer exists in China. The bronze has turned almost black with time. A tremendous change has taken place in this half-century. All the remaining stiffness of the earlier work seems to have melted. The stance is now completely relaxed with the hips strongly bent. What is called in Sanskrit the *tribhanga*, or "thrice bent" pose, removes the last traces of rigidity from the portrayal of the human form. With the indolent sway, the tension disappears and the new T'ang qualities of monumentality and majesty are joined to sensuality. The flesh is rounder and fuller, as if studied with pleasure from a well-covered model. Movement now enters Japanese sculpture. The body is sharply distinguished from the heavy, freely flowing drapery which hangs about it. The outlines of the torso flow with a more generous movement as if in sleepy sensuality. The last traces of the archaic smile have gone and more human characteristics are designed to impress our senses (fig. 31).

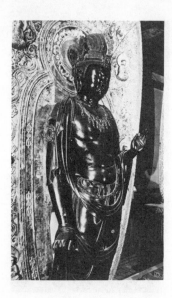

30. Gakkō ("Moonlight") Bodhisattva, one of the attendants to the main Yakushi Buddha. Ca. 720. Bronze. Height: 10 ft. 3 in. Yakushi-ji, Nara.

31. Detail of the companion figure to Gakkō Bodhisattva in figure 30.

It is interesting here to turn back a few decades to the large bronze head (fig. 32) discovered in 1937—all that remains of a huge bronze statue some sixteen feet high which originally stood in the Yamadera, a temple completed in 685. The head dates to about the same time. Here the human modeling inspired by the late Gandharan heads is seen at its best. The sculptural terms used to portray an idealized humanity require no knowledge of Buddhism for their appeal. Japanese scholars are sharply divided on the influences which contributed to this head. Some claim that it shows fully developed T'ang elements, others that it is under very early T'ang influence. Certainly it comes from a time before the rich modeling of T'ang sculpture began to appear in Japanese art. But, as in the Kōryū-ji Miroku, the lyrical approach and the tender expression are essentially Japanese. The unfailing sense of form and the clear-cut simplicity, which form one side of the Japanese aesthetic tradition, are in this head shown in one of their earliest manifestations. A most convincing calm radiates from the features which recall the moving power of the Asuka-period masterpieces and yet look forward to the vivid portraiture of late Nara times.

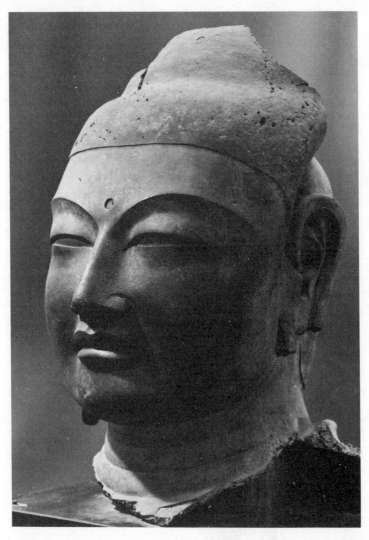

32. Buddha head. Dated 678. Bronze. Height of head: 3 ft. 6 in. Kōfuku-ji, Nara.

The Persistence of the Native Tradition

The change brought about by the introduction of the rich T'ang styles in the seventh century can be exaggerated. Popular traditional types persisted and, as the Yama-dera head shows, much remains of the simple reverence of the Asuka period. The Japanese craftsmen sometimes clung to their earlier visions of the Buddha as a gentle, benign divinity, but more often they exercised their skill in depicting an elegance demanded by a society whose tastes were becoming more sophisticated and applied themselves to the problems of representing the complicated iconography which came with T'ang sculpture. Thus in works of the period they sometimes seem to be more absorbed in the complicated trappings such as glittering haloes and precious jewelry than in the sincere faith which the gods were supposed to radiate.

One of the most perfect examples of the happy union of Asuka and early Nara styles is seen in the Hōryū-ji Kannon, popularly known in more recent times as the Yumetagae Kannon (fig. 33). *Yumetagae* means "to change dreams" (from inauspicious to auspicious omens). Here a balance is held between the voluptuousness of

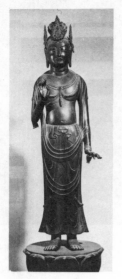

33. Yumetagae Kannon. Early Nara period. Bronze. Height: 2 ft. 10½ in. Hōryū-ji, Nara.

the T'ang and the quiet simplicity of the Asuka styles. The slight, almost imperceptible sway of the figure, more forward than sideways, gives a sense of gentle movement. The sloping shoulders and sensitively carved arms have a flowerlike quality. The lotus base is a later restoration but the original must have been very similar; the whole rhythm of the statue echoes the graceful lines of its petals. The crown, with a Miroku Buddha in the center, balances the proportions of the head. In both the crown and the jewelry which hangs on the breast, the sculptor has resisted the temptation to indulge in an iconographical *tour de force*. The drapery of the skirt shows delicate restraint and even the bottle in the left hand, said to hold the elixir of immortality, has not been overstressed. The same can be said for the gesture of assurance in the right hand. Yet in spite of all the gentle rhythm of this most gentle of "compassionate" bodhisattvas there is no loss of power. The face has the humanity and inspired faith of the Yama-dera head but in the lips there is the sweet, worldly softness of the T'ang models seen in many Chinese clay tomb-figures and in the few paintings which have survived. The eyes, though almost closed, dominate the face. They appear to express the characteristics of forgiveness, forbearance, and the attainment of truth through contemplation—the simpler concepts of Buddhism which attracted the early Japanese adherents to the faith. The figure is a calm introduction to the thunderous majesty of the late Nara or Tempyō masterpieces.

The Golden Age of Japanese Sculpture

The late Nara period (712–94) is sometimes called the Tempyō period from the Tempyō era (729–49), the most important twenty years within it. Many historians, both Japanese and Western, consider it to be the golden age of Japanese sculpture, a period when complete technical mastery combined with the deepest inspiration created the finest works in the history of Japanese sculpture.

In the one hundred and fifty years which had now passed since the introduction of Buddhism, the religion had made tremendous strides. It had become more accessible to all classes, and provincial temples and nunneries had been opened to bring the message to all parts of the country. The central treasury had paid for the building and furnishing of many new temples, and the direction of religious matters was concentrated in Nara. Buddhism held the position of a

national religion, and a vigorous court in the capital encouraged, financed, and protected it. Everything in the Nara period was done on what seems to us an almost megalomaniacal scale. The Japanese seem to have devoted their full energies to spreading the faith.

Contacts with the Chinese became ever closer, and embassies sometimes five-hundred strong visited the T'ang court bringing back with them paintings and sculptures from the very center of Chinese civilization. No actual example of one of these imported sculptures has survived but certainly by now the Japanese were thoroughly familiar with the art of the religion which they had adopted and they began more confidently to impress upon it their own native characteristics.

What are these native characteristics? Some Japanese scholars say that they are "neatness and prettiness," but that hardly does justice to the magnificent images of the late Nara period any more than it would characterize the sculptures of Chartres. Perhaps the outstanding quality of the work of this period comes from the Japanese fascination for surface and texture which at its most sensitive infused their works of art with a rare living quality. Another important characteristic of the period is the attention to line. This can produce the grand sweeping outlines of an early Yumedono Kannon, though it can also lose itself in the fussy trivialities of a T'ang-inspired but overdecorated bodhisattva. In Tempyō art, the artists held line and decoration in masterly balance, and subordinated both to the deep religious idealism which inspired them. The statues have a solidity and fullness which we do not see in the art of other periods. The Buddhism which gripped the nation allowed nothing of the sentimental sweetness of later Buddhism. To look at the sculptures of the period is to be moved by the living force of their creators' beliefs— sometimes tender, sometimes terrifying. But mild or austere, at rest or in violent motion, they are imbued with sincerity and conviction. By comparison, many of the later sculptures look like empty shells. Here is an idealism and a religious art which can compare with any in the world.

Clay Sculptures and a New Phase of Buddhist Thought

In the late Nara period there was a great advance in the already highly developed Japanese ability to give personality to faces. The striking portraiture of the period may have been due in part to the

use of new materials capable of finer expression. This was the great age of clay and dry-lacquer statuary. The Gakkō Bodhisattva, or Bonten, in the Tōdai-ji ("the Great Eastern Temple"), Nara (fig. 34), shows the same calm inwardness as the Yumetagae Kannon, but the modeling of the face, though still idealized, brings out a human individuality—an impression which is increased by the close attention to the hands, drapery, and hair. The deep chest and broad shoulders, by their disproportion with the head, increase the living quality of the work. The Gakkō Bodhisattva shows the "classical" style in Japan at its most mature—the divinely inspired human sculpted in terms which surround it with an atmosphere of sanctity and serenity. It shows Japanese understatement at its best, a sublime work of art. Most historians state that idealism is the fundamental characteristic of the art of this period. Here, at least, it is founded on a very striking appreciation of human qualities.

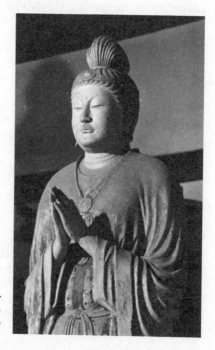

34. Gakkō ("Moonlight") Bodhisattva. Late Nara period. Clay. Height: 5 ft. 10½ in. Tōdai-ji, Nara.

Clay as a material for Buddhist sculpture was well known in central Asia and China. There its plastic qualities had been explored since the first centuries A.D. at least. Chinese historians tell of a great art of monumental clay sculpture but, apart from the provincial works of Tun-huang and large tomb figurines, little has survived to provide evidence of its splendors. It is, however, a most fragile material and it seems almost miraculous that in Japan so many fine early pieces have survived in perfect condition. In these clay sculptures a happy compromise is reached between T'ang richness and Japanese simplicity. The faces, indeed, often look more like portraits than idealizations. The directness of their appeal and the intimacy they create is rarely, if ever, found in the sculpture of China. The makers of these statues approached their subjects more as equals. Their confidence is reflected in every feature. The problems of expressing personality as well as religious faith fascinated them.

There is some confusion about the identity of the Gakkō Bodhisattva and its companion, the Nikkō ("Sunlight") Bodhisattva. It seems that originally these statues were kept in another temple whence they were brought to the Tōdai-ji, located in Nara. Iconographically they appear to be *ten* or *devas*—"divine beings." These were often gods of other religions such as Hinduism and Brahmanism who were incorporated into the Buddhist pantheon of the Mahāyāna, or "Greater Vehicle." If they were "sunlight" and "moonlight" divinities they would usually be shown with a sun or moon among their iconographical attributes. The Gakkō figure, according to many authorities, is probably Bonten, the Brahmadeva of the Hindus, the supreme god, creator of all things. The Buddhists early assimilated him into their pantheon as the ruler of the human world. The two figures must originally have been brilliantly colored with painted and patterned robes and golden hair. The painting has now mostly fallen away to reveal the plain clay beneath. Apart from this, the figures of solid clay are extraordinarily well preserved; even the robes where they pass round the necks still have their sharp edges. This is remarkable, for the damp Japanese climate is most harmful to clay images.

The four heads reproduced in figure 35 give an idea of the heights of expression to which this clay sculpture could rise. They show how close the Japanese had come to the finest art of the T'ang period. In this type of sculpture they may well have surpassed the T'ang. All

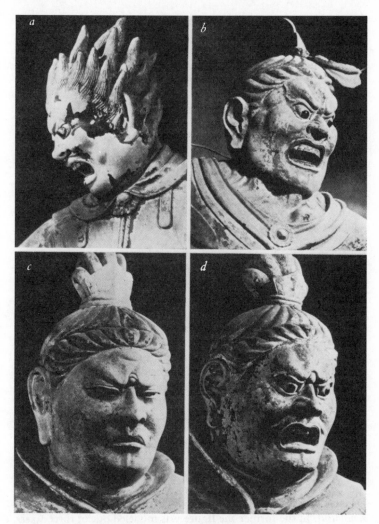

35. Four heads of clay statues. Late Nara period. *a*, Meikira Taishō. Height (of whole statue): 5 ft. 6 in. *b*, Shikkongō-ten (Vajrapāni). Height: 5 ft. 7¾ in. *c*, Kōmoku-ten. Height: 5 ft. 4 in. *d*, Zōchō-ten. Height: 5 ft. The statue of Meikira Taishō is in the Shinyakushi-ji, Nara; the others are in the Tōdai-ji, Nara.

four heads are stern, if not violent, in expression; their furrowed brows and piercing eyes are made even more vivid by the use of obsidian inlays for the pupils, a further move toward realism. They fix the worshiper with their forbidding gaze or stand ready to strike down the offender. T'ang tomb-figures of *lokapāla* go far in this direction but the Chinese with their emotional reticence would probably have been somewhat less effective in communicating the fury of these threatening figures. Symbolic of divine energy, they are the classical forerunners of a stream of images which flowed down into the nineteenth century; they show the Japanese gift for expressing movement and energy which appears in every material from bronze to ivory and in every size from the monumental temple guardian to the lilliputian *netsuke* (see fig. 177).

This type of statue reflects a new phase of Buddhist thought. In addition to the essentially friendly earlier statues with their impassive and contemplative attitude, we find these images which are intended to convey terrifying ideas of punishment for sinners. It is not known which sect inspired them; none of those then popular appear to have stressed this violent side of Buddhism which, generally speaking, belongs to a later period. But as communications improved and T'ang contacts reached out with more ease and security into central Asia, so new doctrines flowed quickly into China and thence to Japan.We must remember that Japan was in touch with the heart of Chinese civilization in the capital and could respond quickly to new innovations. Certainly this ferocious aspect of Buddhism appealed to the Japanese mentality and offered a tempting challenge to the sculptors.

Dry-lacquer Techniques

As the Japanese steadily mastered the basic techniques of sculpture, so too they enlarged their repertoire of images and the range of materials they employed. In addition to bronze and clay, they began to use dry-lacquer in two techniques. These were the hollow dry-lacquer (*dakkatsu-kanshitsu*) and the wood-core dry-lacquer (*mokushin-kanshitsu*). In the former the figure was modeled out of three to six layers of hemp cloth impregnated with lacquer over a light, hollow frame. In the latter, they applied lacquer to a solid, roughly shaped wood-core and the master added the final refinements of modeling in the more plastic material.

The hollow dry-lacquer technique involves difficult processes, which possibly accounts for its being abandoned after this period when the artists discovered the full plastic possibilities of wood. Its products have the advantages of being light and impervious to insects but are very delicate. It is assumed that the method originated in China and that, since hollow dry-lacquer statues were easily transportable, they could be brought to Japan without difficulty. Western museums, notably in America, possess about ten examples from the T'ang dynasty, none of which, however, compares in quality, not to mention state of preservation, with the Japanese masterpieces. As far as we can now judge, it was in Japan that the technique reached its highest development. As happened on other occasions, it seems that the Chinese invented and the Japanese perfected. The magnificent examples preserved in Japan, especially those of the Kōfuku-ji at Nara, now kept in the city's National Museum, give a clear indication of a great art most of which is lost to us.

We can see this unusual technique at its best in two sets of statues—the Eight Guardians and the Ten Great Disciples of Sākyamuni. The whole set of the former has survived but only six of the latter. They can be dated A.D. 734. The three-faced, six-armed figure in figure 36 represents Ashura, a "Spirit of Spirits," a benevolent being who, by both strength and charm, protects the Buddha. The appealing face of this statue has a quite un-Eastern aspect and nothing comparable exists in Eastern art. The clear, boyish countenance with its serious, penetrating eyes radiates an almost discomforting frankness. The straight lines of the body are somewhat sketchily treated and all attention is concentrated on the handsome face. Apart from its esoteric Indian features—six arms and three heads symbolizing his divine omnipotence—the figure is easily intelligible, the faces reflecting a deep, religious faith. Here again the Japanese gift for portraiture, individuality of expression, and accurate, sensitive modeling has placed its stamp on a model ultimately Indian and transmitted through early T'ang China. Opinions are very divided as to whether this statue was in fact made by a native artist. In some ways it is so un-Japanese that it may have been made by, or at least under the instruction of, a Chinese sculptor. The Japanese, like all people who accepted Indian religious ideas and the art which went with them, have from time to time become fascinated by such many-headed, many-armed deities which sprang from the fertile

36. Ashura. Dated 734. Hollow dry-lacquer. Height: 5 ft. Kōfuku-ji, Nara.

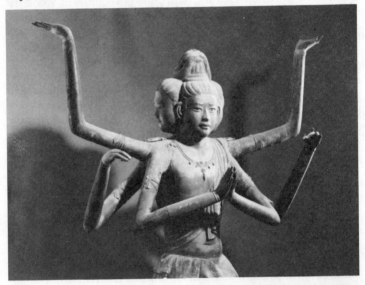

37. Vairocana Buddha. Dated 759. Hollow dry-lacquer. Height: 10 ft. Tōshōdai-ji, Nara.

Indian imagination to people the rich pantheon of Mahāyāna Buddhism. But it is open to question whether these figures ever appealed as strongly to the Japanese as to the Indians. The Japanese were probably less attracted by the systemization which is characteristic of Indian religious thought. There is a certain confusion of purpose in the carefully developed features as compared with the sketchily indicated arms. The Japanese fondness for the grotesque provides many examples of how they were always ready to exploit the possibilities of fantasy, but it was a fantasy which generally sprang from a sense of humor or drama, as in the masks, or from simple imaginative emphasis, as in the terrifying deities. Iconographic peculiarities involving physical abnormalities appealed to them only momentarily, and the statue of Ashura, for all its symbolism, remains essentially an individual human figure.

The soft, sensitive modeling possible with hollow dry-lacquer was not always so successfully employed. The large Vairocana Buddha (the Buddha whose light is shed throughout the universe) (fig. 37) in the Tōshōdai-ji at Nara, for example, appears to the Westerner more as a T'ang-style *tour de force* in the dry-lacquer technique than a moving creation of religious faith. The Vairocana Buddha or, as the Japanese call it, the Birushana Buddha, became popular as a main deity, the center of the universe, in this period. This is the Buddha whose light shines everywhere; it was considered the essential body of Buddha-truth, the eternal Buddha from which all the other Buddhas are supposed to emanate. Only two statues of Vairocana exist in Japan, the other being the great bronze Buddha in the Tōdai-ji. But subsequently a derivation of this figure, the Dainichi, or "Great Sun," Buddha, became very popular. The dry-lacquer Vairocana is beautifully proportioned, and with its Thousand Buddha nimbus behind achieves an impressiveness in keeping with the subject. But the features, for all their stern dignity which the Japanese greatly admire, are somewhat gross, and the figure lacks the sincere inspiration and the gentle modeling of other statues of the period.

The same temple also houses what has often been considered the finest example of portraiture to survive from this early period. This is the seated figure of Priest Ganjin (fig. 38), a Chinese prelate who, at the invitation of Emperor Shōmu, came to Japan in 753. In the course of his six efforts to reach the islands he lost his eyesight, but he lived to teach the faith and to found the Tōshōdai-ji. He died in

763. According to tradition he brought Chinese workmen with him who made the Vairocana Buddha. As Sherman Lee says, "It was at this time that the individual merit of a monk was recognized and the representation of this merit in an image was considered an aid to worship and to right living."[2] His portrait shows all the possibilities of hollow dry-lacquer modeling. Sharp lines are softened by lacquer which smoothes over all transitions between feature and feature, body and drapery. The drapery is not too closely studied and the thin frame of the ascetic is only briefly suggested by gentle swellings where the bones show through the skin. Here is restraint used most effectively. Our attention is immediately drawn to the poignant, sightless eyes, turned inward in deep contemplation, and to the very sensitive mouth with its almost martyrlike expression. Seldom has a finer representation of saintly faith and meditation been produced in art. It is difficult to see whence comes the power of this statue; the features are not in themselves strong or distinctive and every line is muted. But the artist, said to have been Ganjin's own pupil, has given them a radiant calm and sense of serene security which comes of inner triumph. His interpretation enriches the whole of the art of the Nara period and greatly influenced subsequent portrait sculpture.

The most famous wood-core dry-lacquer statue is the Jūichimen Kannon, "the Eleven-headed Bodhisattva of Compassion" owned by the Shōrin-ji, Nara (fig. 39). Each of the small subsidiary heads is intended to represent a different aspect of the divinity, while at the very top is a Buddha head which symbolizes the final enlightenment. The plastic treatment of the body is entirely successful and the swirling drapery moves naturalistically; many of the details such as the hand are exquisite, but the elegant lines of free-moving T'ang modeling have here been made heavier. The face is full and solemn and the work has great strength and vitality. Yashiro considers it to be "one of the greatest masterpieces in the whole of Japanese sculpture, . . . one that can challenge the achievements of any nation."[3]

The wood-core dry-lacquer method seems only to have been a passing phase; gradually the carved wood-cores were more accurately modeled until the final lacquer coatings became unnecessary and the Japanese artists returned once more to the wood in which their genius always found its most congenial material.

38. Priest Ganjin. Made soon after 763. Hollow dry-lacquer. Height: 2 ft. 7½ in. Tōshōdai-ji, Nara.

39. Jūichimen ("Eleven-headed") Kannon. Late Nara period. Wood-core dry-lacquer. Height: 6 ft. 10½ in. Shōrin-ji, Nara.

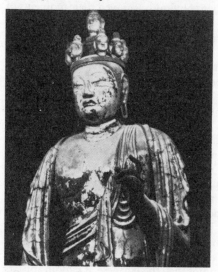

Gigaku Masks

To turn from this to the masks of the period (fig. 40) is to see Japanese humor and technical mastery running riot. The dances in which these masks were used were performed in temples on great occasions, and the most splendid of these must have been the consecration, in 753, of the Tōdai-ji in Nara. The example shown here was used on that memorable occasion and has been preserved in the temple itself. The meaning of these *gigaku* dances or posturings has never been explained and no examples of the masks have survived in China. It is always assumed that they came from China, and they do indeed show strong traces of Chinese and central Asian imagery, but the evidence is lacking. They may equally well be a spontaneous production of a postulated southern strain in the Japanese race, for such masks are a characteristic of many southern peoples. It is as if the solemn development of early Eastern sculpture had for a moment been interrupted by these masks with their infallible sense of caricature and exaggeration. In the flickering light of pine torches their grotesque power was then, as now, most exciting. The strong mark these masks left on Japanese artistic taste is seen in countless reflections in many kinds of material through the succeeding ages. The craftsmen who produced them obviously enjoyed their moments of relaxation from the more serious tasks of circumscribed religious sculpture, and they show the spontaneity and quick observation, the sophistication and wit of a very mature people. Nothing could be farther from the lifeless products of patient copyists. They act as perfect foils to many of the noble figures which sit so impassively within the temple halls. Could it be that this is the portrait of a monk? It is the travesty of a figure that belongs to all times and every religion—the sharp, prying nose and good-humored brow, the cheeks and eyes wrinkled with laughter. Might it not represent the popular but not overintelligent priest, the ineffectual overseer and the butt of everybody's jokes? If Nara could thus throw off its heavy ecclesiastical atmosphere it cannot have been a dull place. These occasional glimpses into the amusements of a perceptive artisan reveal a peculiarly attractive side of Japanese art which has only recently disappeared. The Japanese sense of fun is more acute and comes to the surface in art much more readily than that of the Chinese. It is interesting that, although as a people the Chinese have a far readier sense of humor than the Japanese, it seldom appears

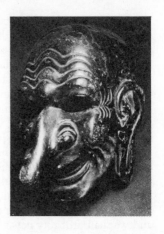

40. Mask for *gigaku* dance. Dated equivalent of 750. Wood; colored red. Dimensions: 11⅞ in. × 9 in. Tōdai-ji, Nara.

in their art. The reverse is true of the Japanese. The ability of artists to cause a smile is an endearing characteristic of almost all periods of Japanese art.

Painting

Paintings are, of course, far more easily transportable than sculpture. The monks who visited China could bring back models (either copies or originals) and one might, therefore, expect painting to reflect its Chinese origins more immediately and more faithfully than sculpture. It is, indeed, often difficult to say whether an early painting was done by a Japanese or a Chinese artist but the tendency recently has been for Japanese scholars to claim that more and more early works of art are native products rather than Chinese importations. An interesting non-Buddhist example of this can be seen in the detail of a portrait of a woman in figure 41. This comes from one of six paper screens entitled *Beauties under Trees* and now preserved in the Shōsō-in (see p. 86); three of these screens have seated and three have standing figures. Only the underpainting of the body remains, but the face, lightly colored and with lips indicated in a more brilliant red, preserves its original appearance. When placed in the Shōsō-in, real feathers were attached to the body itself in imitation of a dress style said to have been popular in China at that period, but these have long since fallen off to leave only the outline.

We may assume that this picture shows the typical mid-T'ang type of feminine beauty as seen also in a thousand Chinese tomb-figures preserved from that time—a plump matronly body, full face and thick tresses of hair, tiny delicate features set in rounded cheeks. All the elements of Far Eastern figure painting are here fully formed—the emphasis on flat planes and outline and the so-called calligraphic line, a vivid sense of movement and a lack of modeling. In the last resort it is impossible to say whether this painting is in fact Chinese or Japanese but elements of Japanese taste can be claimed for it—an alive, personal quality, a sentimentality and softness which are absent in what we understand by T'ang painting of such figures if we can judge from the little that remains of them. Above all the face seems to have more personality and animation and the figures more freedom of movement than the Chinese. But all this is speculation and we shall probably never be able to say more of this painting of an elegant lady under a tree than that it dates from the first quarter of the eighth century when the civilization of the T'ang saw its most brilliant age.

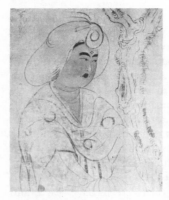

41. Detail from the screen *Beauties under Trees* showing portrait of a woman. First quarter of eighth century. Ink and color on paper. Dimensions of screen: 4 ft. 1½ in. × 2 ft. 2 in. Shōsō-in, Nara.

42. View of the Hōryū-ji compound, Nara, showing the Kondō ("Golden Hall") and the Five-Storied Pagoda.

The Murals of the Hōryū-ji

The few relics of mid-Nara painting are valuable for the light they throw on the arts of China and Japan in that early period. But they are overshadowed by the greatest example of early Eastern religious wall painting, the murals of the Hōryū-ji. Of these, the art historian Tōichirō Naitō remarked, "Indeed it is not too much to say that they represent the highest achievement of Mahāyāna Buddhist painting and the peak of the development of Far Eastern art."[4] In 1949, exactly ten years after Naitō's death, the temple's main hall, the Kondō (fig. 42), which contained these paintings, was burned out in a disastrous fire, and the paintings were scorched to little more than black-and-white outlines. The disaster can only be compared to a loss, say, of the Giotto frescoes. It must also be remembered that they were painted on the walls of one of the East's most treasured monuments, for the Kondō itself was among the oldest and architecturally most important buildings in Japan. Fortunately, just before their destruction a publishing firm had successfully photographed them in color and we therefore have a good record of their original appearance.*

There has been long controversy about the age of the building and the murals which it contained. Modern scholars have concluded that the original Kondō was burned down in 670 and then rebuilt as nearly like the original as possible. They claim that the paintings could not have been done after 741 and most likely were painted about 710.

Not only the date of these figures has been difficult to determine but also what deities they represent. Four wide panels contain trinities and eight narrow panels contain single figures. The theory now held is that the four large central panels depict four Buddhas who were particularly popular objects of worship at that time: Amida, Yakushi, Sākyamuni, and Miroku.

The tradition of wall paintings is, of course, an Indian one of long and impressive lineage. Outstanding examples have been preserved at such sites as Ajanta and Bāgh in central India. Such eminent scholars as Stein, Pelliot, Grünwedel, Lecoq, Kozlov, and Otani surveyed the route by which Buddhism came into northern China,

* These photos appear in *Wall Paintings of the Horyu-ji Monastery*, with an introduction by Ichimatsu Tanaka (Tokyo: Benridō, 1951).

across the Pamirs and the Takla Makan Desert, and they discovered many wall paintings in Turfan and Tun-huang at the gate to central Asia and at other places along the route. These are mainly provincial works and cannot compare in quality and sophistication with the twelve Hōryū-ji frescoes. Who did them with such mastery in this outpost of the Buddhist religion remains a mystery. Even their source of inspiration is disputed. Naitō, for example, claims that they spring directly from the paintings of Ajanta in India while Benjamin Rowland and the French scholar Jeannine Auboyer deny this and find their models in central Asia and northern China. This would appear to be more probable.

The majestic figures were outlined in strong red lines of even thickness. A type of shading, a most unusual feature in Far Eastern art, was used, but more for emphasis than for volume. This, like the draperies, is ultimately inspired by Indian painting. Cave Temple I at Ajanta, dated from the fifth to sixth century, gives an idea of how strongly the Indian manner of painting bodies, facial expressions, and transparent clothing influenced all Buddhist artists from central Asia to Japan. The Japanese, however, have stilled and spiritualized the figures, simplifying the riotous compositions which the Indians enjoyed and could handle with such complete confidence. This simplification is seen in its earlier stages at sites like Turfan in central Asia and in Tun-huang, but the conclusion of the movement, a fitting climax to the art of Nara, is found in the Hōryū-ji. No comparable wall paintings of this period have survived in China but from literary records it appears that their style may have owed much to that introduced into China by a central Asian painter with the Chinese name Wei-chih I-seng who, according to the historians, used brushstrokes "appearing like iron wire bent into shapes," in other words, different from the variable thickness of later calligraphic styles. The heat of the fire, though it destroyed the colors, brought out parts of the drawing hitherto not visible and these give support to a theory that, as in India, stencils were sometimes used for the outlines.

The detail shown in figure 43 is the head of a Kannon Bodhisattva, the attendant to a seated Amida Buddha in a Paradise of the West scene. Even in these reproductions of works which have been fading for twelve centuries, one can see that they share with some of the early sculptures that earnestness and confident sincerity which charac-

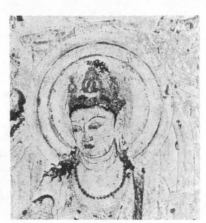

43. Detail from the wall paintings of the Hōryū-ji Kondō, Nara, showing a Kannon Bodhisattva. Ca. 710. Dimensions of whole mural: 10 ft. 10 in. × 8 ft. 6 in. Destroyed by fire in 1949.

terize Japanese religious art. How skillfully the painter has slightly turned the head to look down kindly at the worshiper! How well it balances and softens the steady frontal gaze of the central Buddha! How brilliantly the red and gold crown and the necklaces of rubies and emeralds must once have shone, the emeralds catching up the green in which the hair is depicted!

As a people newly converted, the Japanese were always ready to give a warm welcome to some new missionary or learned priest from China, and they eagerly awaited the latest artistic developments from the mainland. Each one must have appeared more astonishing than the last. The most popular belief of the time was that of the Jōdo, or "Pure Land," sect: salvation was seen as rebirth into the western paradise, and this could be achieved by worshiping the Amida Buddha with sincere faith. The Hōryū-ji painting is of a western paradise and is modeled on the luxury of a Chinese T'ang-dynasty imperial court. Local artists must have seized on everything that was new and exciting and they worked hard to do justice to them. The picture we have is one of a whole society with single-minded faith devoted to the creation of a beautiful, pious city. Even to see, some years ago, the Japanese craftsmen rebuilding the Kondō as an exact replica of the one destroyed was to sense that same energy which built the city and which has perpetuated Japan's artistic heritage through the ages.

The E-Ingakyō

Another survival from the eighth century is the fragments of a painted scroll depicting scenes from the lives of Sākyamuni. It is entitled *E-Ingakyō* ("The Illustrated Sutra of Causes and Effects in Past and Present") and is dated 735 (fig. 44). The pictures illustrate the text below. As the somewhat hack work of a Buddhist copying bureau which aimed at disseminating the faith by simple pictorial means, they do not pretend to be profound or even highly skilled works of art on a level with the Hōryū-ji wall paintings, but their form is interesting since it foreshadows the Japanese *e-makimono*, or painted handscrolls, of later times (see p. 154 ff.) in which the Japanese developed in a unique way their fondness for illustrated stories. These somewhat naive little scenes, though of inferior artistry, recall the paintings on the Tamamushi Shrine (see p. 53) and, of course, Chinese T'ang-dynasty wall paintings in the Buddhist caves at Tun-huang. Like them, they depict outstanding events in Sākyamuni's life. There is little or no characterization in the faces and all other elements are expressed by the simplest means. The landscape features are highly schematized in a manner which adds much to the charm of the composition and are important for the evidence they give of early pre-T'ang landscape styles. The artists completely disregarded natural proportions but attempted simple perspective and three-dimensionality. Fragments exist of several sets of these pictures and probably large numbers of them were made at the time. They employ the same conventions to tell their stories: a group of people, a pavilion or a walled castle, a few dwarf mountains or some rocks and trees. There is no attempt to give more than the barest essentials necessary to set the scene. But for all their brevity they show a strong dramatic feeling and a skillful narrative sense. Their very forthrightness has the same appeal as some of our medieval landscapes. If these were the inconsidered, mass-produced works of a bureau, how much more must we regret the many lost treasures of T'ang Chinese and T'ang-inspired Japanese art.

The Daibutsu and the Shōsō-in of the Tōdai-ji

The greatest artistic event of the late Nara or Tempyō period was a national undertaking to construct in the Tōdai-ji at Nara a giant seated-Buddha figure in gilt bronze some fifty-three feet high. This huge monument to the religious fervor of the people illustrates how

高侍若為信於佐
學道一切眾生愛別
別離唯願皆悉我出家
至言恩愛集會必有
令坐太子坐巳白父
父王即便抱之而勅
既至頭面作礼今時
山言憂喜交集太子
于今者來大王所聞
白見巳而白王言太
如帝釋注詣梵天傍
父王所威儀序猶
宗之時而便往至於
自思惟我今正是出
令時太子年廿九心
妙伎女以娛樂之
離太子時王復增嘆
然而住行止坐臥不
聞勅巳心懷輾娛嘿
那輸陀羅那輸羅
如所思惟即便勅作
去而不知既作是令
涉着等為信於佐

44. Detail from the *E-Ingakyō*
illustrated sutra. Dated 735. Ink
and color on paper. Height: 10½
in. Agency for Cultural Affairs.

deeply Japan was steeped in the faith. But it was an ambitious enter-
prise which heavily taxed the resources of a rapidly expanding
nation, already fully stretched to build other temples and to stock
them with their equipment and religious finery. The clumsy, ugly
figure as it now exists bears little resemblance to the original, which
has suffered greatly from fires and bad restoration. But the size alone
of this Daibutsu, or "Great Buddha," within a room which, although
considerably smaller than the original one, is still the largest wooden
building under one roof, gives an indication of the breathtaking
sight it must once have presented. Only a few of the huge lotus
petals which form the base of the statue and which are incised with
graceful designs (fig. 45) show the splendid workmanship of its
creators who, in casting this colossus, were following the tradition
of the giant stone and clay Buddhas of Bamiyan in Afghanistan and
of such Chinese sites as Yün-kang. We can only imagine the excite-
ment of the bronze casters, as section upon section the Daibutsu
grew toward completion, if we compare it with that of the builders
of our great cathedrals, as they rose tier upon tier into the sky.

Auspicious omens marked the end of the work—perhaps the most fortunate being the discovery of a gold mine in Japan which enabled the gilding of the huge figure to be completed. The statue was dedicated amidst scenes of pomp and fervor in a splendid "eye-opening" ceremony when with a large brush the eyes were painted in. Four years later, in 756, the empress gave the complete household equipment of her late husband to the Tōdai-ji. The thousands of objects included in the gift were stored in the Shōsō-in, a huge log-cabin raised on great pillars, which was built in the forest near the temple to house them. This, the oldest surviving "museum" in the world, has stood there almost untouched through the succeeding twelve hundred years, preserved only by the sanctity surrounding the royal house and by the inviolability of the imperial seals on its doors. Experts open it with the greatest reverence once a year for the traditional airing, and many of its objects are not fully catalogued yet. However, in the last twenty years, work on this has been proceeding apace and selections from the treasury are regularly on display at the Nara National Museum. As one would expect of this sinophile court, the majority of the objects are of Chinese origin—musical instruments, armor as shining as on the day it was made, medicines, glass, pottery, and all the trappings of an imperial household. To walk round this vast storehouse and, with the aid of a torch, peer at a few of the objects so carefully preserved there is a most eerie and moving experience.

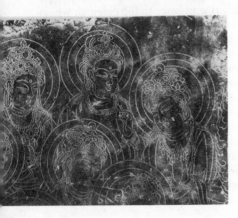

45. Rubbing of a design on one of the lotus leaves forming the pedestal of the Daibutsu ("Great Buddha"). Eighth century. Bronze. Height of entire leaf: 7 ft. 4½ in. Tōdai-ji, Nara.

However, not all the objects found in the Shōsō-in are of Chinese origin, and some of the contemporary native works which it contains show how rapidly the Japanese were mastering the techniques required to copy the treasured Chinese models. This is particularly true in the field of ceramics. The most frequently encountered type of Chinese T'ang-dynasty pottery is characterized by a three-colored glaze of green, brown, and cream on powerfully yet sensitively shaped vessels—the so-called Shōsō-in three-color ware. Similar wares, but not from the repository, are called Nara three-color ware. Thousands of these have been excavated from tombs in China and most museums contain splendid examples. A considerable quantity of this pottery has been found in Japan and whereas it was once usual to refer to it as yet another importation, Japanese scholars now assert—with considerable archaeological evidence to support their claim—that, though modeled faithfully on the Chinese, it is Japanese made. Green-glazed tiles from temples of a slightly later period show that the Japanese could have made such pottery. The bowl in figure 46, unearthed in Ibaraki, Osaka, is an excellent example of the Nara three-color ware with a shape strongly reminiscent of Sue ware and with a glaze somewhat decomposed from burial. It is confidently potted and sturdy in shape, but the smooth, well-fitting lid gives it distinction and elegance. This simple bowl, probably used for cremated human remains, is the result of a most accomplished tech-

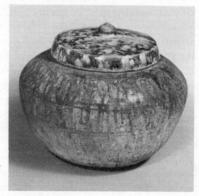

46. Pottery bowl. Eighth century. Three-colored glaze. Height: 6¼ in. Tokyo National Museum.

nique and shows the eagerness of the Japanese to learn not only the religious but also the secular arts of their Chinese teachers. The difference between this and earlier wares provides, in its humbler way, as eloquent an indication of the great leap forward taken by the Japanese as do the more elevated arts of painting and sculpture previously described. A Chinese Yüeh-type jar now in the imperial collection was preserved in the Hōryū-ji since the Nara period, and the Japanese were thus not deprived of examples of the best ceramics that China could produce. Fujio Koyama claims that they were imitated in Japan, which provides an indication that the Japanese had very skilled techniques at their command at this early time.[5]

In metalwork, the Japanese joy in their newly found freedom of expression and in the seemingly endless possibilities that Chinese art and techniques offered is no less remarkable. A youthful bodhisattva on one of the panels of a cast-bronze lantern (fig. 47) which stands outside the Tōdai-ji seems to move freely to the music of his own flute. His celestial robes billow with graceful ease across the latticework, their curves taken up and reversed in the scrolls at the edges. The folds of the robes have an impish carelessness admirably suited to the boyish face, and the whole composition has a pertness emphasized by such happy touches as the way in which the scarf, coming up from the right of the head, curls upward and then down behind the halo.

Lacquer, it will be recalled, was used on the Tamamushi Shrine (see p. 53). Historical records provide evidence of the importance attached to the encouragement of the craft. A legal code published in 701 mentions the establishment of an Office of the Guild of Lacquerworkers and encourages the cultivation of the lacquer tree: "Each farmer employing six hands and over should, during the ensuing five years, plant eighty lacquer trees on his ground, those employing four hands, seventy trees, and those employing three hands, forty trees." Where an area was particularly productive of lacquer, taxes could be paid in the material. Lacquer found its most exalted use in the making of religious sculptures but this was only a passing phase and it is with respect to its secular decorative uses that we shall be mostly concerned.

The Nara period was a time of apprenticeship and experiment for Japanese workers. Lacquer was applied to leather and hemp but these methods proved unsatisfactory and were soon abandoned. The oc-

tagonal mirror box (fig. 48) from the Shōsō-in, however, is a rare example of the lacquer-on-leather technique and of a type of decoration in which gold and silver were mixed with glue and then painted on. This was a forerunner of the *maki-e* technique (see later) in which gold and silver dusts were sprinkled on wet lacquer. Despite the clumsiness of the method, however, the design is very skillful. It is probable that this box, like the majority of Shōsō-in objects, came from China, but again no Chinese examples have survived. In design it reminds one of Chinese silverwork—in particular the lively birds descending on a pond filled with imaginary flowers called by the Japanese *hosoge*, "flowers of precious appearance." The simplification of the wings and feet of the birds and the arrangement of the flowers are indications of a style which, in its maturity, suggests a Chinese rather than a Japanese origin.

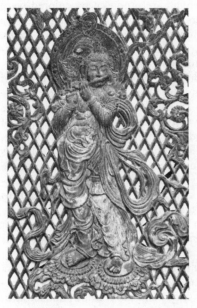

47. Detail from a panel of a cast-bronze lantern showing a bodhisattva playing a flute. Late Nara period. Dimensions of one panel: 3 ft. 10 in. × 1 ft. 5½ in. Tōdai-ji, Nara.

48. Octagonal mirror box. Nara period. Lacquer on leather decorated with gold and silver. Diameter: 8½ in. Shōsō-in, Nara.

The development of the textile industries kept pace with those of all the other arts. Just as the legal code of 701 encouraged the lacquer-workers, so also it provided government protection for the production of textiles. These laws established a Bureau of the Palace Wardrobe, an Office for the Guild of Needleworkers, the Guild of Weavers, and a Palace Dyeing Office. Craftsmen from the Guild of Weavers were sent to the more outlying provinces to teach weaving. Splendid robes of brocade, cut after the latest Chinese fashion, became the favorite dress for the nobility whose ranks were distinguished by specific colors. The costumes for ladies were particularly light and gossamer in effect. The clergy also demanded fine textiles and their exactions must have pressed heavily on the peasant manufacturers of silk, thus increasing the burden placed on them by the equipment of the temples then springing up.

The detail in figure 49 is an example of early warp brocade in which the pattern and background are produced by colored warp threads. The six-petaled flowers amidst foliage with flying birds is a very accomplished design reminiscent of T'ang-cast mirror backs. Later the warp-type brocade gave way to a less technically restricting weft brocade capable of finer and larger designs.

Dyeing also was popular during the Nara period. Examples of batik, tie-dyeing, and stencil-dyeing have survived. A fine example of stencil-dyeing is the screen *Deer under a Tree* (fig. 50) from the Shōsō-in. Like many T'ang-dynasty Chinese textiles the design is of Sasanian-Persian origin. Considering the difficulties of the technique, in which the material was folded and pressed between two boards carrying the design before being dyed, this material is a remarkable example of the sensitive fingers and innate sense of design which distinguish all Japanese craftwork. It is, of course, always difficult to say which of the thousands of textile fragments found in the Shōsō-in were imported and which were native products; many must have been imported, but the inscription on this piece testifies to its Japanese manufacture.

The violent expansion of culture and civilization during the Nara period was not without its dangers. The country had less than one-hundredth of the resources of China and the peasant population in the area of the capital was bled white to supply the manpower and money needed for the megalomaniacal palace and temple schemes. It is understandable that many sought escape, some by emigrating to

more inaccessible regions, others by entering the privileged ranks of the army or better still those of the religious orders. Many joined the roving bands of the vagrant class. In the last decade or so of the Tempyō era, which ended in 794, the national treasury was diminished by half through the extravagant expenditure of the priest-ridden court on buildings and gifts. The Japanese economy was not capable of supporting the vast schemes which Chinese-inspired ambition had conceived. Imagination outran the purse, but the vitality and skill of the Japanese cannot be questioned. A desire to do too much with too little has led many a state to bankruptcy but has also produced some of the greatest monuments of the world's art.

49. Detail from a fragment of warp brocade decorated with large blossoms, arabesques, and birds on a green background. Nara period. Dimensions: 1 ft. 6 in. × 1 ft. Tokyo National Museum.

50. *Deer under a Tree* screen. Late Nara period. Stencil-dyeing on hemp. Dimensions: 4 ft. 11 in. × 1 ft. 10 in. Shōsō-in, Nara.

4

THE EARLY HEIAN PERIOD

794–897

Extraordinary as the creation of Nara may appear to us, the decision which the Japanese now made to desert its splendors and to build an entirely new capital at Nagaoka seems almost incredible. Historians generally agree that it was strongly influenced by the desire of the court to escape from the growing power and ambitions of the clergy. One priest, Dōkyō, toward the end of the eighth century, had even become the lover of an empress and his aspirations to be made emperor were only foiled by the death of his mistress.

Removals on a great scale had many precedents, the custom having grown out of a belief, familiar in many early civilizations, that a house was defiled by death. In early Japan, where a house was a comparatively simple building, such a move, whether of miles or yards, was a relatively easy matter. However, the shifting of a whole city, rebuilt in strict emulation of the finest that China had to show, was an undertaking which the Japanese would certainly not have contemplated without very good reasons. They must have envisaged considerable advantages from the change, for the treasury was already depleted and it required a tremendous effort entailing the labor of over three hundred thousand workers and the income from a whole year's taxation. It says much for the strength and discipline of the Japanese that they could accomplish it all without a major breakdown.

Kōnin (810–23) and Jōgan (859–76) are the names of two important sub-periods, and are sometimes used to refer to the early Heian period.

They had been working at Nagaoka for some ten years in preparation for the move, when just as suddenly the project was abandoned. Sansom, piecing together the many strands of intrigue in Japanese court life of the time, thinks that the cancellation was probably due to the fact that the noble in charge of building was involved in an intrigue over the succession and murdered.[1] The principal conspirator, the emperor's younger brother, met his end as a result of the murder. Misfortunes then befell the imperial family and, despite all efforts to appease the spirit of the dead prince, a succession of calamities ensued. The court, always very conscious of the spirits of the dead, may then have decided that it would be advisable to abandon the ill-fated Nagaoka site and choose a completely new one. Early in 793, after solemn divination, a new site was consecrated in what is now the city of Kyoto, some five miles from Nagaoka. They named it—somewhat wishfully one feels—Heiankyō, "the Capital of Peace and Tranquillity."

This time the emperor did not wait for the new city to be finished but occupied his new palace in 793 while the work on the rest of the capital continued for another ten years. It was again laid out on the scheme of the Chinese capital of Ch'ang-an, and modern Kyoto in some of its quieter corners can still convey a vision of the old Chinese metropolis. A dusty temple today fills the ordained square in the city grid amidst the huts for human habitation which have sprung up around it; a tree-lined canal looks just a little too artfully contrived to be other than man's handiwork; tiny streams which run alongside some of the less built-up roads bear witness to the ancient water system of the city.

The Rise of New Buddhist Sects

In their religion, the Japanese in the new capital were still equally under the spell of T'ang China. New sects introduced from the mainland brought more complicated dogmas. In a country eager for innovations these rapidly took root and prospered, assisted perhaps by the fact that the older sects remained in their Nara strongholds, too content with their established positions to follow the court. It is easy to imagine the excitement that greeted the arrival of the new teachings in the capital. Apart from the intriguing doctrines they offered and the challenge they made to a people anxious to show their abilities, they provided opportunities to enter monasteries for

recruits who could not find places in the older establishments. The most important of the new sects were the Tendai introduced by Dengyō Daishi in 805 and the Shingon introduced by Kōbō Daishi in 806–7.

The Tendai school came from its parent monastery on Mt. T'ient'ai (thus its name) in China. This sect based its teaching on the celebrated *Lotus Sutra*, at the same time incorporating a number of native Chinese beliefs into the religion. It has been defined as a "sort of monistic pantheism of which the central figure is the notion that the absolute is inherent in all phenomena, and that each separate phenomenon is but one manifestation of an unchanging reality."[2] Enlightenment for the follower of the Tendai sect would come as the result of a balance between studies of the scriptures, religious practices, and contemplation. The main temple was set up on Mt. Hiei just outside Kyoto, where it claimed that it could protect the city from evil influences coming from the northeast, and the court provided official recognition and finance to encourage the new sect in the teeth of what opposition the Nara clergy could muster. Perhaps the court hoped to establish greater influence over the new sect than it held over the older ones at Nara. Perhaps it felt that such religious rivalries might direct the energies of the Nara sects away from politics. From that time religious strife, often very bitter, became a feature of the Japanese scene. This, in its turn, enlivened the interest in the art which the new sects introduced. The uncompromising nature of Tendai suited the nationalistic atmosphere of the Heian period and Dengyō Daishi's temple, the Enryaku-ji, in its commanding position outside and overlooking Kyoto, prospered rapidly.

Kōbō Daishi, or "the Great Teacher" Kōbō, an urbane, artistic man of scholarly bent, returned from China in 807 with a different interpretation of Buddhism which emphasized what became in Japan the Dainichi Nyorai—the supreme, omnipresent, eternal Buddha from which all other Buddhas emanate and whose energies made manifest the whole world. The name of his sect, the Shingon, means literally "True Word," and refers to the magic formulae which were thought to represent the elements of the universe. As in the Indian Tantric Buddhism from which it was derived, its adherents placed particular emphasis on incantations, spells, and magic symbols. As E. W. F. Tomlin remarks, it was "a doctrine of such extreme complexity that the faithful need a superb art on which to

nourish their religious sensibility."[3] These new teachings from China continually reinvigorated Japanese religious and artistic life. In a country as small as Japan their struggles seem to have become more acute, the issues clearer, and the fight for existence more desperate than in China.

Esoteric Buddhism and Symbolism in Sculpture

Both the Tendai and Shingon gave an impetus to the movement to incorporate native Shinto gods into the Buddhist pantheon. Buddhist temples and Shinto shrines flourished side by side. That they felt a need to do this shows not only the ecumenical, embracing nature of the so-called Esoteric Buddhist sects but also the strength and persistence of the native Japanese cult. The "Great Illuminator," Dainichi, became identified with the sun goddess, who was considered to be the ancestor of the Japanese people. The Shinto priests also were not slow to learn from Buddhist methods. Kōbō Daishi founded his temple on Mt. Kōya well to the south of Kyoto and away from the distractions and dangers of the capital. It still prospers there, a whole township of temples and halls deep in a dense forest of huge trees which produce an atmosphere of mystery admirably suited to the tenets of the sect, a whole area imbued with religious atmosphere and a repository of art—a moving experience to visit. In fact both sects established their temples amidst beautiful natural surroundings and both stressed the need for their worshipers to meditate in close contact with nature. This influenced their landscape artists. Of the two eminent teachers Kōbō seems to have been the greater, admired and respected by the court for his urbane qualities and artistic talents, a "Jesuit" among Buddhist missionaries.

The court welcomed T'ang learning with the same unqualified enthusiasm with which it accepted Buddhist teachings. The poems of the great masters Po Chü-i, Li Po, and Tu Fu were chanted aloud and even their settings imitated to the last detail. The Japanese carefully studied the Chinese classics and Chinese occult theories. But the desire to communicate ideas rather than emotions can be the enemy of art. The necessity of illustrating a complicated iconography can deaden artistic sensitivity, especially when that iconography is not a spontaneous, native product.

It has been said of the Tendai and Shingon teachings that "both sects emphasized esoteric doctrines of such complexity as to be hard-

ly accessible to any but the trained clergy themselves, and they demanded a multiplication of elaborate, unfamiliar images and paintings and other symbols. . . . formulas too often took the place of honest worship. . . . there came into being icons to express the terrific as well as the benign aspects of the gods. . . . There were also maplike hierarchies of greater and lesser gods set in their ranks about some central Buddha who was himself only one attribute of the single, pure, and all inclusive ONE of the ancient Buddhism. There were wall paintings that showed whole paradises peopled with their divine inhabitants."[4] The whole systemization became so complex that its adherents, apart from those rare spirits who could fathom its deep mysteries, mistook the symbol for the reality and lapsed into polytheism and superstition.[5]

A record of one of the contemporary Japanese seekers after the truth in China, a Tendai monk named Ennin, tells how these travelers collected whatever they could carry in the way of new scriptures.[6] They were particularly attracted by the *mandala*, Buddhist maplike pictures of the cosmos (see p. 103). These were easily transportable and eagerly studied in Japan where one occult mystery seemed more attractive than the next. In all this, the Japanese showed their desire to keep up to date with developments in China—the same quality they showed regarding twentieth-century Western culture.

The Japanese sympathetically accepted the terrifying aspects of the belief in absolute divine power of this new Mikkyō or Esoteric Buddhism and they deeply influenced their art. In sculpture they caused the attractive simplicity of the earlier period to disappear. The great sculptural objects of worship now became more than just superior human beings, ennobled by deep belief or softened by contemplation. Their effect on the spectator was now intended to be overwhelming and awe-inspiring; forms became heavy with symbolic meaning and divorced from reality. The worshiper could hardly have been intended to understand, let alone warm to his idol. The carvers made an attempt to provide something which would at once fascinate and subdue the more sophisticated nobles of the Heian court. Gone were the simple grace and freedom of the Kōryū-ji Miroku, the majestic ideal of a Gakkō Bodhisattva; their place is taken by a heavy, almost overpowering sensuousness. Strangely enough, many Japanese see in these bulky statues an austere dignity

which compensates for the loss of the simple realism and attractive candor of earlier works. They harmonize for them the traditions of Nara, the fully mastered techniques of woodcarving, and the mystic spirit of Esoteric Buddhism. The Japanese art historian Seiroku Noma considers the extent to which the realism of the previous period had been carried as vulgarity and sees in the new esoteric dogma a spiritualism which was needed to reinvigorate the sculpture, "to destroy the shell of stifling realism." The general feeling was that the figures of the previous period were too naturalistic, too human to inspire a correct religious awe, too commonplace for their exalted function.

Two examples illustrate the sculptural tendencies of the period very well. The first (fig. 51) is called in Japanese the Nyoirin Kannon (the Kannon with the gem and wheel which satisfy all desires). Four of the six hands hold a gem, a wheel, a lotus stem, and a rosary (later restorations). This secret statue is enshrined in the lecture hall of the Kanshin-ji, Osaka, which was built between 824 and 827, and the figure is said to belong to that period. It is chiseled out of a single block of wood, a technique which was popular at the beginning of the Heian period and which produced most of its great works. Despite the rather heavy cheeks and the thick neck, the face has a

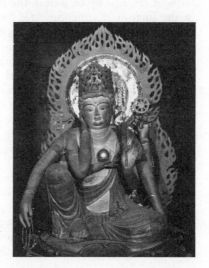

51. Nyoirin Kannon. Dated 824–27. Wood. Height: 3 ft. 7 in. Kanshin-ji, Osaka.

certain charm and feminine grace without any loss of the aloofness befitting an icon of these occult theories. The six arms have a more reasonable arrangement than in many of these many-armed divinities where they seem to be multiplied without any organic meaning, and only because the symbolism demanded them. In this Kannon the pose is relaxed and the body most sensitively represented while still preserving those qualities which the Japanese say distinguish the works of Esoteric Buddhism—a "solemn dignity" and a "sensuous vigor." Yashiro defines this Esoteric Buddhist art as, "the tangible realization in art of the intangible and transcendental" and sees this statue as the climax of esoteric art in Japan.[7] The effect is enriched by the overpainting of the nimbus, figure, and lotus pedestal with fine designs which preserve their original colors. Elements of the Nara styles persist in this early Heian statue. The Westerner will appreciate the skillful carving of the whole statue and in particular of the lotus throne with its elegant "rainbow-colored" petals. The Japanese greatly admire the elaborate decoration which is a feature of the sculpture of the period although at times one is tempted to reflect that it may not be entirely successful as sculpture.

Although the full impact of the new sects was not felt until the early years of the ninth century, the influence of Esoteric Buddhist thought can equally be seen in the slightly earlier Yakushi Nyorai in the Jingo-ji, Kyoto (fig. 52), dated ca. 793, and the Yakushi Nyorai in the Shinyakushi-ji, Nara, of which a detail of the hand is shown in figure 53. The modeling and drapery preserve elements of the late Nara clay styles, but the most distinctive feature is the peculiar heaviness of the shoulders and thighs, revealing the massive block of wood from which it was carved and intended to depict the superhuman physical characteristics of the Buddha and "instead of beauty of form, the aspiring spirit beyond form." The expression of the face is forbidding and compelling, directed at the worshiper with a grimness which seems to contradict the gesture of "have no fear" shown in the right hand.

No Chinese models to which these statues might be compared have survived; they were probably inspired by pictures which could easily have been brought back from places in China like Tun-huang or even from central Asia by the priest-travelers (fig. 54). The connection is suggested by the distinctive deep folds of a technique of carving drapery called "rolling waves"—in which one rounded

wave always alternates with a sharply cut fold. This heightens the unrealistic, rhythmical qualities of the modeling. It can produce a splendid, clear decorative effect but becomes often dry and monotonous. In short, the massive Indian- or central-Asian-inspired style seems peculiarly out of sympathy with Japanese sculptural ideals. It may be best to leave the last word on some of these statues with the Japanese critic who said that they were "too austere to be enjoyed."

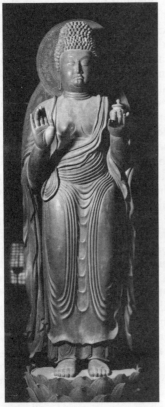

52. Yakushi Nyorai. Ca. 793. Wood. Height: 5 ft. 7 in. Jingo-ji, Kyoto.

53. Detail of the hand of a seated Yakushi Nyorai. Early Heian period. Wood. Height of whole statue: 6 ft. 3 in. Shinyakushi-ji, Nara.

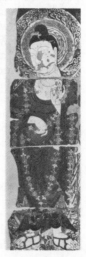

54. Detail of a wall painting from Bezeklik, central Asia.

The Persistence of the Native Style

Fortunately the Japanese gift for inspired portraiture had not died out under the impact of the new styles. The sculptures of Priest Rō-ben (fig. 55), made about 773 in the Tōdai-ji, which he founded, and of the Shinto goddess owned by the Matsuno-o Shrine, Kyo-to (fig. 56), are both excellent examples of an unbroken tradition. The first is a remarkable likeness made from memory some fifty years or so after Priest Rōben's death. The practice of making statues of Shinto gods was encouraged by Buddhist practice, and most of the examples date from the end of this period and later. The goddess, however, is an early example dated ca. 889–92. The carving is simple and heavy and imbues the figure with a solid dignity. The Buddhists, for their part, did not discourage these attempts by the Shinto fol-lowers since they were anxious to incorporate native gods into the Buddhist pantheon as avatars, manifestations of Buddhist divinities. Yet, whereas the Buddhist gods of the period seem very un-human, these Shinto divinities are only thinly disguised human por-traits. Unhampered by any desire to express the "secret doctrines" of the Tendai or Shingon sects, the sculptor felt free to portray a ma-tronly figure of the time with her loosely hanging robe, high head-dress, and gentle eyes directed slightly to one side. The result is a powerful figure which, in its solemn mass, reveals at once the force and limitations of single-block sculpture.

For all its weight and power, it is difficult to agree with some Japanese and Western critics that the early Heian is one of the finest periods of Japanese sculpture. Despite the appreciation of the pos-sibilities of woodcarving and the spiritual revival which came with the new Buddhism, the works of the period are not always attractive or convincing. They seem to lie outside Japanese artistic traditions, as if their creators were not completely at home with the newly imported sculptural ideas. As they interpreted them from drawings they may, indeed, not have understood them very clearly. The complicated iconography of the new sects emphasized one or another aspect of a divinity; a gesture of the hand or an attribute held in it seems to have become more important than the sculpture as an entity; the demand for iconographical accuracy often laid a dead hand on the artist's spirit. In all fairness it must be admitted that it may be difficult for the Westerner to appreciate the spell which Esoteric Buddhist art is intended to cast over the spectator.

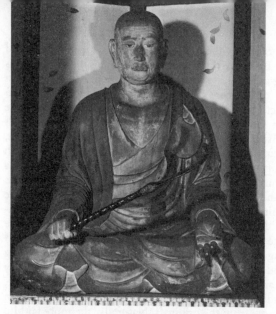

55. Portrait of Priest Rōben. Ca. 773. Wood. Height: 3 ft. 5¾ in. Tōdai-ji, Nara.

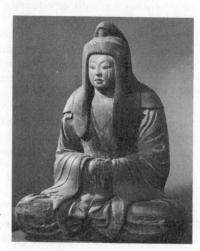

56. Shinto goddess. Dated 889–92. Wood. Height. 2 ft. 10¼ in. Matsuno-o Shrine, Kyoto.

The problem raised by these sculptures is that of the fundamental approach of the Eastern artist in some periods to his work and of his aims in creating a Buddhist statue. The observations that Benjamin Rowland made on Chinese copies of Indian images apply also to Japanese products of this period. Prior to the T'ang dynasty the images made in China were not based directly on Indian models but on central Asian models. But intrepid travelers and missionaries, such as the Chinese Hsüan-tsang, established direct contact with India. After many years spent there Hsüan-tsang returned to China (A.D. 645) to translate the sutras he had collected and to impart his knowledge to the people. He gave the first real conception of the Mahāyāna teachings to the Chinese. His work has rightly been compared to the "discoveries and the influence of the Renaissance humanists on the late development of classic learning in the West."[8] But Hsüan-tsang was only one of many. The imperial envoy Wang Hsüan-ts'ê is said to have brought back pictorial records of the holy places in India and replicas of important statues. For the Chinese, there was a definite merit attached to copies of famous images even if they were remote from the originals. Naturally, the more faithful the copy, the more of the magic of the original it would contain, and the more effective it would be as a religious representation. Nobody expected an artist to express his own personality; he was more concerned with representing proportions accurately. This approach is visible in a number of early Chinese bronze figures which, perhaps for this reason, are not of outstanding artistic merit.

In the early Heian period the same restricting influences seem to be working on Japanese sculpture. Indo-Asian models suddenly seem to dominate the Japanese. Fortunately their inventive and independent spirit led the Japanese to tire quickly of these uninspired copies. Neither the heaviness nor the impassivity of their models completely satisfied their aspirations and they occasionally turned with relief to the Shinto deities in which they were not so restrained by the need to express iconographical formulae but which they would portray as figures of the ancestors of the race dressed in contemporary clothes.

Mandala and Fudō Pictures

What is true of sculpture in this period is true also of the paintings. Many more have survived than from earlier periods, and this sug-

gests that, as an art form, painting acquired greater importance for the new sects. The more involved nature of Shingon and Tendai teachings could be better expressed by painting than by sculpture; much more subject matter could be compressed into a pictorial representation. The complex rituals demanded also more variety and change. One of the principal forms of painting was the *mandala*, which in Sanskrit means "circle" (fig. 57), a complicated maplike type of painting in which whole cosmologies are represented in tabular form. It aimed at overwhelming the worshiper with the limitlessness of the suprahuman worlds which awaited him, as well as with the seeming profundity or, at least, complexity of the beliefs held by these sects. *Mandala* are often incomprehensible to all but the most erudite iconographical specialist. While admiring the fine line-drawing of the individual figures and their impeccable draftsmanship, one cannot overlook a certain repetition and stiffness in both figures and compositions; this is characteristic of all strictly iconographical painting but does not tend to produce inspiring works of art.

Of greater interest is another type of painting introduced during this early Heian period which expressed in broader pictorial form the same terrifying aspects of the new Buddhism that are seen in the

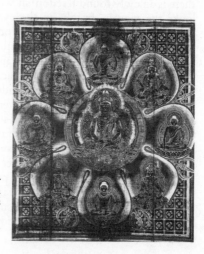

57. Detail of *mandala*. Nara period. Gold and silver paint on purple figured silk. Dimensions of entire *mandala*: 11 ft. 5 in. × 10 ft. 1 in. Kojima-dera, Nara Prefecture.

sculpture. These are the Fudō pictures. A Fudō is a manifestation of the Dainichi Buddha, one of the Five Great Kings who are supposed to protect the Buddhist world, and, like the guardians of earlier periods, are, of course, intended to deter the evildoer. Yet, though fierce in aspect and effect, he also has attributes of love. The most famous, and indeed the finest, of the Fudō pictures is the Aka ("Red") Fudō reverently housed in the Myōō-in, a temple of the Shingon sect on Mt. Kōya (fig. 58). So sacred are these pictures that it is extremely difficult to obtain permission to see them. The Ki ("Yellow") Fudō in the Mii-dera is perhaps the most inaccessible and the visitor must carry the highest introductions and references before, after a necessary interval for prayer, the priests will produce any of them from storage. Often the visitor will have to be content with seeing the twelfth-century copy of the Mii-dera Yellow Fudō which is kept in the Manju-in, Kyoto.

The Japanese artists delighted in painting these grim portraits because they gave scope to their natural fantasy. Some authorities date the Aka Fudō slightly later than the early Heian period to which it has generally been attributed. It has even been placed as late as the Kamakura era. The asymmetrical arrangement of the figures, it is true, reveals an unexpected compositional advance on earlier works; there is a newly found freedom in which the main figure no longer looks the viewer straight in the eyes but glares balefully out to one side. He sits on naturalistic rocks. The two young acolytes beneath him are Seitaku, who symbolizes the subjugating power, and Kinkara, who stands for sustaining virtue. The Fudō's two young attendants are effectively placed together in one corner and not one on each side in the stiff, traditional symmetry. The rugged mass of the landscape further heightens the impact of the scene. The brushwork of the whole work, and in particular of the face, is most vehement. The strong, rhythmical drawing conveys a feeling of tenseness and of threatening force. The sweep of the composition in one arc from the bottom left-hand corner to the top left-hand corner has the effect of a drawn bowstring and projects an intimidating impression. One of the attendant figures remains calm and friendly and thus, by contrast, admirably heightens the effect of the composition. The color adds to the lurid impression. There are no Chinese parallels to this painting.

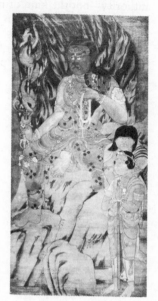

58. Aka ("Red") Fudō. Early Heian period. Color on silk. Dimensions: 5 ft. 5 in. × 3 ft. 1¾ in. Myōō-in, Kōya-san, Wakayama Prefecture.

Ceramics and Metalwork

Into the ceramic and metalwork crafts little new was introduced in the early Heian period and the tendency was to return to the heavier potting techniques of an earlier Japanese ceramic tradition. Both were hardly touched by the new sects. In ceramics, the techniques of highly fired wares spread to several other kilns which, founded at this time, were to establish their reputations later—Bizen, Ōmi, Tamba, Owari, and Mino; the Seto kilns in Owari had a particularly illustrious career. Monochrome green wares have been unearthed which carry on the tradition of the three-color glazes of the T'ang-inspired pottery, and written records exist of the importation of the materials from which glazes were made. By this time Chinese Yüeh-type pottery must have been well known in Japan, and pieces have been excavated which were buried in 904–5. These, it seems, the Japanese tried to imitate.[9]

As the T'ang dynasty moved toward its unhappy close in A.D. 906 China was a land of confusion and rebellion against imperial

authority—not the kind of model which the Japanese rulers would have liked to see repeated in Japan. The last Japanese embassy to the T'ang court went in 838–39. After this, Japan was increasingly on its own, and to the flowering of the indigenous art it then produced in the late Heian or Fujiwara period we now turn.

5

THE LATE HEIAN OR FUJIWARA PERIOD

897–1185

The late Heian or, as it is more often called, the Fujiwara period is perhaps the most important of all for an understanding of Japanese art and taste. Hitherto the arts of Japan had been strongly under the influence of China but during the Fujiwara centuries the native Japanese artistic spirit confidently asserted itself. This is evident in the traditional forms as well as in essentially Japanese innovations. In a broad sense it can be said that what the T'ang dynasty did for Chinese taste, the Fujiwara period did for that of Japan.

One of the factors which had led to the decision to move the capital from Nara to Kyoto had been the desire of the court to escape from the suffocating grip of the clergy. But by this very move it played into the hands of certain members of the aristocracy. The most powerful of these noble families were the Fujiwara, an ancient line so established that, like the emperor, they could claim kinship with the gods, though naturally not with quite such exalted gods. In these years, through a succession of weak emperors who were little more than puppets, the effective control fell into the hands of regents or advisors whose ambitions were even greater than those of the Nara church. This was the form of government presaged by developments in earlier times. The decay of the political power of the court was more than offset by the general development in the provinces and during this period there emerged the concept of the knight on horseback defending his estates against all comers. Throughout the succeeding centuries the emperor was preserved only as a figurehead, while behind his august person more ruthless

men waged a bitter struggle for real power.

The politics of the period are extremely complicated. Court intrigues, challenges to the Fujiwara power, behind-the-scenes activities of retired emperors, and the warlike behavior of the monks continually agitated society. The inhabitants of the Tendai monasteries outside Kyoto and of the Kōfuku-ji at Nara often made the streets of the capital unsafe for the peaceful traveler.

The Fujiwara family, by marrying girls of their line to the emperors and princes, by placing their nominees in office, by obtaining tax-free estates, and by ruthlessly removing all opponents, steadily tightened their grip on the effective power. By the mid-ninth century they achieved control of the imperial family and exerted an influence which was felt down to the mid-nineteenth century. It has been said that their progeny multiplied faster than posts and sinecures could be found for them. It proved unfortunate for the subsequent history of Japan that they further developed the system of hereditary administration which completely ignored the great Chinese concept of government through scholars who had proved their worth in open examination. It is interesting to speculate that this may have caused men, whose talents would otherwise have led them to expect high office in the state, to take to the arts instead. The status of artists may well have gained from the low condition of state service and the dangers of political life. Even some emperors found it wise to retire and devote themselves to the arts. This was a custom which the Fujiwara encouraged.

Heian Sophistication and The Tale of Genji

The life of the court at Kyoto was as refined and as sophisticated as any the world has seen. Its delicacy and sumptuousness almost defy description. Perhaps at no time has life been lived so consistently at the level of aesthetic refinement. It was a period in which, as Alexander C. Soper has said, the conventionalization of life begun with the move to Kyoto reached its highest degree, not to be broken until the civil wars of the 1150s.[1] Sansom has summarized the atmosphere of this sybaritic world: "preoccupied with art and letters, quick to criticise a weak stroke of the brush, a faulty line of verse, a discordant colour or an ungraceful movement; great connoisseurs in emotion and judges of ceremonies and etiquette; sentimentally aware of the sadness of this dew-like fleeting world, but intellec-

tually unconcerned with its problems; prone to a gentle melancholy but apt to enjoy each transitory moment; and quite without interest in any outlook but their own."[2] It was a world of calculated artificiality from which all unpleasant experiences of normal life were rigidly excluded. The isolation from foreign countries increased the atmosphere of artificial calm. No discordant note was allowed to disturb the precious, regulated harmony of noble life.

This is the elegant, profligate society mirrored by one of the world's greatest novels, the classic *Tale of Genji* written between 1008 and 1020 by Lady Murasaki. The story has long been familiar to the West in Arthur Waley's translation—the only criticism of which has been that it does the original more than justice.* Despite occasional tedious passages, almost any page of the book will transport the reader to a world where sensibilities are almost too fine for our appreciation, where motives are so delicate that they hardly seem credible bases for human behavior, and where the fate of people great and small often hangs by the slenderest thread. A love affair could be ruined by an unskilled piece of calligraphy or a carelessly tied ribbon, a man banished for a minute breach of etiquette.

The novel is a romance played against a brocadelike background. But, when reading it, one must remember that Lady Murasaki was a woman of the court and her knowledge of life restricted by her sex and position. She shows mainly one side of the picture in which politics intrude only when they affect a sentimental love-affair. She talks little about the unceasing struggle for power constantly in progress behind the gaiety and sadness of the flirtations which she records with such literary finesse. Savage feudal wars raged throughout the eleventh and twelfth centuries, and the vigor of the Japanese race was, for a time, spent in constant battles. While recognizing the suzerainty of the emperor in Kyoto, the more powerful Japanese noblemen remained virtually secure and independent behind the massive walls of their huge fortified castles. Around them they gathered their hereditary fighting-men—the *samurai*, or "serving men," whose code of honor, *bushidō* ("the Way of the Knight"),

* A more literal rendering appears in Edward G. Seidensticker's recent two-volume translation of that work (New York: Alfred A. Knopf, 1976). See also Ivan Morris, *World of the Shining Prince: Court Life in Early Japan* (New York: Alfred A. Knopf, 1964).

governed their behavior as rigidly as the code of chivalry did that of the medieval Western knight. Later propagandists exploited this Japanese feudal ideal to inspire every Japanese soldier down to the present day. The single-minded, blind devotion to their masters which the samurai were expected to show and the all-important virtue of preserving their honor unto victory or death form the themes of a thousand stories and plays. These stories are generally built around the complications created by the interaction of conflicting loyalties and emotions; the problems often become so tangled that suicide is the only honorable way out. One set of circumstances seems to be more involved, one solution more difficult—and to the Westerner often more unexpected—than the last. Behind them all, at its best, is a deep sadness, at its worst a contrived sentimentality.

The Reformist Sect of the Pure Land

The Buddhists of the time now quite frankly abandoned the attitude of humanity and pacifism which formerly distinguished them even in their moments of political scheming. The Tendai and Shingon monasteries henceforth accepted the feudal world of violence on its own terms and fought it with its own weapons. Their warlike behavior discredited them in the eyes of genuine believers among the population and politically made them dangerous allies for the court. The emphasis of Buddhism began to change radically. The occult mysteries and stern discipline, the threats of the hells to be encountered by the lecherous and voluptuous, all graphically illustrated in the arts, were hardly likely to appeal to a luxury-loving nobility. The masses to which Buddhism would henceforth appeal could hardly understand them.

Toward the end of the period a new reforming sect, the Jōdo, or "Pure Land," sect, known in T'ang China and introduced into Japan long before the Fujiwara period, began to gain widespread popularity, particularly with Fujiwara nobles, through the zeal of a priest named Hōnen (1133–1212). This reaction against the abstruse Tendai and Shingon teachings provided a simple evangelical way to salvation through faith alone. It demanded of the believer only that he should sincerely invoke the name of the omnipresent Amida Buddha, "the Lord of Boundless Light," thereby securing final entry into paradise, the Pure Land.

Salvation by the mere repetition of the formula "Namu Amida

Butsu" was an attractive dogma which the older sects found difficult to combat. With that happy eclecticism found so often in the history of Eastern religions, they sometimes tried to incorporate the new approach into their own more demanding or complicated teachings. The influence of Hōnen's views was particularly strong in the following Kamakura period but already in Fujiwara times it made itself felt.*

Jōchō's Statue of Amida Buddha

Buddhist temples began to mirror as invitingly as possible the Pure Land into which believers would be born, and a new lightness and elegance appear in their architecture and decoration. The Byōdō-in at Uji had been the villa of Fujiwara-no-Yorimichi and was subsequently made into a temple. Its sculptors responded to the escapism and sentimentality of the age. Their statues reflect softer, more feminine ideals. The Amida statue (fig. 59) in the Byōdō-in exemplifies the slender, well-balanced grace of Fujiwara sculpture. The massive bodies, the heavy faces with their stern expressions, and the stiff drapery of the early Heian period are here modified to a more human scale and certainly to more elegant proportions. The body is placed in calm stability, the face, at once noble and gentle, is benign, as if in sympathy with the problems of worldly beings, and behind the whole figure rises a great nimbus with a characteristically rich, involved decoration which, by contrast, brings out the simple lines of the main figure. It speaks directly to the viewer.

This figure, in which the aspirations of a new generation of artists found expression and which influenced all later sculptors, illustrates two important developments of the period. First, we learn the name of the artist who carved it—it is the late work of the famous sculptor Jōchō, who died in 1057. Hitherto, Japanese sculpture had been almost entirely the work of anonymous craftsmen. Henceforward, and particularly in the next period, the individual and his school became increasingly important. During the Fujiwara period,

* A good, clear description of Amidism is given by Miyeko Murase in *Japanese Art*, pp. 20–21(in Bibliography). Amida is the Japanese for the Sanskrit Amitābha ("Immeasurable Light") and Amitayus ("Limitless Lifespan"). The belief entered China around the second century A.D. and dominated Chinese thought by the seventh century. Japanese representations are found as early as the seventh century in the Hōryū-ji.

under the patronage of eminent noble families, a number of master sculptors, some of whom were Buddhist priests, rose to fame. Jōchō, for instance, was patronized by Fujiwara-no-Michinaga, the powerful scion of the Fujiwara family during its most influential period. Prior to this time we know little of the ateliers which supplied the temples. The tendency now was for temples to open their own workshops for the creation of Buddhist images, and the church occasionally paid high honors to the sculptors. Sometimes they even conferred religious ranks on them. It was but a short step from this to the sculptors liberating themselves from their artistic and financial dependence on the temples and setting up their own studios. There they also trained pupils to carry on their traditions.

In China we know very few sculptors by name. The emergence in Japan of artists like Jōchō marks the continuation of a movement begun long before in which they raised the arts to a recognized and even honored occupation for men of outstanding ability. The results of this development were far-reaching. It gave the arts a new flexibility and a quicker response to current ideas; it made them more subjective and varied. It also had important consequences for the crafts. Unlike in China, the Japanese never considered it menial for the individual artist to practice a craft. Lacquer, ceramics, metalwork, and textile designing gained greatly in later periods from this changed attitude and position of the artist.

Jōchō, who set the pattern for Fujiwara and much of the subsequent sculpture, came from the studio of the Kōfuku-ji at Nara, and, although he had his workshop in Kyoto, he continued to work a great deal in the old capital. This is of considerable significance for it meant that he was often in close contact with the early masterpieces of Nara times. Thus he must always have had before him the clearly conceived figures which are the glory of that period. He is unlikely to have had much sympathy for the iconographic exercises produced in Kyoto and on Mt. Kōya by the Tendai and Shingon artists.

Assembled-block Sculpture

The second significant development of the time was the expansion of the demand for statuary. So great was this demand that the old laborious system of carving from a single block could no longer keep pace with it. The technical problem was solved by making statues from a number of separate pieces of carefully selected wood which

were first roughly carved, then assembled, and finally finished by a master. The custom of masters finishing their pupils' work, later to become familiar in the painting ateliers of the West, was new in Japan at this time. The Amida in figure 59 was made by this technique. It is immediately evident that the artist has paid greater attention to details—all of which are beautifully proportioned and assembled in such a way as to produce an idealized type. The calm pose with the hands in the gesture of meditation, the soft eyes and quiet beauty, make visible on earth a serenity to be expected only in paradise. The Fugen Bosatsu (the bodhisattva of universal sagacity) in the Ōkura Museum, Tokyo (fig. 60), and the Kichijō-ten in the Jōruri-ji, Kyoto (fig. 61), are outstanding examples of the technique at its best. The latter is dated 1212 and chronologically belongs

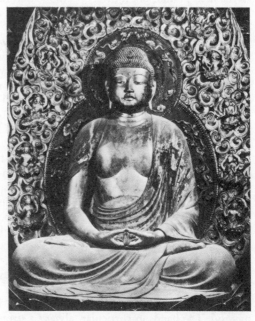

59. Amida, by Jōchō (d. 1057). Assembled-block wood. Height: 9 ft. 8 in. Byōdō-in, Kyoto.

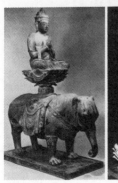
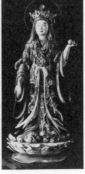

60. Fugen Bosatsu. Late Heian period. Assembled-block wood with *kirikane* gold leaf. Height: 1 ft. 9¾ in. Ōkura Museum, Tokyo.

61. Kichijō-ten. Dated 1212. Assembled-block wood with *kirikane* gold leaf. Height: 2 ft. 11½ in. Jōruri-ji, Kyoto.

to the next period, but it preserves the sculptural style and aesthetic atmosphere of the Fujiwara age and provides a striking vision of its ideal of feminine beauty.

Both statues are highly colored as were many of the works of the period. Gold is used in the Fugen statue following what is called the *kirikane*, or "cut-gold," method by which very thin strips of gold leaf cut to simulate textile designs are applied to the surface. This takes the place of painted decoration. The technique is a purely Japanese invention, dating back to the Asuka period, and in Fujiwara times it was developed and used extensively. The Kichijō-ten is an extraordinarily rich and complicated piece of work, as befits a goddess of beauty and fecundity—a *tour de force* of the assembled-block system. The wealth of decoration, the reflection perhaps of the very strongly feminine-oriented society which inspired it, somewhat impedes an immediate appreciation of the splendid rhythms in which the body is conceived. Originally it stood in a richly colored shrine where the whole impression must have been more that of a painting than of a work of sculpture. Each section considered separately is a marvel of woodcarving; sleeves, jacket, sash, hands, and the many jewels—which in former times would have been made of metal—are carved in a masterly fashion. Such a complicated piece of work could never have been created by the single-block method. The hands in particular, always a strong point of Japanese woodcarving, are exquisite. The stance is regal and the face, though modeled in the simplest lines with an almost masklike effect, conveys

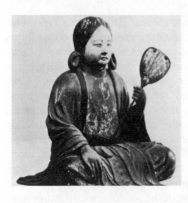

62. Portrait of Prince Shōtoku as a child of seven. Dated 1069. Wood. Height: 1 ft. 11 in. Hōryū-ji, Nara.

admirably the benevolence attributed to this goddess. Yet, for all its queenly grace, it radiates a seductiveness which implies a complete relaxation of previous sculptural norms.

Decoration and Portraiture

In spite of these highlights of the assembled-block technique, the dangers of mass-production inherent in such a method are obvious. As soon as a work becomes successful, the possibility of producing a great number of academic copies rapidly tends to stifle originality of thought. Repetition and conventionality robbed the technique of its advantages, and Jōchō's innovations were followed by his successors right down into the last century but with steadily decreasing power.

The Japanese genius for decoration and for beautifying surfaces also had its dangers. The *kirikane* method developed in this and the following period to an astonishing degree of skill. It was a technique which, if applied in excess, could completely ruin a work by over-decoration. At first, however, it merely added luster to the surfaces and realism to drapery, reflecting the sculptural taste of the age. In later times it has been said that it was only this "fine angularity of shape produced by a knife on metal" which saved some of the works from sentimentality.

The Japanese never neglected their gift for portraiture. A good example is a sculpture of the often-portrayed Prince Shōtoku. The statue, dated 1069, is now in the Hōryū-ji (fig. 62). This idealized

portrait of the prince, whose name means "Sage Virtue" and who was mainly responsible for the successful introduction of Buddhism in the seventh century, is supposed to represent him at the age of seven reciting a sutra. An inscription inside the statue records that it was the joint work of the sculptor-priest Enkai and the painter Hata Chitei. Another inscription, dated 1384, states that the hands and clothing were repaired in that year by a sculptor named Shunkei. The lifelike quality and the intensity of the face are a remarkable achievement. The painted hairline coming down in a severe triangle to cover the ears effectively sets off the fine, young, sensitive features. Two unusual, large loops of hair serve to frame the very long head which appears even longer through the high parting of the hair. The eye of the spectator follows the line of the red robe which hangs over the pedestal and the edges of the upper garment to the serene face strongly outlined by the black hair. The statue is beautifully colored and housed in a simple black-lacquered shrine. It is an intense and very impressive portrait which shows the confidence with which the Japanese were now working quite independently of their Chinese teachers.

The Fujiwara period, so important because of its achievements in sculpture, is also a decisive period in the history of Japanese painting. Its two hundred years saw the first real flowering of a native art which led, in the following period, to the creation of some of the most remarkable paintings of the Far East.

The Break with China

In the middle of the ninth century Buddhism in China suffered a serious persecution and toward the end of the century official relations between Japan and China were broken off. This in itself is an indication of a new Japanese mood of self-reliance, for before this period any such break with China would have been inconceivable. The Japanese quickly realized that the great period of the T'ang had passed and that Chinese power was disintegrating. The sad last years of the T'ang dynasty must have shown a tiredness and faded quality which did not appeal to the energetic inhabitants of Fujiwara Japan. It was probably at this time that the Japanese for the first time fully understood the fundamental difference between their own aristocratic society and the more egalitarian system of China and the dangers to them inherent in the latter. The Japanese rulers, furthermore,

probably did not want their subjects to witness the spectacle of the Chinese imperial house in decay and eclipse. However, too much can be made of this break in diplomatic relations, for monks continued to visit China quite regularly and Japan must have been informed of artistic developments on the mainland. This is borne out by the discovery in 1954 that a sculpture in the Seiryō-ji, Kyoto, was brought back to Japan in 987 by the Japanese priest Chōnen.

The elegance of the Fujiwara court encouraged the painters to relax from the forbidding outlook of early Heian art. The world of Prince Genji was more interested in the color of a robe, the shadows on a brook, the shape of a pretty face, than in the grim aspects of a stern religious art. Its tastes are reflected in a movement away from the grandeur of the ninth and tenth centuries toward the supple tenderness of the eleventh and twelfth.

A triptych, *Amida and the Twenty-five Bodhisattvas* in the Kōya-san Treasure House, of which a detail is shown in figure 63, shows how this change affected Buddhist art. In this typical product of the friendly Amida sect, the Buddha is seated in the center surrounded by numerous bodhisattvas forming a gay circle to welcome the faithful. These paintings are sometimes known as Amida Raigō paintings—the "Amida Buddha Descending to the World." In this most simple of beliefs the Buddha even descends to earth to take the believer by the hand and lead him to paradise. No more does a grim Fudō threaten the unfortunate sinner from a canvas said to have been painted in blood. Here a jovial, shapely figure with laughing

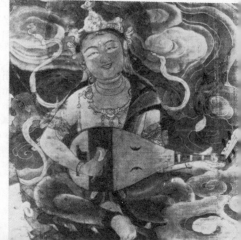

63. Detail from the triptych *Amida and the Twenty-five Bodhisattvas*. Late eleventh century. Color on silk. Overall size: 6 ft. 11 in. × 16 ft. 8¾ in. Kōya-san Treasure House, Wakayama Prefecture.

mouth and eyes plays a seductive song of welcome on the lute. The round-faced bodhisattva is dressed in colorful silks—red with a gold design on the knees and diaphanous printed gauzes which swirl rhythmically round the head and shoulders. A feeling of warm humanity pervades this riot of lovely color. The gold decorations on the neck and arms simulate real jewelry intended to beautify rather than to symbolize. The head is slightly bent as if to keep time with the heavenly music which fills the air around. There is not a single austere line in the whole imagery of this delicate figure. Sculptors endeavored to match these pictures with corresponding sets of statues, but painting was the true medium for depicting such religious concepts.

Yamato-e: The Genji Scroll

Even more important than Buddhist painting is the development of *yamato-e*, or "Japanese painting," as opposed to *kara-e*, or "Chinese painting." The first recorded use of the word *yamato-e* occurs in 999, but the distinction between the Japanese and Chinese styles must go back still farther—perhaps as much as a century. *Yamato-e* denoted paintings dealing with essentially Japanese topics and inspired by Japanese sentiments. It is essentially concerned with the close relationship between man and nature, and its tradition persisted down to the flowering of *ukiyo-e*, the paintings of the "Floating World" of much later times. The style originated in the highly colored paintings of the T'ang dynasty but by this time it was completely Japanized. According to the Japanese, the subjects of *yamato-e* fall into four main groups—landscape scenes depicting the four seasons, views of famous beauty spots, paintings illustrating the tasks of the twelve months of the year, and finally and most important of all, the *monogatari-e*, or "story paintings," inspired by contemporary literature. The *monogatari-e* are the most interesting.

By far the most famous examples of the fully developed *yamato-e* are the fragments of scrolls illustrating incidents from the *Tale of Genji*, of which figure 64 shows a detail. The basic technique of scroll painting in which the spectator unrolls section by section of a continuous narrative was, of course, a Chinese invention which the Japanese had known for centuries. As early as the Nara period, such illustrated texts as the *E-Ingakyō* (see fig. 44) had been a familiar type. The form was now taken up and a style was developed which be-

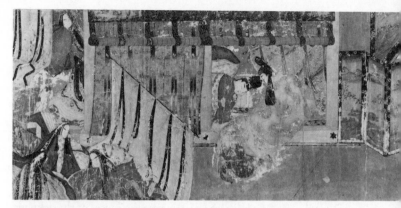

64. Detail from the Kashiwagi chapter of the scroll painting *The Tale of Genji*. Mid-twelfth century. Height: 8½ in. Tokugawa Reimeikai Foundation.

came an exclusively Japanese art of major importance.

This new secular painting, using material from popular stories, has an intimacy of expression very rarely found in early Chinese painting. The surviving sections of the *Genji* scrolls are attributed (though by no means with certainty) to a mid-twelfth-century painter, at least a century after Lady Murasaki's death. There are two sets of fragments—one of fifteen sections in the Tokugawa collection and one of four sections in the Gotō Art Museum. They are obviously by different hands and the Tokugawa set is the more interesting.

The arrangement of the scenes, in which a view is given of the interior of rooms by the simple expedient of omitting the roof, is brilliant. Skillfully the eye is led on from one episode to the next by a crowd of people or a sloping rail. In later scrolls when the text with which the *Genji* scroll is interspersed disappeared, these devices were greatly developed. Mood and tempo are cunningly modulated. The faces, almost hidden by the billowing robes, are so simply drawn as to appear almost characterless, but they reflect faithfully the etiquette-bound life of the time. The technique of "one dash for the eye and one hook for the nose" may well be derived from Chinese models and it is often claimed that it is merely a painter's convention. In fact it may have been a very realistic representation. Etiquette of

the time demanded that ladies should wear a thick mask of powder which left little else showing than the slits of heavily penciled eyes and a small scarlet mouth. Fashions were more important than faces, and passions were concealed behind a richly brocaded sleeve. The lack of facial expression in no way detracts from the drama.

Alexander Soper, who has made a close study of these Tokugawa fragments, sees in the compositions a deliberate effort by the artist to express the underlying mood of the scenes by the manner in which he uses his lines.[3] The scene in figure 64 illustrates the Kashiwagi chapter of the Genji story in which Kashiwagi has fallen in love with Genji's neglected consort, Nyōsan. He dies from the hopelessness of his suit. The clashing lines and colors of this section seem to express the confusion in the household caused by Kashiwagi's illness and the calling in of a holy man to exorcise the causes of the sickness. The whole picture conveys an impression of restlessness and agitation while attention is directed toward the monk, the central figure of the scene, by the way the other figures are turned toward him. In other scenes where a calmer mood prevails the lines are quietly ordered into restful horizontals to create an impression of order and tranquillity. It responds to the Japanese ideal of *mono no aware o shiru*, which is difficult to translate but can be rendered as "to understand and indulge in the emotional appeal of objects to the human heart"—a hyperrefinement of emotionalism. "Color, intrigue, sensualism, quickness—all are woven into a fabric as silkily decorative as that of Fujiwara society and the new Japanese art style it created."[4]

The *Genji* scroll, with all its subtle and evocative atmosphere, is from every point of view a remarkable and original work. Its combination of painting, exquisite calligraphy, and the finest paper give it a unique quality. It inspired, directly or indirectly, the large production of *e-makimono* in the following Kamakura period.

Lacquer

In the crafts, a nation's genius often seems to express itself preferably through one material rather than another. Thus, jade is perhaps the material most characteristic of Chinese culture while lacquer seems to suit the taste of the Japanese most naturally. It was in the Fujiwara period that the Japanese craftsmen finally made its technique and expression completely their own.

Prior to the Fujiwara period, craftsmen used three methods to decorate lacquer: either they mixed gold and silver dusts with glue and painted them on the lacquer or they mixed the dusts with lacquer and similarly applied them. A third technique, called *maki-e*, was invented by the Japanese. In this they painted the designs in lacquer, sprinkled the metal dusts on it while it was still wet, and then smoothed down the whole surface. This is, of course, a method related to the earlier techniques but it gave the craftsman greater flexibility in his designs and made his products far more durable. From this period onward the *maki-e* technique, very skillfully developed, achieved a degree of perfection which no other nation could hope to equal. As a result, the Japanese product became highly esteemed abroad and much sought after in Korea and even in China.

The finest example of Fujiwara lacquer is generally acknowledged to be a cosmetic box (fig. 65) which combines the faultless technique and refined taste, a combination of the casual and poetic, of the period. Lacquer is a material very difficult to work. It is a toxic gum which requires a craftsman to have or develop an immunity

65. Cosmetic box. Late Heian period. Gold and mother-of-pearl on lacquer. Dimensions: 9 in. × 13 in. × 6½ in. Agency for Cultural Affairs.

to it. It cannot be worked quickly, especially when incorporating other materials or using a number of colors, and it must dry in a highly humid atmosphere. The Japanese mastered these difficulties and surpassed their Chinese masters in ingenuity and richness of design.[5] The design here is composed of segments of wheels rising out of water and may have been inspired by the custom of immersing them in a stream to prevent their drying and splitting. It is worked in *maki-e* and mother-of-pearl. Two shades of gold were used—plain gold and gold mixed with silver. These alternate on the waves, wheels, and spokes to produce a subtle but lively variety. Some of the wheels are of mother-of-pearl, which blends with the precious metals and yet sets them off and holds the design together. The composition, though giving the impression of great freedom, is nevertheless most carefully contrived. In this it is characteristic of the art of the period. For all the elements of Fujiwara taste are here brought together in a harmonious unity—a simple realism unspoiled by overattention to detail, an easy rhythm and movement, a close relation of form and design, and, most important of all, a boldness in execution which refused to be bound by conventionality and tradition. In this earliest of all Japanese cosmetic lacquer boxes, very simple elements are cleverly grouped and varied to produce a design of great clarity, refinement, and vigor.

Ceramics, Textiles, and Metalwork

It is strange that the ceramics of the Fujiwara period did not reflect the distinctive, native Japanese taste as clearly as the other arts. The formal break with China, from which the Japanese potters had always received their inspiration, was here felt most seriously and it seems to have left them without direction. A trickle of fine Sung wares still reached Japan but only the aristocratic classes could afford them while poorer households used Japanese-made wares. In fact, from the mid-Heian period the craft went into a sharp decline. Why this happened is not clear. Perhaps the clumsy-seeming native ceramics did not accord with the refined aesthetic taste of the time. Even the Sue kilns, we learn, were mostly abandoned. What has been discovered is of little distinction in shape, glaze, or decoration. The craftsmen seem even to have forgotten the technique of the potter's wheel and it seems that they returned for a time to the primitive method of making pots by coiling strands of clay. The products of

the time are accordingly heavy and rough. The neglect of ceramics may partly be due to the tremendous development in the quality and output of lacquerware which came to take the place of pottery in well-to-do households. Lacquer products, which seemed to suit the spirit of the times, were lighter, more brilliant, and more durable than any ceramics and, as a result, fine pottery or porcelain became less necessary.

More surprising is that the textile craft in its more sumptuary forms declined. The kind of lavish costumes described in such minute detail by Lady Murasaki depended on subtle hues of solid colors dyed in the clear waters of the Kamo River in Kyoto. Twelve layers were quite normal and even more were sometimes worn. For brocades they used Sung imports.

The nationalization of styles in the crafts is particularly evident in the metalwork of the Fujiwara period. Silver and gold were more frequently employed for objects produced for the aristocratic families. The pierced work commissioned by the temples matched the elaborate grace of the new architecture and became more and more delicate. Designers paid greater attention to detail in such decorative elements as figures and flowers. Figure 66 shows part of a *keman*, a hanging ornament used in temples. The cord pattern in the center shows how these *keman* were developed from bunches of real flowers which were later replaced by hide, wool, or metal substitutes. The piercing and embossing of these copper plates produces a much more sculptural effect than the work of earlier times. The whole design with its graceful curling flowers and delicately posed figures is of a superb elegance.

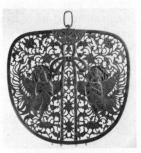

66. Hanging ornament (*keman*). Late Heian period. Copper. Dimensions: $11\frac{1}{4}$ in. × 1 ft. $\frac{7}{8}$ in. Chūson-ji, Iwate Prefecture.

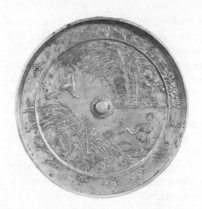

The backs of metal mirrors (fig. 67) show the Japanese sense of design even more clearly. Whereas Chinese-style decorations on mirror backs tend to be regular and repetitive, the Japanese tend to be pictorial, treating the whole area as a single unit. In order to achieve a unified effect even the divisions created by the casting, such as the inner circle, were ignored. Graceful autumn plants, bent over in the wind, cross with unconcern under it and onto the border. (This distinctively Japanese tendency to ignore borders and frames is a feature of later art.) The cranes move freely and realistically; one carries a twig of pine in its beak, another seems to be standing in water. Technically the casting is of the highest quality and the design full of interest, sensitive and without the monotony and the traces of careless repetition which often spoil later mirror backs. During the Fujiwara years the Japanese became as confident in metal casting as in the manufacture of lacquer and in both the newly discovered native decorative genius went hand-in-hand with technical mastery.

6

THE KAMAKURA PERIOD

1185–1338

It says much for the political adroitness of the Fujiwara that they were able to maintain their position long after the effective power had passed from their hands and into those of the big provincial landowners. Some of these almost independent chieftains, the *daimyo* (meaning "great names"), were themselves offshoots either of the Fujiwara clan or of the royal family for whom no room could be found in the capital or its immediate vicinity. During the Heian period the two greatest rural families were the rival Taira and Minamoto clans. The Fujiwara were only able to hold the balance by offering rewards for good behavior—generally in the form of taxfree lands—to the more powerful of the warlike local lords. This expedient naturally hastened their own downfall. They had also the church to contend with. For it was an age of power politics, when the great monasteries followed the example of the landowners and built up their own private armies. The Fujiwara could only resist them by appeals for help to either the Minamoto or the Taira, and this in turn weakened their authority still further.

One emperor tried to override the power of the Fujiwara and to reestablish direct government, but his efforts were short-lived, and he lacked the backing necessary to enforce his reforms. A peculiar feature of the age was the number of abdicated emperors who ran their own courts and administrations, sometimes from the monasteries to which they had retired. Their orders often carried more authority than those of the actual emperor. It was only because the local lords were to all effects independent and self-governing and the

central authority little more than a charming façade that the Kyoto regime was, for a time, allowed to continue.

Nevertheless, this delicate balance was bound to be disturbed as soon as the final battle for power between the Taira and the Minamoto was joined and decided. At first the Taira were successful, but the Minamoto, under a great leader, Yoritomo, managed to regroup their forces and, after years of civil war which devastated the country, they finally overcame the Taira.

All this was accompanied by a fearful loss of life and property and it created a deep change in the emotional life of the country. This is the period graphically recorded in *The Tales of Heike* (*Heike* is another name for the Taira family), the closest in Japanese literature to the Western epic and the endless source of legends which have enlivened Japanese art and literature.

It was the age of the worship of the sword. As a symbol of man's honor, it has been respected down to the present day. In Japan ancient swords are still preserved and the Westerner may admire their unsurpassed technical perfection, their hardness and edge. They are acknowledged to be the finest swords ever made. But he often finds it difficult to share or even understand the emotions with which a Japanese connoisseur will unsheath a polished blade, not even letting his breath fall on it for fear of contamination. Centuries of Japanese history are reflected in its surface and the craftsmen who forged it shaped also the destiny of Japan.

The Move to Kamakura

By 1185 the Minamoto had achieved a position of undisputed dominance in the country. The Kamakura regime which they established gave political form to a conviction which had been steadily gaining strength throughout the Fujiwara centuries: that no military ruler was safe in Kyoto. The warring barons respected, and perhaps even secretly envied, the traditions and elegance which surrounded the court and the royal family, but they could not afford to allow the debilitating effects of court life to sap the vitality of their warriors. This was a lesson which any provincial lord with a practical appreciation of history would have learned. Power in medieval Japan, as in medieval Europe, demanded constant vigilance. Therefore, when the Minamoto emerged supreme they established a well-disciplined military headquarters in eastern Japan at Kamakura, some three

hundred miles from Kyoto. Kyoto, which had been very badly damaged in the wars, remained the showplace, a capital only in name and inhabited by an impotent court while the effective power emanated from the soldiers in Kamakura.

This was the first time that the center of government had left the Kyoto–Nara area, and the move was significant in so far as it implied a determination, if not to make a conscious break with the past, at least not to allow outworn traditions to prevent necessary changes. Minamoto-no-Yoritomo thought in economical and military rather than in political terms. His main ambition was at first merely to preserve the efficiency of his fighting men and through them to increase his control over the large feudal estates. It is doubtful if he relished the responsibilities which the direction of national affairs entailed. For his primary purpose Kamakura was ideally situated. He considered himself initially only as a *primum inter pares*—as a steady fulcrum in a delicate balance of power. In his need to control men as ruthless as himself, the institution and person of the emperor were not only useful but indispensable.

Steadily, however, the commitments and responsibilities of the *shogun*, a title meaning "the Great Barbarian-Subduing General," grew. Many able men, seeking opportunities which the privilege-ridden Kyoto court denied them, joined the *bakufu*, or military headquarters, where the new rulers welcomed their administrative talents and learning. Not only did they prove useful in mundane administrative affairs of which a fighting man would grow impatient, but they added those seemingly harmless touches of refinement which often attract even the most warlike regime. They helped to clothe the naked power of the Kamakura rulers with a mantle of respectability and learning. That men like Yoritomo felt a need to do this shows how deeply Chinese traditions had taken root.

The Minamoto, and the Hōjō family who succeeded them, gradually expanded their control over the feudal domains and organized an efficient administration with a strict legal code to enforce it. It is an interesting sidelight on the complicated nature of the Japanese hierarchy at this time that the Hōjō regents, acting for the military dictators who followed Yoritomo, were themselves descended from the Taira clan defeated by the Minamoto in their fight for supremacy. For one hundred years they were the effective power in the land. It has been said that Japan in the thirteenth century presents

"the astonishing spectacle of a state at the head of which stands a titular emperor whose vestigial functions are usurped by an abdicated emperor, and whose real power is nominally delegated to an hereditary military dictator but actually wielded by an hereditary adviser of that dictator."[1]

It was not long, of course, before the attractions and pleasures of court life at Kyoto began to undermine the simplicity of Kamakura life; yet for a period the dictators remained rough, able, and, on the whole, fair administrators.

The arts responded to the outlook of the new regime in Kamakura. The sophistication of Kyoto life reflected in its decorative elegance was now regarded as effeminate and weak. "The new virtues of austerity, the avoidance of rich materials and conspicuous display; of 'astringency' (*shibui*) in taste; of the rough exterior with a subtle interior; and of the Japanese equivalent of studied nonchalance, were a complete reaction against the grace of Fujiwara decoration as well as an economic necessity."[2]

The Rebirth of Nara Styles

From such a radical break one might have expected a completely new style to emerge. Instead, what can be called a renaissance of Nara styles took place. The revival of interest in Nara sculptures was stimulated by the fact that the civil wars from 1180 onward had caused great damage, especially by fire, to the temples in the old capital and to their sculptural treasures. The Kyoto monks had supported the Minamoto and in the course of the struggle the Taira had destroyed their temples. So, when Yoritomo emerged supreme, he financed their restoration. The Hall of the Great Buddha in the Tōdai-ji was burned down by Taira troops in 1180, and the Great Buddha itself remained exposed to the elements for fifteen years until the hall was rebuilt in 1195 (this was again burned down in 1567 and only rebuilt in 1709; see p. 84). The restoration of Buddhist sculptures of the Nara period provided work and experience for a large number of artists. How great an influence this kind of work exerted is clear from the great popularity enjoyed by skillful contemporary reproductions of classical masterpieces, a number of which have survived.

However, there was a very real difference between the spirits which animated the sculptors of Nara and of Kamakura. The

Nara-period workers, while retaining the human characteristics of the bodies inhabited by their gods, had idealized and spiritualized them. The Kamakura artists, by their use of a wider vocabulary and above all by the perfection of their modeling with its love of natural forms, emphasized the human and personal qualities of their models. The naturalism of these images with their glass eyes, clothes and jewelry of real silk and gold was designed to make an immediate appeal to ordinary people and so be in harmony with the new Buddhist dogmas of the age. If the Japanese craftsmen neglected the idealization of the Nara masterpieces, in returning to the human modeling of the Nara period they were at least picking up the threads of their most fruitful tradition. Under the influence of the past they produced, from the late twelfth to the thirteenth century, some remarkable sculptural works. With them Buddhist sculpture turned full circle—and expired. After this brilliant renaissance the art stagnated in fixed forms which steadily deteriorated over the centuries into insensitive repetitions. It is tempting to draw a parallel with the early sculpture of the Renaissance in Europe and the later armies of marble figures which fill so many galleries in our stately country homes.

The Shichijō Guild: Kōkei and Unkei

Sculptures by eminent craftsmen known by name are more numerous in the Kamakura period. A number of guilds of sculptors, or *busshō*, grew up on the pattern of the Shichijō Busshō, which Jōchō had established in the eleventh century. This same guild under its master Kōkei, a direct descendant of Jōchō, produced many of the finest surviving works of the period. The school had its headquarters in Nara, while most of the others, which had been formed during the Fujiwara period, had their workshops in Kyoto. Schools and artists strove to outdo each other in skill and artistry. The atmosphere in Japan, with each temple competing for the services of famous sculptors like Unkei, must have resembled that in Italy during the High Renaissance. Unfortunately fewer records have been preserved from the thirteenth century in Japan than from the sixteenth century in Italy. However, as in Europe, the emergence of the individual meant more freedom for the artist in so far as it enabled him to impose his own concepts. He became, to a degree, free from the stifling restrictions of iconography. But independence brings its

own obligations: he now had to satisfy a public and attract patronage.

At the same time, artistic imagination continued to find its most productive field in portrait sculpture, which was unhampered by religious dogmas. The Chinese continued to regard sculpture, as opposed to painting, as a relatively lowly craft, and important individual artists never emerged from the ranks of craftsmen. In Japan, the unmistakable imprint of a single artist's personality revitalized the art of the age.

The conservatism of the artists of the Shichijō school at Nara accounted for their comparative lack of popularity during the Fujiwara and at the beginning of the Kamakura periods. Kōkei's work in the Kōfuku-ji, while not yet showing the fully developed characteristics of the Kamakura style, gives evidence that the Shichijō guild was not content simply to supply graceful works corresponding to Fujiwara ideals. But it is with the work of Kōkei's son, Unkei (1151–1223), that this school began to dominate the artistic scene.

Unkei's works show that he was active from ca. 1175 to 1218, a period of over forty years, during which he held an unrivaled position. For him sculpture was the expression through realism of solemnity, dignity, and monumentality. Already in the Dainichi Nyorai statue in the Enjō-ji at Nara (fig. 68), done in 1175–76 before he was thirty and at the very end of the Fujiwara period, although

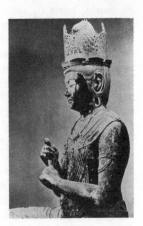

68. Dainichi Nyorai, by Unkei (1151–1223). Wood. Height: 3 ft. 3¾ in. Enjō-ji, Nara.

elements of esotericism remain in the gesture of the hand, it is possible to recognize the beginnings of a return to the calm, compassionate expression which characterizes the Nara masterpieces. The simple halo behind the figure, in its uncompromising plainness, is itself an indication of the artist's aim. The crystal inset eyes—a feature of Kamakura work—heighten the human effect. The draped knees are powerfully modeled and provide a firm base for the stern set of the body, arms, and head. The whole composition is conceived as a regular triangle centered on the hands, and the sculptor has subordinated everything to this basic concept.

This Dainichi Nyorai shows also influences from the sculpture of Sung China in the soft, fleshy feeling of the body, the beauty of the face, and the tall coiffure. The Japanese had reestablished official contact with China at the end of the Fujiwara period, and scholars have noted a certain similarity between Chinese paintings and Japanese sculpture of this time. Altogether, as contacts with China were reestablished Chinese Sung and particularly Southern Sung influences strengthened.

Unkei's Muchaku and Seshin

We see the fully developed style of Unkei and his school in two of Japan's finest works of realistic sculpture—those of the priests Muchaku and Seshin (figs. 69, 70) who occupy positions as attendants to the Maitreya, the main object of worship in the North Octagonal Hall of the Kōfuku-ji. These large, over-life-size figures (each over six feet tall) are imaginary portraits of the Indian priests and brothers Asanga and Vasubandhu, who, according to tradition, lived a thousand years after the *nirvāna* of the Buddha and formulated the teachings of the Hossō sect to which the Kōfuku-ji belongs. There were originally nine statues in the group. The project was started in 1208 under the superintendence of Unkei and with the cooperation of his six sons and two pupils. It represents the perfection of Japanese classicist portrait sculpture. The figures are carved completely in the round and the bodies give the impression of regal power. The drapery is modeled with complete naturalism and splendid variety. The heavy folds swing across the bodies from left to right in a weighty rhythm and fall with natural ease into long sleeves. The heaviness of the robes acts as a perfect foil to the intense faces—particularly that of the Muchaku figure with its emaciated features and piercing eyes.

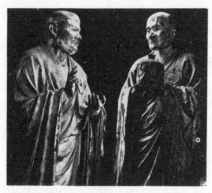

69. Muchaku and (*left*) Seshin, by Unkei (1151–1223). Wood. Heights: Muchaku, 6 ft. 2 in.; Seshin, 6 ft. 2½ in. Kōfuku-ji, Nara.

70. Detail of the head of Muchaku in figure 69.

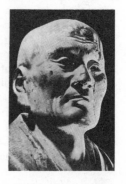

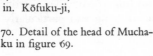

The bones and muscles of breast and neck stand out powerfully, and the heads are poised in attitudes of compassion. The variations in the deep-set eyes, sensitive brows, strong lips, and large noses give each of these figures an appealing individuality. No muscular exertion is expressed in either but they convey a deep latent strength by the tenseness of the neck and hands, the slight asymmetry of the shoulders, and the way they hold their heads. Through both of them runs a vitality which, unlike that in other works of this period, is implicit rather than explicit.

Miyeko Murase points out that this naturalistic approach, for the first time in the history of Japanese sculpture, freed the artist from strict adherence to the frontal position and enabled him to portray figures in true three-dimensional form.[3]

Let us compare these figures with the earlier seated statue of Priest Ganjin (see fig. 38), made in the Nara period. The three statues belong to different ages but the same desire to portray inner compassion has inspired them. All three express pain as well as triumph, but where the earlier statue sits calmly locked in contem-

plation, eyes turned inward to the soul, the two later works look outward toward suffering humanity. The one having risen above the human condition is sublime, the others having conquered the world remain human. The latter share the troubles of the world, preaching their doctrine of salvation to their fellow men. The trials of the Fujiwara wars are mirrored in their powerful, almost pugnacious faces. It is easy to imagine them being called to arms and wielding the sword when the occasion demanded. If the Nara statues represent the triumph of the spiritual over the material, those of Kamakura show the victory of humanity over the gods. They illustrate the differing outlook of Buddhism in their respective periods and at the same time the fundamental change in techniques. In the later figures, the carvers are greatly interested in a faithful reproduction of physical details whereas in the Ganjin figure they are hardly concerned with them. The drapery above all gives the clue to Kamakura work. It is no longer simply a necessary covering glossed over in a graceful but perfunctory manner and hardly distinguishable from the body. Here the folds are those of real clothes with a surface quite distinct from that of the bodies over which they are draped and rendered with a delight for their own sake. One is almost tempted to reach out and touch the cloth from which they are cut.

The sculptor has varied the two figures by lifting their opposite shoulders and by advancing their opposite feet. A slight twist of the hand, a different sway of the robe, and above all a contrasting nobility of feature and expression reveal the subtlety of their maker. The hands perform a gesture of benediction almost as eloquent in expression as the faces. Here is no complicated iconography to appeal only to the initiated; in its place an almost overpowering sincerity sweeps the spectator into a world where the force of individual personalities is used to express spiritual values. Such figures would cause no surprise in the sanctuary of an austere Christian order. They rank among the world's most noble and appealing works and epitomize the Japanese sculptor's gifts for portraiture. Nothing comparable has survived from Chinese art.

Unkei's Kongō Rikishi

A short walk through the streets and parks of Nara from the Kōfuku-ji to the Tōdai-ji is hardly enough to prepare the visitor for the different, almost shocking impact of another pair of statues, also

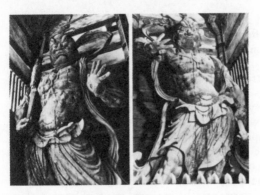

71. Kongō Rikishi, by Unkei, Kaikei, and pupils. Thirteenth century. Wood. Height: 26 ft. 7 in. Tōdai-ji, Nara.

by Unkei, Kaikei, and others of his school. It hardly seems possible that the hands which carved the calm Muchaku and Seshin could also create the two huge writhing Kongō Rikishi (or *vajra* bearers; a *vajra* is a weapon symbolizing a thunderbolt to strike down the evildoer) (fig. 71). These remarkable creations, nearly twenty-seven feet high, are the largest of all wooden sculptures in Japan. According to the temple records, they were fashioned and assembled in the incredibly short period of less than three months and finished in 1203, five years before the two priests. Exposure to the elements in the portals of the main gate of the temple where they stand has resulted in considerable damage to their surfaces but, considering the seven hundred and seventy years that have passed since their creation and the material of which they are made, they are remarkably well preserved. The figure on the east has its lips closely shut expressing thereby its inhaling power or latent might, and the other with its mouth wide open symbolizes its exhaled power. These two figures in their violent movement invite comparison with some of the earlier divine protectors of Buddhism such as the clay Vajrapāni (see fig. 35) in the same temple. The Kongō Rikishi embody the Kamakura predilection for violent, exaggerated action. Here every plane is conceived in terms of restlessness and movement and in this they

differ basically from the earlier statue. The modeling of the torsos is so rich that the eye is never allowed to rest. They are intended to terrify and this they do by the ferocity of their facial expressions, by the muscularity of their bodies, and above all by a tense, poised swiftness which is conveyed by their poses and by the swirl of draperies round the shoulders. These draperies, as well as heightening the effect of movement, serve also to lighten the bulk of the huge figures.

Originally the statues were brightly painted, the heads in brown, the ribbons in white, and the exposed parts of the bodies in red. The clubs, or *vajra*, retain part of their gold leaf and some of the thirteenth-century decoration can still be seen on the skirts. Both have been extensively repaired but much of the originals remains, and the powerful hands, where the tension is consummated, are untouched. It is as if Unkei and his collaborators were determined to carry *à outrance* the realistic tendencies of the times. But for all their size and exaggerated energy, towering above the mortals who must pass them to enter the temple, they are extremely well balanced. Spiritual and physical power are admirably combined. When the temple ordered such figures, it naturally demanded that they should equal the Great Buddha in size and impressiveness. Unkei has tried to match the monumental feeling of the eighth-century bronze casters with his fierce expressions and bunched muscles. No doubt he took equal pride in the complex detail which taxed and displayed his sculptural virtuosity. He was also consciously responding to the spirit of the Kamakura period in which a direct appeal to the worshiper was more effective than an intellectual or spiritual approach, a simple warning better understood than an indirect exhortation. In expressing active rather than latent power, Unkei produced figures which rough men in an age of violence could appreciate. It is true that the Japanese love of exaggeration has often run away with them. Yet some degree of exaggeration is indispensable to a vivid representation of movement, and some of the most powerful and original works of Japanese art owe much of their effect to it.

The Tōdai-ji was at this time being rebuilt and about to enter the second great period of its history. Emperor Shōmu had founded it in A.D. 743 "for the protection of the country and the welfare of the nation," and throughout the centuries the great sanctuary had always been what might be called a "national temple." From the time

of its foundations in the eighth century, when it was placed at the head of the provincial temples and nunneries, it always closely reflected the national temper. It had always responded to the styles and influences of China and, when in the previous period communications with China were interrupted, the Tōdai-ji seems to have remained for a time static—as if in a vast backwater. In its second great period, now approaching, the huge Buddha damaged by fire was under repair and Unkei, inspired by the ancient works of the Nara period all around him, was producing his masterpieces in the old capital.

To look at the wooden sculptures of Unkei is to understand what Langdon Warner meant when he said of Japanese woodcarving, "Stubborn, insisting on its own run of grain, sudden with knots, in the hands of a man who respects it wood helps the carver to unexpected beauties of line. Although Japanese modellers of the eighth century have left us statues as glorious as any the world has produced in those other mediums, wood was perhaps, after all, what fitted the genius of the race. We see it persisting through the ages, shifting its shapes with the changes of fashion, flourishing, atrophying, decaying and then, of a sudden, alive with new purpose and fresh form under the knives of another generation. Down from the aloof Korean beauty of the Chuguji and the Yumeidono Kwannons, through the flowering of Nara times, lapsing for a century, over-delicate for nearly three, we find statues in wood to charm us till Unkei, in the thirteenth century brings up the line with trumpets."[4]

New Buddhist Sects

The restoration of the Tōdai-ji was carried out under the determined leadership of a great monk, Chōgen, then just returned from his third visit to China. The opening of China once more stimulated religious thought and new dogmas swept Japan, completely revolutionizing Buddhist theory. The Fujiwara Shingon and Tendai beliefs, which promised salvation to a limited number of initiates, had already begun to lose favor and the process was accelerated during the Kamakura years. Henceforth Buddhism was to become an essentially popular religion. The most important of the new sects was the Jōdo, or "Pure Land," sect whose introduction was noted in the previous chapter. Members of the royal family, the court, other sects, and even hard-bitten samurai at Kamakura accepted

the teachings of the Pure Land sect from its great exponent, Hōnen (1133–1212). The commoners were particularly enthusiastic—especially those among them who were by now sufficiently educated to read Buddhist literature. The popularization of the Japanese phonetic script opened a world of learning to those who could not master the infinitely more complicated Chinese characters. But Hōnen's teachings struck at the root of the privileges enjoyed by the older clergy and they attacked and persecuted him. They argued that the easy means of salvation offered by this reformer led to the corruption of morals among those who followed the letter and not the spirit of the teaching. But the Pure Land sect offered a solution which was too attractive and spread too rapidly to be restrained by the jealous clergy of the entrenched sects, especially when their own immorality was often so blatantly conspicuous. Shinran (1173–1262), the founder of the Jōdo Shin sect, even opposed the celibacy of monks and simplified still further the Pure Land theories.

Dangerous opponents of the Pure Land were the followers of the Lotus sect, the Hokkeshū, founded by Nichiren (1222–82), who had been a Shingon priest. He rejected and attacked the Pure Land sect and its teachings as vehemently as all other interpretations. For him the way to salvation lay exclusively in the words of the *Lotus Sutra*, which, he claimed, embodied in purest distillation all the Buddha's teachings. Through this scripture any man or woman could identify with the Buddhahood. This dogma was in a sense a return to the old Tendai, although it was now colored by popular Buddhism. Again the only action required of the believer was a simple repetition; he need simply repeat the title of the sutra. The vigor and invective of Nichiren's sermons appealed to the fighting men of Kamakura and his prophecies concerning the Mongol invasion brought him an easy fame. Women also flocked to hear him, for he alone offered salvation to women on an equal footing with men. Exile and threats of death failed to shake his faith and he finally returned in triumph to Kamakura. The universal appeal of these teachings encouraged the sculptors to produce statues which would appeal to believers from even the humblest walks of life.

Zen and Zen Portraiture

These new sects, however, had to contend with yet another and more significant new Buddhist dogma directly introduced from

China—the Zen. The foundations of the sect were already very ancient. In A.D. 520, a great Indian Buddhist missionary, Bodhidharma, whose name means "Law of Enlightenment," brought the teaching from India to China, where it is known as Ch'an. It is a highly mystical concept which gained great popularity in China, incorporating there much of the popular esoteric beliefs of Taoism. Known in Japan as early as the Nara period, it gained its main following from 1200 onward, particularly after the Mongol conquest of China drove many Chinese Ch'an monks to seek safety in Japan, and especially at Kamakura itself. The name *Ch'an* comes from the Chinese transliteration of the Sanskrit word *dhyana*, which can be translated, although with only partial accuracy, as "meditation." Its teachings as formulated in China are most concisely summed up in words attributed to Bodhidharma himself as "a special transmission outside the scriptures; no dependence upon words and letters; pointing directly to the heart (or intuitive mind) of man; seeing into one's own nature and the attainment of Buddhahood." The third sentence is perhaps the most important one. Only by introspection and sudden enlightenment could man achieve the truth; explanations, scriptures, ceremonies, priestly introduction, worship—all were useless. The stern discipline it demanded of its adherents appealed to the samurai, and the saintlike frugality it encouraged was peculiarly fitted to the rigorous standards of early Kamakura life.

The philosophers of Zen have written surprisingly lengthy works to explain that Zen cannot be transmitted by words. This irrefutable position has naturally enough always infuriated its more vulnerable opponents. But for all its incommunicability by words, the teachings of this sect had the most profound influence on the art of both China and Japan. Zen monks were men of letters skilled in calligraphy and painting, and they opened up to the Japanese new areas of art which they eagerly exploited. Zen introspective, intuitive methods could be applied directly to art, resulting in a mystical, highly imaginative approach which could not fail to enrich the artists' vision. The influence of Zen on art was particularly strong on painting (see p. 178). Since the followers of the Zen sect did not believe in the value of icons, religious imagery in sculpture declined in popularity. But a number of portrait sculptures produced at this period are of exceptional interest. The first is the portrait statue of the priest Chōgen (figs. 72, 73), mentioned above as the driving force in the restoration

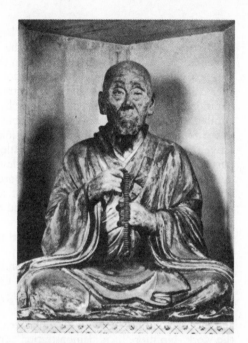

72. Portrait of Priest Chōgen.
Early thirteenth century. Wood.
Height: 2 ft. 6½ in. Tōdai-ji, Nara.

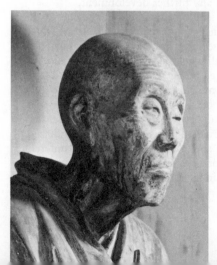

73. Detail of Priest Chōgen in
figure 72.

of the Tōdai-ji at Nara. Originally he had been a Shingon priest but he left this sect to join Hōnen and help in the spreading of Pure Land principles. He was already sixty-one when the emperor put him in charge of the restorations, and he died in 1206 at the age of eighty-six after completing the great work. His portrait is a work in the best tradition of priestly portraits, of which we have already illustrated a number. The artist's name is not known but he probably belonged to the Shichijō school of Unkei, Kaikei, Jōkei, Kōben, and others active at Nara. The statue was probably made at the beginning of the thirteenth century shortly before the priest's death. It is a most powerful uncompromising likeness, the portrait of a grimly determined old man driven by the strength of an indomitable will to achieve a revival of the faith. The emaciated face with one eye half-closed is that of the bigot; the pugnacious attitude with head thrust forward, that of the zealot. The violent spiritual energy in the cadaverous face is so powerful that the spectator almost shrinks before it. The rosary seems almost out of place in his hands, but just as it was the center of his faith in life, so it also forms the calm pivot for this image of restless, undiminished energy.

The contrasts seen in the soft lines of the robe, the tender hands, and the hard outlines of the face emphasize the tortured intensity of the work. No more lucid demonstration could be given of the extent to which the Japanese sculptors were prepared to go in their search for truthful likeness. The chisel has been used almost to a degree of cruelty. The portrait has an air of finality about it beyond which it is difficult to imagine any further development.

In the British Museum is a sculpture from about the end of the thirteenth century (said by some Japanese scholars to be later) which is in the best tradition of these priest portraits in Kamakura (fig. 74). It is rare that they were allowed to leave Japan. The gesso and lacquer which originally covered it have now disappeared and parts have been restored, the chest somewhat clumsily. The robes are most skillfully worked and the face has a fine tranquillity of expression. However, something of the intensity and austerity of the earlier statues is lost and the face is somewhat idealized, almost romanticized. It almost looks as if the head and robes were carved by different sculptors. Yet it is a most impressive ensemble which shows Japanese religious wood sculpture in its last great moment.

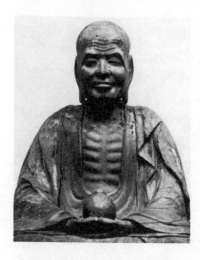

74. Portrait of a Buddhist priest. Late thirteenth century. Wood (originally lacquered). Height: 2 ft. 8 in. British Museum.

The Kamakura Daibutsu

To the Kaikei-Unkei style also belongs the colossal bronze Amida Buddha at Kamakura itself (fig. 75). It was begun in 1252 and completed by 1255 but strangely enough, nothing is known for certain of its creator. As Rosenfield and Shimada point out, in comparison with the thirteenth-century Great Buddha at Nara which was created at imperial order and expense, the Kamakura Buddha was financed by public subscription organized by an obscure evangelist monk, and, whereas the earlier image represented the esoteric conception of a prime creative principle in the universe, the Kamakura Buddha represents the Lord of the Western Paradise, the chief object of devotion in the Pure Land cults.[5] Including the pedestal, it is over forty-two feet high and is modeled on the Great Buddha of the Tōdai-ji, Nara. The handsome face radiates a compassionate calmness. Although technically perfect, it has been criticized on purely academic grounds for a certain lack of proportion; the Japanese say that the legs are too "flat." The proportions may owe something to the fact that it was originally housed, and therefore intended to be seen, in a large wooden hall. This suffered badly from earthquakes and tidal waves until it was finally swept away in 1495. Since then

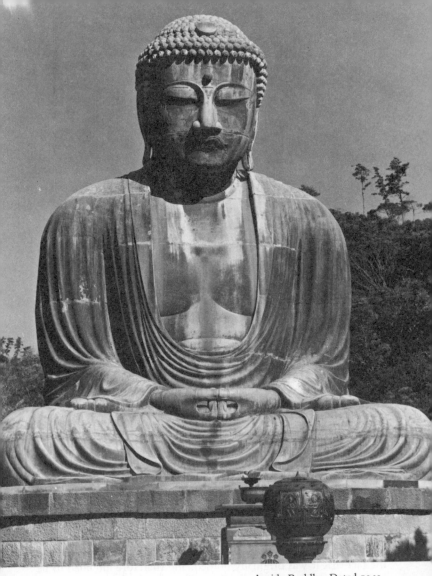

75. Amida Buddha. Dated 1252–
55. Bronze. Height: 42 ft. 6 in.
Kōtoku-in, Kamakura.

the Buddha has remained exposed to the elements, and as Kamakura is by the sea, these have been fairly damaging. Over the centuries the huge statue has acquired an attractive patina. Unfortunately, in the years succeeding the last war, a modern snack-bar and similar tourist attractions have been placed almost at its feet, completely destroying the atmosphere of the precincts. One hopes that these monstrosities will be removed.

Sung Influence

When the Japanese reestablished relations with the mainland at the beginning of the Kamakura era, it was possible for priests like Chō-gen to visit China frequently. But the China from which Japan was now to draw inspiration differed considerably from that of earlier times. The glories of the T'ang dynasty (618–906) were long past. After the mid-T'ang period, moral and political weakness destroyed the grandeur of that virile age. After a half-century of civil war the country was reunified under the Sung dynasty (960–1279). The Sung emperors ruled over the whole of China for only a comparatively short time. Under pressure from the warlike Tartar tribes in the north, they were forced back south of the Yangtze River where they established the Southern Sung dynasty, expending the energies and wealth of the country in fruitless efforts to recover the lost northern half of their kingdom. Eventually the Sung dynasty was completely crushed by the Mongols, who overran China and established the Yüan dynasty (1280–1368).

In spite of their later military and political failures, the Sung centuries produced what many historians consider the finest artistic achievements of the Chinese race. It was an age in which Confucianism was reinterpreted and revitalized. Through the invention of printing, Confucianism and all literary achievements found a broader public. Daring reforms were attempted to put the country on a sound economic footing. Learning and the arts flourished. During the Sung centuries the temper of the Chinese people was fundamentally calm and philosophical. The search for spiritual values behind material phenomena engrossed all men of artistic inclination. Thus a poet and painter like Su Tung-p'o could say, ". . .the inner law of things can be comprehended only by the highest human spirits" and dwell at length on the need for an artist to satisfy the soul of man by identifying himself with nature. But the

Sung ideals—elegance, perfect proportions, and a sensual, relaxed dreaminess—were incompatible with the vigorous art demanded by a more violent age such as the Kamakura. The coming of the Mongols destroyed the Sung introspective mood forever.

The Kamakura period spans the second half of the Sung and the whole of the Mongol, or Yüan, dynasty. Both left a deep impression on Japanese art, though in very different ways.

Sung painting and its influence on Japan will be discussed later. Sung influence on sculpture is well represented by the flying angels in the Kōfuku-ji. It is interesting to compare a typical Chinese Sung-period Kuanyin (Japanese: Kannon) in figure 76 with one of the Kōfuku-ji angels (fig. 77), which shows the same relaxed pose, fleshy face, and appreciation of body surfaces. The similarities are equally apparent in larger-scale figures such as the Shō Kannon in the Kurama-dera (fig. 78) or in the fourteenth-century Suigetsu Kannon in the Tokei-ji.

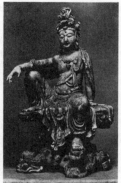

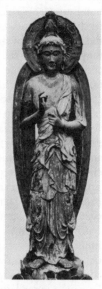

76. Chinese Kuanyin (Kannon). Sung period (960–1268). Wood. Height: 3 ft. 9 in. Victoria and Albert Museum, London.

77. Angel. Kamakura period. Wood. Height: 1 ft 10¾ in. Kōfuku-ji, Nara.

78. Shō Kannon, by Jōkei. Dated 1229. Wood. Height: 5 ft. 8½ in. Kurama-dera, near Kyoto.

Realism and Worldliness

But the Japanese, though accepting the sensuous curves and mellifluous drapery of the Sung carvers, never feminized their works quite as much as the Chinese. Discipline in Japan at that time was perhaps too severe to allow a complete relaxation, and the statues, for all their beauty, preserve a strong, dignified core. The Zen influence on Japanese sculpture is seen at its best in the portraiture of the Kamakura period. The practice of making images of gods was not in harmony with the spirit of Buddhism as interpreted by Zen adepts but they saw no objection to recording in wood the likenesses of great teachers. A most powerful statue of this type is the Basu Sennin (Sanskrit: Vasu Bandhu) in the Sanjū-Sangen-dō, Kyoto (fig. 79). This is one of the twenty-eight protecting spirits of the Thousand-armed Kannon in that temple carved by Tankei (son of Unkei) in 1254. It is constructed in the assembled-block technique (see p. 112), the cap is separate, and the eyes are crystal insets as usual in this period. The staff is not original but probably a faithful restoration. The emaciated face consists of little more than skin stretched over a skull. A few rags encircle the loins, and the legs seem hardly able to bear the weight of the emaciated body. But the inlaid eyes shine as if with brilliant religious fervor. Here, too, spiritual energy is contrasted with physical decay, though less painfully than in the statue of Priest Chōgen. The position of the body as it leans forward aided by the staff looks at first surprisingly simple but is, in fact, most complex. The balance is skillfully planned to create the impression of halting movement and insistence. How far the sculptors had traveled from the smooth softness of the Fujiwara ideals!

Another example of this realistic mid-thirteenth-century spirit is the extraordinary figure of Kūya by Kōshō (the fourth son of Unkei) (fig. 80). Kūya was one of the most powerful priests of the Pure Land sect, whose principal means of salvation, it will be remembered, was to call endlessly on the name of Amida Buddha. He is shown as a typical traveling monk carrying a gong to call attention to his arrival. A string of little Amida Buddha figures is shown emerging from his mouth, as a way of representing the essentials of his teaching in plastic form. The modeling of this statue foreshadows the thousands of well-carved, small wooden statues of priests and peasants which can still be found wherever oriental art works of a lesser order are sold.

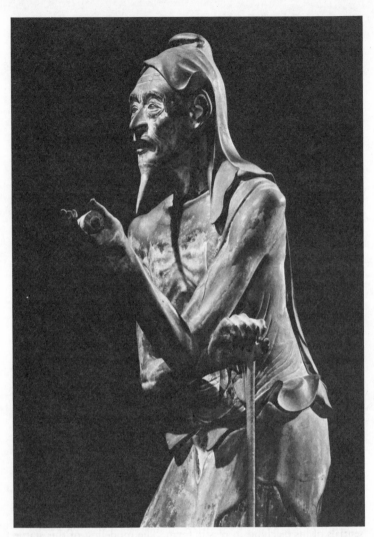

79. Basu Sennin, by Tankei.
Dated 1254. Assembled-block
wood. Height: 5 ft. 9 in. Sanjū-
Sangen-dō, Myōhō-in, Kyoto.

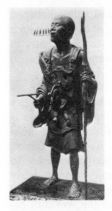

80. Kūya, by Kōshō. Mid-thir-
teenth century. Wood. Height:
3 ft. 10 in. Rokuharamitsu-ji,
Kyoto.

81. Portrait of Uesugi Shigefusa.
Second half of thirteenth century.
Wood. Height: 2 ft. 3 in. Meige-
tsu-in, Kamakura.

The trend toward portrait-likeness and away from religious sculp-
ture was encouraged by the vanities of important men in secular life.
If priests could be honored by a portrait why not they as well—
especially when, as so often, they provided the finance for the tem-
ple? The seated figure in figure 81 is of Uesugi Shigefusa, founder
of the Uesugi clan, one of the families appointed as advisors to the
shogun in Kamakura. The dictator gave this family lands in the
Kyoto–Nara area and it thus became one of the strongpoints of his
influence in both the old and new capital areas. The Meigetsu-in,
Kamakura, where the statue is housed, is a monastery belonging to a
Zen temple supported by the Uesugi family. The statue, which
dates from the second half of the thirteenth century, contrasts
strongly with the usual religious figures of the time. The ceremonial
dress and headgear of a samurai are purely Japanese and owe nothing
to continental example. Such a worldly type of portrait sculpture is
uniquely Japanese. The smooth but incisive lines of the stiff, inflated
formal dress so carefully arranged direct the attention to the stern,
hard features of the successful warrior. The back is ramrod straight,
the eyes are calculating; he could equally well be wearing armor.

With its ample proportions, broad shoulders, and balloon-shaped trousers, the Uesugi figure is the most compelling of a group of such secular figures which has survived. The type appears frequently in paintings of the period (see fig. 85), but the sculptural interpretation has an amplitude which no painting could reproduce.

To the second half of the thirteenth century also belongs the remarkable figure of the goddess Benzai-ten (Sanskrit: Sarasvatī), a female divinity of speech and learning, generally depicted as a beautiful woman (fig. 82). She was normally shown dressed in splendid robes with a stringed instrument in her hands. As a nude figure, however, she represents the climax of the Kamakura tendency to bestow worldly qualities on its gods. The female Japanese body with its smooth lines and almost childlike softness is most faithfully represented. In one step we are transported from the world of religion to that of man, from reminders of the corruptibility of the flesh to visions of its desirability. One is reminded of the gay yet innocent seductiveness of the *devas* in the paradise paintings of the Heian period (see fig. 63) which the sculptor has here, with a different emphasis, transposed into wood. He surely modeled the face on some beauty of the day; it cannot be simply an idealization. There is a new interest in anatomy; the studies of muscular contortions in

82. Benzai-ten. Thirteenth century. Assembled-block wood. Height: 3 ft. 1 in. Tsurugaoka Hachiman Shrine, Kamakura.

some other works of the period such as the huge Kongō Rikishi are further examples of this tendency.

Mannerism and the Decline of Japanese Sculpture

The Fujiwara and Kamakura periods saw the full expression of the native Japanese character in sculpture. After the Kamakura period the art of religious sculpture declined rapidly. So much so that Japanese histories of sculpture generally ignore what was produced. How can one explain this decline?

The return to Nara ideals, allied with greater technical skill in realistic modeling, produced many great works but it seems in the end to have had a fossilizing effect. The sculptors looked back instead of forward to a possible new enrichment of Japanese art. The desire for realism degenerated into a search by lesser craftsmen for sensational detail in which the Japanese love of exaggeration found limitless possibilities for expression.

Mannerism is the word which springs immediately to the mind in considering later works of Japanese (and Chinese) sculpture. Kenneth Clark in his work *The Nude* says; "what we call mannerism has its origin in the expressive distortions of Michelangelo to which, in the female nude, must be added the elegance of Parmigiano."[6] It is interesting to draw a parallel in Japanese art where we can substitute Unkei for Michelangelo and the anonymous carvers of the Benzaiten figures for Parmigiano. In the East, as in the West, mannerism in the female form expressed itself in countless graceful figures (notably Kannons).

Religious sculptures, of course, were made in later centuries, but few can compare with the earlier works either in workmanship or inspiration. The mass-production of traditional religious types deprived the artists of the incentives to seek new forms in Buddhist images. If some new inspiration had arrived from China, Japanese sculpture might have risen to fresh heights, but the centuries of the Yüan and Ming dynasties made no great contribution to the art. After the Sung dynasty, Chinese sculpture languished and died; the Japanese craftsmen turned to other materials and sought inspiration outside the religious world which had hitherto absorbed them.

Buddhist Paintings and A New Intimacy

The pictures of the Buddhist painters equally expressed the

teachings of the new sects. As the Pure Land sect with its belief in the all-powerful mercy of the Amida Buddha spread throughout Japan, a new interest arose for painting scenes called Raigō in Japanese (see p. 117) in which the Buddha is shown descending in all his radiant glory to meet the believer. In the Kamakura interpretations of these scenes there is a new sense of closeness to paradise; the divinity seems to be directly encouraging the efforts of the believer to achieve salvation. It should be noted that the gods descending to meet the faithful often shed their light over a purely Japanese landscape.

While expressing the hopes of the new Buddhism, painting was employed also to depict its fears—the deterrents to sin, the hells awaiting the wicked. But these fears were represented in a new way. In the previous age a grim Fudō or a menacing guardian stood ready to strike down the offender. These avenging spirits were far removed from the world of man. But with the rise of the Pure Land sect, even these darker gods were humanized. The belief in the transmigration of souls provided more scope for the horrific side of the Eastern artistic imagination than even the hell of Christianity did for

83. Section of the handscroll *A Handbook on Hungry Ghosts*. Kamakura period. Ink and color on paper. Height: 10$\frac{7}{8}$ in. Tokyo National Museum.

84. Section of the handscroll *A Handbook on Illnesses*. Kamakura period. Ink and color on paper. Height: 10¼ in. Private collection.

the West. The Amidist, for instance, envisaged various postmortem conditions for the soul of man—infernal hell, the hell of hungry ghosts, that of the animals, the human world, and finally the world of the divinities. *A Handbook on Hungry Ghosts* (fig. 83) in the Tokyo National Museum in places outdoes the imagination of a Dante or a Bosch. *A Handbook on Illnesses* (fig. 84) illustrates man suffering from the various diseases of the flesh. The example reproduced here shows a man suffering from loose teeth. The picture, a masterly combination of mockery and pathos, is full of a rather brutal humor.

With what emotional resonance the figures are contrasted and how expressive is the brushwork which depicts them! The woman, a sturdy peasant swift to mock the misfortunes of others, kneels in relaxed amusement. She points an admonitory finger at the sufferer who sits in agony clutching his stomach, his legs drawn up in convulsions, to suggest that his teeth have poisoned his whole system.

The man's eyes seem to be trying to follow his fingers down his own throat. For all its jovial sadism, this is no secular *plaisanterie*; rather it is the portrait of a sinner—of a glutton with his heavily loaded plates hardly touched before him. The artist has managed to convey something of the man's pique at not being able to touch his tempting meal. The chopsticks point tantalizingly at him. At any moment one feels the woman will take them up herself.

The drama is the simple, eternal one of the unexpected, and its effect is produced by a remarkable economy of means. With what apparent relief the artist has turned away from the masklike figures of the Fujiwara time as seen in the *Genji* scroll to the much more intriguing animated faces of the Kamakura man-in-the-street! There is nothing in Chinese art to compare with this intimate vignette which comes surprisingly close to Western modes. It is an astute comment on plebeian life of Kamakura times by a Japanese painter with the common touch of a Breughel.

Portraiture

The portraits of the period are quite different. They, too, are essentially Japanese and, like the portrait sculptures, show how the nobles, although lay figures, have come to share the stage with the divinities. The portrait of Minamoto-no-Yoritomo (fig. 85), the founder of the new regime, is a typical product. The paintings of the hells are anonymous and probably the work of some gifted artisan priest; but the name of the painter of Yoritomo is known. He was a certain Fujiwara-no-Takanobu (1142–1205), famous at that time for the truth of his likenesses. The conception of this masterpiece is in keeping with the severe character of the sitter. His dress is austere and dark, the face white and almost luminous against the somber background. Looking sideways out of the picture, the eyes of this warrior remind us of an Aka Fudō and, as if to dispel all doubt about the man's fundamental character, a sword-hilt peers obtrusively from beneath his voluminous ceremonial dress. The dramatic rigidness of the lines is peculiarly effective in characterizing his determination. The emphasis falls on the three main features, the hard face, the ready sword, and the scepter of office, and the eye is brought to bear on them in that order. This is Yoritomo the dictator seen through the perceptive eyes of a great portrait painter. Like Uesugi Shigefusa (see fig. 81) he is almost godlike, an incarnation of the sword that

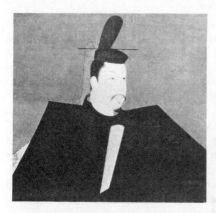

85. Portrait of Minamoto-no-Yoritomo, by Fujiwara-no-Takanobu (1142–1205). Color on silk. Dimensions: 4 ft. 7 in. × 3 ft. 8 in. Jingo-ji, Kyoto.

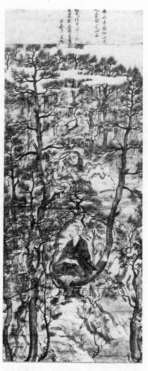

86. Detail of *Myōe Shōnin Meditating in the Mountains*, attributed to Jōnin. Thirteenth century. Hanging scroll; color on paper. Dimensions of entire scroll: 4 ft. 9 in. × 1 ft. 11 in. Kōzan-ji, Kyoto.

brought Japan together in the twelfth century. The portrait is the epitome of the stern, impassive dignity which the Japanese consider to be the proper outward expression of a powerful personality. There is nothing of the elegance of Kyoto in the portrait.

The Zen teachers of the period condemned the worship of images, and in art this is reflected in a preference for portraits of eminent Zen priests. One of the most remarkable is that of Priest Myōe Shōnin (1173–1232) meditating in the mountains (fig. 86). Behind the Kōzan-ji which he founded is a wooded mountain where, in the peaceful atmosphere of its natural surroundings, he sought enlightenment. The landscape in which he is shown seated is strangely atmospheric and the birds and animals are very naturalistically represented—all contributing to a most unusual vision.

Fans, Handscrolls, and Hanging Scrolls

The alliance of court sophistication with popular Buddhism was continued in a series of Buddhist sutras written on fans in the second half of the twelfth century (fig. 87). The rich, decorated paper has genre scenes of noble or plebeian life in *yamato-e* ("Japanese painting"; see p. 118) style with religious texts written over them. Beneath the coloring, traces of block printing can be distinguished which antedate the perfection of the woodblock print by some five hundred years. Woodblock printing for holy texts and pictures was used in China during the T'ang dynasty, though never to depict such secular subjects. The charming genre scenes, almost obscured by the holy writings, are a new departure. This combination of secular and religious motives is perhaps the most revealing indication of a changed mood in Buddhist art.

During the Kamakura period the range of paintings was suddenly and greatly enriched. Popular Buddhism accounts for part of this expansion. As Buddhism became more easily understandable, so the need arose for a type of painting with secular subjects or references which would appeal to the ordinary man. In addition, popular literature, steadily growing since the *Tale of Genji*, kept pace with the spread of literacy. It provided a rich fund of interesting material suitable for painting—fairy tales, biographies, battles, histories of temples, and travel stories. The many artists who took advantage of this wider range could choose one of their own, by now highly developed, native styles or seek inspiration from freshly introduced Chinese modes.

Although handscrolls are preoccupied with the human being, they sometimes include landscapes as backgrounds. Where Japanese scenes are depicted, the artist tended to choose a Japanese rather than a Chinese style. The Japanese must have had examples of Chinese Sung landscapes before them, but the painters of the time seem to have preferred their own *yamato-e* styles. These are quite different from the Sung monochrome work which became so popular in later times. As previously mentioned they are closer to what we believe to be the T'ang style. The Japanese landscape elements in these scrolls are generally brightly colored; gold and silver is often used to increase the decorative brilliance; above all they are extremely formalized. Whereas the Chinese painter was fascinated by the grandeur of inaccessible mountains in all their moods, the Japanese

87. Fan on which is written a Buddhist sutra. Kamakura period. Ink and color on paper. Height: 10 in. Shitennō-ji, Osaka.

used broad sweeps of color washes, sometimes without outlines, to show his gentler native landscape. His brush was softer and calmer, expressing a lyricism which the Japanese attribute to their milder climate. The Chinese painter was awed by the overwhelming grandeur of nature and hinted at the delights that the human soul will find by seeking identity with it; the Japanese approached his landscape in a more friendly mood and beckoned the spectator to share in its simple enjoyments. The spirit which in China results from a deep mystical strain and produces the recluse has in Japan produced the flower-viewing parties which appeal to the native sense of form and color. The instinct which led the Chinese artist respectfully to observe in a long landscape scroll the thousand miles of the Yangtze River expresses itself at the hands of a Japanese painter in a more intimate view of the soft regular slopes of rolling hills. There is a direct link between the *E-Ingakyō* of the Asuka period, these handscrolls, and the Japanese decorative manner so adroitly exploited by the masters of the Tosa school in later times.

The *yamato-e* style emerged in a time of violence; appropriately enough, its genius is not so much for landscape as for depicting dynamic action. The vivid sense of movement seen in the handscrolls (called *e-makimono*) undoubtedly owes something to the vigorous Chinese use of line, but the subjects of Chinese painting are seldom

dramatic. They are generally contemplative. The continuous narrative and powerful action displayed in Japanese scrolls are an entirely native invention. The Chinese emphasis is on nature; the Japanese shifted it to man, which remained thereafter their chief interest. Genre works are found in Chinese painting but the acute observation of man in all his activities and conditions is a salient characteristic of Japanese painting. Mankind alone provided the fullest opportunity for the Japanese artist to combine his predilections for the dramatic and sentimental, the sensational and grotesque which, it has been suggested in earlier passages, often dominate his art. In this respect, the *e-makimono* in *yamato-e* style, which have no counterparts in China or the West, are the purest expression of Japanese art.

Yet one splendid hanging scroll of landscape has survived which is more than a simple landscape. The painting of Nachi Waterfall in the Nezu Museum, Tokyo (fig. 88), is to the Japanese an object of deep religious significance and is an outstanding example of what Harold P. Stern described as the sanctification of nature.[7] The follower of Shinto believes that all natural phenomena contain spirits; and this landscape is intended to depict the spirit of the waterfall as it plunges down the mountainside with very impressive power. At the time when the painting was done Buddhism and Shinto had to a degree been reconciled in a system called Dual Shinto (Ryōbu) in which the Shinto gods were accepted as manifestations of the Buddha. It was very important for the survival of both faiths that they should be reconciled. This is a typical example of the way in which Buddhism was able to adapt itself to native beliefs without giving offense, and the painting of Nachi Waterfall represents a combination of Buddhist inspiration and native religious thought. Unfortunately it is too darkened by age to make reproduction easy. The follower of Dual Shinto, identifying himself with divine power, would see in the sun in the top left-hand corner a suggestion of the Dainichi Buddha (the Buddha of all-pervading light). His eyes would follow the dominating line of the heavy waterfall with its Shinto spirit, Hiryū Gongen, down to the misty secluded shrines at the bottom where the god was worshiped. The Kumano district in which this waterfall is situated was a popular center of Dual Shinto beliefs, and the painting was probably made in the last years of the thirteenth century or early in the fourteenth century. This Nachi

88. *Nachi Waterfall*. Late thirteenth to early fourteenth century. Color on silk. Dimensions: 5 ft. 3 in. × 1 ft. 10¾ in. Nezu Museum, Tokyo.

landscape is a monumental work. It has a dramatic quality which is often found in Japanese paintings, and occurs even more strongly in the color prints of waterfalls made in the nineteenth century. A solid sheet of water falls heavily to the shadowy precincts below, cutting the landscape into two equal parts. The stillness of the rocks and trees contrasts with the urgent, almost audible, speed of the water. Japanese forests do indeed inspire the sense of mystery which this ancient painting so admirably evokes and it is easy to appreciate how it became an object of veneration to be worshiped in a shrine. The area is too holy to be spoiled by the intrusion of man—even by the tiny respectful figure which in a Chinese landscape would be found regarding the universe around him.

89. Section of the handscroll *The History of Mt. Shigi*. Twelfth century. Ink and color on paper. Height: 12½ in. Chōgosonshi-ji, Nara.

Predecessors of the Great Kamakura Scrolls

A number of *e-makimono* have been preserved, but unfortunately, since their effect depends upon the viewer following and identifying himself with a long and continuous action, they are difficult to reproduce satisfactorily. However, something of their vitality appears even in the details, which are all it is possible to show. Even if the sweep of the composition and the mounting tension created by successive scenes is lost, they at least give some idea of the urgency and concentration of the whole and of the compositional skill of their creators.

The *Genji* scroll was discussed earlier under the Fujiwara period, since it is a unique work which belongs there and nowhere else. However, two other famous scrolls actually made at the end of the Fujiwara have far closer affinities with the great Kamakura *e-makimono*. So to these we must for a moment return. The first, made in three parts, is entitled *The History of Mt. Shigi* (fig. 89). It recounts most graphically a simple and amusing story with a Buddhist moral.

A priest called Myōren, founder of the Chōgosonshi-ji on Mt. Shigi, outside Nara, had been accustomed to receiving alms from a

wealthy man. By his miraculous power, the priest would make his alms bowl fly to the granary of his patron who was expected to fill it. It would then return to the priest by the same magical means. One day the rich man was too busy or too impatient to pay attention to the persistent bowl which he left neglected in the corner. The angry priest then made the alms bowl rise in the air and carry the entire building with all its contents to the priest's cottage on Mt. Shigi. The rich man and his friends, thrown into consternation, followed its flight to the mountain where they found both priest and granary. Myōren declined any interest in the grain but said that he needed the building for his own storage needs. Then, using the bowl once more, he flew the sacks back to their original home where they were joyfully received by their owner.

The artist of this scroll is unknown, an indication perhaps of the lowly station of painters at this time. He was probably a professional Buddhist painter of the first half of the twelfth century. The technique for joining the various scenes of the story, as seen already in a well-advanced stage in other scrolls has here been skillfully developed into a much more natural continuous method. The style is also different. The stiffness of line, the immobile composition, and the heavy color of the *Genji* scroll have been replaced by a free flowing line, a black-and-white technique with soft color washes, and a greater continuity. Only a few objects are emphasized by bright colors, such as the bowl itself and the tassels on the horses. The draftsmanship is infinitely more skillful. The figures leap about and gesticulate in genuine consternation when they see the granary leaving the ground, jumping up, as if to try to hold it down. Every figure is a precise and individual study in movement and emotion. Each scene is alive with its own humor and character. Even the few landscape elements have a distinctive freedom. Nothing in the earlier scrolls leads us to expect these witty, unaffected stories in pictorial form which enliven the late Fujiwara period with their vivid glimpses into the lives of ordinary people. A whole new world seems to open up to the artists by their "democratization" of subject matter. Here, if anywhere, are the forerunners of the intimate studies which fill so many of the color prints of some five hundred years later. No sterile conventions stifle their expression, no mannerisms reduce them to pure decoration. It is difficult to imagine more vitality of brush or spirit.

The second set of these scrolls (fig. 90) in the Kōzan-ji is even more surprising. This set is in black and white only and two of the four scrolls appear to be somewhat later. The earlier two are commonly attributed to Toba Sōjō (1053–1140), an eminent, appealing, and indeed exuberant Buddhist priest—though this attribution has been challenged. The deeper meaning of these paintings, if any, has not been determined but on the surface they seem to satirize man in the guise of animals. It has been suggested that a priest painted these figures as a protest against the squabbles and unpriestly, even mocking, behavior of his fellow monks. Some of the scenes—especially in the finest scroll, which shows animals and frogs in human activities—are singularly irreverent. The Buddha is depicted as a frog and the clerics fight among themselves (as indeed the quarrelsome monks of that time may often have done). The sprightliness of the strokes is uncannily effective. Chinese line drawings of divinities may have provided the priest with the models for this kind of black-and-white draftsmanship but they are here transformed by the Japanese artists into something quite unique. It is unlikely that the painter of this scroll intended it as anything more than a private joke. Certainly

90. Section of *The Frolicking Animal Scrolls*, attributed to Toba Sōjō (1053–1140). Ink on paper. Height: 12¼ in. Kōzan-ji, Kyoto.

it could not have served as an object of worship. It is most significant in denoting a complete break with Chinese styles and the establishment of a native mode.

The History of Mt. Shigi and *The Frolicking Animal Scrolls* show that, however effete late Fujiwara court life may have been, there was no lack of invention and vitality in these priest-artists who could turn with such complete mastery of technique and pungent wit to the commoners and the animals for their subjects. And how refreshing it is to escape from the monotonous idealism of many Buddhist paintings of the Fujiwara period to the humor and imagination of these spontaneous creations!

Scrolls of Kamakura

By the thirteenth century three main styles had emerged in scroll painting—the *Genji* type which relied mainly on color, the *Mt. Shigi* type in which line is most important and color used only sparingly, and finally the black-and-white type which we see at its best in the *Frolicking Animal Scrolls*. The Kamakura period produced a flood of scrolls. Some follow one style, some another, and some aimed at combining two or more. Their titles, and there must have been very many such scrolls, give the best clue to their subjects: *The History of Kokawa Temple, The Story of Subduing the East* (the account of the Chinese priest Ganjin's mission to Japan), *The Illustrated Biography of Priest Hōnen, The Story of the Great Minister Kibi in China, The Handbook on Long-nosed Goblins, The Story of the Battle of Heiji, The Story of the Mongol Attack, The Life of an Artist* (fig. 91), and so on.

Two of these superb thirteenth-century scrolls are worthy of special study. *The Story of the Battle of Heiji* is one of the few paintings of this type which the Japanese have allowed to leave their country. One of its three scrolls is in the Museum of Fine Arts, Boston. Around the turn of the year 1160, when the Minamoto and Taira were fighting for supremacy in Kyoto, the Sanjō Palace was set on fire. The Boston scroll, of which a section is shown here (fig. 92), gives a magnificent battle scene with the actual burning of the palace most graphically depicted. The artists of these scrolls already had long experience in painting crowd scenes, but the unknown artist of the *Heiji* scroll was particularly skilled in portraying the high excitement and panic of the event.

The set of scrolls *The Story of the Mongol Attack* (fig. 93) portrays

91. Section of the handscroll *The Life of an Artist*. Kamakura period. Ink and color on paper. Height: $11\frac{7}{8}$ in. Imperial Household Collection.

92. Section of the handscroll *The Story of the Battle of Heiji*. Thirteenth century. Ink and color on paper. Height: 1 ft. $4\frac{1}{2}$ in. Museum of Fine Arts, Boston.

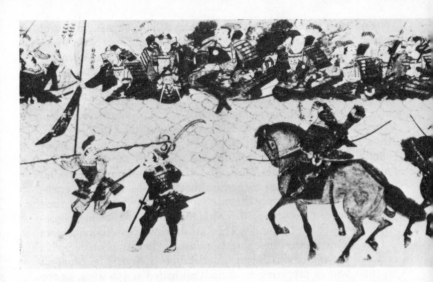

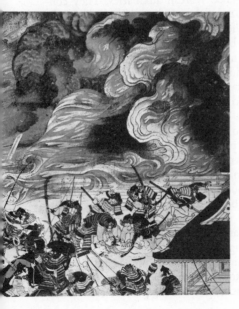

93. Section of the handscroll *The Story of the Mongol Attack*. Dated 1293. Ink on paper. Height: 1 ft. 3¾ in. Imperial Household Collection.

one of Japan's greatest historical moments and the outstanding event of the dramatic Kamakura period. In 1263 Kublai, Khan of the Mongols, made himself emperor of China and founded the Yüan dynasty. The Mongols, "the Golden Horde," were merciless fighters who swept through China, across Asia, and into Europe, pillaging and destroying wherever they went, establishing and controlling by an iron discipline the largest empire the world had hitherto known. Their arms were irresistible. The peoples who stood in the way of their early campaigns had only two alternatives—surrender or annihilation. They often suffered both. In 1268, the Mongol emperor, by now secure in China and confident of his power, made his first approach to Japan, suggesting that relations should be established. This meant simply that the Japanese should surrender their independence completely; the Mongol hinted at the dire consequences of a failure to comply. The Kamakura warriors, though aware of the significance of these threats, refused to be intimidated. Such a refusal was the equivalent of a declaration of war. The Mongols spent a year in preparing an armada estimated at 450 ships, 15,000 Mongol fighting men, and 15,000 Korean auxiliaries. They confidently landed on the west coast of the southern island, where the local chieftains and their retainers opposed them with tremendous courage. Honors seem to have been even in the first day's encounter of Japanese sword against Mongol arrow and artillery. The Mongols returned to their ships and that same night a storm blew up, scattering and destroying their fleet. This disastrous campaign cost the invaders, unaccustomed to such reverses, 13,500 men, to say nothing of their loss of prestige.

By 1280 Kublai was ready to return to the attack. He was determined to revenge the two groups of envoys who had paid with their lives for the journey to Kamakura to demand submission from the Japanese. This time both sides had more time to prepare. The Mongol force, now numbering about 150,000 men, landed in June 1281. The battle lasted for fifty days before another storm destroyed their fleet and, in a strange analogy to the fate of the Spanish Armada, drove what remained, perhaps as little as one-fifth, back to the mainland in complete rout. Although the threat of invasion lasted for another twenty years, the enemy never made another attempt and the Japanese could thus claim to be the only people successfully to have resisted the Mongols at the height of their power. This valiant

defense and the providential storms provided the Japanese with the cornerstone of a belief in their divinely aided invincibility which lasted into our own times. A Japanese artist recorded his nation's most heroic moment in this scroll. It gives an authentic eyewitness account of actual battle scenes, the first incidentally in which cannon are represented.

One cannot leave the painting of the Kamakura centuries without mention of the sympathetic paintings of animals, particularly of the ever-laboring bullocks which played a large part in the economy of the time (fig. 94). Stern comments, "Heavy masses of black and touches of brown form the bodies of the animals. The forms are all carefully contained within a skillfully drawn enclosure of lines. . . . the artist has used a device of shading to create the rounded and massive volume and musculature of the beasts. The tonalities of black, gray and brown are most adroitly handled. The artist also contrasts the full and forceful bodies of the beasts with the extraordinarily delicately drawn hair of their tails."[8]

The Birth of Japanese Ceramic Art

In the minor arts, the all-pervading influence in this period was that of the Chinese Sung dynasty. Chinese ceramics, with a thousand years of development behind them, were the finest both technically and aesthetically that the world has produced. It is not surprising that the Japanese, although in the other arts capable of rapidly learning from and even surpassing their teachers, could not equal the perfection of Sung wares.

Nevertheless, the Japanese claim that their ceramic art was established during the Kamakura period by a man named Tōshirō who is

94. Section from *The Handscroll of the Swift Bulls*. Kamakura period. Ink and slight color on paper. Dimensions: $10\frac{5}{8}$ in. × $12\frac{1}{4}$ in. Seattle Art Museum.

known as "the Father of Japanese Pottery." He went to China with a Buddhist priest and studied the craft during his stay there. When he returned to Japan (about 1229), he settled in the area now called Seto, near Nagoya, and for the more wealthy families began producing pottery, mainly for ritual purposes, in which he used Chinese techniques and aimed at Chinese glazes such as celadon and the *temmoku* brown-black. Hundreds of kiln sites dating back to this period exist around Seto, and it is still possible to find fragments of fine glazed brown and black pottery from this time. One can therefore claim that high-fired wares originated in these centuries. Seto has remained the largest pottery-producing area in Japan—so much so that the word *setomono* ("Seto things") is still the accepted term for pottery.

The wares produced at Seto, and at a few other sites such as Tokoname in particular, Shigaraki, Tamba, Bizen, and Echizen (called the Six Old Kilns of Japan) were far more primitive than the Chinese wares. These other kilns produced wares that were different from Seto wares, mostly utensils for everyday use, and the products of one kiln are often very difficult to distinguish from those of others. However, the Japanese have always admired a certain powerful roughness—especially for their tea-ceremony wares. But at this time taste probably did not enter into it, though some Japanese critics like to see in these rough early wares the beginning of that studied carelessness, "the concealing of its consummate artfulness," which became the essence of later tea-ceremony taste. It is more likely that, although new continental techniques were introduced, they just could not match the Chinese workmanship. Tradition, skill, and spirit were lacking in Kamakura Japan, and of these the most vital failing was the lack of spiritual atmosphere. Sung ceramics were the result of a long tradition going back to the Han dynasty with which Japan could not compete, and they reflected a world of sensibility unknown to the Japanese, particularly at this time.

The vase shown in figure 95 is a typical Japanese product of the period. Strangely enough, some potters continued for a short period to use the earliest Japanese pottery-making technique revived during the Fujiwara time, that of coiled clay, as seen in the neolithic Jōmon pottery. The basic form was shaped by this primitive method and then both outside and inside were finished on a wheel. The pots were sometimes made in parts and then assembled. This clumsy technique

95. Vase of Old Seto ware. Kamakura period. Black glaze over gray body. Height: 9½ in. Tokyo National Museum.

can usually produce only very heavy wares. It is surprising that the Japanese potters by these crude means were able to produce such comparatively fine shapes. The black glaze of our example is uneven and not too skillfully controlled. What beauty the vase contains lies in its powerful shape allied to vigorous free-hand decoration which successfully covers the whole surface. The vase recalls some of the Sung Tz'u Chou wares. Although its place of manufacture is not known, it is the kind of ware produced at Seto where at one time there were as many as three hundred active kilns. Green and yellow glazes also were made by adding kiln ash which reacted with the iron in the body. The black and yellow glazes were produced by putting iron directly into the ash-glaze, probably in imitation of the Chinese *chien-yao*, popularly known in Japan as *temmoku*.

Lacquer and Textiles

Styles of lacquerware and textiles were perhaps the slowest to react to the austere atmosphere of the Kamakura court. Kyoto always remained the arbiter of fashion in these two crafts and neither would have welcomed a move away from the elegance of the Fuji-

wara toward the sobriety of Kamakura taste. The new trends in lacquer are first noticeable in more solid and severe shapes. The decorative designs increasingly reflect the more spontaneous and individual *yamato-e* styles and tend to take their inspiration from nature. The broad sweeps and soft curves of the new type of landscape paintings were admirably suited to lacquerwork. But even so, the influences of the gentle Fujiwara court taste persisted in what was essentially a luxury art. Techniques in lacquer application developed rapidly. Where previously gold and silver powders had been combined to enrich the surfaces, now gold or mother-of-pearl alone was sometimes favored. The result was greatly to increase the impression of luxury and solidity.

Variety in the manner of applying the gold in different grades ranging from fine dust to flakes and even squares distinguishes the products. When gold dust alone was used the textures were often mixed in a technique called *nashi-ji* which was frequently employed for backgrounds. In earlier periods the *maki-e* had been a comparatively simple method in which the metal dust was sprinkled on the wet lacquer of the design and the whole surface then polished down with charcoal (see p. 89). Now the *maki-e* was used in two important new techniques which served to emphasize the designs by raising them in relief. In the *hira*, or "flat relief," *maki-e* the decoration is applied in the usual manner, but wherever it is intended to raise the design slightly it is overpainted with lacquer. In the *taka*, or "high relief," *maki-e* the decoration itself is made up of a number of layers

96. Detail of a cosmetic box. Kamakura period. Lacquer with mother-of-pearl and inlay of precious metals. Dimensions of box: 10 in. × 1 ft. 2 in. × 8¼ in. Hatakeyama Museum, Tokyo.

97. Top of incense box with a design of peonies. Kamakura period. Carved lacquer (*kamakura-bori*). Diameter: 1 ft. 1 in. Nanzen-ji, Kyoto.

of lacquer in relief and then finished in the same way as ordinary *maki-e*.

The detail of a cosmetic box in figure 96 illustrates the Kamakura spirit in decoration. *Maki-e*, mother-of-pearl, and sheet design are all used. The butterflies in sheet silver were further enhanced by skillfully incised lines filled with gold dust. Other parts of the decoration are in burnished gold and *nashi-ji*. The total effect is saved from confusion only by the liveliness of the design. Here the Japanese love of nature is happily fused with the equally strong native passion for pleasing decorative effects. Butterflies and insects were favorite themes for Kamakura decorators and their very lightness serves sometimes to offset the heaviness of the new techniques.

Lacquer became a very popular means of decorating armor and saddles, and some fine specimens of the latter with rich mother-of-

pearl inlay have been preserved. Yet fundamentally the very elegance and luxury of lacquerwork seem somewhat out of harmony with the austerity of the Kamakura period—at least in its earlier decades. For a type of lacquerwork more in keeping with the spirit of this age we must look to a new kind which was made in Kamakura itself. This *kamakura-bori* (fig. 97) was directly inspired by a type of lacquer said to have been made for the first time during the T'ang dynasty in China. Although no early examples have survived, its Ming and Ch'ing equivalents are thoroughly familiar to the collector. In this technique, layer upon layer of lacquer is applied to build up a solid body of the material which is then carved very much like wood. Sometimes red and green layers alternate so that by a cameolike technique of carving both colors could be used together; thus in a floral design, for example, leaves were left green and flowers red. The method was suitable for architectural decoration in temples and it is known that eminent sculptors, even descendants of the great Unkei, worked in this medium. The craft has survived in the city of its origin and has lately been enjoying a revival. Good examples in old and modern styles can be found there.

Kamakura textiles, like those of the Heian period, have not survived the centuries in any numbers. But paintings provide evidence of styles and decoration. Generally speaking, the twelfth and thirteenth centuries contributed little of importance. It is easy to understand that the austere atmosphere the new warlords encouraged did not stimulate the creation of opulent styles or the use of rich materials, and it seems that even the silk produced during the period was of poor quality. In dress design the general trend seems to have been toward simplification and sobriety (see the Yoritomo portrait, fig. 85). Dresses hitherto reserved for the plebeian classes became popular among the nobility. Men who lived by the sword needed freedom of movement in their clothing. The *kosode*, or "short-sleeves," which had been the innermost—and the simplest—of numerous robes, now worked its way to the surface as one after another of the inconvenient outer garments were shed. Sometimes it was used with *hakama*, the long, loose trousers which are still worn on ceremonial occasions. Both garments had larger, bolder designs and these were often laid down by regulation; paulownia leaves or bamboo and phoenixes for the emperor, a modification of the same design for retired emperors, and so on down the scale. The crests

(*mon*) of the great families became popular motifs for the robes of the nobility. Tie-dyeing was revived, but now the rough outlines of the design resulting from the process were sharpened by painting the material after the dyeing. This so-called *tsuji-ga-hana* technique later produced some beautiful fabrics, but most of the materials which have survived from the Kamakura period have a dry, archaistic appearance and are singularly dull compared with those of other times.

7

THE ASHIKAGA OR MUROMACHI PERIOD

1338–1568

Yoritomo's fear that the luxuries of court life would sap the strength of his warriors was well founded. All the legislation which the Hōjō regents enacted to prevent overindulgence in the enervating, expensive refinements of life proved useless. The plottings in Kyoto, the constant fighting between the clergy, the insubordination of unruly clansmen, and finally their efforts to repel the Mongols, all weakened the internal strength of the regime. By the beginning of the fourteenth century the *bakufu* had lost its authority. The regents could no longer claim the allegiance even of their own vassals and the struggle for power between the great landowners entered a new phase. The succession to the emperor's throne in Kyoto which had been controlled by Kamakura was no longer undisputed but had to be decided between the regents and other discontented warlords. In the ensuing struggle, the Kamakura faction lost its power, and in 1336 the Ashikaga family, led by a defector from the Kamakura ranks, Ashikaga Takauji, established Emperor Kōmyō on the throne in Kyoto and assumed the old Kamakura title of shogun. Japan seemed to be on the verge of a new and more auspicious age. The country was weary of the interminable rivalries between the great lords which the late Kamakura regime had been unable to control, and looked back with nostalgia to the great days of Nara when the local lords paid allegiance to and were ruled by the emperor at the capital. The emperor had then seemed an effective sovereign, his authority unquestioned, and the nation prosperous. Throughout their history the Japanese have been deluded by

the conviction that an escape from their troubles could only be found by a restoration of imperial power.

Unfortunately, in this period too, their hopes were rapidly disappointed and Japan entered one of her most unhappy periods. The first fifty-four years (1338–92) are called the Namboku-chō, the period of the Northern and Southern Courts. It took its name from a prolonged rivalry between the Emperor Kōmyō in Kyoto and a pretender who fled south to establish his court in Yoshino. Both had powerful supporters. Fundamentally the struggle, which lasted throughout the whole period, was still between the great feudatories to decide who should exercise the actual power behind the imperial throne. Very soon the emperor was again stripped of all but the dignity attached to his position and at times there remained little even of that.

The problem which remained unsolved during these two hundred years was how to bring the great lords into a system which guaranteed national stability. The discipline to which they had submitted during the early Kamakura period had disappeared. The ambitions of the landowners, especially those in the provinces, in this new phase of their history were now directed toward complete independence based on loyalty to local lords rather than to the central authority. The Kyoto nobility, which over the centuries had progressively lost control of whatever lands it once possessed, became a colorful but pathetic anachronism. It was swept away by economic forces. Thus, trends initiated by the Kamakura dictatorship were brought to a logical conclusion. Those court nobles who could salvage some of their lost position by merging with the new shogun class in Kyoto did so. But for all its promising start the Ashikaga power was at all times more apparent than real. Like that of the Fujiwara it survived because no single lord was strong enough to take over the undisputed control of the capital. The Ashikaga seem to have exhausted themselves in the battles of the Northern and Southern Courts period, which left them no reserves to consolidate their power. And the blandishments of Kyoto were ever at work upon their character: refining, sensitizing—weakening.

Political Sterility and Social Change

However, by 1392 the problems of imperial succession were settled and the Ashikagas under Yoshimitsu (ruled 1368–94) brought

a welcome, if insecure, peace to the weary country. But the new overlords, different in temperament from their single-minded predecessors of the early Kamakura times, were never able to restore the authority of a man like Yoritomo. Yoshimitsu himself was thwarted by the rapaciousness of the local chieftains. Under Yoshimasa (ruled 1449–73), whatever authority the Ashikaga had ever had was whittled away, and the feudal lords again held the ultimate power in their own hands. The new rulers, who returned to Kyoto and built a palace in the Muromachi district just north of the city, fell willing victims to its enchantments and desired luxury rather than authority. Luxury, however, requires money, and since the pillage of neighbors provided only a limited and decreasing scope for enrichment, they sought new methods. Trade with China became one of the principal sources of income. Under the guise of embassies, a very considerable trade grew up in which the Japanese exchanged swords and lacquerware for bullion, iron, textiles, pictures, books, and drugs. The feudatories were quick to share in this commercial activity and the Ashikaga were not able to turn the proceeds to their exclusive benefit. The proportions of the trade and the drain of currency from the Chinese treasury alarmed the Ming court no less than the unruly behavior of the "embassies" under whose cloak this trade was carried on. Nevertheless, these commercial activities continued almost unchecked and were of considerable significance for the development of the arts in Japan.

In this politically sterile period, however disrupted by civil wars, a number of interesting social developments had an invigorating effect on Japanese life. The emergence of a virile merchant class was perhaps the most far-reaching. The peasants, who since the sixth century had suffered without respite, also began to make themselves heard through risings to which they were driven by the misery of their condition. The sharp barriers between the classes began to break down and, with the decline of feudal loyalties, the importance of the family as a unit increased. This, however, affected adversely the position of women. Hitherto they had enjoyed considerable rights on an equal footing with men but, when the unity of the family became of paramount importance, it proved impossible to allow women to inherit and so to split family holdings. From this time dates the subordinate legal position which Japanese women held for such a long time.

Warfare, too, became more complex and a new class of masterless and landless samurai came into being. They formed a body of mercenaries, of wandering fighting-men whose trade was the sword but who were less bound by the strict code of the old samurai. As in earlier times, their exploits and their loyalties to a now outmoded code provided material for a rich popular literature which is reflected in the arts, particularly in later times.

Throughout the social and political upheavals of these two centuries, the emperor and the Ashikaga shoguns survived because they were in effect powerless and because there was no person or institution ready to take their place. A parallel is often drawn between this period in Japan and the quattrocento in Italy. The authority of the emperor of Japan had disintegrated like that of the emperor of the Roman Empire. The feudal lords resembled the Rimini, Borgia, Visconti, or Medici in their independence and ambition, in their mutual distrust and treachery, in their patronage and their exchanges of works of art. In Japan, as in Italy, the same importance was attached to the acquisition of a painting or the writing of a poem as to the winning of a battle.

History provides many examples of politically decadent times which have nevertheless been artistically most fruitful. Why was this true of Ashikaga Japan? First, the country craved the pleasures and luxuries of peace and was prepared to support the large numbers of artists and craftsmen indispensable to a vital artistic life. Fine works of art were the rewards of success at a time when other benefits were mostly illusory. The feudal courts often considered themselves the equals of the shogun's court in Kyoto and, backed by ample financial resources, they strove to rival the opulence of the capital. It is interesting to note that, unlike in medieval Europe, the feudal lords were men of artistic bent. Men of letters and artists were, therefore, always welcomed at these provincial centers, and their untutored masters gave them considerable freedom in matters of taste and looked to them for guidance. Such men of culture often preferred the relative safety of court or temple protection to the rigors of life in the constant civil wars; they were safe and able to pursue their activities untroubled. We see here another stage in the development of the influence of individual artists whose emergence from the ranks of anonymous craftsmen was noted in the Fujiwara period.

Yoshimitsu, a man of taste and patron of the arts, built and decorated his palace in the Muromachi quarter of Kyoto whence the period takes one of its names. He erected other fine monuments such as the Kinkaku, or "Golden Pavilion," where, in 1394, he retired, ostensibly to live the life of a priest while in fact he still manipulated the government. Yoshimasa emulated Yoshimitsu by building the Ginkaku, or "Silver Pavilion" (fig. 98), and surrounded himself with priests, poets, and actors; but, unlike his predecessor, he completely neglected administrative affairs. He is perhaps best remembered for his vast collection of Chinese paintings which formed a splendid body of reference material for Japanese artists of the time. Both Yoshimitsu and Yoshimasa were enthusiastic admirers of Zen-inspired art, and of all Chinese artistic qualities in general.

Zen art had flourished in South China under the troubled times of the Southern Sung dynasty and ". . . it is no coincidence that the sombre and austere atmosphere of Ch'an [Zen] non-thought, poetry, and art found a second home in the place of troubles that was Japan from the fourteenth through the sixteenth centuries."[1]

The influence of Zen Buddhism on the life and art at this time can hardly be exaggerated. It was perhaps the dominating force of the period. The teaching of the sect under such outstanding leaders as Musō became the official religion of the court. However, it surrendered to Kyoto some of its earlier austerity. Zen priests developed a taste for fine buildings, often artificially "modest," set in beautiful gardens which their predecessors in the Kamakura period would have frowned on. As teachers they directed the colleges and they even served as political advisors to the shoguns. In this role, they developed what Sansom calls "a useful type of practical wisdom" and Warner, "a sort of common sense along with the highest flights of metaphysics." The direct, intuitive approach of Zen appealed to the unschooled military mind of the Ashikaga as it had to the rulers of Kamakura before them, and the studied simplicity of the Zen aesthetic in architecture, gardens, and the tea ceremony appealed to the Ashikaga—as they do to our own twentieth-century sensibilities, weary as we often are with machine-made repetition. But the influence of the Zen priests was not allowed to develop unchallenged, for the militant monks of the Tendai monasteries on Mt. Hiei, just outside Kyoto, often descended on the city and forced the court

98. Ginkaku ("Silver Pavilion") of Jishō-ji, Kyoto. Fifteenth century.

to satisfy their demands. Other sects, too, followed the example of the times in taking to politics and the sword either for expansion or protection. Many monasteries were razed to the ground in the intersect and interfamily wars. However, the Shinto beliefs, like the position of the emperor, seem by their very passivity to have survived the turmoil unscathed.

Art during the Ashikaga period became mainly concerned with paintings. Zen influence, first evident at Kamakura, increased but, like the priests of the sect, lost much of its austere quality. Chinese Zen priests visited Japan and Japanese priests entered monasteries in China where they were often highly respected. The great age of illustrated scrolls had passed and paintings which set out to express the Zen ideal of union with the infinite became the fashion of the time. Unqualified admiration of China doubtlessly stimulated the popularity of Chinese-style ink monochrome painting but its masculinity must also have fitted the atmosphere of the time. It appealed equally to a deep Japanese love of simplicity and nature which is reflected in all the products of the age from gardens to painting. The style of painting as seen in the *Genji* scroll, with all its *yamato-e* traditions, went for a time completely out of favor—a phenomenon which can only be explained by the flood of Chinese paintings which were imported in the hundreds by Japanese monks or by agents sent by the shoguns to buy them. The influence of an artistically minded priesthood cannot be overestimated. Generally speaking, the Ashikaga made a complete break with the past and created in Kyoto a new artistic world. These "agents" accompanied the trade missions which were stimulated by the rapid development of Japanese technology and power. When they were not allowed to trade, the Japanese became pirates ravaging the coastal areas of the mainland.

The Zen-inspired painter seeks the "truth" of a landscape, like that of religion, in sudden enlightenment. This allows no time for careful detailed draftsmanship. After long contemplation, he is expected to be able to seize inner truth in a swordlike stroke of the brush. This "essentialism" can be expressed equally well in a large landscape or in the branch of a tree, in the broadest panorama as well as in each of its minute components. The flights of imagination manifested by these artists in black and white are one of the great contributions of the East to the art of the world. In their efforts to discover the very essence of reality, the Zen artists turned away from the "emotional superficiality" of color and the "trivialities" of accurate detail. To them all natural phenomena were mere illusion, not to be copied painstakingly. They developed a highly stylized, seemingly spontaneous, black-and-white style to depict the various moods of nature and its inner reality. Selectivity was carried

to its highest degree, and with the most economical means of black ink in all its nuances, the *suiboku* ("water ink") painters achieved a landscape painting of remarkable imaginative depth. Unfortunately, sooner in Japan than in China, the means often became the end. The result was that mannerism and dexterity with the brush took the place of artistic vision, thereby destroying the very foundations of the art. In art as in religion it was too easy for the facile and quick-witted to exploit the thoughts and ideals of Zen Buddhism.

The Zen sect had been established in Japan in the thirteenth century, and by the Muromachi period the Rinzai sect with its wealthy possessions in Kyoto and Kamakura became virtually the official religion. But it was not until the early fourteenth century that eminent *suiboku* painters known by name emerged. The two outstanding artists in this early period were Moku-an, who went to China in 1333 where he stayed until his death, and Kaō (early fourteenth century). Figure 99 shows an imaginary portrait by Kaō of a simple

99. *Kanzan*, by Kaō (active in early fourteenth century). Hanging scroll; ink on paper. Dimensions: 3 ft. 2½ in. × 1 ft. 1½ in. Private collection.

Chinese priest called Kanzan ("Forlorn Mountain") in Japanese, one of the favorite subjects of Zen painting. This seemingly stupid, or at least highly eccentric, priest who is said to have lived in the T'ang dynasty, but is probably a mythical figure, idealizes a Zen way of life—that of the poor, eccentric beggar-priest who scorns the intellectual attitudes of other sects. Having attained enlightenment, such followers of Zen were content to ignore all worldly considerations. He is often depicted in company of his fellow priest, Jittoku. Pairs of paintings showing them both are frequent and many stories are told of their apparent simplemindedness. They were popular subjects with such Chinese artists as Liang K'ai (active about 1200) and Yin-t'o-lo (thirteenth century), both of whom were highly esteemed in Japan. The subject belongs to a group of paintings called in Japanese *dōshaku* which illustrate the deeds of great Zen priests or depict objects likely to stimulate a believer to achieve sudden enlightenment.

The brushwork of the Kanzan portrait is masterly in its powerful economy and the strong outline contrasts effectively with the softer washes used for his apron and the tree above. The change in content is no less striking. The artist has lost interest in scenes of paradise and in representations of the Buddha. The intention is no longer, as with the handscrolls, to illustrate literature. The penetration of Zen ideals into his consciousness is complete. It is difficult to imagine a more revolutionary concept. The formalized superhuman figure of iconographic tradition has descended to the lowest human plane. The half-witted priest is the final development of the tradition of dignified Buddhist figures of past centuries. Yet the Zen adept will find that his face reflects the condition of mindless rapture which is the aim of Zen philosophers. His unworldly character and actions are symbolic of profound religious enlightenment—a complete detachment from mundane concerns. To appreciate its spiritual message demands knowledge of Zen ideals. There is, as well, a great deal of humor which the Japanese enjoy in this as in many Zen-inspired contradictions. The painting attempts to give an easily comprehensible lesson in salvation administered in the form of a shock. It is so contrived as to disturb the aspirant to spiritual truth whose mind was fettered by traditional thought and religious practices. The posture of the monk, stomach thrust out, hands behind back, head craning forward, is the epitome of the idiot. Even his

flat-footed stance and his gaze toward the largest blank space in the composition, contribute to the impression of vacuity. His face, like that of some cheerful gaper at a spectacle, is crowned with a shock of unkempt hair. The contours of the figure are set off by the tree; its trunk repeats the strong backward line of the left arm and the branch echoes the silhouette of the outthrust stomach.

Ink Landscape Painting

It was not long before the Japanese *suiboku* artists, like their Chinese forerunners, found the best outlet for their talents and ideas in landscape painting. Yashiro points out how ink painting was admirably suited to reflect one aspect of the Japanese countryside. "The semi-tropical seas surrounding Japan bring sharp changes of atmosphere to the islands. When the sun shines the colours are brilliant but the clouds and rain quickly change the landscape into a misty, grey world. These changes are reflected in the character of the Japanese people—at one moment excitable and gay but quickly depressed and sentimental."[2]

Minchō, sometimes called Chō Densu (1352–1431), is representative of the late-fourteenth to early-fifteenth-century landscape masters. *The Hermitage by a Mountain Brook* (fig. 100), dated 1413, is, with some uncertainty, attributed to him. The scene is an imaginary Chinese landscape and a number of poems are written above it. It belongs to the class of paintings called *shiga-jiku*, which are hanging scrolls with poems and paintings. The lonely cottage over the stream is intended to suggest the ideal solitary retreat of the Zen priest where, in peaceful communion with nature, he will achieve enlightenment. The composition is typical of Sung-Yüan painting in the manner in which it divides the picture plane into foreground and background with the eye skillfully led from one to the other by a bank of mist from which a few trees emerge. The ink tones are subtle and the brushwork of the rocks, the trees, and the hut is most determined. There are, however, certain elements in the work which suggest that, in addition to his study of Sung-Yüan paintings, the artist had also seen early-fifteenth-century Ming paintings. This is revealed in the brushwork of the leaves, in the closeness of the spectator to the scene, and, perhaps above all, in the absence of an indefinable quality of mystery and awe which abounds in the earlier works.

The priest-painter Shūbun (active 1430s to early 1460s) was put in charge of the first Ashikaga Bureau of Painting (*e-dokoro*) and through him *suiboku* painting became the official style. Many important works are attributed to him, but these attributions raise a number of problems since there were three artists with the same name. Scholars, almost inevitably, do not agree on a corpus of original works by Shūbun. Nevertheless, the style which the most famous of the three Shūbuns used is quite clearly distinguishable. The smaller pieces attributed to this enigmatic artist tend more toward the Sung ideals of the Northern school of Ma Yüan and Hsia Kuei in which the line is the dominant feature, especially in the "strokes like axe cuts" of the rocks and the soft brushwork of the trees and the hut. But his larger landscapes (fig. 101) are typical Yüan-inspired works, recalling such eminent Chinese painters as Huang Kung-wang (one of the Four Great Yüan Masters). In the works attributed to Shūbun, signs can already be seen of the virtuosity which was to endanger the sincerity of later works. The mysterious aspect of Chinese landscapes, the life-spirit of this style, as formed by the Chinese, is completely dispelled; foreground and background become flat and dead and the whole painting is artificially dramatized. The brushwork is strong but seen here in the first stages of formalization. This is particularly noticeable in the towering cliffs and in the gnarled roots of the pine trees; and the hut is consciously overemphasized. The theme is familiar from Chinese examples though not less charming for its familiarity. Trees surround a scholar's hut deep in an Arcadian country where alone with his books he seeks enlightenment. But the eye is tempted to explore the brushwork more than the landscape, to admire the technique rather than to respond to the spirit behind it. The painting does not inspire the viewer to contemplate its deeper meaning but only to share its nostalgia and to delight in its skilled draftsmanship.

In Chinese and Japanese ink painting the brushwork is a vital, indeed sometimes almost an overwhelming, consideration. The ability to use the brush oneself is doubtlessly a great help in appreciating it but, contrary to the expressions of some critics, it is certainly not indispensable. The Far Eastern brush, conical in shape and narrowing down to the finest point, is a most sensitive instrument. It is very absorbent and flexible. The slightest difference in pressure varies the thickness of the stroke much more than with a Western

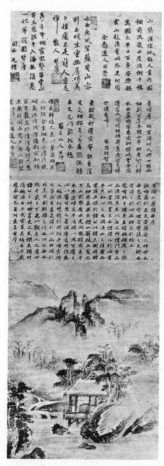

100. *The Hermitage by a Mountain Brook*, attributed to Minchō (Chō Densu) (1352–1431). Hanging scroll; ink on paper. Dimensions: 3 ft. 3½ in. × 1 ft. 1¾ in. Konchi-in, Kyoto.

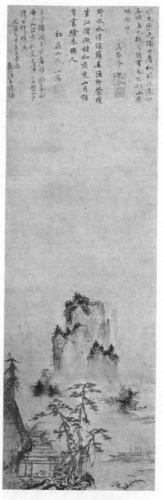

101. *Landscape*, attributed to Shūbun (active from 1430s to early 1460s). Hanging scroll; ink on paper. Dimensions: 3 ft. 6½ in. × 1 ft. 8½ in. Private collection.

brush. The speed and assurance with which the artist makes his strokes impart to them the life and vitality that are considered as all-important. The angle at which it is held is also significant. Held upright, the brush produces a hard, strong, and incisive line. When held at a slant, the line tends to become softer and weaker—in other words, the tip of the brush produces a powerful stroke and the side or "belly" of the brush, a more diffused, softer line. In practice most brushstrokes share both qualities in various degrees. A brushstroke can also indicate a degree of shading and this too depends upon the angle at which the brush is held. Hence it is possible to depict a spherical object with a single outline stroke. Generations of Japanese painters were made to practice the painting of a round jewel for as much as two years before being allowed to graduate to more advanced studies. Understandably enough, the weaker brethren did not survive the discipline! An experienced judge of brushwork can tell with what part of the brush a stroke was made, the angle, speed, and direction of the stroke, and even how the brush was held in the fingers, the angle of the wrist, and the height and position of the arm which made it. Thus, to quote the Japanese, "the line is the man himself." In Far Eastern painting the brush reveals more of the painter's personality than in any other painting in the world.

The "Three Amis"

Throughout the fifteenth century, the assimilation of Chinese styles went hand in hand with the development of Japanese style. The stage following that of Shūbun can be seen in the works of the "Three Amis"—Nōami (1397–1471), his son Geiami (1431–85), and his grandson Sōami (1485?–1525). *The Waterfall* by Geiami (fig. 102) shows an increasing preoccupation with brushwork for its own sake and an advanced degree of stylization. The subject is a familiar one from centuries of Chinese painting and already somewhat hackneyed. A priest or scholar with his boy attendant approaches the simple hermit's hut in the peaceful depths of the countryside. The viewer, entangled in the multifold cares of the world, is expected to respond to the relief that this vision offers. But it takes a great artist to revitalize such a well-worn theme and in this painting everything is artificial and contrived. In his efforts to achieve a dramatic effect, Geiami has sacrificed the subtle union of reality and mystery which inspires the greatest Chinese landscape painting. The artist reveals,

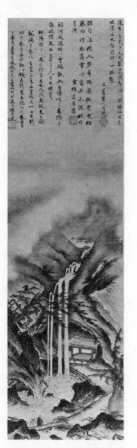

102. *The Waterfall*, by Geiami (1431–85). Hanging scroll; ink and slight color on paper. Dimensions: 3 ft. 5¾ in. × 1 ft. 1 in. Nezu Museum, Tokyo.

it is true, one of the great gifts of Japanese painters—the ability to see a rhythmical design in nature and to work it out boldly. The framework of the composition lies in the lines which repeat the basic curve at the top of the cavern sheltering the hut. These curves are taken up again and again. But brushwork outstrips his vision. The waterfall, from its source in the lake at the very top of the picture to where it disappears bubbling at the bottom, is reduced to lifeless, formalized lines.

Geiami knew nothing of Western perspective; nevertheless he has successfully solved the problem of what the Chinese call "the far and the near." In this he has been helped by the Ming painters who possibly were the first to overcome the difficulties of rendering the middle distance. But the outlines of the rocks are hard and dry in a manner alien to Chinese practice. The landscape completely lacks any relation to reality—an impression never created by Chinese landscape painting at its best. Geiami's affected rusticity and too elaborately balanced composition do injury to nature. The humbleness of Chinese masters before the grandeur of landscape is replaced by overconfidence and artificiality.

The Genius of Sesshū

It remained for Sesshū (1420–1506) to raise *suiboku* painting to its highest level. He stands head and shoulders above his contemporaries and many critics, both Japanese and foreign, consider him to be the greatest landscapist of Japan. Sesshū was a Zen priest and a pupil of Shūbun. He spent the years 1468–69 in China where, it is recorded, so great was his reputation that the Chinese even offered him the headship of a great monastery. Close familiarity with Chinese painting in the country of its origin and knowledge of the Chinese landscape which had inspired it gave him an advantage over many of his fellow painters and his works thereby gained authority and conviction. Unlike many other *suiboku* artists, Sesshū did not slavishly follow the styles and compositions of Sung-Yüan artists and their Ming-dynasty followers. Influences of Chinese artists such as Li Ts'ai are noticeable in his work but it would be difficult to find any Ming painter from whom he could have derived his unique style.

In China at this period the painters and critics, tired of repetitions, were voicing the need for a return to nature. A little later Mo Shih-lung formulated this dissatisfaction in the words, "Painters of the past took the old masters as their models, but it is better to take Heaven and Earth as one's teacher." Sesshū learned this lesson better even than most Chinese painters of that time for whom dry copying was the rule rather than the exception.

Sesshū left notes of his stay in China in which he complains of the poor quality and lack of originality in Ming painting of his day. He was anxious to find something new from which he could learn, but

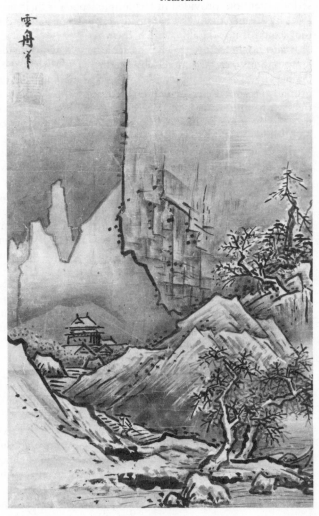

103. *Winter Landscape*, by Sesshū (1420–1506). Hanging scroll; ink on paper. Dimensions: 1 ft. 6¼ in. × 11½ in. Tokyo National Museum.

did not find it in China. It was highly significant for the history of Japanese landscape painting that he was able to convince Japanese *suiboku* artists that their own landscape, which through some peculiar intellectual snobbery they seem to have considered unworthy of serious attention, provided in fact ample scope for their talents and that, by freeing themselves from dependence on Chinese models, they could immeasurably enrich their art.

Winter Landscape (fig. 103) is typical of the style which made Sesshū famous. Snow, created merely by leaving parts of the paper blank, lies heavily over the countryside, giving the mountains in the background the appearance of white sheets and capping the rocks and trees with white. The roofs are covered with a heavy mantle. A traveler, bent with the cold, hurries toward a distant township huddled beneath the winglike eaves of a great temple.

The scene is Chinese but the brushwork is unique to Sesshū. His work offers the supreme example of the nervous intensity which characterizes the Japanese brush. The thick, black ink has a sheen which makes it appear almost wet. He allows no Sung vagueness or softness, no hint of overrefinement. There is never an indeterminate or superfluous line: every jagged brushstroke has its reason and its life. Sesshū always understood just how much of his unusually powerful brush a picture could stand and he resisted the temptation to overdo it. What the Chinese call the "bone structure" of the composition is emphasized so as to be almost a bare skeleton. It is understandable that the Ming-period Chinese scholar-artists might see in him a reincarnation of one of the great masters of Sung times before, as they would think, painting had degenerated into conventionality.

This is more than just virtuosity. It is the work of an original artistic personality completely transforming into a valid Japanese interpretation the traditions of Chinese ink painting as they had developed from Sung to Ming times. He has produced a synthesis of four centuries of Chinese painting. In his own way Sesshū with overpowering self-confidence succeeded in reinvigorating styles which in Ming China itself were rapidly degenerating into mannerism.

Sesshū was a great wanderer in the tradition of his Chinese contemporaries and his *View of Ama-no-Hashidate* (fig. 104), painted by him at the ripe old age of about eighty-six, shows the artist in a more gentle mood dealing with the landscapes of his native land. The

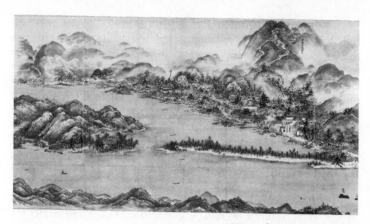

104. *View of Ama-no-Hashidate*, by Sesshū (1420–1506). Hanging scroll; ink on paper. Dimensions: 2 ft. 11 in. × 5 ft. 6½ in. Kyoto National Museum.

place, situated on the picturesque Japan Sea, is one of the Three Scenic Beauty Spots of Japan. A sand bar extends tenuously toward an island; in the center is a Buddhist temple and on the right a Shinto shrine, both with their names written over them to facilitate identification. The painting has a Chinese grandeur of conception but, in keeping with Japanese landscape, it is more intimately visualized. The softer and warmer ink tones capture the steamy atmosphere of a Japanese summer—the mists enveloping the hills, the hot calm of the sea, the whiteness of the sand, and the luxuriant foliage in which temples and houses are almost lost. This shows the artist in an eclectic mood, painting in what the Chinese call the Southern style of ink wash and indistinct misty atmosphere as is typical of the landscape in southern China. It is doubtful if the artist was familiar with the Southern school as it became formalized but he probably had experienced the work of some of its artists. Sesshū is painting directly from nature and curbing his fantasy in order to do so. The minute details he wished to include have restricted his love of powerful abbreviated brushstrokes. The high viewpoint, which comes from Chinese painting, adds a bird's-eye dimension.

The composition is masterly. Three horizontal planes are skillfully connected. The foreground is almost neglected in order to draw the eye to the sand bar and the town beyond. To give interest to the top register, the artist leads one up a winding path to a cluster of dwellings in the crown of the mountain. Its mass balances the heaviness of the island on the left and breaks the monotony of the three horizontal planes. A Chinese painter would have been preoccupied with spiritual values and the mysteries of nature. Sesshū is engrossed in portraying its warmth and in exploring its intimate beauty—he created a direct and intensely personal approach which became one of the main distinguishing characteristics of all Japanese landscape painting.

Yet a third style used by Sesshū is seen in a pair of screens owned by the Freer Gallery of Art, Washington, D.C. These depict the four seasons—always a popular subject for Far Eastern artists. Figure 105 shows the screen which combines the seasons of spring and summer executed in a more decorative style than he used for other works. The influence of the Chinese painter Lü Chi is clear. Color is employed sparingly and the brushwork is incisive but restrained. The decorative effect at which he aimed is superbly achieved but he seems to be working within a smaller compass which gave little room for the exercise of his particular gifts. In spite of the clarity of the brushwork and the admirable organization of the various elements, there is less to stir the imagination in this work.

No account of Sesshū's art, however brief, would be complete without mention of his two great landscape scrolls. Figure 106 is taken from his *Larger Landscape Scroll* dated 1468 when he was sixty-seven. Nearly 60 feet long by $15\frac{3}{4}$ inches high, it is a most remarkable feat of sustained imagination which compares well with any landscape scroll produced in China. Sesshū takes the spectator on a friendly journey through the Chinese countryside in the four seasons. Hills and valleys, streams and rivers flow by; a path leads up jagged, beetling rocks under shady trees. A fishing village huddles amidst the reeds; its boats lie becalmed in midstream; a pagoda rises above the misty roofs of a township. Two travelers stop to pass the time of day on the way up to some mountain retreat; a crowd gathers at a rest house in a rocky glen. Following down a hill we find a jolly crowd gathered around the buildings of a village bedecked with buntings, a *gemütlich* but not sentimental scene. Through

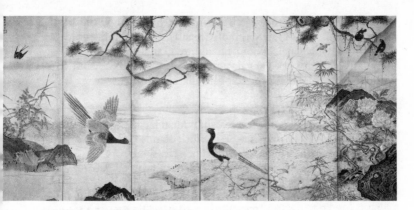

105. *Spring and Summer*, one of a pair of screens representing the four seasons, by Sesshū (1420–1506). Ink and color on paper. Dimensions: 5 ft. 3¾ in. × 11 ft. 9½ in. Courtesy Smithsonian Institution, Freer Gallery of Art, Washington, D.C.

106. Section from the *Larger Landscape Scroll*, by Sesshū (1420–1506). Ink and slight color on paper. Height: 1 ft. 3¾ in. Private collection.

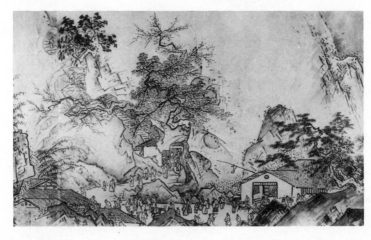

the whole length of the scroll the interest never flags, the brush never weakens. This microcosm of China is strongly influenced by the style of Hsia Kuei, whom he admired, and his successors, but the incisive brushwork is again unmistakably that of Sesshū. It is without doubt the masterpiece of his mature old age.

The Kanō Painters

Sesshū was the greatest and most individual Japanese master in the Chinese-inspired *suiboku* style. His work stands comparison with anything produced in China at his time. His successors like Sesson (fig. 107) with his own turbulent style continued the Japanization of these Chinese modes. In the process they removed the Zen Buddhist inspiration and tended to replace it with the overpowerful native sense of decoration. This began in the work of Kanō Masanobu (1434–1530), a contemporary of Sesshū, but was firmly established by his son Kanō Motonobu. The school of painting which the Kanō family created was to dominate the following two periods and,

107. *Wind and Waves*, by Sesson. Sixteenth century. Hanging scroll; ink on paper. Dimensions: 8¾ in. × 1 ft. Private collection.

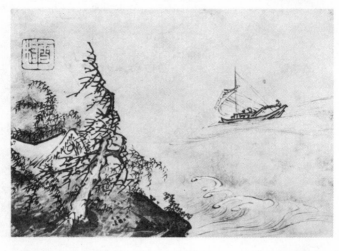

incredibly enough, lasted down to the end of the nineteenth century. It produced generation after generation of famous painters (either genuine or adopted members of the family), many of whom occupied important official positions in the service of the various rulers of the country, and it produced many fruitful offshoots and substyles. In the Tokugawa period the Kanō was recognized as the "official" school.

Masanobu, the first of this long line, was not a Zen priest. This, in itself, shows a break with the *suiboku* tradition. Although he inherited the style of Shūbun, he obviously felt himself free from any restrictions imposed by Buddhist thought. Only two authenticated works by him have survived. Figure 108 shows his painting of the Chinese sage Chou Mao-shu (1017–73). Chou Mao-shu is ranked second only to the great Sung philosopher Chu Hsi whose interpretations dominated Confucian philosophy for nearly seven centuries. He is venerated as an ideal Confucian scholar-official and is a popular subject for didactic Chinese and Japanese paintings. His famed love of lotus flowers provided painters with an ideal setting.

Japanese scholars see in this painting a great difference from that of Geiami, illustrated in figure 102. But, apart from the fact that the subject, Chou Mao-shu, had nothing to do with Buddhism, there seems no great diversity between the approach of the two painters. If anything, Masanobu's work shows a finer appreciation of the true Chinese Sung feeling for landscape. However, the somewhat dry, formalized brushwork and the tendency to an uninspired neatness in this essay in the Chinese style, as seen particularly in details like the large lotus flowers, unmistakably reveal the Japanese hand. The typical Kanō quality of this painting is visible in the clear-cut lines and still atmosphere although it must also be said that some Japanese critics see in it a quality of the ethereal and lighthearted. Certainly it lacks any potential of Zen overtones and sets out just to appreciate the beauty of landscape for its own sake. Masanobu's other surviving painting is of a Zen subject, the priest Pu Tai. This in itself is an added indication that, although not a member of the priesthood, he sometimes painted very much in the manner of the Zen *suiboku* masters. It is tempting to conclude that the Chinese style was more a social convention inherited from the Ashikaga shoguns' veneration of Chinese work than a genuine native predilection.

The true Kanō style is seen more clearly in the work of his son

108. *The Sage Chou Mao-shu in a Lotus Pond*, by Kanō Masanobu (1434–1530). Hanging scroll; ink and color on paper. Dimensions: 2 ft. 9¼ in. × 1 ft. 1 in. Private collection.

109. Detail of *Landscape with Flowers and Birds*, by Kanō Moto-nobu (1476–1559). Originally painted on a sliding screen and now mounted as a hanging scroll; ink and slight color on paper. Dimensions of entire scroll: 5 ft. 10 in. × 3 ft. 10½ in. Reiun-in, Kyoto.

Motonobu (1476–1559). The detail in figure 109 was originally painted on a *fusuma* in the Reiun-in, a temple in Kyoto where most of his works are still preserved. These *fusuma*, light sliding partitions made of reinforced wooden frames covered on both sides with paper, are used to divide Japanese rooms. They provide ideal surfaces for large-scale decorations, but are extremely delicate and easily damaged—as anybody who has lived in a Japanese house knows to his cost. This painting is one of forty-nine landscapes with flowers and birds which Motonobu did to decorate the temple and which have now been mounted as hanging scrolls in order to preserve them.

The artist's aim here was simply to decorate a room in Chinese style and the painting has no greater pretensions. Judged by these standards the work has many good qualities—confident brushwork and strong ink tones are used in a striking composition. The elegant bird contrasts well with the gnarled pine branch. It is conceived in two sharply differentiated planes—the background of the hills being only sketchily indicated—and it shows a decorative interpretation of Sung styles inherited from such eminent landscape masters as Hsia Kuei together with elements of *yamato-e*. But there the relationship ends. Although of excellent draftsmanship, it has neither the humility nor the depth of feeling of the Sung masters. Motonobu's aim was a satisfying decoration expressed in terms of generally accepted brushwork, and everything is sacrificed to these two requirements. In this aim, one must admit, he succeeds admirably. The standards by which we judge Kanō works must therefore be different from those applied to Chinese ink painting. They inhabit a less exalted world. Nevertheless they enjoyed a great vogue and Motonobu's paintings were the forerunners of a vast school of decorative art which will be discussed later (see p. 253).

Yamato-e and the Tosa School

The Kanō paintings were made under Chinese influence. But what became of the native Japanese style of painting which flourished so vigorously in the early Kamakura period?

During the fifteenth century another great painting family made its appearance—that of the Tosa. In this school the traditions of *yamato-e* were preserved for later generations to develop. The *yamato-e* style of painting had perhaps been the greatest achievement of the Kamakura period. By the end of the Ashikaga period it had

been somewhat overwhelmed by the impact of Chinese styles but it never died out completely. Some of the painters of this time seem to have worked in both the Kanō and Tosa styles so that it is not always easy to say whether an artist belonged exclusively to one or the other school. A further indication of the friendly mixture of schools and the happy eclecticism of Japanese painters can be inferred from Kanō Motonobu's marriage to the daughter of Tosa Mitsunobu (1434–1525), who is generally considered to have established the Tosa school. Kanō Motonobu occasionally worked in the Tosa style, although whether this was for family reasons is not recorded.

Only a few good *yamato-e* scrolls were produced toward the end of the Kamakura period. In 1414, however, a number of artists of different schools cooperated to paint a scroll entitled *Yūzū Nembutsu Engi* ("History of the Yūzū Nembutsu [Buddhist] Sect"). Among them were a certain Tosa Yukihiro (active 1406–34) and his son Tosa Yukihide (active ca. 1430s), the two painters who are credited with founding the Tosa school proper.

Tosa Mitsunobu, who, as noted above, firmly established the school, was the grandson of Yukihide. In 1469 he was put in charge of the *e-dokoro* (Bureau of Painting), thus receiving official recognition and patronage from the Ashikaga shogun. This was against the general run of Tosa school fortunes, for mostly the Kanō school effaced the Tosa and, after Mitsunobu, few great Tosa names appear until the Tokugawa period. Mitsunobu's grandson was even forced to leave Kyoto, the center of artistic life; he was probably driven to seek employment in less fashionable areas.

The eclipse of the Tosa by the Kanō is an indication of the weakness of the native traditions in the face of foreign art styles even when the latter were pressed into a usage for which they were unsuited. Considered purely as decoration, however, the stylized compositions and rich colors of the Tosa were far better media than the inflated Kanō works with their formality and dry ink. It is fortunate for the Japanese decorative arts that the *yamato-e* traditions did not entirely vanish. A small number of screens painted at the end of the Ashikaga period give a foretaste of the decorative splendors of the next period. The survival of the *yamato-e* interest in genre and crowd scenes of contemporary life can be seen in the screen by Kanō Hideyori, a son of Motonobu. *Maple Viewing at Takao* (a famous beauty spot outside Kyoto), of which a detail is shown in figure 110, is a

110. Detail of a six-panel screen *Maple Viewing at Takao*, by Kanō Hideyori (d. 1557). Ink and color on paper. Dimensions: 4 ft. 11 in. × 11 ft. 11¼ in. Tokyo National Museum.

remarkable essay in the style of the handbooks (see pp. 151–52) applied to large decoratives surfaces. In the treatment of the figures it recalls the "Man with Loose Teeth" (see fig. 84). There is, of course, no didacticism in this work. Very real human figures, townsfolk enjoying a picnic under colorful autumn maple trees, are arranged in a highly decorative landscape which includes elements of Kanō-style brushwork in the trees and rocks. Strangely enough, the combination does not disturb the eye, perhaps because there are no pretensions. The colors are rich and effectively matched. Everything is subordinated to the demands of gaiety and pure decoration in which the Japanese are here seen in their element. Its very colorfulness gives it a particularly unaffected charm. "Detachment without lifelessness" is the quality which the Japanese admire in this work. After some of the stiff, self-conscious Kanō products, it comes as a warm breath of gay spontaneity in which the Japanese spirit shows itself without reserve.

Ceramics: Seto and Temmoku Wares

Just as Chinese styles dominated Ashikaga painting in general so, too, its ceramics were inspired by the products of the great Chinese kilns. Japanese records list large numbers of Chinese Sung- and Yüan-period wares imported into Japan at that time, and Korean inlaid celadons were very popular. The Ashikaga period was, above all, the age of the Seto kilns and the large production from them is an indication of the demand for good ceramics.

Wares with a high-fired celadon-type glaze had been introduced into Japan from China as early as the ninth century, and the Japanese first made them at the Owari kilns near Seto which previously had produced the finest Sue-type pottery. In the twelfth century, the center for the manufacture of celadon-type wares moved to Seto itself where the potters further perfected the techniques necessary for their production and made their finest examples in the fourteenth and fifteenth centuries. The wide-mouthed jar in the Tokyo National Museum is one of the best known of these Old Seto wares (fig. 111). It has strong shoulders and a crackled glaze which runs in streaks to the rough base in a manner typical of the type. The design is a well-organized, incised scroll of peonies which suits the boldness of the shape and infuses it with a vigorous rhythm. Broadly speaking, one can say that the Ashikaga period saw the real beginning of Japanese ceramics.

These Seto kilns produced their celadon-glazed wares in a large variety of shapes. The most popular colors were yellow and amber, and occasionally both were applied to produce a two-colored ware. Though heavy, the shapes of these wheel-made wares are much more graceful than in the Kamakura period and the clay is more refined. The decoration, frequently of peonies, became more stylized and is often carefully arranged in wide bands round the bodies. Sometimes pairs of fish were incised in imitation of Chinese celadon plates. At the same time, the shapes and often the designs of the wares begin to show indications of Japanese taste, especially in objects which were then beginning to be used for the ceremony of tea drinking.

One of the most popular Chinese wares of this period was the *chien* type, a deep brown or black iron-glazed ware, probably first made in the Chien-ning district of Fukien in the tenth century. The Japanese call this type of ware *temmoku*, which is the Japanese read-

111. Old Seto ware. Muromachi period. Yellow glaze with arabesque pattern. Height: 10¾ in. Tokyo National Museum.

ing of T'ien-mu, the name of a mountain in Chekiang. Several famous Buddhist temples situated on this mountain popularized the *temmoku* pottery which the priests used in tea-drinking ceremonies. The deep, lustrous glazes of this ware appealed to the eye and especially to the touch of the connoisseurs of tea. The conical shapes are simple but most perfect in their union of strength and elegance. The glaze, subdued and lustrous, is allowed to form a pool at the bottom of the cup and runs into large globules where outside it comes down to the foot-rim. The ware was copied at Seto.

The Tea Ceremony

The cult of tea-drinking ceremonies originated in China where it was popular among the Ch'an (i.e., Zen) monks and it was introduced into Japan with the Zen sect. There it was taken up, at first in a dilettante manner, by Ashikaga Yoshimasa (1435–90) and aristocratic circles around him. Under the most famous tea master, Sen-no-Rikyū (1522–91), it was refined and developed into a cult which had great influence on pottery design and on other arts such as architecture and painting.

Reduced to its essentials, the ceremony gave an opportunity for active men to retire from the busy world for an hour or so, to a small hut carefully designed and landscaped in their own gardens.

There they could enjoy, in the most beautiful and peaceful sur-roundings, a bowl of tea prepared and served by their host with quiet grace and gentility according to a prescribed ceremony. It is a peculiarly Eastern concept whose aim is to induce men to con-template the more refined and eternal aspects of life. To conform to the basic requirement of strict equality, the samurai was required to leave his sword outside the hut and crawl through a small door. In China a recluse, perhaps with a few friends, would drink his tea before some broad landscape and contemplate a famed panorama; in Japan everything was reduced in scale and the grandeur of nature was simulated by the most cunning landscape gardening. Peace, respect, rustic serenity, and solitude were the aims of the ceremony in its purest form. Under Ashikaga Yoshimasa its general lines were formulated. The great age of the ceremony was short, and later under the Tokugawa shoguns it was stripped of all its sincere, spiritual values and popularized to such a degree that it bordered on vulgarity.

Sen-no-Rikyū is an important figure in the history of the cere-mony. Through the financial support of a wealthy father, he was able to devote himself completely to the study of the arts. His con-cept of the tea ceremony became extremely popular, especially with the more bucolic samurai who came to Kyoto in search of political fortune. For them, his classes were an easy finishing school in manners, putting them at their ease in the refined society in which they found themselves. (The ceremony still fulfils this func-tion for aspirants to the social graces.) Conversation on art and poli-tics flowed freely in these salons and it has been suggested that, had they continued in the course set out for them by Sen-no-Rikyū, they might have fulfilled the same function as the *sociétés de pensée* of eighteenth-century France in the diffusion of liberal thought and democratic ideas.

Unfortunately, Sen-no-Rikyū was put to death by Hideyoshi, the dictator of the next regime. The reasons for this are not clear, but there is evidence to suggest that the tea master, a man of very high moral standards, did not approve of Hideyoshi's exploitation of the ceremony for political purposes.[3]

The Cult of the Rustic

For the arts, the most important result of the tea ceremony was the cult of the rustic which it created. This colored the whole artistic

outlook of Japan in succeeding centuries. Elegant Chinese Sung and Ming wares were greatly appreciated for use in the tea ceremonies but, since it was the aim to approach nature as closely as possible, many of the rougher, less sophisticated native wares seem to have been even more popular. The old Bizen and Shigaraki kilns were at the time producing strong but crude wares for everyday use which now became very fashionable—both for their vigor and because they served to offset the elegant Chinese products. Often these Japanese wares contained flaws—dents, faults of shape, places where the glaze did not cover the body, and volcanic-looking irregularities. These were so much admired that later potters consciously, though not altogether successfully, imitated them. Sometimes these later craftsmen in the rustic style created outstanding works. At others they produced objects as senseless as the more exaggerated niceties of the tea ceremony itself. At their best the rough tea wares have an organic, monumental quality which can only be discussed in sculptural terms; often they are only as "genuinely rustic" as the seats and pergolas in an English garden suburb.

Jean-Pierre Hauchecorne, a Frenchman and long-time resident of Japan, reached deeply into the Japanese way of life and wrote about the true Zen influence which permeates all aspects of Japanese life. His remarks have a bearing on the basic concepts which animated the early tea-ceremony masters. Referring to the spirit of Zen as one of "clear poverty" he says, "The lesson of Zen . . . has taken me toward human beings, and it has shown me the beauty which is expressed in the least movement, in the most humble type of work: those of the peasant, as he attends carefully to his earth, as he plants his rice stem by stem, as he decorates the very ridge of his humble straw roof, as he also beautifies the entrance of his farm with a few rocks and a twisted plum tree; those of the craftsman, as he turns his pot and, with a few strokes of the brush, throws on it a design, the sheen of which will never be known until it comes out of the wood-fed kiln; those of the most ordinary way of packing, where wood, straw or a twig of vine will wrap up in living warmth the inanimated object inside."[4]

The aesthetic approach inspired by Zen leads to the perception of beauty in the most lowly object and to the appreciation of even its most insignificant variation. This is by no means a small contribution to art appreciation and to the formation of a sensitive taste. The

tea ceremony provided the stage for the display of this refined rusticity, this conscious play of opposites.

Metalwork: Sword Guards and Tea Kettles

The finest metalwork of the Ashikaga period is found in two kinds of objects which throw light on two conflicting sides of the Japanese character—the brutal and the sensitive. Each of them, taken separately, shows this same contradiction of spirit. They are sword fittings and iron kettles for the tea ceremony. The aim of the decorators of the sword fittings was, especially in later times, to make them as elegant and sophisticated as possible. The casters of the kettles tried to give them a virility of shape and design which seems, at first sight, almost out of keeping with the gentle spirit of the ceremony.

Sword guards, or *tsuba*, were first used as early as the Nara period but few of these have survived, and not until much later was so much artistry applied to their manufacture that they rank as works of art. Large collections of these guards exist outside Japan. Their technical and decorative variety is inexhaustible—piercing, chiseling, punching, inlays of all kinds create an unending variety of highly original decorations. Among the thousands which poured from the workshops to satisfy the cult of the sword the collector seldom finds two which are identical, even in the products of the same workshop.

Many of these *tsuba* are signed by their makers, and works of acknowledged masters were much treasured—and consequently forged in later times. These craftsmen took as much pride in the perpetuation of their families and schools as did the painters.When a line was in danger of dying out, they often adopted a suitable apprentice to continue the family name. Thus Gotō Yūjō worked during the reign of Yoshimasa (1435–90) and the family continued for seventeen generations of craftsmen down to the end of the nineteenth century when the carrying of swords was forbidden by law.

In the Ashikaga period the craftsmen began, though still only very tentatively, to explore the possibilities of decorating the surfaces of these *tsuba*. At first, simple designs based on figures or simple motifs taken from nature were made in relief or incised on the flat surfaces. The small area and circumscribed shape presented a challenge which constantly tested the Japanese genius for decorative invention. It always seems to thrive under such restrictions, and the solutions which

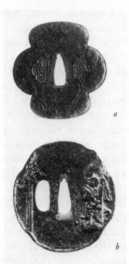

112. Two sword guards, by *a*, Nobuie and *b*, Kaniei. Late fifteenth century. Iron. Longer diameters: *a*, 3¼ in.; *b*, 2¾ in. Private collection, Tokyo.

the *tsuba* makers discovered are inexhaustible.

Two *tsuba* by two of the most famous masters of the time are representative of the late fifteenth-century styles. The guard by Nobuie in figure 112(*a*) is of a graceful quatrefoil shape and, to offset this, very simply decorated with an incised branch simply but effectively arranged to curl round three-quarters of the circumference. It is placed in such a way as to follow the line of the fist. The guard in figure 112(*b*) is fist-shaped with a figure of Bishamon-ten* on the right balanced by a tree on the left. The decoration is in relief with touches of gold and silver set into the figure. The maker was the famous Kaniei. Such simple guards, however, are only just beginning to move away from the purely functional. They hardly give a suggestion of the technical masterpieces of the following centuries when the designers replaced their practical vigor by decorative fantasy and sumptuous ingenuity.

* The equivalent of Kuvera, the Hindu god of riches. He is shown in full armor with a fierce expression, carrying a small pagoda-shaped shrine in his right hand and a lance in his left. The latter accounts for his being confused with the gods of war.

Cast-iron kettles as objects of art developed from the everyday kitchen pots of earlier times. The tea ceremony lifted them out of the kitchen into the cultivated atmosphere of the tea hut and transformed them to serve the Japanese cult of the rustic. The humbler an object, the more the Japanese delighted in exploring its potentialities. But popularity is the greatest enemy of the craftsman. It is remarkable that, even when the rustic taste became an affectation, enough skill and tradition remained to produce simple works which come up to the highest standards. The example in figure 113 was made about 1500 and is typical of one of the most famous makes of the period, the Ashiya type, so-called from its place of manufacture, a seaside village in Fukuoka. The beautiful proportions of the kettle reflect the assurance of centuries of experience in the craft. The well-fitting lid, slightly concave with a coiled-animal handle, increases the firmness of the outline. The animal-mask handles lighten the sense of heaviness in the body. The design is carefully planned to set off the material and attract the eye. Five energetic horses gallop round the sides against the faint outlines of hills on the shoulders of the kettle. This is very much in the style of Chinese Yüan-Ming horse painting and shows how such artistic knowledge had permeated down even to the village craftsmen. The successful adaptation of painting styles to cast iron is proof of a rare taste and ability. The designs and workmanship of European gold and silver work are admirable—how much more surprising is the loving care which the Japanese lavished on plain iron!

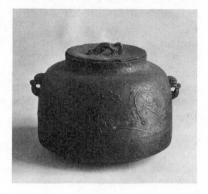

113. Ashiya-type kettle for the tea ceremony. Ca. 1500. Cast iron. Height: 7½ in. Tokyo National Museum.

These iron kettles were, of course, intended to contribute to the atmosphere of simple country life sought by the adepts of the tea ceremony. They served also, by the roughness of their material, as a foil to the more delicate objects in the tea ensemble—to the pottery bowls or the bamboo ladle, to the small square of rich brocade which glittered all the more brilliantly against their dull black surface. Everything in the little room was carefully planned to catch and reflect or to set off the qualities of the various components—smooth and rough, simple and intricate, rustic and sophisticated. The possibilities were infinite and they still exercise the Japanese mind.

Lacquer

As one might expect, the lacquerworkers of the Ashikaga period rapidly adopted the contemporaneous painting styles and adjusted their products to the taste of the times. Thus boxes and tables reflect Chinese painting styles as interpreted by the Kanō masters. However, craftsmen also kept alive the *yamato-e* traditions which seem to show more persistence in lacquer than in painting. The lacquerers had less need to adhere to any particular style and they indulged in greater eclecticism. In this they were encouraged by their luxury-loving patrons who restlessly sought novelty and opulence. Thus a typical Kanō element is sometimes quite happily combined with a *yamato-e* background—a tree will come straight from a Kanō screen while above it hang the horizontal bands of mist used so effectively in the Japanese handscrolls.

The peculiar taste for combining elegance and rusticity pervades especially articles made in the Higashiyama period when Yoshimasa was in power. Techniques became more involved and strove to create richer effects, designs became less meticulous but heavier. *Taka-maki-e* was particularly popular as were also objects made in China from the familiar red lacquer. Accordingly *kamakura-bori*, which had been inspired by it (see p. 170), found favor, and there seems to have been a considerable interchange between Japan and China of their respective lacquerwares. It is of significance for the wedding of the arts and crafts that Michinaga, a lacquer master who served Yoshimasa, used the work of such famous painters as Nōami, Sōami, and Tosa Mitsunobu as prototypes for the designs on his wares.

The *maki-e* box in figure 114, formerly owned by Yoshimasa,

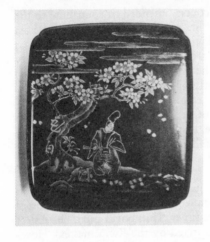

114. Box to hold an inkstone. Muromachi period. Lacquer. Dimensions: 9 in. × 8¼ in. Nezu Museum, Tokyo.

shows a typical and happy combination of Kanō and *yamato-e* styles. It also illustrates a distinguishing feature of the lacquer of this period —a preference for simplified pictorial motifs boldly expressed. The designers of the preceding Kamakura period generally chose crowded surfaces, often filled with repetitive designs; Ashikaga work shows more restraint and feeling. The designers, at least in this period, resisted the temptation to surrender to the extremes of over-brilliance and sentimentality. The designs on these lacquer objects often carried strong literary overtones. This box illustrates a poem about "the falling of cherry blossoms in the spring at Shirakawa." A clue to the source of inspiration is provided by the characters for Shirakawa on the tree trunk and the rock at its base. The possibilities in the decorative use of characters, so greatly developed in later periods, first occurred to the designers at this time.

An atmosphere of springtime pervades the design—in the mists and the falling petals which settle around the lonely figure. All unnecessary detail has been omitted to clarify and simplify the scene. The spectator is induced to identify himself with the wistfulness of a passing moment in an intimate, confidential way which is typically Japanese. This gift for the communication of intimate experiences is rarely found in Chinese craftwork. There the Westerner stands back and admires a product which is quite obviously perfect and

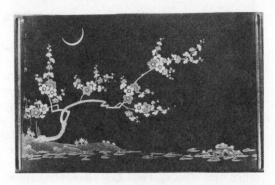

115. Writing table. Muromachi period. Lacquer. Dimensions: 1 ft. 2¼ in. × 2 ft. Tokyo National Museum.

just as obviously of a world entirely different from his own. The experiences communicated by Japanese art are more warm, passionate, and universal.

The writing table in figure 115 shows how the Zen ideals of simplicity and "emptiness" influenced the crafts. Here an oblong shape has been skillfully filled with a springy plum tree reaching out over a stream and dividing the surface into two triangles. A crescent moon forms the compositional counterpart for a rock in the water. The movement of the stream is shown by a few schematized waves which push in toward the bank. By opposing the direction of the plum branch, they provide balance and tension. Could anything better illustrate the Japanese instinct for design—the union of the natural and the artificial, the appeal to the eye and the sentiment? It is easy to understand why such objects, which seem to combine the skill of the craftsman and the sensibility of the painter, appealed to the Chinese. Their workmen had nothing comparable to offer.

Textiles

Unlike the lacquerer's craft, that of the textile designer reached its nadir in the Ashikaga period. When the Kamakura regime destroyed the wealth and power of the Kyoto aristocracy, it removed the patrons of the expensive textile industry. The elaborate many-

layered costumes which envelop and weigh down the figures in the *Genji* scroll belonged to a past age. Dress had become more simple and austere in the Kamakura period and this tendency, allied to the Zen ideals, continued in the Ashikaga period. In the civil wars and social disturbances of the fourteenth and fifteenth centuries many of the skilled techniques of textile manufacture, with few exceptions, were forgotten. Even good-quality silk was no longer produced. Thus the Ashikaga period was the drab conclusion of a process of decline which had been gaining momentum since Fujiwara times.

However, it should be noted that this was the period of the development of the Nō play and its farcical counterpart, the Kyōgen, from a simple musical and dance entertainment to a highly polished and subtle art form combining tragedy and comedy in a very prescribed order. In Nō, masked and elegantly costumed actors dance in very stately rhythms accompanied by a kind of "Greek chorus" intoning historical stories or early myths based on Buddhist concepts or Shinto beliefs. Great theorists and writers like Kan'ami (1332–84) and in particular his son Zeami (1363–1443) formalized the essential aspects of Nō, and their development of this theatrical form had an influence on theater costume.

In this period of eclipse, however, there begins a significant development which was to have major consequences in the next period. The garment called *kosode* (referring to its short hanging sleeves), which replaced court dress, was the forerunner of the modern kimono. To decorate it, the Japanese returned to an earlier technique of tie-dyeing suitable for large, bold designs (fig. 116). This was quicker and cheaper than the old system of weaving and enlivened the dress of the poorer classes. The tastes of the richer sections of the population were satisfied largely by imports from abroad. Fine textiles of the Sung, Yüan, and Ming dynasties came from China. Indian cotton prints and fabrics from the South Seas, materials from the Near East and Europe also found their way to Japan—especially after the Portuguese opened their trading activities in the Far East. Fragments of the most costly of these were used as mountings for valuable paintings and for wrapping the precious objects used in the tea ceremonies. They were highly treasured and, in their turn, they stimulated local factories to emulate them and thus to revive a dying craft. This is another example of the readiness of the Japanese to accept and assimilate foreign products which has enriched Japan

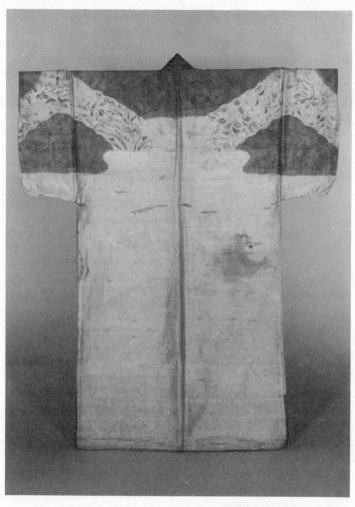

116. *Kosode* (short-sleeved garment) as example of *tsuji-ga-hana* tie-dyeing. Muromachi period. Silk with bird-and-flower design. Height: 4 ft. 3 in. Tokyo National Museum.

from the earliest times. The effect on later craftwork provides many interesting sidelines to the general development of Japanese art.

It is interesting to observe how, when foreign example inspired the Chinese, their products usually lack the vitality and charm which we see in Japanese products made under similar influences. Perhaps the Chinese, lacking the adaptability of the Japanese, are temperamentally less suited to making the inventions of other lands their own.

The Ashikaga shoguns proved no more successful in solving the vital problem of disciplining the feudal lords of the provinces than the late Kamakura rulers before them. In the new fight for supreme power, which lasted a hundred years, old families disappeared, new ones took their place and their possessions. Slowly the lands and forces of many of the old daimyos were absorbed until the struggle resolved itself into a contest between about half a dozen of the most virile competitors. From these one emerged supreme—Oda Nobunaga (1534–82).

8

THE MOMOYAMA PERIOD

1568–1615

The Momoyama period initiated by Nobunaga was short—it lasted only forty-seven years. Yet politically and artistically it was a most important half-century in the history of Japan. It was a period of intense warfare, yet it laid the foundations of modern Japan, and of two hundred and fifty years of peace such as the country had not enjoyed since the tenth century. "Modern" Japanese art likewise stems from these fifty years, the most ebullient and colorful phase in the whole development of Japanese art.

Nobunaga, though of an ancient clan, was a typical example of the way in which members of relatively obscure families could rise to power in the anarchical sixteenth century. He had consolidated his strength steadily at the expense of neighbors less virile than himself and, by the early 1560s, was numbered among the most formidable of the lords. His actual seizure of national power followed the pattern established by the rise of the great shoguns before him, for a helpless and threatened emperor appealed to him to come to his aid. In 1567 he answered the call, marched on Kyoto and made himself the effective ruler. It is an indication of Japanese respect for traditions that he retained not only the emperor but also a member of the Ashikaga line in their positions of empty dignity. The latter, no sooner secure, was rash enough to plot against Nobunaga, who promptly disposed of him.

Nobunaga spent the following years in ensuring his supremacy. This entailed defeating the most powerful of his fellow barons and putting an end to the threats of the militant monks. His general

Toyotomi Hideyoshi and his ally Tokugawa Ieyasu, both of whom had risen from humble origins, served him well. Death or defeat removed some of his main rivals. He put down the warlike monks on Mt. Hiei, whose descents on the capital had been such a constant threat in previous centuries, and burned their monasteries. Other more impregnable temple strongholds and fanatic sects gave him greater trouble. The most powerful of these, at Osaka, fell in 1580 only after ten years of siege.

In 1582 Nobunaga was assassinated by one of his own men and it was left to Hideyoshi to revenge his master and to complete the work begun by him. By 1587 he controlled the southern island of Kyushu; by 1590 the north was subdued and one-third of the country was in his power. After this, other lords found it wise to come over to his side.

Hideyoshi, who is often compared with Napoleon, was the first plebeian ever to rise to supreme power in Japan. He was more astute than many shoguns before him in his appreciation of the difficulty and danger of disbanding an army which in some of his campaigns had numbered a quarter of a million men. Judging from the results of earlier pirate raids on the mainland, foreign conquest seemed a practical and profitable way of exploiting their energies and diverting their ambitions. He felt strong enough to contemplate attacking even China (then in the last weak decades of the Ming dynasty) but finally chose Korea. He invaded this country twice—in 1592 and 1597–98. The second campaign was cut short by the death of Hideyoshi in 1598 and Tokugawa Ieyasu was forced to spend the next seventeen years in a struggle for absolute control at home, which he finally secured only in 1615. With this the short Momoyama period gave way to the long Tokugawa period which lasted until 1868.

Decorative Brilliance

The Momoyama, or "Peach Hill," period is named after a castle of that name built by Hideyoshi at Fushimi in 1593. The decorations which artists evolved for such castles and many other opulent villas set the pattern for the arts. Nobunaga had initiated the fashion with a splendid stronghold beautifully situated on the shores of Lake Biwa near Kyoto. This was destroyed in 1582 after his assassination. The largest of all these fortresses, erected by Hideyoshi at Osaka from 1583–85, also perished in 1615. But a number built by other feudal

117. Himeji Castle. Momoyama period. Himeji, Hyōgo Prefecture.

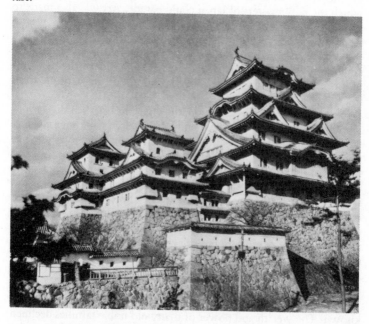

lords throughout Japan have survived. The recently restored Himeji Castle, also known as the Shirasagi, or "White Heron," Castle (fig. 117) is one of the finest. A fortress existed here in the fourteenth century but its shape is unknown. The present castle was built at the end of the sixteenth century and expanded in 1608-9. The large seven-storied tower built on granite walls is about one hundred feet high and around it cluster smaller four- or five-storied keeps forming one massive compound. This type of castle architecture is unique in its combination of elegance and strength, a bold union from which Momoyama art drew its authority and its momentum.

The new warlords spared no expense to furnish their rooms in the richest styles that artists could devise. It was a truly baroque age of buoyancy and brilliance. Feudal lords vied with each other in the splendor of their castles. Lavishness of decoration and entertainment

became a mania; precious metals and costly lacquer were squandered in efforts to produce ever more dazzling backgrounds against which the new masters of Japan could parade. Art was also made to serve politics, for the aim of Nobunaga and his successors was to secure obedience from possible rivals by every available means—by the display of material advantages as well as by threats of military sanctions. The works of the decorators who enriched the castle interiors are among the world's finest products of the baroque spirit in art.

In the short Momoyama period, the divisions between the various schools seemed to break down and styles were in the melting pot. Color was liberated from all restraint and artists welcomed the opportunities this freedom gave them. What were the causes of this sudden outburst? The new men in power were of a coarser grain than their predecessors and the refining influences of Kyoto had lost their centuries-old appeal. The desire of the dictators to impress only partly explains the phenomenon. There was also a practical reason: gold and silver backgrounds were needed to bring light into the otherwise gloomy interiors of these huge fortresses. But in fact Japan was growing tired of the austerity of the Kamakura period and of the restrained good taste of the Confucian-flavored Ashikaga periods; even the spirit of Zen simplicity was losing its attraction and vigor. At the same time, with peace came a prosperity hitherto unknown. The wealth and power of many old noble families declined and their place was increasingly taken by wealthy merchants who became moneylenders to the old lordly families.

If the rulers set the fashion, it was joyfully followed by the rest of the country. The *recherché* Ashikaga atmosphere of tiny tea hut and rustic clay pot gave way to vast gardens lined with painted screens in which hundreds sat down to drink tea from golden vessels. The discreet alcove which offered but a few evocative brushstrokes of black and white surrendered to vistas of florid color in magnificent sweeps intended to overwhelm the senses. The simper of the late Ashikaga court went down before the swagger of men like Nobunaga. Everything gave way to the search for novelty, and economic conditions as well as the social atmosphere of the times encouraged this heady movement.

The garden of the Sambō-in of the Daigo-ji (fig. 118), restored under the patronage of Hideyoshi and completed in 1615, gives an im-

118. Garden of the Sambō-in. Completed in 1615. Daigo-ji, Kyoto.

pression of the rich effects that were sought for even in temple settings.

In art, color and movement took the place of monochrome and stillness. Through the centuries artists had been feeling their way toward techniques which could be used in exuberant ways—one sees glimpses of it in Tosa scrolls, in *yamato-e* landscapes, in lacquer, and even in metalwork. The artists often seem to have restrained their native urge for vivid decoration with only the greatest difficulty. From now on all restraint is removed and even the oldest themes find new life and original interpretations. The general conception of Japanese art in the West is understandably, though not always fairly, based on this art of the "modern" period as the Japanese call it. The quieter but nobler products of earlier ages are often overlooked.

Sherman Lee summarizes the style so admirably that one can do no better than quote him extensively: "This original style, quite unique in the Far East, is composed of certain forms and combinations repeated with subtle and seemingly infinite variation. Like other decorative styles, it relies heavily on the use of precious materials, particularly gold and silver, in juxtaposition with pure color. Its basic compositional devices are markedly asymmetrical, unlike so much of the decorative art of China, and very much like the modes of European *art nouveau*. Indeed, some of the assumptions of this particular early twentieth-century Western style owe much to Japanese influence. Within the asymmetry characteristic of Japanese decorative style we find a thorough use of patterning, both in the arbitrary use of cut or sprinkled gold and in the exploitation of textile patterns in represented costumes, as in the paintings of Vuillard. Motifs, or more prosaically, decorative units, were used almost as if they were interchangeable parts from a pattern book. Aesthetic importance rested in their tasteful arrangement in carefully adjusted relationships. Space is minimized in the style, emphasis being placed on flat, plain or patterned, shapes that reinforce the flat surface of the painting or object. The motifs are relatively limited in number and are repeated again and again in different media, in varying sub-styles, and over a long period of time. Significantly, they have strong literary connotations of a particularly aristocratic and esoteric type, derived from such traditionally hallowed masterpieces as the *Genji Monogatari* by Lady Murasaki (d. 1031?), or the loosely organized combinations of narrative and poetry in the *Isé Monogatari*. Like some of the decorative art of the *dix-huitième siècle*, one had to be cleverly literate to extract the full pleasure of nostalgic literary remembrance from the equally sweet but more evident visual pleasures of the decorative style. Finally, this style was applied to the whole range of Japanese art materials and techniques: painting, some sculptures, ceramics, lacquer, textiles, sword fittings, and many others. It is not a technical manner but a style. Perhaps its most important product is among the most conspicuously decorative works ever produced—the folding screen, a movable and flexible wall of dubious utilitarian value, but perhaps the most significant creation of this Japanese decorative style."[1]

Among the few furnishings in Japanese rooms are such folding screens, which consist mainly of panels, and sliding doors covered

with paper. Every possible space on these was now covered with bold paintings generally planned in pairs or series. One reads of commissions even for sets of a hundred such screens. These paintings on walls, doors, and screens (with the generic name of *shōhekiga*) are yet another typically Japanese development. Large painted screens, of course, were not an innovation. Early examples have been preserved in the Shōsō-in (see fig. 41). Chinese paintings dating back to the eleventh century show them although, curiously enough, none have survived on the mainland. In Japan, too, they were used in the Kamakura period or even earlier. Kanō Motonobu painted ink monochrome screens in the Ashikaga period, and *yamato-e* styles, particularly suitable for decorating large spaces, had also been revived for decorating them. But the Momoyama artists combined the two styles now—giving the outlines the powerful brushwork of *suiboku* painting and filling the areas so defined with bright colors. To this they added the extravagance of gold which was lavishly used for the backgrounds. The large areas to be decorated naturally lent themselves to broad, sweeping brushstrokes, monumental designs, and large-scale motifs. In what seems an attempt to bring nature itself into the castles to serve the new rulers, trees, flowers, birds, and animals are often introduced, even in life-size.

Kanō Eitoku and Hasegawa Tōhaku: A Contrast in Styles

At the head of the movement stands Kanō Eitoku (1543–90), the grandson of Motonobu. Nobunaga commissioned him to decorate his castle at Azuchi. The castle was soon burned down, but we know that he, possibly aided by his pupils, furnished five of its seven stories with both Chinese- and *yamato-e*-style paintings. It is likely that what now remains of his work does him less than justice. The six-paneled screen of Chinese lions (*kara-shishi*) in the imperial collection (fig. 119) is one of the few that have survived. The animals, symbolical of peace and dignity, recall the fierce mythical beasts which decorated Chinese roofs from the Ming period onward. The background is a rich sweep of gold applied in squares. The manes of the animals are in green and brown and their bodies are mottled. A few cliffs and rocks on the left are in green and brown. A small twig of a tree provides the only naturalistic element in the whole composition. After the restrained paintings of the Ashikaga period, such work comes as a shock. It is frankly gaudy and not very sensitive but

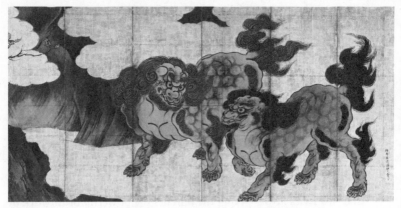

119. Six-paneled screen *Chinese Lions (kara-shishi)*, by Kanō Eito-ku (1543–90). Color on gilt paper. Dimensions: 7 ft. 4½ in. × 15 ft. 1 in. Imperial Household Collection.

it has a tremendous verve and ebullience. The composition is audacious—the dynamic figures seem hardly containable within their frames. The style is overwhelmingly bold. The artist has abandoned himself completely to the demands of a lusty, unconventional age and one senses a joyous release from the restraints of the last centuries.

Other works by the same artist show that, like many Japanese painters from the fifteenth century onward, he, too, was very eclectic in his sources. He could adapt the new rich style to imposing landscapes filled with realistic trees set against a decorative gold background. He painted also, if not at his most original, such familiar subjects as "Sages in Landscape" in the traditional Chinese ink styles. The combination of monochrome and polychrome painting is one of the features of Momoyama work. It must always be remembered that these men were decorators and, like good craftsmen the world over, they fitted their styles to their commissions. The records are confusing and, since most of the screens are unsigned, many problems of authorship remain unsolved. A screen painter, Kaihō Yūshō (1533–1615), is mentioned in literary sources as having the skill of the Chinese painter Liang K'ai, yet a typical work by him

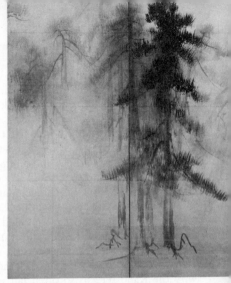

120. Two-panel detail from one
screen of the pair of six-paneled
screens *Pine Trees*, by Hasegawa
Tōhaku (1539–1610). Ink on
paper. Height of entire screen:
5 ft. 1½ in. Tokyo National Muse-
um.

of peonies and plum blossom against a golden background is the
complete antithesis of a Chinese monochrome. It seems that the
forces which swept away the Ashikaga destroyed for a short time
also the snobbism which had insisted on painting rigidly in the
Chinese fashion.

Hasegawa Tōhaku (1539–1610) was another painter who, like
Kaihō Yūshō, was equally at home in both Chinese and Japanese
styles. The detail in figure 120 shows a most striking individuality
of style in ink painting combined with a very Japanese lyrical feeling
for landscape. This detail is taken from two screens of pine trees
probably painted in his sixties. They are among the finest achieve-
ments of the Japanese talent based on Chinese technique and inspira-
tion. The artist has used mist and light rain as a black-and-white
lens through which to see the dark green of the trees, adapting in a
most subtle manner the Chinese use of light and shade to Japanese
sensibilities. The soft Japanese ink, quietly modulated from black
down to pale gray, creates an impression of hazy depth; the tops of
the trees emerge from an eerie mist which evokes the stillness of the
Japanese landscape in one of its mysterious moods. Thus the cool
calm of the woods is brought into the house as if to provide a visual

relief during the humid heat of summer. Tōhaku's work represents an attempt to revive Zen *suiboku* traditions and to give them meaning in a more modern context. He disliked the Kanō school—an attitude shared by his friend, the great tea master Sen-no-Rikyū. He traced his origins back to the great ink paintings of Sesshū and styled himself "Sesshū the Fifth." It is an indication of the importance attached to such a claim that he had to fight a lawsuit for the right to the lineage. How unfortunate it is that no verbatim records exist of what must have been a most interesting litigation! He lost his case but his work shows without any doubt that he belonged to the same lineage as Sesshū, which includes the Sung Chinese ink painter Mu Ch'i who has had a great influence on Japanese artists and whose soft brushwork can be seen reflected here. Tōhaku's art illustrates the persistent Japanese love of the dramatic in its simplest and purest form, but how closely it borders on sentimentality!

It is worthwhile digressing for a moment to discover, if possible, why the Kanō screens so often fail where Tōhaku brilliantly succeeds. Ink painting is only suitable for broad landscapes if the actual elements of the painting are on a comparatively diminutive scale—if the brush is small and delicately used. To use a term from another art, it is suitable for lieder and not for grand opera. To attempt in such media a full-scale imitation of nature in huge spatial compositions destroys its most sensitive qualities. Only a few artists like Tōhaku were able to modify the Chinese method and to impose their own personalities on views of purely Japanese landscape. Even then, the nearer they came to the Chinese ideal, the more fruitful were their efforts. But the Japanese have always been able technicians; perhaps it was inevitable that they should have become absorbed with the pure mechanics of Chinese painting and, as a result, unable to resist the temptation to push them to extremes—destroying them in the process. Nevertheless the example of Tōhaku shows that some artists were impatient with the formalism and insensitivity of the Kanō-school screens. If they could not all find a solution to the problem in painting screens they could, like Eitoku, reserve their Chinese style for smaller works which tended to be essays in the classical manner of Liang K'ai or Mu Ch'i.

Niten

A painter who successfully fused the Japanese vision with the

Chinese manner was Miyamoto Musashi (1584–1645) (better known by his "art-name," Niten), who spans both the Momoyama and Tokugawa periods. He was a famous swordsman, and the adopted son of a samurai. With such a background one might expect him to reflect the tastes of the newly victorious generals. But, strangely enough, this is not so. His painting of a shrike (fig. 121), which is one of about ten surviving paintings that are attributed to him, is in the best Chinese tradition; yet its dramatic quality and its studied simplicity immediately show the Japanese hand. The picture plane is divided vertically by a single, impetuous sweep of the brush depicting a dead, dry branch. The Japanese like to compare this line to the stroke of the sword, a simile with which Niten no doubt was familiar. The comparison is not entirely inappropriate.

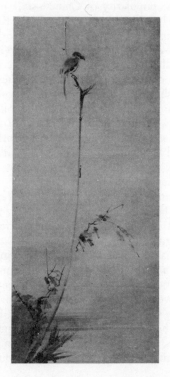

121. *Shrike*, by Niten (Miyamoto Musashi) (1584–1645). Hanging scroll; ink on paper. Dimensions: 4 ft. 1½ in. × 1 ft. 9½ in. Private collection.

The bird perches precariously at the top of a branch hardly strong enough to bear its weight. The interplay of forces in the painting is masterly. At the bottom of the picture the artist had started a thick bamboo branch but, no sooner started, than he left it to fade into the mist, lest it should detract from the bird on its branch and destroy the balance. Horizontal streaks of mist in the Japanese manner provide an illusion of depth and loneliness in the cold season. Throughout the painting the ink tones are skillfully modulated (much more so than in Ashikaga work), ranging from pure black to a luminous gray. Miyamoto's work shows influences not only of the classical Chinese masters like Liang K'ai but also of late Ming painters whose work he must have seen.

The fortunes of the Tosa school during this period declined as those of the Kanō rose. The snobbism attached to the Kanō name and the popularity of Chinese-style painting in general reasserted themselves. We have seen that many Kanō masters were well able to use *yamato-e* elements when they wished, and the very few pure *yamato-e* paintings which have survived are most colorful and sprightly. The majority of the Tosa artists, however, were either driven out to the provinces where they had to earn their livings in less fashionable circles or, if they chose to stay in Kyoto, necessity sometimes forced them to provide rough drafts for their Kanō employers. A new genius was needed to fulfill the possibilities of *yamato-e* style. He appeared in an early-seventeenth-century artist named Sōtatsu whose work will be discussed in the next chapter.

First Contacts with the West

During the Momoyama period, Western influences first began to affect Japanese art. In 1541 and 1543 Portuguese trading vessels landed in southern Japan. Only a few years later, in 1559, the Portuguese Roman Catholic missionary Francis Xavier introduced Christianity to the islands, where it met with considerable success. The number of Christian converts may have reached 150,000 by 1582 and by the beginning of the seventeenth century Japanese delegates were traveling to Rome. The Japanese appetite for novelty was greatly stimulated by the Portuguese. Before the end of the century it had become the fashion at the shogun's court to wear Portuguese clothes, even to carry rosaries and to exchange a word or two in Portuguese. The missionaries also brought sixteenth-century Euro-

122. Detail of a *namban* ("Southern Barbarian") screen showing the arrival of a Portuguese ship in Japan. Early seventeenth century. Color on paper. Lisbon Museum.

pean religious paintings that fascinated the Japanese and inspired many copies made by artists in seminaries the Portuguese established. Between 1590 and 1614 a number of screens were painted showing the ways of life and the adventures of the Portuguese in Japan. Some of these were brought to Europe in the Portuguese ships which had a monopoly on the trade at the time. Basil Gray says of this influence, which extended to guns, architecture, and Western learning as well as art, " . . . it is not something to be thought of as imposed, but on the contrary the result of a sustained curiosity and of a readiness to learn or adapt which was strikingly different from Chinese self-sufficiency."[2] This openness to foreign influences is a Japanese characteristic which we have seen in one form or another in most periods from the sixth century onward. The detail in figure 122 is from a typical *namban*, or "Southern Barbarian," screen. The wit and acute perception, the variety and character study in this gay scene are a delight in themselves. The chief merchant, cigar in mouth, sits on deck in oriental splendor; his crew unload the boxes and chests to trade with the Japanese waiting on the shore. Two villainous-looking sailors peer excitedly from the bows; a sad priestly figure, breviary in hand, is almost obscured by the rigging. Three assistants stand ready to receive the instructions of their master—one points to the rolls of material behind them as if dis-

cussing the prices, another looks slightly apprehensively over his shoulder, the third seems to have had his cap knocked off by the sunshade held over the master trader. All is bustle and eagerness, nothing has been missed. The Japanese artist has obviously welcomed the opportunity to exercise his talents for depicting personality offered by the strong, unusual features of the Europeans; priests seem to have intrigued him particularly. Western influences had free play only for a brief half-century before all Westerners were excluded, but from what was produced during this time it is interesting to speculate on the possible effect on Japanese art had the West been tolerated in Japan.

Modern Ceramic Art

To turn from the arts to the crafts is to appreciate to the full the *éclat* of the Momoyama period. The great age of Japanese ceramics began in these years. The Japanese had seen and admired the ceramic art of the Chinese Sung period, but they had never learned its secrets. Until this period their products were comparatively crude wares, strong but of little finesse. From the sixteenth century, when modern ceramics may be said to have started, they took a very individual turn.

It used to be difficult for many Westerners—especially those with a taste for Chinese ceramics—to appreciate the aesthetics of Japanese tea-ceremony wares. Compared with the highly accomplished Chinese products they appear at first sight, sometimes rightly, as rough, misshapen, and even thoroughly ugly. A snobbery of the antique, found not only in Japan, has given false values to a number of pieces which have little artistic or technical merit. On the other hand, the tea ceremony, and the large demand for pottery created by it, provided an incentive to study and experiment with form, a demand for originality, and a deep knowledge of the organic qualities of clay. Generations of craftsmen-potters contributed to the development of an art form which is still very much alive in present-day Japan. It is one of the few old crafts that have successfully withstood the impact of the West and the mass-production methods of the twentieth century. The genius of the Japanese potters and the value placed on their creations raised them to the status enjoyed only by the most successful painters in the West. Such is the continued appreciation and demand that a well-known potter will enjoy an

affluence unknown by his Western counterparts. The respect enjoyed by potters encouraged them to cultivate the bold expression of personality, a development quite unknown in China. As a result, Japanese pottery has perhaps had the greatest influence on modern potters throughout the world. What Chinese porcelain did for the European factories in the eighteenth and nineteenth centuries, Japanese pottery is now doing for the artist-potters of the West.

It is extremely difficult even for Japanese experts to distinguish some of the pottery produced by Japan—especially in its early period. A number of small kilns were established and they often imitated each other's wares in similar clay. It is not possible here to illustrate objects from each kiln or even the variety of wares from a single kiln; only the most important groups will be considered.

The Seto Kilns

It is to the old kilns that we must look first. The Seto kilns near Nagoya had, by this time, a considerable experience of pottery making. They were the first to react to new tendencies in the craft. Strangely enough, Japan turned once again to one of her earliest sources of inspiration—Korea. The most fruitful result of Hideyoshi's otherwise barren campaigns in Korea was that his armies brought back with them, often as prisoners, Korean potters who instructed the Japanese in the manufacture of Korean-style wares. New ceramic centers in addition to the Seto kilns were set up in Karatsu and Arita in the south. Arita was soon making porcelain, hitherto known only in wares imported from China. It was not long before the Korean element was displaced by the Chinese enameled wares of late-Ming–early-Ch'ing Chinese porcelains, but Korean influence resulted in some pottery of high technical and artistic skill.

The wares of the Korean Yi dynasty (1392–1910) which appealed particularly to the Japanese were celadons with inlaid decoration in white under the glaze and white glazed wares with underglaze decoration. In the late sixteenth century the Seto kilns for a time, due to disturbed local conditions, moved to a nearby site in Mino province. As Soame Jenyns remarks, "The gay appearance and rich variety of texture and pattern and elegant, if eccentric, shapes of the Mino wares in the Momoyama period were a radical departure from the austere and astringent monochromes of the

Muromachi period which preceded it."[3] The products of these kilns, however, are still considered as Seto wares. The most outstanding of these Mino-Seto wares are the Ki Seto (or "Yellow" Seto), the Shino, and the Oribe. As the name suggests, the Ki Seto wares have a yellow opaque glaze often covering an incised decoration which was colored with a brown iron-oxide or copper-green glaze. Japanese experts see in these wares the influence of Ming "three-colored" wares rather than that of Korean styles.

Shino and Oribe Wares

The Shino and Oribe wares made at Seto are more difficult to distinguish. The difference is mostly in time, for the Oribe were developed from the Shino. The Shino products usually have a thick, white glaze with brown iron-oxide decoration under the glaze. The drawing of the decoration is very free, recalling the Korean *egōrai* wares or even the Chinese *tz'u-chou* types. Sometimes the white paste is completely covered with a brown glaze and the decoration is cut *s'graffiato*-like to reveal the paste before the whole vessel is again covered with a white glaze. This produces what the Japanese call Nezumi Shino or "Mouse Gray" Shino (fig. 123). In both types of Shino ware the designs are notable for their free drawing and vitality.

The tea bowl in figure 124 is generally recognized to be the second most famous tea bowl in existence. It is coarse, irregularly shaped, and hand-modeled, "bulky but stable in appearance with a deeply pitted uneven crackled surface on which the white glaze has receded leaving numerous bare spots and blemishes which add to its interest."[4] The iron rust-brown decoration suggests a bamboo fence.

Oribe pottery is said to have been named after Furuta Oribe (ca. 1544–1615), a famous tea master of samurai stock who, it is claimed, established their style but whose direct influence is now somewhat discredited. Although closely related to Shino, it has a very different character. The earlier types (Shino-Oribe) are a compromise in which Shino glaze was refined and the colors made brighter. The most famous of these Oribe wares are the Ao Oribe or "Green" Oribe, in which a green glaze predominates. The designs on this type (fig. 125) tend to be geometric and very Japanese in their conscious unevenness. Sometimes they include Western, even Christian, elements such as crosses. But their manner of arrangement is peculiarly

123. Rectangular plate of Nezu-mi ("Mouse Gray") Shino ware. Momoyama period. Length: 9⅛ in. Seattle Art Museum.

124. *Uno Hanagaki* ("Hare Flow-er Trellis") tea bowl. Momo-yama period. Pitted white glaze with grayish brown decoration. Height: 3½ in.; diameter at mouth: 4½ in. Private collection.

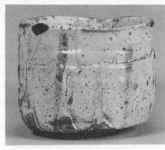

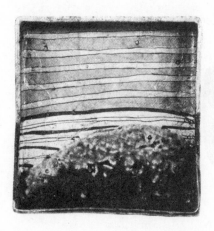

125. Square bowl of Ao ("Green") Oribe ware. Momoyama period. Width: 9 in. Nezu Museum, Tokyo.

Japanese and they are the most colorful of the late-sixteenth-century wares. This is a very avant-garde approach which appeals to Western taste.

Karatsu and Raku Wares

The products of the Karatsu kilns, next in importance to the Seto, are technically much less advanced than the Seto wares and much closer to their Korean Mishima inspiration. The painted Karatsu wares with designs in brown iron-oxide under the glaze resemble the painted Shino ware. These types will be discussed in the next chapter. Kyoto, the center of the tea ceremony, was not far behind the Seto kilns in producing pottery. One of the most characteristic and valued types was initiated by Chōjirō (1516–92) under the artistic guidance of the tea master Sen-no-Rikyū. Chōjirō is credited with the invention of *raku* wares (fig. 126), so called because Hideyoshi gave his son, Tōkei, a gold seal with the character *raku*, which means "pleasure." This he stamped on each of his pieces. The character has been used as a mark in one form or another by fourteen generations of the family down to the present day, a record surely unsurpassed anywhere in the world. The ware is low-fired and the glaze generally plain black, salmon-colored, or white with a high, waxlike sheen and pitted surface. The shapes are rough and irregular but not fantastically so. The bases are generally small, the bodies wide and capacious, often turning in slightly at the lip to

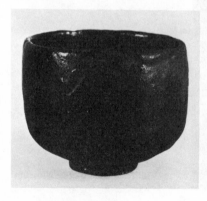

126. Tea bowl of black *raku* ware, by Chōjirō (1516–92). Height: 3¼ in.; diameter at mouth: 4½ in. Private collection.

give the impression of a fruit shape. These bowls, the classical ideal of the tea-ceremony wares, are quite simple but very satisfying to the touch and their glaze exemplifies the sophisticated simplicity which was the aim of the tea ceremony. In some respects one can call them a revival of Chinese *temmoku* along Japanese lines.

Textiles

In all the crafts during these fifty colorful years styles were created which were to dominate the next three centuries. Textiles were particularly richly developed. The Asuka-Nara period had been the first great age of Japanese textiles based on the example of the Chinese T'ang-dynasty craft. In this second great period the Japanese built on their own native traditions. The sumptuousness and variety of design is all the more surprising as this period followed on the Ashikaga period when the craft had reached its nadir.

Japanese design from this time bewilders by its inexhaustible variety. It has been said of European design that it should not seriously engage the mind or strike deep into the imagination but should be accepted without question, like an ancient code of behavior. In consequence, it must make free use of clichés, of figures which, whatever their origin, have already been reduced to satisfactory hieroglyphic form. The Japanese have never been content to treat decoration in such an uninspiring manner and it is this restless search for originality, for eye-catching splendors, which makes their decoration so unusual and ever fresh to the Western eye.

Just as the taste of Nobunaga and his successors in interior decoration was frankly extravagant, so they also demanded robes to match the brilliance of the screens against which they would be seen. And for the first time for centuries money was available to support factories which could produce them. No jaded court aesthetic hindered the free expression of a *nouveau-riche* taste. The products were only saved from vulgarity by the ingenuity of the designers and the skill of the textile workers.

Every possible technique new and old was tried—tie-dyeing, hand painting, embroidery, weaving, gold foil, gold-foil appliqué, and the previously mentioned *tsuji-ga-hana* method (see p. 171) in which the color was tie-dyed and the outlines added in ink. A combination of embroidery and metal-foil appliqué provided a particularly brilliant type of decoration (*nui haku*). But the most original aspect of

Momoyama textiles was the way in which materials made or decorated in different techniques were boldly combined in a manner which exploited to the maximum all possible contrasts of color, material, and design. In some, the two sides of a garment were made of contrasting material (*katamigawari*) or the robe was divided horizontally; in others only the shoulders and wide hem were used for the contrast. Figure 127, a short-sleeved garment, shows how the shoulders and the hem were made to stand out against a plain wide central band. The decorated surface is made of embroidery on gold foil. The robe was worn by an actor taking a child's part in a Nō play and it was intended to create a gay, youthful impression. The technique used in the embroidery suggests that it was ultimately inspired by Ming examples, but that is all that remains of Chinese inspiration.

The astonishing vividness and variety of the design, the richness created by adding embroidery on gold and, perhaps above all, the treatment of the entire surface as a single decorative unit is characteristic of the Momoyama feeling for the decorative arts. What a brilliant impression the actor must have created as he posed on the stage in this scintillating gown—a masterly combination of the simple and the gorgeous.

Figure 128 shows a Nō costume which is even more dramatic in its design and use of color. Tokugawa Ieyasu, whose circular crests (*mon*) it bears, gave this striking man's gown to a group of Nō actors. The background is white and the shoulders purple. A thick yellow-green branch of bamboo sweeps up one side of the back in a powerful curve, intersected by a slenderer branch crossing from halfway down to the left shoulder. A few sprays of pale blue leaves in the *tsuji-ga-hana* technique curve gracefully from the bamboo joints to complete the design. The most surprising feature is the unusual harmony between geometric and natural forms which are subtly connected by the curve of the thinner bamboo where it runs parallel with the zigzag pattern on the shoulders. The few basic elements, in unconventional lines and strong colors, are boldly and clearly used in a manner more typical of painting than of textile design. The Japanese have successfully solved the problem of combining elements and colors which are normally considered as alien to each other. The results, though sometimes a little gaudy, are brilliantly original and full of imagination.

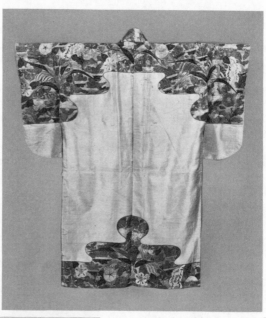

127. *Kosode* (short-sleeved robe) decorated with embroidery on gold foil; used as Nō costume. Momoyama period. Silk. Height: 4 ft. 3 in. Tokyo National Museum.

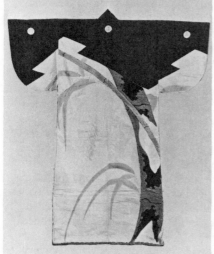

128. *Kosode* (short-sleeved robe) decorated with bamboo on a white and purple background; used as Nō costume. Momoyama period. Silk. Height: 4 ft. 9 in. Tokyo National Museum.

Metalwork

The arts of the metalworker contributed their share to the decorative splendor of the Momoyama. In these, too, the Momoyama period provided the foundation on which the craftsmen of the next two hundred and fifty years were to build. The rich metal decorations, sometimes in gold, which the shoguns used for the clasps and catches of their screens, have already been mentioned and a commentator of the time mentions even gold catches on their lavatories! But it was chiefly in sword fittings that Momoyama metalwork excelled. From this time onward the ingenuity of many hundreds of artisans in workshops throughout Japan produced an unending stream of *tsuba* of astounding variety.

In the Ashikaga period the guards had been comparatively plain with rough designs added as if by afterthought (see fig. 112*a*, *b*). Subsequently a far wider variety of techniques raised the craft of guard making to a standard of artistry in the forefront of all metalwork. New metals such as silver, bronze, and pure copper were introduced. Three alloys peculiar to Japan were invented: *shakudō* (copper with a small amount of gold), *shibuichi* (copper and silver), and *sentoku* (a variety of brass). Even solid gold was used but in 1830 a law was passed prohibiting such extravagance. None of these gold *tsuba* have survived; one can only imagine how they would have appealed to Nobunaga, Hideyoshi, and Ieyasu. The various alloys were often submitted to a pickling process which gave variety and beauty to their surfaces—*shakudō* thus treated acquired a lustrous raven-black or violet-black hue, *shibuichi* took on a wide range of colors from deep olive-brown to a pale tint resembling oxidized silver, *sentoku* turned chrome-yellow, and copper itself gained a subdued, fox-red tone. Such processes were often closely guarded studio secrets which to this day have remained undivulged.

Many innovations were made in the physical treatment of the surfaces. In the popular *nanako* ("fish roe") technique, for example, by incredibly accurate punching, the whole surface is covered with tiny granules which at their best are perfectly regular and uniform. This technique was first introduced as early as the fifteenth or sixteenth century and many different schools subsequently used it, particularly for soft, dull backgrounds against which the polished decoration stood out even more boldly.

Piercing and openwork in a wide range of styles were also very

popular. These range from simple geometric designs to the most complex patterns. Effects were created which resemble the finest relief or types of low intaglio. Engraving methods attempted to reproduce in metal the effects of painting. Incrustation and inlay were perhaps the most popular methods of decorating the surfaces of the guards.When three or more metals are used, the type is called *iro-e*, or "color picture." The *nunome* ("cloth-texture") technique popular in the Momoyama period was another method involving the application of gold or silver foil. By this method it was possible to simulate the impression of color-wash drawing and it opened up an inexhaustible mine of decorative possibilities. The metalworkers thus followed other craftsmen in their emulation of the painters.

The guard in figure 129(*a*) is signed by Umetada Mioju (1558–1631). He was the twenty-fifth master of the Umetada school of swordsmiths which had flourished for centuries before him. His headquarters were in Kyoto but he traveled widely, leaving his influence on many schools throughout the provinces. The guard is flatly modeled in the form of three comma-shaped wisteria sprays leaving three tapering perforations which spring from the *seppadai*, which is the stand for the *seppa*, the two elliptical washers separating the front of the guard from the hilt and the back from the scabbard mouth. This is pierced by the *tang* hole. The widest end of this was fitted with a plug to enable the guard to be used for a narrower blade than was originally intended. Originally the guard was probably adorned with gold *nunome*. Sir Arthur Church recorded in his catalogue that, when he acquired this specimen, the signature was invisible as were many of the details which had been obscured by rust. The decoration is simple and bold, although very sensitive in detail. The effect is energetic and rhythmical, and preserves a masculinity which the later guard makers were to lose.

Figure 129(*b*) is an unsigned work by a *tsuba* master as opposed to the armorers or swordsmiths who made the guards in the earlier periods. Specialization in *tsuba* manufacture is said to have begun about 1400 when the Ashikaga shogun Yoshinori (1394–1441) established private guard makers at his court in Heian-jō (Kyoto) and employed artists to design guards with piercings (*sukashi*) of a more refined and decorative character than those produced by the earlier swordsmiths and armorers. This is a *heianjō-sukashi* of the seventeenth century, possibly of the Momoyama period or slightly

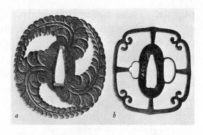

129. Two sword guards, by *a*, Umetada Mióju (1558–1631) and *b*, an unknown master of the seventeenth century. Iron. Longer diameters: approx. 3 in. Museum of Eastern Art, Oxford.

later. The piercing technique is fairly advanced and the design in positive silhouette. The border is formed of four brackets, each joined by a bar either to the *seppadai* or to the *ryōhitsu* (meaning "pair of compartments") intended to hold the *kozuka* (knife) and *kōgai* (skewer) which are housed in the scabbards of certain types of swords. By means of these separate holes, the smaller blades can be drawn without unsheathing the whole sword. The design, a typical Momoyama fusion of elegance and power, maintains a fine proportion between decoration and utility.

These two early-seventeenth-century guards, however, give little hint of the fantasy and refinement later lavished on *tsuba*. They preserve a stern quality and a workmanlike technique in keeping with the practical use. Within a short time the *tsuba* became more like the work of jewelers, and their function ceremonial and decorative rather than practical. Many were never even intended for use.

Lacquer

The craft of the lacquer maker, like those of the screen painter and the textile worker, was well suited to express the taste of the Momoyama period. Lacquer had always been a luxury product demanding a great deal of time and skill. Japanese lacquer had already established a high reputation, and throughout the East (including China) kings were pleased to accept it as presents. Examples even reached Holland, but often foreigners who obtained examples of Japanese lacquer did not realize its value. T. Volker, who has made an extensive study of the Dutch trade with Japan, tells how some magnificent lacquer presented to Aurangzeb in 1662 was valued by the Indian court appraisers at nearly two-thirds less than it had cost in Japan itself![5] Officials of the Dutch East India Company sta-

tioned in countries other than Japan showed how little they appreciated the difficulties involved in lacquer manufacture by thinking that rush orders for the objects they wanted could easily be met. They did not realize that in Japan itself there was always a ready market for first-class lacquerwork.

Momoyama lacquerwork shows the same bewildering variety which gives all the works of the period their particular interest. But the design differed greatly from that in the Ashikaga period, when a complete picture, a landscape with figures, for example, was reproduced on a box so as to be contained within the area to be decorated. In the Momoyama period the designers no longer took a whole scene but rather a segment which was then emphasized or exaggerated and splashed gaily over the whole surface. If parts of the design fell outside the borders of the main surface, that offended nobody's sense of symmetry; on the contrary it added to the attraction. The Kanō screens served as inspiration. Just as one had to stand back to admire the screens, so also the designs on lacquer no longer required minute inspection. It was as if the lacquerworkers eagerly responded to the manner in which the new rulers had taken liberties with the traditions. It was, indeed, an age of showiness but also one in which freedom from the old restraints enabled the craftsmen to indulge their fantasies.

The search for novelty, the keynote of Momoyama art, colored the following three centuries of Japanese art. New forms from other countries—Ming China, Korea, and even Europe—were quickly absorbed into the lacquerworker's repertoire and fitted to the Japanese taste. We have seen frequent examples of the way the Japanese adopted and adapted Chinese art. But, since Chinese art itself is so foreign to the West, the differences between the two are possibly not so easy for the Western observer to recognize. The host container, presumably made for a resident Catholic missionary (fig. 130), has the familiar Western Christian "IHS" on its top, but lively scrolls of grapevine in *maki-e* decorate the sides. The grapevine scroll is, of course, one of the oldest decorative motifs in the East; by this time it had been used well over a thousand years. But here the craftsman has joyfully revitalized and reinterpreted it. Like much of Momoyama art it is a happy marriage of careful observation and conscious simplification. It bounds along the outside, overflowing its borders, the leaves and grapes overlapping

130. Top of Catholic host box. Momoyama period. Diameter: 4¼ in. Tōkei-ji, Kamakura.

131. Reading stand of *kōdai-ji* lacquer. Momoyama period. Dimensions: 2 ft. 10 in. × 1 ft. 7 in. Tokyo National Museum.

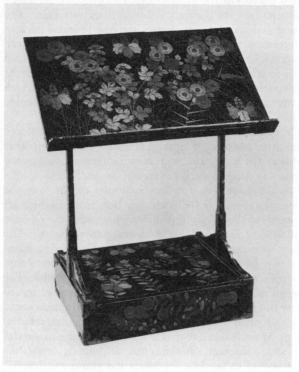

in a most natural manner. It has a carnival quality. After centuries of formalization this new naturalism is intensely refreshing. The balance between design and detail is so well maintained that the eye never tires. Even in such a small object there is a bursting self-confidence, a new gaiety which shows the craftsman as the main arbiter of his own products.

The host box is inspired by the West. What of Japanese-style decoration? The Kōdai-ji in Kyoto has a number of objects presented by Hideyoshi or his widow. The generic name *kōdai-ji* is given to the most characteristic type of Momoyama lacquer. The reading stand in figure 131 does not belong to the temple group itself but is similar in technique. It shows the fundamental approach of Momoyama craftsmen, their desire to treat decoration and object as inseparable aspects of a unity, and results in the same breadth of treatment which distinguishes the robes of the period (figs. 127, 128). The design of plants is in flat *maki-e*, the favorite technique of the period. Unlike in other periods, no attempt was made to obtain variety and richness by contrasting techniques. This they entrusted entirely to the sureness of the brushwork and to the effective contrast of black and gold, which emphasize simplicity of line and boldness of motif. In the painting of the autumn plants which cover the surfaces there is hardly a single straight line. This offsets the stiffness and angularity of the sober lines of the furniture itself. It typifies the extraordinary feeling for the charm of the exquisite which put a civilizing touch on the rough manners of the Momoyama warriors.

As in textiles, designs in contrasting halves were popular. In a new "untouched sprinkle" (*maki-e-hanashi*) method the gold dust was dropped on the lacquer but left in its natural state and not ground down or polished. This produced a rough glitter reflecting the taste of an age which worshiped both wealth and power. Aventurine (*nashi*), which had hitherto been used mostly for backgrounds, now formed elements of the design itself in a technique called *e-nashi-ji*.

We have here treated the many changes and innovations of the Momoyama in a separate chapter. This can be defended on grounds of convenience rather than validity. It was a very short era; many of its artists lived on into the next period, and many of its innovations were only then fully developed. For the full flowering of modern Japanese art we must turn to the Tokugawa period.

9

THE TOKUGAWA OR EDO PERIOD

1615–1868

Hideyoshi died in 1598. But it was not until 1615 that Tokugawa Ieyasu, the third of the triumvirate and his logical successor, was able to establish undisputed control over the country. This he enjoyed for only one year, since he died in 1616. Nevertheless, so complete was his domination by then that his family was able to maintain its position for the next two hundred and fifty years.

Ieyasu spent the seventeen years following the death of Hideyoshi in bringing the most powerful local daimyos under control and in organizing an efficient system to keep them permanently submissive. Some of them had seen in Hideyoshi's death a last chance to put down the parvenu generals and restore their own independence. Ieyasu's victory over them at the Battle of Sekigahara, in 1600, destroyed their hopes and laid the foundation for his final supremacy. The last group of opponents who stood out in support of Hideyoshi's son was finally destroyed at the siege of Osaka in 1615. The Tokugawa period dates from this year.

The capital was moved from Kyoto to a little village called Edo then situated in the middle of a marsh. From such an unpromising beginning it has grown into the modern Tokyo, "the Eastern Capital." The period is sometimes called the Edo period from the name of this village.

Once, in earlier times, Kamakura had been made the capital, but its bleak atmosphere could not compete with the attractions of Kyoto. Ieyasu determined to make Edo not only a military and administrative headquarters but also an economic and, above all, a

cultural center to outshine the old capital. Like his predecessors, he did not destroy the monarchy, but he reduced it to landless impotence, weaker than the least of the feudal lords. Under Ieyasu, feudalism reached its highest integration and the institution of emperor, its lowest point. That in 1868, after two and a half centuries of ignominy, it could be revived and the emperor restored to the dignity and influence befitting his high office is an indication of the latent strength of the Japanese respect for their monarchy—a respect which seems to survive all humiliations.

The dictatorship of the Tokugawa shoguns was of a type which today would be called fascist. Supervisors or censors were placed among the feudal lords to watch their behavior and to report to Ieyasu. The heads of families were obliged to attend court in Edo or, when they left the capital to look after their lands, they were required to leave hostages. Communications were closely guarded and the building of local fortifications was rigidly controlled. As a result of the hostage system there was much travel to and from the capital, news of the latest fashions spread rapidly, and skilled craftsmen became much sought after to satisfy artistic rivalries.

Two important developments, one in the field of foreign relations and one in the economic sphere, deeply influenced the cultured life of the period. The first was the complete isolation of Japan through the exclusion of foreigners and the prohibition of foreign travel. The second was the rise to power of an astute, active merchant class.

An Isolated Japan

The closing of the country was intimately connected with the activities of Christian missionaries who had steadily gained influence since their arrival in the mid-sixteenth century. The rulers of Japan shrewdly recognized in the Portuguese and Spanish missions the thinly disguised forerunners of military conquest. They could observe the process close at hand in China and the Philippines. The quarrels between the Jesuits and Franciscans, each jealous of the other's influence, increased the shoguns' fears of foreign intervention. Unlike the Buddhist missions, their Christian counterparts were backed by foreign militaristic powers. The Japanese warlords very quickly appreciated the significance of Western guns and cannon which gave their owners an overwhelming advantage over their rivals. They even learned to produce them. Before the 1620s,

Christianity had occasionally been attacked but never entirely sup-pressed. Had it not been for the foreign military threat, the Japanese would probably have granted the Catholics the same amount of religious tolerance as was enjoyed by the various Buddhist sects. But the shoguns could not run the risk of local daimyos allying themselves with foreign powers and the Tokugawa could not allow any other loyalties. They would certainly not tolerate citizens with a higher loyalty to Rome than to their own lords. By 1626, after some harsh measures, Christianity seemed no longer dangerous, and the authorities began to relax the restrictions imposed on it. But in 1637 some thirty-seven thousand peasants at Shimabara, apparent-ly inspired by some vague Christian ideals, rose in rebellion. The shogun's forces put down the insurgents with great brutality, sparing only about one hundred and fifty of them. This rising convinced the Tokugawa rulers that they must ruthlessly eradicate Christianity and exclude all foreigners. It is remarkable how much European-influenced art has survived the persecutions; examples in painting, ceramics, lacquer, and other materials are still being uncovered. The Tokugawa also found it convenient to divert the social unrest evi-denced by the Shimabara rising into a campaign against foreigners. Only a closely guarded handful of Chinese and a small settlement of the Dutch on an island near Nagasaki were allowed to remain. No seagoing ships could be built, and vessels calling at Japanese ports were curtly turned away. Japan was hermetically sealed off from the rest of the world.

It was unfortunate for her that the following centuries were periods of great Western progress in all fields of knowledge and it is interesting to speculate what Japan, with her great ability to absorb foreign cultures, might have achieved had she been open to them. But it would be wrong to regard the period of isolation as one of sterility. Japanese culture may have been inbred but it was never emasculated. One sees in this period the vitality of the race working at a feverish pace. During the decline of feudalism in the West national energies were turned to the creation of parliamentary institutions; in Japan the same energies were spent in a pursuit of pleasure and extravagance which is most vividly reflected in the arts. It is a peculiar feature of Japanese life in this period that, for all its intellectual stagnation, the arts flourished. Such is their wealth and diversity that it is impossible to summarize their achievements.

The Rise of the Merchant

The rise to power of the mercantile classes in Japan is particularly important for the study of Japanese art. It created, among much that was new, the art of the color print—often called Japan's most individual contribution to the world's art. A distinct class of merchants had existed at least as early as the Ashikaga period, partly as a result of trade with China and partly to serve as commissariat to the armies of the large landowners. Priests and daimyos shared in this earlier trade with China, and the guilds of merchants had then been content to pay the monasteries and landowners for their protection. But merchants of Sakai, near Osaka, became so wealthy that they even acted as moneylenders to the Ashikaga shoguns, a development which should have served as a warning to the Tokugawa rulers. In fact, although the Tokugawa made it quite plain that they would not tolerate the power which the guilds had gained, they were unable to check the rapid growth of the merchant class in Edo. In the course of less than a century these tradesmen amassed large fortunes and took over the real economic power in the land. As in Ashikaga times, it was the peasant-farmer class which suffered. Although in good Confucian fashion lip service was paid to the importance of the farming population in the economy of the country, the peasants were, in fact, crushed between the samurai and the merchants, exploited and cheated by both. A commentator of the time likened them to oil-seeds: "the harder you press, the more you squeeze out."

A poet of the time, Rai Kyōhei, described the life in the countryside as follows: "A village is like a palsied invalid, too weak to stand on his own feet. The people flee from the villages like leaves before the wind and it is impossible to stop them." Those who could find employment in the cities swelled the bustling urban population. Those of an independent turn of mind sought refuge in the remote districts of the northeast where for a few more generations they could enjoy their freedom.

Under the centralized Tokugawa regime and its elaborate bureaucracy, Confucianism with its emphasis on right thinking, right living, loyalty to ruler, piety to father, observation of the rules of conduct, faith in reason, education, and hard work, finally came into its own and remains a deep though overlaid strain in the Japanese mentality.[1]

The new, growing city of Edo itself created a large population of merchants and transport contractors to supply their own needs and those of the samurai. The complex city life stimulated the development of exchange by currency rather than by rice. This led to speculation which in turn increased the wealth of the merchants. By the end of the seventeenth century, the samurai, too, found themselves deeply in debt to the townspeople whom they professed to despise. The shoguns issued edicts aimed at depriving the merchants of the enjoyment of their wealth. On occasions, they even confiscated the fortunes of overconfident tradesmen—but they were overwhelmed by a modern, complicated economic process which they did not understand. They could neither control it nor exploit it for their own ends. The isolation of the country deprived them of the benefits of foreign trade which could have filled their purses. That they withstood the steadily mounting pressure for so long is only to their credit, and the country benefited greatly by the peace they preserved in the country. Histories often do the Tokugawa rulers less than justice.

By the time of the Genroku era (1688–1703), the heyday of Tokugawa art, the so-called commoners (i.e., the townspeople rather than the farmers) had consolidated their position. They not only became far more literate than hitherto but also the patrons and arbiters of taste in certain new arts which their needs created. Two distinct standards now became evident in the arts as well as in society. On the one hand there was the samurai with his dignity and the consciousness of high social standing who clung desperately to his privileges endeavoring to preserve his traditions while the *chōnin* (commoners), unfettered by a strict ethical and social code and with no prestige to uphold, could afford to be spontaneous and experimental. At this time, therefore, we find two separate cultures: the old, which was a perpetuation of "classical" standards, and the new, which was popular and unrestrained.

There are, of course, no watertight compartments in art or in society. Wealth, like poverty, is a great leveler. Distinctions between classes tended to become vague and, as wealth was more widely distributed, the new rich often patronized artists who in former days would have catered only to the aristocracy. Sansom records how a shogun confiscated the fortune of a rich Osaka rice merchant which included no less than 50 pairs of gold screens and 360 carpets. A new

and wider market was being created for the products of the artists and craftsmen.

Hon'ami Kōetsu

All classes, for instance, seem to have appreciated the works of what is known as the Rimpa style or Sōtatsu-Kōrin school. The founder of this very distinctive decorative style is generally acknowledged to be Hon'ami Kōetsu (1558–1637), a sword appraiser by profession but also a calligrapher, potter, and lacquerworker.

Working in the early seventeenth century, he seems to have been the spiritual leader of a group of artists in a village called Takagamine north of Kyoto on a tract of land granted him in 1615 by Tokugawa Ieyasu. Examples of all his types of work have survived and they show that he had a very original mind; he was perhaps the most representative artistic personality of his time. He seldom painted and his most striking achievements are in pottery and lacquer and in printing of superb illustrated books by movable type. Pottery tea bowls ascribed to him are of the *raku* type with strong irregular shapes and thick glazes subtly enlivened with luminous undertones. It is known that Kōetsu was an intimate friend of several tea-ceremony masters and these bowls show the influence of their taste.

His lacquer pieces are far more sophisticated and refined. Without appreciating the conscious rusticity of the tea-ceremony wares, it is difficult to understand how they could come from the same hand. The most famous of his lacquerworks is a box made to hold an inkstone and writing equipment and decorated with the design of a pontoon bridge (fig. 132). The bridge is represented by a wide band of lead which contrasts effectively with the golden background of boats and waves. A few characters in silver, taken from a poem about a bridge in Sano, eastern Japan, are scattered over the surface. Calligraphy as an integral part of design was not a new departure (see fig. 114), but the emphasis placed on it characterizes the works of the Sōtatsu-Kōrin school.

Sōtatsu, his collaborator in many works, was a perfectionist and admirer of the aristocratic elegance of the Heian court and particularly famous for his calligraphy. Some authorities have suggested that this box, like so many other works, is a joint production of the two artists. Japanese critics say that the characters merge into the design. In fact they dominate it. But if Kōetsu stressed the

132. Box for writing accessories,
by Hon'ami Kōetsu (1558-1637).
Lacquer and lead. Dimensions:
9½ in. × 9 in. × 3½ in. Tokyo
National Museum.

calligraphic aspect, he also made the design broader and bolder
in order to compensate. A few simplified elements are splashed with
artful carelessness across the surface with no effort to contain them
within their boundaries. All is movement and eye-arresting effect.
Proportion is disregarded in such works—a fan looks as if it had by
chance fallen on the surface and stuck there, a tablet with an inscrip-
tion lies at a striking angle across a branch of plum blossom, a leaf
of bamboo wanders off the edge of a tray onto its border. This un-
containable, irrepressible quality is the essence of modern Japanese
decoration. Quirks in design sometimes come dangerously near
to whimsy and occasionally the effects are a little too artful. Never-
theless, the compositions are brilliantly original. At their best they
have a breathtaking audacity—the power to make even a small area
appear like a broad canvas imaginatively and boldly decorated. Size
was a challenge which the artists always welcomed as a test of their
ingenuity.

The Rimpa is a highly decorative style in which are fused ele-
ments of *yamato-e*, Muromachi ink painting, Tosa, Kanō and
Chinese traditions—all to create something diversified, original,

and above all highly pleasing to the eye and the sentiments. In the school or art colony at Takagamine, individuality became the touchstone.

Sōtatsu

Sōtatsu, the real founder of the school, died in 1643 and was related to Kōetsu; very little else is known about his life. Most of his works were probably done in the early years of the Edo period. A considerable number of these have survived which show him to be an extremely eclectic painter using and combining the styles which his predecessors had created. It was mainly the *yamato-e* tradition and the Tosa style which appealed to him, but his products were Tosa with a difference. Although he, too, often took his subjects from Japanese literature, he allowed himself considerable artistic license, and his interpretations are far from literal. There is a good deal of humor in his work—and his was an age which set great store by a sense of humor. In many of his works we find a combination of the powerful Kanō line and the Tosa sense of color. He had studied the scrolls of the Kamakura period as well as the works of Kanō masters like Eitoku. But he subordinated everything to a decorative effect. Hills become broad, flat sweeps of color, unnecessary detail is omitted, and he often ignored perspective or even inverted it if it suited his purpose. He paints in rich colors a still world of suspended animation. It was as if these artists regarded the whole world as a stage and their screens as huge backdrops to an eternal pageant.

Figure 133 reproduces a screen called *Sekiya* ("The Barrier Hut"), its subject taken from the evergreen *Tale of Genji*. The composition is carefully balanced and highly dramatic in a peculiarly Japanese way which leaves the most pregnant moments as if suspended in motionless silence. To those familiar with the Genji story, the scene represents the highly sentimental climax to the tale of the Prince's affair with the Lady Utsusemi.

Quite early in the *Tale of Genji*, the Prince has a fruitless encounter with Utsusemi. Sometime after this episode she married a provincial governor and went to live in a distant province. Genji had meanwhile been disgraced and banished from the capital, but he had just been pardoned and was back in court. The incident shown in this screen took place when Utsusemi's husband was returning with her via the Barrier to Osaka and Genji happened to be on his way to

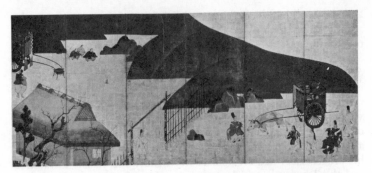

133. *Sekiya* ("The Barrier Hut")
screen, by Sōtatsu (d. 1643). Color
on paper. Dimensions: 5 ft. 2 in.
× 8 ft. 7½ in. Seikadō Founda-
tion, Tokyo.

attend a service at the Ishiyama-dera in the company of a vast
procession. Genji's entourage was so numerous that Utsusemi's
husband, in order to let him pass, had to halt and unharness his
carriages at the Frontier Hill. Genji scanned the coaches and then
quickly lowered his blind for he had recognized Utsusemi's brother
of whom he had been very fond. He called him over and jested,
" 'See, I have come all the way to the barrier. Should this not tell her
something?' Affectionate memories came flooding back, but he had
to make do with this most ordinary of greetings."[2]

The picture is dominated by the barrier hut surrounded by a few
old tree trunks to suggest the time of year, the frosty ninth month.
Utsusemi's decorated oxcart, unharnessed, occupies the top left-
hand corner. Genji's cart surrounded by his followers has just ar-
rived at the gate. We feel the clandestine atmosphere as Genji peeps
from his curtain and then secretly sends Utsusemi a letter. Yet for all
the literary and dramatic overtones, the screen is a beautiful work in
terms of pure decoration.

Sōtatsu shows so many styles that it is hard to account for his art
in any other way than as a continuous search for aesthetic alterna-
tives. His conscious simplification is an attempt to escape from the
trivial and the detailed. Even with such broad canvases to work on,
these artists are unwilling to keep within the given framework. The
impact of their huge areas of bold colors is overwhelming.

Ogata Kōrin

The school continued under a number of less-inspired painters until the appearance of Ogata Kōrin (1658–1716), who was related to Kōetsu through the latter's sister. Kōrin brought the decorative style to its climax. His work seems to synthesize the elegance and taste of the sumptuous Genroku period (1688–1703). He, too, had many styles at his command and he shows the same restless seeking for new subjects to enliven his paintings: portraits, Shinto ceremonies, illustrations of stories, flowers, birds, and even a delightful imaginary portrait of the Lady Murasaki writing her novel flowed from his brush. His most famous and most characteristic works are perhaps the screens on which he painted dense clusters of irises growing against a rich background of squares of gold (fig. 134). Their leaves are painted in a naturalistic bright green, the flowers in two shades of blue. This contrast of realistic flowers in front of an artificial background faithfully reflects the Tokugawa attempt to combine art and nature. The balance between blank space and design shows a fresh effort to reinterpret, in decorative terms, one of the basic Far Eastern pictorial concepts. In the hands of a lesser artist this mass of flowers would have created only a confused effect. With only four strong colors Kōrin produces a brilliant design out of a superb natural phenomenon without in any way doing violence to nature.

Many rich merchants patronized Kōrin but his wealth and elegant way of life courted the disfavor of the shoguns as they tried in vain to curb the exhibitionism of the *nouveaux riches*. A delightful story is told of a picnic which he and his friends held. Kōrin had wrapped the food in bamboo leaves which, when opened, revealed delicate paintings in gold done by himself. After the meal his guests casually tossed these wrappers into the stream where they floated down to be retrieved by less fortunate aristocrats. Gold was prohibited to the lower classes and Kōrin was prosecuted. As a result, he is said to have moved from Kyoto to Edo. Although this story is probably apocryphal, it illustrates the bravado and the growing confidence of the merchant classes which found their outlets in the commoners' art of the period. Color instead of outline, clipped compositions, daring angles, eye-catching disproportions, stimulating subjects, all appear in very original forms and combine into a highly sophisticated art form.

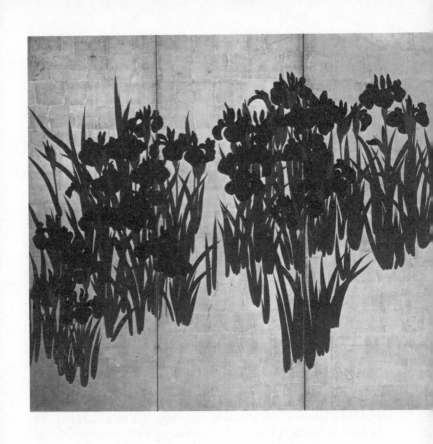

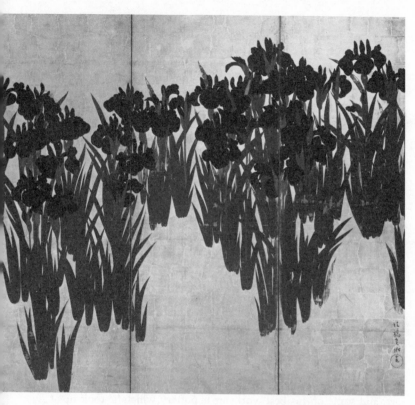

134. *Irises* screen, by Ogata Kōrin
(1658–1716). Color on gilt paper.
Dimensions: 5 ft. × 8 ft. 6 in.
Nezu Museum, Tokyo.

Kenzan and Sakai Hōitsu

Kōrin's younger brother Kenzan (1663–1743) was a man of milder, introspective temperament and quieter tastes. His *Flowers in Baskets* (fig. 135) shows a close connection between painting and poetry. It is the composition of a literary-minded man who had probably seen Chinese paintings of the early eighteenth century when individualistic painters and poets were doing similar things. Indeed, most of his work stands near to Chinese traditions. The poem above the painting can be translated:

> Flowers, even wild flowers,
> Are enticing,
> Bewitched by their color and fragrance
> The mist of the fields emulates them.

This fusion of poetry, calligraphy, and painting, unfamiliar to Westerners, is common in the East. Each element is of equal importance in the whole. The poem sets the mood, adds another dimension to the enjoyment of the work and acts as an emotional bridge from artist to spectator. It also gives the artist an opportunity to show his skill in the basic exercise of brushwork, that is, calligraphy. The few characters, which look casually scribbled in an empty space as if in afterthought, were generally as carefully planned as the painting itself. The danger, inherent in such Japanese work, is that the verses, like the paintings, tend to substitute sentiment for profundity.

Kenzan's temperament fitted him more for the Zen approach to art, and some of his best works are in pottery, which he took up at the age of thirty-seven or according to other authorities as early as twenty-five. His brother Kōrin often did the designs for these as in the hexagonal dish in figure 136. The subject, a favorite with ink painters, is Jurōjin, an old man who symbolizes for the Chinese and Japanese a much-admired longevity. Kenzan has transferred his brother's subtle nuances of ink to the much less sensitive medium of pottery decoration with remarkable skill. The freehand, brownish-red lines abound in vigor and the *raku*-type glaze adds the rustic component. Eclectic taste and complete technical mastery go hand-in-hand.

The last great flowering of the school was embodied in the works of Sakai Hōitsu (1761–1828), who was an ardent student of Kōrin

135. *Flowers in Baskets*, by Kenzan (1663–1743). Hanging scroll; color on paper. Dimensions: 3 ft. 8 in. × 1 ft. 7½ in. Matsunaga Memorial Gallery, Kanagawa Prefecture.

136. Hexagonal dish, made by Kenzan (1663–1743) and painted by Ogata Kōrin (1658–1716). Stoneware. Longest diagonal: 10 in. Ōkura Museum, Tokyo.

and strongly influenced by the naturalism of European artists and of Ōkyo. His *Morning Glory and Corn* combines a careful and loving observation of botanical detail with a most powerful artistic sense (fig. 137). The two plants form a dramatic contrast, the one heavy, unadorned, overpowering, the other delicate, vinelike, and modestly colorful—almost a floral representation of male and female.

137. *Morning Glory and Corn*, by Sakai Hōitsu (1761–1828). Hanging scroll; color on paper. Dimensions: 4 ft. 7 in. × 1 ft. 7 in. Private collection.

In later generations the painters of this school did not reach the same heights but the decorative style is still alive and some contemporary artists—especially those of the Nihon Bijutsu-in, the Japanese Academy for the Fine Arts—are influenced by it.

Kanō Tan'yū

To the average observer in the seventeenth century it must have seemed that the Kanō dominated the world of painting. Members of the Kanō family were the official painters to the Tokugawa shogunate, which was anxious to establish a separate cultural identity from that of the Kyoto aristocracy which favored the Tosa-style artists, and such patronage meant a great deal financially and socially. They were given land, houses, and honors in return for their services. Their official position was unassailable but it was not long before lavish privilege removed all incentive for individual, creative work. They became far removed from the Zen traditions which had once enlivened the works of Shūbun, Sesshū, and Shūbun's pupil Kanō Masanobu (1434–1530) who founded the long Kanō line (see p. 192). They reduced their school works to a series of monotonous variations on wearied themes. Originality is seldom a feature of academy painting and the many works of the Kanō, broadly speaking, were no exception.

The ramifications of the Kanō school would require volumes to explore. The main line of the school answered Ieyasu's summons to the capital at Edo where he counted on their help in establishing a new cultural center to outshine Kyoto. Some Kanō painters remained in the old capital and continued the southern branch of the school, but the most ambitious and accomplished artists chose Edo, where more tempting rewards were offered. The foremost of these was Tan'yū (1602–74), who became official court painter at the early age of seventeen and the owner of a splendid estate which went with the office. Various other members of the family established in Edo their own schools known by the names of the quarters in which they lived. The principal four families held the monopoly of palace commissions and were called collectively "the Palace Painters." Other members of the family were not favored with quite such eminent patronage. Some fifteen families of these were called "Outside Painters." Somewhat lower down the scale came "the Town Painters," who were members of the Kanō family or pupils allowed

to use the name. All were blood relations or connected by the ties of master to pupil which are even more binding in the East than in the West.

It is remarkable that there was enough work to support all these Kanō painters. Fortunately for them the provincial lords, quick to follow the Tokugawa lead, provided a market for their huge output and the more affluent, society-conscious among the merchants and townspeople were eager to acquire Kanō paintings.

Tan'yū, the founder of the Edo branch of the Kanō school, was a painter with a very definite consciousness of his aims. His Chinese-style landscapes are full of the moralizing which the Tokugawa appreciated. *Lute, Chess, Reading, and Painting* (fig. 138) on a wall of Nagoya Castle (destroyed during the bombing of the war) was a work of his early thirties and shows clean, accomplished brushwork applied to a hackneyed theme. The "four liberal accomplishments" of the ideal Chinese gentleman may have meant something in Sung and even in early Ming China but in seventeenth-century Japan they were little more than an anachronistic affectation. The landscape itself is composed of a series of painter's clichés—none of which cohere spontaneously. A waterfall comes from nowhere, froths around an impossible-looking rock, and then, as if the artist did not

138. *Lute, Chess, Reading, and Painting*, by Kanō Tan'yū (1602–74). Ink and color on paper. Dimensions: 9 ft. 8½ in. × 12 ft. Painted on a wall of Nagoya Castle but destroyed by bombing during World War II.

know what to do with it, is allowed to fade out. A dramatically conceived tree without roots dominates the foreground. The whole left side of the painting is left blank in a manner which only reveals the artist's lack of imagination. The brushwork affects the power of Sesshū but is studied, smoothed out, and emasculated. A comparison with the Sesshū reproduced in figure 106 provides perhaps the best lesson for a Westerner anxious to understand what is vital and what is shallow in the Eastern brush. Tan'yū's work illustrates the fact that even the loftiest sentiments are no substitute for genuine artistic experience. Whereas Sesshū's work is a valid naturalization of Chinese forms, that of Tan'yū is an impersonal façade created by technical virtuosity, without life or meaning. However, one must not forget that to meet the demands being made upon them, most of the great masters employed large numbers of pupils in their ateliers. This accounts for much of the mass-produced quality of many later paintings.

Maruyama Ōkyo, Itō Jakuchū, and Hanabusa Itchō

While the Kanō style still dominated the art world of Edo, the old capital of Kyoto saw the rise of a new school under Maruyama Ōkyo (1733–95). His style sprang from that of the Kanō but later he came under the influence of Western painting which reached Japan in the form of Dutch etchings brought into the small colony allowed to stay on near Nagasaki. Also at Nagasaki was a small group of Chinese painters which included Shên Nan-p'in, a realistic painter of the conservative Chinese tradition. The works of these Chinese artists, already influenced by the West, include botanical studies comparable in accuracy with any the world has produced. As works of art, however, they are dry and spiritless. The followers of the Maruyama school were particularly intrigued by Western-style perspective and Ōkyo eventually perfected a realism which combined with the adroit Chinese brush and ink to produce a vision which was new in Japanese art. This acted as a healthy corrective to the technically perfect but empty brushwork of the Kanō masters and the overformalized patterns of the successsors to the Sōtatsu and Kōrin school. At its best, Ōkyo's work has a natural atmosphere and an imposing grandeur. His famous screens, *Pine Trees under the Snow* (fig. 139), painted in ink and slightly colored, have a freshness and a clean quality which are the outcome of a rare artistic purpose and

139. One of a pair of screens *Pine Trees under the Snow*, by Maruyama Ōkyo (1733–95). Ink and color on paper. Dimensions: 5 ft. 1 in. × 11 ft. 10½ in. Private collection.

integrity. The general concept owes much to the decorators and preserves strong traces of the idealism of Chinese ink painting, but his finished works show a bold and original mind facing and solving problems of the synthesis of East and West which have defeated most of his successors.

One must include among the group of artists who successfully married the Eastern decorative genius with Western naturalism a solitary figure in Japanese painting named Itō Jakuchū (1713–1800). A man of independent means working in Kyoto, he was particularly intrigued by barnyard fowl, which he kept in his garden for study purposes. His paintings of these and many other animals (fig. 140) show a bold eye for color and pose, "rendering them with attractive exaggeration, transfiguration and almost shockingly bright colors to create a fantastic realm of beauty." One readily senses the influence of Kōrin's colors and design. He also painted in very daring ink styles quite unlike the meticulous birds and fishes—again illustrating how artists of this period could enjoy a broad eclecticism without censure from purist critics. Relatively ignored until the late nineteenth century, his work now enjoys a considerable vogue.

Hanabusa Itchō (1652–1724), the founder of another school, was trained in the Kanō tradition but seems to have been too free a spirit to be tied by its restrictions (fig. 141). He enjoyed Edo city life,

140. *Fowls*, by Itō Jakuchū (1713–1800). Color on silk. Dimensions: 4 ft. 8 in. × 2 ft. 8 in. Imperial Household Collection.

141. *Driving the Horse on a Sunny Morning*, by Hanabusa Itchō (1652–1724). Hanging scroll; color on paper. Dimensions: 1 ft. × 1 ft. 8½ in. Seikadō Foundation, Tokyo.

studied *haiku* poetry under Bashō, and was somewhat too witty (especially in caricature) for his own good. Like the *ukiyo-e* school (see later) he enjoyed the colorfulness of the Edo popular scene and the characters inhabiting it. His studies of plants, birds, and particularly animals entitle him to a place in any survey of Edo painting however broad. It is easy to follow Eastern practice and try to place the countless artists of this period in neat schools and categories. However, the fluid nature of Edo society led to far more interaction than can properly be traced, and many artists who studied in the Kanō tradition lived to challenge it.

The Literati Painters

The Kanō school took its inspiration from Chinese ink painting from five to seven hundred years earlier. Since then painting in China had developed along different lines and important changes had taken place. What were these and how did they influence Japanese art?

By far the most important was the rise of the *wên-jên-hua*, transliterated into Japanese as *bunjinga*, or "literary men's painting." During the Ming dynasty the ability to paint became indispensable for every "man of culture" and many were also musicians, poets, potters, philosophers, masters of literature as well as painters. Their works demand a high level of cultural appreciation by those who view them. The use of brush and ink for writing was in itself a training for it. As the amateur steadily encroached on the art of painting, a tendency developed to denigrate the professionals as prostituting the art. The political atmosphere in Tokugawa Japan favored such Chinese scholar-official ideals. Like the Chinese Manchu rulers, the Tokugawa saw in Confucian traditions the best way of governing the country. They also saw no political dangers in the pursuit of literature and art. Politically and socially, the School of Chinese Learning was a stabilizing influence.

The style of painting popular among the literati of late Ming China was called Southern painting. This is a vague distinction created by contemporaneous Ming theorists whose writings were closely studied in Japan. According to them, the Southern style stood in opposition to the drier, more formal and studied styles of the so-called Northern painting. The distinction is a very confusing one and by no means watertight. Were it not for the influence

it has had on later generations of Eastern painters, it would be best ignored. Southern painting, or *nanga*, was said to have developed from Yüan-Ming painters who lived in the fertile and more atmospherical south of China along the Yangtze River. Southern-style painters were supposed to be more spontaneous and freer in their use of the brush. But this spontaneity and the individuality it was said to encourage had, by the end of the Ming dynasty, begun to wither. A large number of pattern books were produced which provided the amateur painter with ready-made models for every aspect of nature he might care to represent. This spelled an end to the great tradition of Chinese ink painting. Japanese artists eagerly studied such pattern books and many followed their directions. However, looking through the creations of the Japanese *bunjin* one is struck by the variety of styles and influences which they reflect. There can be little doubt that the Japanese, with their happy eclecticism, modeled their styles upon any Chinese painting wherever it might have come from, provided only it pleased them. They certainly wanted their art to be an affirmation of a new direction in the long development of Chinese painting. Stephen Addis says, "The varied kinds of brushwork, derived from Chinese literati paintings of the past, can seem to take on a life of their own in subtle variations and arrangements, while the forms dissolve in space in a curious and continually fascinating manner."[3]

Yosa Buson and Ike-no-Taiga

The *bunjin* movement in Japan started about 1700 but was not firmly established until half a century later. Among many hundreds of such painters, famous and obscure, its two greatest exponents are Yosa Buson (1716–84) and Ike-no-Taiga (1723–76). Buson, who came from a humble farming background, first studied poetry and then painting—coming under the influence of Kanō and Tosa styles. He finally settled in Kyoto, where he studied other styles and particularly Chinese ink paintings as reproduced in the Chinese painting manuals. Zen Buddhism also influenced him and he had many pupils who achieved fame. He achieved full mastery of painting in the 1760s but devoted his last years to the writing of poetry. In painting, he seems to have been self-taught and to have followed whichever master of the Ming and Ch'ing dynasties appealed to him.

Buson's *Visiting a Hermitage on a Bamboo-covered Mountain* (fig. 142) echoes clearly a typical mid-seventeenth-century Chinese style. The landscape is very atmospheric with that sharp contrast between the black ink and the white paper which is a characteristic of Japanese painting in the Chinese style. A hermit is shown traveling to the mountains to visit a well-known beauty spot or a famous temple. Visions of such idylls have exercised the artistic imagination of Chinese artists for almost a millennium and were often as conventional as the classical ruins which decorate the backgrounds of some European paintings. Buson's composition is well balanced and carefully thought out but not particularly original. By this time it was difficult to produce anything new within the framework of such threadbare ideas. For more original work we must look elsewhere.

Ike-no-Taiga had a training similar to that of Buson, and his larger works on screens show the same reliance on Yüan-Ming masters. His grandiose sweeping landscapes with grotesque rocks and fanciful mountain formations (fig. 143) are sometimes little more than an excuse to outdo the Chinese in exaggeration. Nevertheless, Taiga was perhaps the greatest of the *nanga* painters and a key figure in eighteenth-century painting. He mastered the art early in life and was most prolific. He was a master of calligraphy and his compositions show a highly personal combination of simplicity and varied, playful brushwork. He knew his Chinese sources but took inspiration from many streams. At times a fussiness creeps in which stiffens the brushwork and weakens the whole effect.

However, both Taiga and Buson, the leaders of the second generation of *nanga* painters, painted also in another style which they seem to have reserved for smaller works. This is seen at its best in an album entitled *The Ten Conveniences and the Ten Enjoyments of Country Living*, of which, also in good Chinese fashion, each painted ten leaves. The *Conveniences* were painted by Taiga and the *Enjoyments* by Buson. These scenes are inspired by simple poems by Li Li-wêng, a Chinese poet of the Ch'ing dynasty. They are said to be replies to a visitor who commiserated with the poet on his uncomfortable living conditions at the foot of a mountain in the depths of the country. The "conveniences" listed by the poet were cultivating the land, drawing water, washing, watering the garden, angling, reciting poems aloud, gardening, gathering fuel, safe and quiet

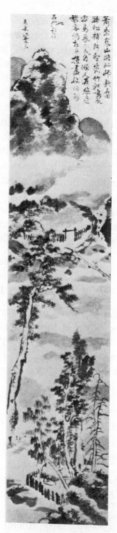

142. *Visiting a Hermitage on a Bamboo-covered Mountain*, by Yosa Buson (1716–84). Hanging scroll; ink and color on silk. Dimensions: 3 ft. 10½ in. × 1 ft. 4 in. Private collection.

143. *Landscape*, by Ike-no-Taiga (1723–76). Ink and color on paper. Dimensions: 4 ft. 1 in. × 10 in. British Museum.

nights, and beautiful scenery. The "enjoyments" painted by Buson were the views of the four seasons both at dawn and at night, and the landscape in wind and rain, in fine and in cloudy weather. Figure 144, the "Convenience of Cultivating the Land" in ink and water colors, is a delightful impressionistic study. The crops painted in various shades of green are pushing up young shoots. Around the open, thatched hut grow trees and bushes rendered in washes of pale blue. With all this to please him and good hard work to tire him out, why, indeed, says the poet, should he read books?

Poetry greatly influenced these painters. A particular type of short evocative poem called *haiku* was very popular and still remains so. An estimated million or more are composed every year in Japan and the movement supports no less than fifty magazines. Nature and travel through nature were always the most popular themes and the great master of this short seventeen-syllable poetic form was Bashō (1644–94). Typical are the following lines by Buson:

> Of scattered peonies,
> Two or three petals lie piled,
> In a little heap.

Many painters tried to express such sentiments in painting.

The painting in figure 144 is obviously different from the more familiar paintings inspired by Yüan-Ming models. Where does it come from?

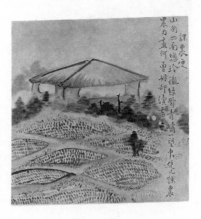

144. "The Convenience of Cultivating the Land," by Ike-no-Taiga (1723–76), from *The Ten Conveniences and the Ten Enjoyments of Country Living.* Album leaf; ink and slight color on paper. Dimensions: 7 in. × 7 in. Kawabata Memorial Gallery, Kamakura.

The answer is again from China but from a very different artistic milieu. In addition to the painting manuals, new forces were emerging in Chinese painting. From 1600 to 1750 a group of painters, discontent with the copying of former masters, began to paint in a very individual manner. They stressed the need for a painter to express original ideas even though his training may have begun with a close study of the old masters. These Chinese painters are grouped together as Individualists and their work is one of the most refreshing aspects of later Chinese art. One of them, Tao Chi (1630–1714), is famous for his trenchant remark, "The beards and eyebrows of the old masters cannot grow on my face. The lungs and bowels [i.e., the thoughts and feelings] of the old masters cannot be transferred into my stomach [i.e., mind]."[4] His work (fig. 145), like that of Hsü Wei (1521–93) and Chu Ta (1626–1705?), must have reached Japan in the late seventeenth to early eighteenth century. Furthermore the Obaku sect of Zen Buddhism had been importing books and paintings from the seventeenth century and along with this there were new movements in China in the art of calligraphy. The calligraphers, who were also often the painters, sought new courses of inspiration in T'ang and pre-T'ang styles. There was doubtless a movement among the more individual painters to épater le bourgeois. The movement was involved with the opposition of the more independent (and generally unemployed) scholars to the foreign Manchu dynasty then ruling China. A literary or political protest would have

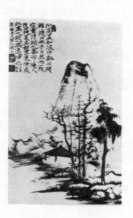

145. *Landscape Inspired by Ni Tsan*, by Tao Chi (1630–1714). Chinese; ink on paper.

been most dangerous and the artist-scholar could best show his op-
position to the status quo by producing eccentric, very untraditional
work. We have evidence that their work was highly considered in
China, and many of their paintings have been preserved in Japan.

The works of Taiga and Buson reflect the Japanese attempt to es-
cape from conservative styles of painting and to create a new Jap-
anese interpretation of Chinese styles. We do not know if they
were fully aware of the political atmosphere which influenced the
Chinese but it is possible that the stifling restrictions which the To-
kugawa imposed on the country made them likewise insist on their
artistic liberty. The free brushwork and greater spontaneity of the
new Chinese styles struck a responsive chord in the Japanese and
helped to release them from slavish dependence on Chinese models.
Landscape painting became more personal and less mannered.

Uragami Gyokudō, Tanomura Chikuden, and Aoki Mokubei

This new trend in painting is carried a stage further in the work of
Uragami Gyokudō (1745–1820) and Tanomura Chikuden (1777–
1835). Both in their earlier years were officials but, in mid-life, fol-
lowing an old Chinese ideal, they gave up their positions to devote
themselves exclusively to the arts. In Kyoto they found an atmo-
sphere congenial to their mood and, although this kind of artistic life
was supposed to be conducted on a strictly amateur basis, there can
be little doubt that, as in China, they found a ready and profitable
market for their work.

Gyokudō had no teacher and formed his own original style. Like
his Chinese counterparts, he spent much of his later years in travel as
an itinerant musician seeking inspiration from the beauty spots of
his native land (fig. 146). As James Cahill comments, "Gyokudō's
paintings appeal powerfully to the twentieth century eye and sensi-
bility because, like the works of some Chinese individualist painters,
. . . they are satisfying and exciting in two ways: as pure form, in
their ink-and-paper existence, and as profoundly moving visions of
nature. These two aesthetic modes of being are so perfectly fused in
Gyokudō that the fairly few writers who have tried to deal with his
paintings at all have seemed uncertain whether to treat them as
abstractions or as landscapes; they have been called objective,
subjective, impressionistic and expressionistic."[5]

Chikuden's work reflects the same demand for something new

146. *Snow Falling from the Eastern Clouds*, by Uragami Gyokudō (1745–1820). Hanging scroll; ink on paper. Dimensions: 4 ft. 9½ in. × 2 ft. Kawabata Memorial Gallery, Kamakura.

on the part of the educated public. He is considered by the Japanese to be the purest "literary man" painter and is one of the main theorists of the third generation of *bunjinga* masters. He came of samurai stock and was well educated in the Chinese Confucian classics and, perhaps as a result, had the reputation of being a gentle but conservative man. He was very familiar with Chinese literati painting and, in his own *Guide to Literati Painting* he stressed the need to study the manuals of Yüan and Ming masterpieces. His was a light, playful, almost naive charm. All the painters of this school felt a great nostalgia for the China they had never seen and an admiration for the Chinese scholar-painter. It is easy to fall in love with such an ideal.

In 1829, during a journey to Kyoto via the Inland Sea, he painted a typical Japanese *bunjin* album in ink and faint color to record his

passing impressions. Figure 147 is one leaf from this album, *Sketches from a Boat Window*. It depicts an incident at Tadami where he saw a boatman trying to sell an octopus. This simple scene is painted with great sympathy and humor and with the sure touch of a master. The daring angle of the boat and the rhythmic swirl of the water give added movement to the lively and spontaneous scene. An attractive genre quality, a feature of later *bunjin* painting, shows the new zest with which artists of all classes were turning to the colorful world around them for inspiration. When they did so, the pertness and wit of the Japanese artistic spirit came to the surface with irrepressible force. In such unpretentious, often bizarre, sketches of everyday life, the tradition of Chinese painting remained alive until the middle of the eighteenth century in China and until the middle of the nineteenth century in Japan.

A third painter in the *bunjin* style was Aoki Mokubei (1767–1833), a poet, calligrapher, and painter but perhaps even more esteemed for his pottery. As with Kōetsu and Kenzan before him, his wide interests show a catholicity and a protean talent in both the arts and crafts which was unknown in China and has occurred only recently in the West. Mokubei's most famous painting, *Sunny Morning at Uji* (fig. 148), in color on paper, is a highly personal impression of the beauty spot where the graceful Byōdō-in stands. The painting in its gentle atmosphere recalls Sesshū's *View of Ama-no-Hashidate* (see fig. 104) and the work of the Chinese Individualist Tao Chi. It is more abbreviated, fuller of suggestion and intimate touches than Sesshū's work and closer to the whirling, swift freedom of Tao Chi (see fig. 145). The Chinese tradition persists but the vision is purely Japanese. The boat in the center of the Uji River is the focal point, the whole landscape seeming to revolve around the lonely traveler who drinks in the still beauty of the early morning sunlight. The brushwork is varied and full of vigor, the color tones are skillfully blended to create the impression of soft clear light. Centuries of Chinese painting are reflected in this landscape but it is essentially a Japanese synthesis of their own and Chinese art in the Tokugawa period. The friendly, human Japanese temperament strikes a happy compromise with a style alien to it. Like most good Japanese landscapes it is the result of a sharp rather than a profound eye and the product of a warm love of their own country rather than of a universal mysticism.

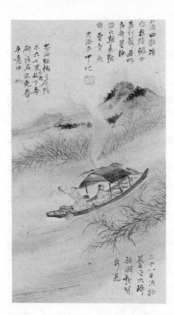

147. "The Octopus Fishermen" from an album *Sketches from a Boat Window*, by Tanomura Chikuden (1777–1835). Ink and slight color on paper. Dimensions: $8\frac{1}{4}$ in. × $5\frac{1}{4}$ in. Agency for Cultural Affairs.

148. *Sunny Morning at Uji*, by Aoki Mokubei (1767–1833). Ink and color on paper. Dimensions: 1 ft. $7\frac{1}{2}$ in. × 2 ft. Agency for Cultural Affairs.

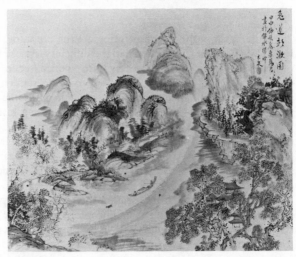

Later Painters

Later literati painters were legion. Their works, which continue well into the nineteenth century, are highly accomplished. It is impossible to do them justice in a short space. Typical was Yamamoto Baiitsu (1783–1856), a man of all the arts—the tea cult, poetry, and music. Typically, too, he took from all the schools he studied. His *Winter Landscape* (fig. 149) has been aptly called "a totally realized atmosphere of unyielding winter," and one can trace in it many centuries of Chinese visions. For the trained eye this provides a fascinating exercise.

One cannot leave the *nanga* painters without mention of Tomioka Tessai, who was born in 1836 and died at a ripe old age in 1924. He was born in Kyoto, the son of a wealthy dealer in priests' robes. He studied Shinto, Buddhism, and Confucianism as well as classical Japanese literature. He studied *nanga* painting in Nagasaki and spent much of his life traveling on foot throughout the country, painting as he went. This was in the best Chinese tradition. It is estimated that this prolific painter produced some twenty thousand paintings mainly on themes taken from Chinese and Japanese classical literature and legend. Although he was the last great exponent of *nanga*, his vigorous and seemingly undisciplined brush expressed great individuality and independence (fig. 150).

Zen Painting

Finally in the realm of ink painting are the *zenga*, or "Zen paintings." We have already mentioned the difficulty, indeed the futility, of trying to put Zen philosophy into words (see p. 138). The strange paradoxes which are intended to bring sudden enlightenment appear a little inane except to those already some way along the path to self-realization. Zen painting has a long history but its modern form began with the Obaku sect which came to Japan in the mid-seventeenth century and established its headquarters at the Mampuku-ji near Kyoto. Another Zen sect, the Rinzai, produced a succession of fine painters and calligraphers, especially after Hakuin (1685–1768) revived the sect.

Zen painters sought the true rather than the formal appearance—an aim which many painters in Europe from the late nineteenth century onward would appreciate. In keeping with Zen philosophy there should be no rules, no complexity, no intellectualism, no

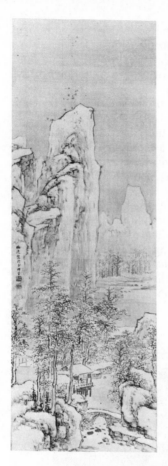

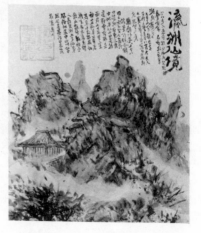

149. *Winter Landscape* from *The Four Seasons*, by Yamamoto Baiitsu (1783–1856). Hanging scroll; ink on silk. Dimensions: 3 ft. 4½ in. × 1 ft. 7¾ in. Mrs. Jackson Burke Collection, New York.

150. Detail of *The Realm of the Immortals on the Island Ying Chou*, by Tomioka Tessai (1836–1924). Color on paper. Dimensions of whole painting: 4 ft. 4 in. × 1 ft. 8 in. Private collection.

hindrance to means of expression, and no interference with them. The result of this approach is an immediate impact produced by a few quick, seemingly unskilled brushstrokes which should "point directly to man's heart [and enable one to] see one's own nature and become Buddha."

Such paintings are often very humorous, and the master of Zen humor was Sengai (1750–1837). Most of his work dates from the twenty-five years after he retired and shed the administrative responsibilities of being an abbot of a monastery. His wide repertoire, ranging from landscapes to figures, birds, and plants has a wild, almost zany quality combined with eccentric brushwork and often accompanied by equally odd verses.

Figure 151 shows Sengai's way of illustrating a profound Zen parable concerning the delusory nature of life and death, the essence of Zen, and a moment of truth leading to enlightenment. Apart from the philosophical subtleties, Sengai's brushwork is so strong that it almost seems to compel the hand of the viewer to follow it in imagination—much as the rhythms of a strong melody will move one's arms involuntarily. It can be read on many levels of understanding. A Zen painting is never as frivolous as it may seem.[6]

151. *Nan-chuan Killing the Kitten*, by Sengai (1750–1837). Hanging scroll; ink on paper. Dimensions: 1 ft. 7 in. × 9 in. Kimiko and John Powers Collection.

The Urge to Creativity

Facility with the brush was an indispensable accomplishment of any man with pretensions to culture. "Ink plays" became a feature of Japanese intellectual life which has by no means entirely disappeared. Even today a host, though perhaps not one of the younger generation, will sometimes produce a piece of gilt-edged paper about a foot square, mix some ink, and dash off a charming black-and-white sketch with the ease with which a Westerner will sign an autograph. During the last two centuries such souvenir sketches were even more common and must have been produced in very great numbers. Often amateur and professional artists would gather together in clubs to discuss the arts. On special occasions, the various guests of these bohemian gatherings would contribute to an album which would then be presented to a member of their group whom they wished to honor. T. Volker has drawn our attention to some of these *libri amicorum*.[7] The combination of sensitivity and skill in some of their pages entitles them to a high place among the minor masterpieces.

Artistic sensitivity was not restricted only to professional artists or to relatively well-educated amateurs. The most surprising aspect of art in the Tokugawa period was the immense creative urge which flowed through the artisan and craftsman classes. The amazing variety of their output, which reached staggering proportions, makes originality seem almost commonplace. Even the most humble craftsman seems to have had the eyes and the skill to produce attractive works of art from the smallest details of the world around him. Lafcadio Hearn, at the beginning of the century, was completely captivated by these works of art on a minor scale. "Aesthetic taste," he said, " . . . followed the line of least resistance. Observation concentrated itself upon the interest of everyday life,—upon incidents which might be watched from a window, or studied in a garden, . . . upon trees, flowers, birds, fishes, or reptiles,—upon insects and the ways of them,—upon all kinds of small details, delicate trifles, amusing curiosities."[8] Seldom in any other country or time has a whole nation been so constantly on the alert for a scene or a moment which could be turned to artistic purpose. Each slight change added emphasis or nuance, each adaption or novelty was noted and applauded by a wide and critical audience.

A village in the north of Kyoto called Ōtsu, for instance, became

famous in the eighteenth and nineteenth centuries for a type of painting which at the time sold for only a few pence. These ōtsu-e, which are lively, imaginative colored sketches of local deities or illustrations to proverbs, are now highly prized by collectors. Unpretentious and generally anonymous, they are full of rustic good-humor and broad, sometimes bawdy, wit. They abound in the vitality which is a feature of peasant art throughout the world. The desire for originality and variety seems to have permeated the whole of society. They are folk art at its very best—the pure distillation in line and color of the peasant imagination.

Figure 152 shows an early ōtsu-e now mounted as a hanging scroll. It pokes fun at a humble spear carrier who is using his position in a daimyo's entourage as an excuse to put on airs before some prostrate villagers. Comparison with the previous illustration is illuminating. Instead of the highly accomplished brushwork of a cultured scholar deeply versed in the arts of China, a peasant painter of acute perception here gives a sarcastic interpretation in a lively, intimate

152. Ōtsu-e showing servant carrying a spear. Tokugawa period. Hanging scroll; color on paper. Dimensions: 1 ft. 11 in. × 8 in. Private collection.

manner. The skill betrays a long tradition and the only possible comparison is with some of the figures on Tosa screens. The range is restricted, but within it the artists were completely confident of their ability. The irrepressible native humor shows itself as readily in these paintings as in the masks of earlier times. This window on Tokugawa village life is as amusing and stimulating to the Westerner today as it was to the traveler through Ōtsu over a century ago.

The Color Print

Finally in this survey of Tokugawa painting we come to the color print. Snobbism and official disfavor in Japan resulted in the finest collections being formed in London, Boston, Chicago, and Paris. A pioneer in oriental-art studies, Dr. Cohn, recalls how on his first tour of Japanese art collections in 1908 he was not shown a single color print. Even the Kabuki theater which inspired many prints was still not considered respectable and visits to it were perforce incognito. However, it is one of the few branches of Japanese art adequately represented in the West. From the second half of the last century when, about 1890, French painters like Pissarro, Cassatt, Bernard, Gauguin, Dégas, Van Gogh and, of course, Toulouse-Lautrec discovered that Japanese color prints and book illustrations vindicated their theories of design and color, they have enjoyed a tremendous vogue. Western writers have produced a flood of excellent studies of the color print which have made it the best known and most deeply explored aspect of Far Eastern art. The originality and vitality of the prints, their beauty of design and perfection of technique, and above all their infinite variety can only be outlined here. For all its interest, the color print is only one facet of the long history of Japanese art and should not be overemphasized.

The printing of pictures from woodblocks did not originate with the Japanese in the seventeenth century. It had been used in T'ang China in a more rudimentary form and in Japan during the Fujiwara period for the outlines of background paintings on which scriptures were then written (see p. 154). The Chinese had used the color-print technique for their pattern books such as *The Ten-Bamboo Studio* and *The Mustard Seed Garden* published in 1622–43. Van Gulik's excellent but unfortunately inaccessible book on the erotic color prints of China shows that the Japanese owed much both in technique and content to the Chinese forerunners, but it was left

to the Japanese to develop the art from the early seventeenth century and refine it to a twin perfection in the eighteenth century.[9]

The Floating World and "Spring Paintings"

What gave the Japanese color print its unique character? Above all it was a cheap form of reproduction within the means of all, created in order to meet an insatiable demand among the plebeian classes of Edo, the people who could not aspire to the Kanō products even if they had appealed to them. In brief, it was art, if not for the masses, at least for a very wide clientele, principally samurai and townsfolk; as a popular art it was the most highly developed and sophisticated the world has ever seen. The Chinese subjects and calm styles of the Kanō schools made no appeal to the citizens of the busy capital. This robust society, somewhat intoxicated by its growing power, earthy and quick-witted, colorful and chafing under the restraints which their rulers had put on their enjoyments, demanded a frank and sensational art form. The disfavor and censorship of the authorities gave the color-print movement a clandestine flavor which added considerably to its zest. Nothing is more stimulating than the opportunity to flout ineffective regulations. This "underground" aspect was due partly to the fact that a considerable proportion of the prints were what the Japanese call *shunga*, or "spring paintings" —a delicate Eastern euphemism for what is the world's most explicit erotic art. It seems that then, as now, it was difficult to define exactly what was pornographic or whether they were intended as sex manuals or for private titillation. Certainly albums of erotic prints were produced from about 1580 to 1640. Figure 153 gives a very modest hint of what these artists could achieve in this direction. Others show how the commoners of Edo made bawdy fun of their superiors. In these gross confections they mostly ridiculed the samurai or even the shoguns, the nobleman being revealed a cuckold to his servant, the rulers inextricably entangled with tea-house courtesans. The shoguns made constant efforts to control or censor the prints but with little effect. Alack, even today in our ever more permissive society the really outspoken *shunga*, for all their artistry, can seldom be reproduced. This is sad for, apart from their art, they are an interesting social and political phenomenon. Certainly they make it extremely difficult for the scholar to produce a catalogue raisonné of almost any artist's work.

153. *Two Lovers*, by Harunobu (1725–70). Color print. Dimensions: 9¼ in. × 7⅝ in. British Museum.

Richard Lane, who has made a close study of this social and artistic phenomenon, describes how the courtesans and their licensed quarters became very important for the Japanese, who found in them the only outlets for their desire for romance and adventure. Love was for sale but a man was free to choose his woman and even reserve her for himself. Those areas became the centers of male social, cultural, and artistic life, dominated from the mid-seventeenth century by wealthy townsmen rather than samurai. The Japanese courtesan was at once a prostitute and not a prostitute. She could be bought but still enjoyed considerable freedom, integrity, and influence within her limited world. She would not tolerate a boor. The celebrated beauties, though named in art, were more types than personalities. Altogether this demi-mondaine world inspired a remarkable body of literature and art over a period of some three hundred years.[10]

When the print designers turned away from the set manners of traditional painting to the genre scenes of everyday life around them what a rich, gay, colorful world they found! The limits of painting seemed to burst apart. Almost every print reflects the joy of some newly discovered beauty, some striking moment seen with fresh eyes. The *ukiyo-e* movement may have had no deeper aim than to render this "Floating (or Fleeting) World" but how much more alive and real it was than the countless repetitions of *Sages in a Bamboo Grove* or *Landscape in the Style of "Such-and-such" a Chinese Master*.

The graceful beauties of the Yoshiwara, the great prostitute area of Tokyo, parade before us in all their finery; we look into the bath houses with their nude figures and into the theater with its grimacing actors in their bright costumes; ladies with their attendants exhibit their charms and their dresses by the river; a thousand intimate scenes in the houses and streets are exquisitely recorded; the newly discovered beauties of the Japanese countryside are vividly captured. There is hardly an aspect of public or private life which has not been explored by the long line of color-print masters from the last half of the seventeenth century to the middle of the nineteenth. Through them we share the excitement of the bustling, seething life of the time. Edo is brought to life, a city of "brawling samurai, pleasure loving merchants, skilled craftsmen, its streets swarming with retainers, flunkeys, palanquin bearers, a swaggering and truculent horde." Above all a new intoxicating spirit of freedom pervades society. The lifeblood of Japanese painting during the Tokugawa period ran in the *ukiyo-e*.

The combination of talents which made possible the vast output of color prints is one of the most remarkable features of the movement. The publisher who commissioned the print, if he were a man like Jūsaburō, would have been a guiding force, an impresario in his own right. The designer, whose name is probably familiar to Western readers—Harunobu, Hokusai, Hiroshige, Utamaro, Sharaku—produced the model. Finally, they all relied on the block-cutters and printers, the countless unnamed craftsmen whose deftness assured the perfection of the final product. To these must be added as a formative quality the taste of an eager and discriminating public which demanded the best of artists and craftsmen, whose fickle favor kept the designers constantly on their toes, but who faithfully supported the craft through nearly two centuries. An intense spirit of competition within society enlivened the whole atmosphere of the Tokugawa scene.

Early Prints: Moronobu

Until about 1740, only black-and-white prints appeared, produced from a single block. These were subsequently often colored by hand, *beni-e* ("red" prints) or *urushi-e* ("lacquer" prints), but only about two hundred a day could be produced by this method and demand outstripped it. Then came two-color printing from the

same block. Later, by increasing the number of blocks, true color-printing was introduced, a technique which, once discovered, the printers rapidly developed, until in 1764 they perfected the full polychrome print for a private edition of a calendar for the following year. Sometimes, by using more than ten separate blocks they produced what the Japanese call *nishiki-e*, or "brocade paintings." The accurate cutting and printing of so many blocks in perfect register, and the mixing of the dyes required the most exacting standards.

The first *ukiyo-e* artist is generally held to be Matabei (d. 1650) but there is little in his surviving work to support his claim as the founder of the movement. Historians have tended to attribute any very early painting in *ukiyo-e* style to Matabei. Moronobu (1618–94), together with his contemporaries like Ryūho and particularly from the 1670s, was certainly the man who established the art. He produced about 130 illustrated books, and it was he who discovered that by using the woodblock printing method he could produce pictures cheaply to satisfy a wide market. He illustrated books, particularly works that were mainly pictorial and intended for the less literate, made albums, designed large single sheets and eventually hand-colored prints. These hand-colored prints are called *tan-e*—*tan* being an orange-red color. Sometimes the addition of yellow and gray areas produced a three-colored effect. The colors of these *tan-e*, originally very brilliant, have not lasted and their present discreet shades, although greatly admired, bear little resemblance to the originals. Moronobu's strong black line influenced not only his contemporaries but all later artists. He had been trained in Kyoto in the Kanō and Tosa styles, and in adopting the Kanō line he took over the one element of value which the Kanō style had to offer. The Tosa style provided the interest in people. Figure 154 is typical of much of his work.

He was the first to reveal the intimate, lively aspects of everyday Edo life—fishermen selling their wares, ladies viewing flowers, scenes of Yoshiwara, and guides to the varieties possible in love-making. Variety and interest abound but the figures, though pleasing individually, tend, as often in *ukiyo-e*, to be somewhat monotonous *en masse*. The faces show little variety and the compositions are often stiff and synthetic. However, he was one of the first Japanese artists to explore human relations and his successors owed

154. *Street Scene*, by Moronobu (1618–94). Unsigned black-and-white print. Dimensions: 1 ft. 3 in. × 11 in. Museum of Eastern Art, Oxford.

much to this departure. Some of the earliest *ukiyo-e* prints were produced for illustrated guide books to places of interest and as illustrations to popular novels. The most respected author in this genre was Saikaku (1642–93), known in the West through translations of his *Life of an Amorous Woman* and *Five Women Who Loved Love*, both of 1686.

Kabuki

Two of the most characteristic and colorful aspects of Edo city life were the Kabuki and the Jōruri, or puppet theater. The theater as a source of inspiration for artists is familiar in the West, so the form does not surprise us; only it is a different type of theater. The fully developed Kabuki, which means literally "song-dance art," was a product of the Tokugawa period but had its roots in many traditional Japanese forms—in the old religious dances often performed with masks, in the Nō drama which developed from them, in the popular puppet plays which thrived then as now in Osaka. The Kabuki theater as still performed today, what Faubion Bowers claimed is "the world's most splendid classical theater," provides one of the most impressive dramatic experiences to be found on any stage. The settings in the vast proscenium openings are breathtaking; the costumes are gorgeous beyond description. It should be noted that the chalk-white makeup originally made it possible for spectators far from the stage to see the expressions on the faces of the actors more clearly, and the importance of the kimono cannot be overemphasized. Technical equipment and production compare favorably with any in the world.

The plays, mimes, and dances, "living history" as they have been called, are generally well-tried favorites known word-for-word, action-for-action. "Popular themes are the conflicts between obligations and human feelings, duty versus passion—not as in western heroic tragedy where they are on so lofty a plane that passions bound to heaven and duty involves the fall of empires. The passions and duty are here intimate, near to home, well within the world of the ordinary man and his next-door neighbour."[11] Their most important function has always been to act as media for the personalities and talents of outstanding actors. The idolatry given to English actors like Kean and Garrick was nothing compared with the worship of the matinee idols of the Kabuki theater. Their every gesture on the stage was noted and compared with those of their predecessors, their behavior and dress off-stage dictated the popular fashion. Even their makeup was reproduced by pressing tissue on their faces, to be signed and highly prized by the fans.

Although no Westerner can fail to be impressed by the dazzling spectacle that this theatrical form provides, few, without considerable help, can understand its studied grimaces and tortured poses. These are intended to express the emotional struggles of the actor and can move a Japanese audience to scenes of wild excitement. For all their artificiality they are extraordinary histrionical feats. The tradition of an all-male cast has survived and the skill with which slim, adult male actors impersonate female roles is completely deceptive. "As the actors in their high sing-song or deep mumbling growls move from the audience to the stage in paces sometimes so steady as to be static or leap in dance steps so fast as to blur the eye, they enact plots of enormous complexity."[12]

The personalities and plays of Kabuki provided the color-print designers with a vivid world of subjects peculiarly suited to their art. The popularity of the actors ensured a ready sale for prints depicting them in their successes. Many of the finest prints show either actors or the girls of the Yoshiwara. A social commentator of the time complains of the energy spent in endless sexual adventures, in continual experiment with luxury and extravagance, of the addiction to lust, drinking, gambling, profit hunting, songs and dance, music and artistic accomplishments, and so on. The explanation is that these were the only ways in which the commoners could use their wealth and express their political frustration. Thus many plays

deal with the heavy expenses incurred by venturing into the "Floating World" which could lead the unwary merchant or poor samurai into hopeless debt and the ruin of his family.

A description of one of the most popular Kabuki plays may help a Westerner to appreciate the actor prints. The classical version of *Chūshingura* ("The Storehouse of Loyal Retainers"), for example, which was written by three playwrights, Takeda Izumo, Namiki Senryū, and Miyoshi Shōraku, has remained a firm favorite with Japanese audiences. Any Kabuki troupe in financial difficulties immediately turns to *Chūshingura* to solve its problems—in the same way in which its Western counterpart used to put on *Charley's Aunt* or a bedroom farce.

The play is based on a historical event of 1701 in which a lord, insulted by an avaricious superior in the shogun's palace, was goaded into raising his sword and wounding his insulter. For the serious crime of unsheathing a sword within the palace precincts, he was sentenced to commit suicide. His retainers banded together and, after a year's plotting, brought about the death of the original wrongdoer. Their mission achieved, they then gave themselves up to the authorities. The crime would normally have carried the death sentence, but they were permitted the honorable end of committing mass suicide and were buried in a temple. They rapidly became national heroes.

For political convenience, the authors placed the play they wove about this event in the Ashikaga period and changed the names. They added a great deal of romance, incidental drama, brigandage, intrigues, murder and suicide, plots and counterplots so that the audience is never deprived of tension and exciting climaxes. The speed of the action sweeps one along from castle to geisha house, from forest to battlefield, from one scene of violence to another. The play is designed to show the ultimate triumph of right over wrong, and the various rights and wrongs in the main plot and subplots are skillfully interwoven. Forty-six of the forty-seven heroes belong to the masterless *rōnin* ("wave men"), a class of fighting men which increased rapidly during the peaceful Tokugawa period. Some turned outlaw and became serious social problems. But their code of honor, inherited from earlier times, remained a romantic ideal with the admiring Japanese population even if occasionally it had to suffer from their arrogance. One of the most eagerly awaited mo-

ments in the play occurs when a merchant, a commoner like most of the audience, speaks the famous words, "I, too, am a man among men" and, as a reward for his courage and loyalty to the cause, is allowed to join the band as the forty-seventh avenger.

The leading parts in this play are still considered as the test of an actor much as Hamlet and Macbeth are in the West. Each of the eleven scenes or acts has its dramatic moment which provided an excellent subject for a color print.

Actor Prints: The Torii Masters and Kaigetsudō

Actor prints flourished to the end of the nineteenth century but the finest appeared in the first half of the eighteenth century when the Torii masters including Kiyonobu I, Kiyomasu I, Kiyonobu II, and Kiyomasu II dominated the period.

A print by Torii Kiyomasu II, *Arashi Wakano as the Poetess Ono-no-Komachi, Dancing* (fig. 155), produced about 1745, illustrates the actor prints of the Torii school, which line of artists, incidentally, lasted down to the end of the nineteenth century. It is hand colored and further beautified by sprinkled metal dust on a gum base to create the impression of metalwork. It is typical of the so-called

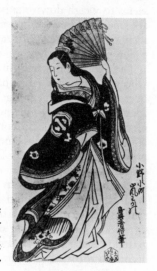

155. *Arashi Wakano as the Poetess Ono-no-Komachi, Dancing,* by Torii Kiyomasu II (ca. 1720–63). Hand-colored print. Dimensions: 10¾ in. × 6⅛ in. British Museum.

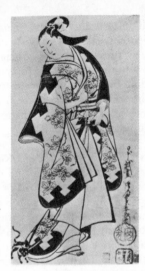

156. *Courtesan with Cat*, by Kaigetsudō Dohan (active first half of eighteenth century). Black-and-white print. Dimensions: 1 ft. 11½ in. × 1 in. Musée Guimet, Paris.

primitives and shows a large figure in bold, flowing lines with the body strongly curved. The heavy drapery with its large designs seems to weigh down the body, the face is plump but the features are small and very simply indicated. The stately, sweeping movement of these large figures, as they appear to move slowly across the paper, produces a pageantlike effect.

The greatest master of line in this early period was Kaigetsudō, who was active in the first half of the eighteenth century. Although over one hundred paintings have survived, all belonging to about 1720–50, only thirty-nine prints from the hand of this master have survived, or as some authorities say, from these masters; for four different names—Ando, Anchi, Doshin, and Dohan—appear on the prints after the characters for Kaigetsudō. However, they are so similar in style that historians generally treat them as the work of one man, although modern scholars are now attempting to distinguish the works of Ando and his followers based on criteria of diminishing strength and a tendency toward prettiness. Figure 156, signed Kaigetsudō Dohan, shows a courtesan, the celebrated "Kaigetsudō beauty"—a typical woman of the Yoshiwara with her gaily decorated robes around her. Although in black and white, the print

gives the unmistakable impression of color. The studio of the Kaigetsudō painters was near the Yoshiwara, and their paintings have been called "publicity pictures for the inmates of Edo's largest quarter of commercialized vice." America is fortunate in possessing twenty-four of the surviving thirty-nine Kaigetsudō prints.*

Masanobu and Harunobu

In about 1740 the invention of true color-printing immeasurably enriched the woodblock technique. Instead of the hand-colored prints, pale red and green were printed with blocks. The credit for this invention is given to Okumura Masanobu (1686–1764), though the technique was known before Masanobu applied it to prints. However, in doing so he gave the art a new lease on life. Masanobu, like many print designers, was a prodigy and his interests included poetry, stories, and book illustrations. His output was enormous and, in common with his contemporaries, he would copy the designs of others where it suited him and if he thought that thereby he could find a market. He was an excellent businessman and ran a shop of his own to sell his prints. Stylistically these range from the powerful black-and-white prints of Kaigetsudō to a more gentle, graceful style of his own which is typical of the early two-color prints and which was taken up by Harunobu.

The change in the *ukiyo-e* style from the statuesque of Kaigetsudō to the willowy, petite, more familiar Japanese female figure made famous by the prints is best seen in the work of Harunobu, who died in 1770. Masanobu's pioneering in two-colored prints led rapidly to the extension of the technique so that eventually as many as thirty different colors could be applied. This was made possible by the invention of a register or alignment device known as the *kentō* sometime before 1744. This made possible microadjustments even when the printers were using damp paper and saturated blocks.[13] *Girls Fording a Stream* (fig. 157) by Harunobu is a representative example of his work in which everything centers on the sweetness and grace of the ensemble. Charming, slim girls, perhaps a little monotonous in their sentimentality and lack of individuality, pose decoratively

* For a consideration of the Kaigetsudō conundrum, see Takahashi Seiichiro, ed., *Kaigetsudō*, English text by Richard Lane (Rutland, Vt. and Tokyo: Charles E. Tuttle, 1959).

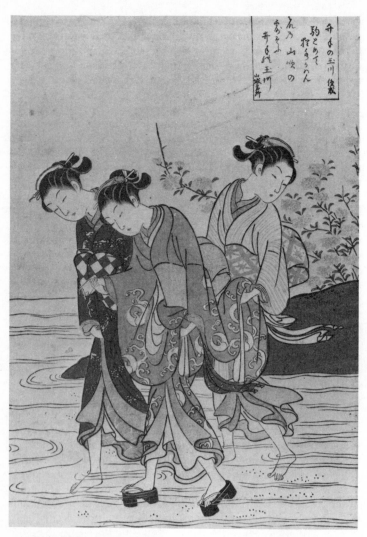

157. *Girls Fording a Stream*, by
Harunobu (1725–70). Color print.
Dimensions: 9¾ in. × 7⅛ in. Brit-
ish Museum.

284 CHAPTER 9

against a few architectural or landscape elements. His work is always the apogee of good taste and gentility. Harunobu often plagiarized and repeated his own themes, but his genius lies in his appreciation of the possibilities of the polychrome print, in his masterly use of color, and in his impeccable harmonies. His illustrated-book masterpiece of 166 color portraits of courtesans each accompanied by a poem is generally considered to have begun the golden age of printmaking from 1770 to 1830 and had an enormous influence on his contemporaries. Hillier remarks on the perennial youthfulness of his girls, "not merely young in years, but playful and childlike . . . acting out scenes every bit as artificial and unrealistic as the girls and youths in a *Fête champêtre* of Watteau."[14]

The Popular Appeal of Utamaro

Despite their fertility, few of the great names who fill the world of *ukiyo-e* designing were able to live by their art. An overnight change of fashion could make their prints unsalable. A famous courtesan might change her hairstyle, a new actor could create a sensation. Above all, the innovations of a new artist might capture the public fancy and eclipse the products of his rivals. One of the greatest was Kitagawa Utamaro (1753–1806), who took over the leadership of the print movement in the early 1790s. His smooth, refined prints of tall, elongated girls with complicated hair-dresses were an immediate success and constitute his best-known work. More original, however, are his large heads which are masterpieces technically as well as artistically. His work covers a wide range; some of his insect prints show a close observation of nature and faultless draftsmanship. One of his most successful series illustrates the life of Kintoki, "the Golden Boy," the son of a dead samurai who, according to folklore, was brought up by a wild woman of the mountains, Yamauba. Figure 158 shows this mad, wild woman suckling the child. The concentration and fierce emotion expressed in this print come as a surprise after the idealized portraits of Yoshiwara prostitutes in their costly robes attended by their equally elegant attendants. Utamaro seems to have enjoyed the opportunity that this series gave him to express the savage protecting instinct of the wild foster mother and to escape for a moment from his beautiful girls whose company and pleasures are said to have taken up much of his time and energies.

Sharaku

The appearance of such revolutionary designs may well have been due to the influence of a courageous publisher like Jūsaburō who backed and stimulated promising young artists. Many of the finest prints come from his Tsutaya, or "Ivy Shop," and carry his stamp. Like discriminating patrons of art through the ages, he supported unknown artists in whose work he had faith. The production of a print involved a considerable financial investment and the backing of a new talent was a risk. Jūsaburō's enterprise was responsible for some of the best prints of the whole movement.

Without him, for instance, an artist like Tōshūsai Sharaku, whom many critics consider the greatest of all the print masters, would never have had his chance. Everything about this artist is mysterious. His origins are obscure; he was possibly a comparatively unknown actor of the Nō drama. In the course of about ten months of one year, 1794, during which he was backed by Jūsaburō, he produced over one hundred actor prints which are unique in the whole of *ukiyo-e*. They were not a popular success at the time and did not sell. Jūsaburō was forced to cut his losses and discontinue his backing. Sharaku, after a brief but brilliant moment, disappeared without a trace from the print-designers' world.

Sharaku worked on a heroic scale designing portraits of actors with such acute observation of personality that they seem at times almost cruel. It is understandable that his version of stage idols made little appeal to the public which was accustomed to idealized portraits of their favorites. They have been called caricatures but in fact they transcend our conception of caricatures. Figure 159, *Segawa Tomisaburō in a Female Role,* shows how Sharaku synthesized the personality of the actor and the character he was portraying on the stage. The elaboration of the butterfly-shaped coiffure crowned with a huge comb and long hairpins offsets the extraordinarily simple lines with which he captures the facial expression. The innermost secrets of personality are laid bare with a few expressive strokes. The fusion of simplicity and complexity, tenseness and relaxation, whiteness and color, warmth and coldness produces a depth of character study unparalleled in the whole movement. Sharaku's portraits breathe the authentic atmosphere of the theater in the same way as do the ballet pictures of Dégas and the posters of Toulouse-Lautrec. His sardonic humor completely transforms the actor print, impart-

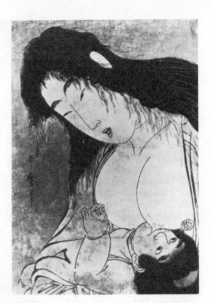

158. *Yamauba and Kintoki*, by Kitagawa Utamaro (1753–1806). Color print. Dimensions: 1 ft. 3 in. × 10¼ in. Museum of Eastern Art, Oxford.

159. *Segawa Tomisaburō in a Female Role*, by Tōshūsai Sharaku. Dated 1794. Color print. Dimensions: 14½ in. × 9⅜ in. Musée Guimet, Paris.

160. *Nakamura Konozō and Nakajima Wadaemon*, by Tōshūsai Sharaku. Dated 1794. Color print. Dimensions: 1 ft. 2⁵/₈ in. × 9 in. British Museum.

ing to it a new grandeur. Altogether these profound studies are one of the most baffling expressions of all Japanese art.

Figure 160, a rarer study with the two actors Nakamura Konozō and Nakajima Wadaemon in the frame, shows the artist in his most ruthless mood. With a few decisive lines he exposes the meanness and grossness of his subjects with a clarity which takes us back to some of the early sculpture. In an exhibition at the Musée Guimet, Paris, this print was aptly entitled *The Moneylenders*. It is easy to see how Sharaku alarmed and infuriated his victims. His work is a splendid climax to fifteen hundred years of Japanese portraiture.

The Landscapes of Hokusai and Hiroshige

The first half of the nineteenth century, the last great period of Japanese color prints, was dominated by two outstanding designers, Katsushika Hokusai (1760–1849) and Ichiryūsai Hiroshige (1797–1858). Both produced a vast number of prints in large editions and it is generally their designs which swell the tattered piles of old prints in antique shops. Unfortunately, many of them were printed from old or recut blocks, and colors even more harsh than their originals have helped to damage their reputation. Landscape was the main preoccupation of these great artists and their works include some of the most original designs ever produced.

Hokusai lived with unimpaired energy and restless inquiry to the age of ninety. He created many of his most inspired prints during his last twenty years, among them some of the *Random Sketches*, a vast compendium in many styles which seems bent on illustrating every aspect of Japanese life, and his great series of landscape views such as *The Thirty-six Views of Mt. Fuji*. His gifts of improvisation are inexhaustible. In the Mt. Fuji set nothing could be more unlike the jagged Chinese-style Kanō rocks than the gentle, symmetrical slopes of this most Japanese of all mountains. It made a magnificent leitmotif, sometimes dominating, sometimes almost invisible, always seen from a fresh, unexpected angle. Some of the designs seem a little forced in their search for novelty but even these show an astounding fantasy and fertility of ideas. The well-known "Wave of Kanagawa" and "Mt. Fuji in a Storm" are perhaps the best-known of this series and have frequently been reproduced. Both are violent, dynamic backdrops conceived in the broadest terms and vitalized by the tremendous power which bursts through them. Accustomed as we are to the modern artist's efforts to achieve originality, their daring and powerful draftsmanship still impresses. His *Waterfalls of the Provinces* (fig. 161) and his *Views of Famous Bridges* show how Hokusai does not so much study landscape as tyrannize it. In him one sees yet again the Japanese love of the grotesque appearing in nineteenth-century landscapes as it did in the masks of the eighth century. David Chibbett says of him, "In the time he lived, he stood against an overwhelming tide of mediocrity and the strain sometimes shows."[15]

Hiroshige's output of landscape was even greater than that of Hokusai; a rough estimate puts it at 5,460 designs. Inevitably many of them are hurried, crude designs dashed off to satisfy an avid public, but a remarkable number are outstanding; his snow scenes are superb (fig. 162). He is the master *par excellence* of light and atmosphere and his genius for depicting rain gives many of his designs a peculiarly pungent atmosphere. The landscapes of Japan were almost ransacked by his restless imagination. His prints are softer in feeling than those of Hokusai, readily understandable, and often humorous, particularly when, as so often happens, he depicts puny mankind being buffeted by the giant forces of nature.

Apart from their large prints some of these designers welcomed every opportunity to show their skill in different forms. In addition

161. "Yoro Waterfall" from the series *Waterfalls of the Provinces,* by Katsushika Hokusai (1760–1849). Color print. Dimensions: 1 ft. 2¾ in. × 10 in. British Museum.

162. "Kambara" from the series *Fifty-three Stations on the Tōkaidō,* by Ichiryūsai Hiroshige (1797–1858). Color print. Dimensions: 1 ft. 2¾ in. × 10 in. Museum of Eastern Art, Oxford.

to his landscapes, Hiroshige made a number of most pleasing designs for printing on such things as luxury envelopes. Figure 163 shows how he decorated a difficult area 2¼ by 7 inches. With a few delicate strokes and some gauffrage (embossing) he produced *Monkey Trying To Fish the Moon out of the Water*—a gentle sketch none the less masterly for its unassuming aims and limited scope. One is constantly struck by the evidence of the underlying taste and refinement of this burly Tokugawa society.

The same delicacy of sentiment is found in the *surimono* ("printed things") which designers made to order to celebrate special occasions like birthdays or New Year's Days (fig. 164). In these rarer small prints with their fine lines, muted colors, gauffrage, and profusion of sprinkled metal dust, the actual technique of printmaking reached its zenith.

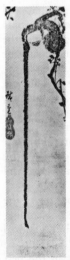
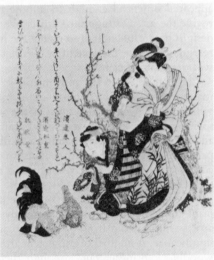

163. *Monkey Trying To Fish the Moon out of the Water*, by Ichiryū-sai Hiroshige (1797–1858). Color print for envelope. Dimensions: approx. 7 in. × 2¼ in. National Museum for Ethnology, Leiden.

164. *Feeding the Chickens*, by Eisen (Ieisen) (1790–1848). Example of *surimono*; color print on paper. Dimensions: 7¾ in. × 7 in. Museum of Eastern Art, Oxford.

The Decline of the Color Print

In the mid-nineteenth century, after two hundred years of prodigious activity and the vast output of countless artists great and small, the quality of the art of color printing decayed sadly within only a few years. It is difficult to understand why this happened. The restrictive measures of the shoguns can hardly have affected it. Garish European aniline dyes carelessly used created a horrible clash of strident tones, cheapened the look of the prints, and destroyed their line. A deterioration in the taste of the Edo public may have been a major factor but it is always difficult to determine the reasons for such a decline. Perhaps the mass production encouraged by the success of men like Hokusai and Hiroshige lowered the standards. Whereas a set of blocks once served for two hundred prints and was then discarded, toward the end they were made to serve for three thousand impressions with a corresponding loss of quality. Perhaps *ukiyo-e* simply exhausted itself—no talent or combination appeared powerful enough to impose its taste on the public and revive the art. Distinguished artists like Kuniyoshi produced some designs powerful enough to match the hard dyes, but generally the rearguard of the movement was either sensational and coarse or weak and superficial.

Chibbett sums up the movement, ". . . its origins and subject matter were basically popular and it catered for a mass audience, which might well be described as the world's first true consumer society. In the end, however, it became more dependent on its audience than the reverse, and just as ukiyo-e was born and prospered in a period of social change, so a new era engendered by contact with the West gave birth to a new kind of audience and sounded the death knell of ukiyo-e."[16]

It was possible to give here only the most sketchy outline of the print movement and to mention only a few of the outstanding artists who raised it from a folk art to an art form of international significance. A number of competent artists are now trying to revive woodblock printing but, although their technique is in the best tradition, the impetus for and the spirit behind their artistry owes little to the *ukiyo-e* world of the Tokugawa period.

Textiles

It is only a small step from the color prints to the textiles of the

period. One of the most striking features of the prints is the beauty and extravagance of the robes worn by many of the figures. The courtesans wear dazzling kimonos with large, gay *obi* (waist bands); the actors pose in bold, colorful costumes. As previously mentioned, an artist's success often depended on his keeping closely in touch with passing fashions. The color prints, in fact, often acted as fashion plates; a quick comment on fashion, or on an innovation in dress or hair which appealed to the public could make the fortune of a print. We can now seldom distinguish the subtle changes which they reflect, but in Tokugawa Japan the provinces eagerly followed and imitated the changing modes of the capital. It seems highly probable that some of the *ukiyo-e* artists also tried their hands at textile designing.

Textiles and dress are dictated by the whims of fashion and they change more rapidly than any other form of the arts. Since they are also the most intimate and most widely used of all art products, they reflect very closely the character of the times in which they are made. Thus, in Tokugawa Japan, their brilliance reflects the exhibitionism of the newly rich. The sumptuary laws were largely directed against the elegant dress in which the merchants liked to see their wives and paramours. Yet laws against luxury are always the most difficult to enforce and tend to have the reverse effect of that intended. They merely emphasized the importance of dress and encouraged the quick-witted to evade the spirit without breaking the letter of the law. One can imagine how the public would have applauded the flouting or evasion of restrictions as reported in the prints!

As in all the crafts, it was the Momoyama period which laid the foundations for the textile designs of the Tokugawa period. The search for ever freer, bolder patterns is the keynote of the period. The restrictions on trade with China enacted in the 1630s increased the cost of gold and silver thread used for the embroidery which had hitherto provided the finest costumes and threw the Japanese back on their own resources. The sumptuary laws of 1680 forbade the use of embroidery except for *obi* or for the robes of actors and priests. Simpler means demanded bolder treatment. Thus the restrictions stimulated the development of new, eye-arresting methods for decorating textiles which dispensed with the need for embroidery in precious metals. The laws restricting embroidery also

encouraged the creation of methods to produce the broad asymmetrical patterns which are a feature of modern Japanese design. The wider market provided by the increasing numbers of wealthy people further stimulated these new techniques.

The most popular was tie-dyeing (*kō-kechi*) applied in a number of ways. This method could produce a small fish-egg pattern or a large overall sweeping design with sharply defined contours. The most characteristic textile feature of the period was the large patterns which swept like boldly conceived pictures from hem to shoulder. Smaller repeat-patterns were less popular. However, it was not until the textile workers perfected the resist process of pattern dyeing that these large designs could be economically produced. A rice-paste resist was invented about 1665 by Morikage but the credit for the perfecting of the process is given to the painter Miyazaki Yūzen (active during the Genroku period, 1688–1703), after whom the process is named. It is a relatively primitive method, but in the hands of the Japanese, capable of producing splendid pictorial designs. The inspiration for the process may have come from the batik textiles which the Dutch introduced into Japan from the East Indies in the sixteenth century. But the way the Japanese developed it equals the manner in which they made the Chinese color print into the finest *ukiyo-e*. Figure 165 shows a detail of a short-sleeved garment decorated with scenes of the Yoshiwara on a brown background. The figures in this example were produced by embroidery which, despite the restrictions, was sometimes added to these *yūzen* textiles to increase their rich effects. This *yūzen* dyeing, especially in the Genroku period, as Richard Lane comments, "transformed the streets of Japanese cities into a spectacle of lovely women gowned in colorful splendor."[17]

The art of weaving also progressed during the period, especially at places like Nishijin in Kyoto, which still produces the finest Japanese silks. The Nishijin products were largely reserved for the use of the ruling households but this was only one of many silk-weaving centers throughout Japan, each with its own speciality and renowned for its particular colors.

From 1800 onward it became necessary to invent an even cheaper method of decorating cloth capable of mass-production. As one might expect, the craftsmen turned to woodblock-printing techniques. These satisfied the demands for speed and economy but not

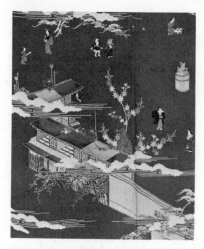

165. Detail of a short-sleeved garment decorated by *yūzen* dyeing and embroidery to represent a scene from the Yoshiwara. Tokugawa period. Silk. Total length: 5 ft. 3 in. Kanebō Collection, Osaka.

166. Four stencils. Late nineteenth century. Paper. Each 8 in. × 1 ft. 2 in. Museum of Eastern Art, Oxford.

for the popular large designs that treat the whole surface as a single picture plane. Perhaps the most ingenious technique used at the time was the stencil process. Stencils were made which are the finest produced anywhere in the world. The ingenuity and originality of the designs, to say nothing of the skill required to cut them, are typical of the imagination and care lavished on all the crafts. Figure 166 shows a number of these stencils cut at the end of the nineteenth century.

Lacquer

The technical perfection of Tokugawa art is seen in lacquerwork perhaps better than in the other crafts. It seems to epitomize the taste of the period in the applied arts. A lacquer box with its many compartments, all tastefully decorated and fitting perfectly, the motifs repeated with subtle variations, reflects the Tokugawa artistic atmosphere as accurately as a color print.

Tokugawa lacquerwork, like its textiles, took inspiration from the innovations of the Momoyama period. The tireless search for what was new and original and the wealth available to back it created ideal conditions for a luxury art of bewildering variety which combined perfection of manufacture and originality of design. Every possible technique was employed to give lacquer objects the sparkle of jewelry and the scope and interest of painting. It is difficult to think in terms of "art" as opposed to "craft" when handling the products in this sensitive idiom. New techniques appeared and old ones were revived. One of the most interesting of the revivals was of the "oil painting" type of lacquer decoration last seen in the painting on the Tamamushi Shrine (see p. 53). In this the lacquerworker, like the textile designer and print artist, thought in terms of free brushwork and bold pictorial styles. Every artisan seems to have been a born painter.

Figure 167 shows a tray in the revived painted-lacquer technique.

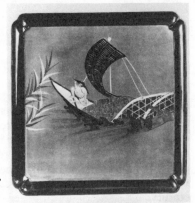

167. Tray. Tokugawa period. Example of lacquer painting. Dimensions: 1 ft. 1 in. × 1 ft. 1 in. Tokyo National Museum.

Its sides are in black lacquer and the background in red while the design is in yellow, green, and black. The tips of the waves are in silver, and the figure in gold. A boat, propelled by one small sail, forges upstream, so heavily laden with its wicker baskets of rice that the stern is almost under water. Even the well-fed boatman, holding on to his wide hat as he leans against the wind, cannot keep the prow down and stop the waves lapping hungrily over the gunwales. A few branches of bamboo balance the boat and provide a second diagonal, thus avoiding any possible monotony in the composition.

The design unites the twin affections of the Japanese craftsman of the period—a love of nature and a close, friendly interest in human behavior. He felt no need to force his designs into set patterns; the whole world was his pattern book.

The Japanese added to this love of nature and mankind a very sensitive appreciation of the inner qualities of the material in which they worked. This is a sensibility which Western craftsmen are only now rediscovering. In Japan it is seen at all times—in a tea-ceremony bowl as much as in a noble wooden sculpture.

The beauty of a fine piece of lacquer owes much to the mirror-like perfection of its smooth finish and high polish. Anybody who handles Eastern art objects of jade, porcelain, or lacquer develops a sense of appreciation through touch. This tactile sense is impossible to express adequately in words but it can quickly be gained by handling Japanese lacquer. The effect produced by setting simple, natural forms against the most refined material, though sometimes capricious, never jars. The Japanese have developed to perfection this combination of the rough and the smooth, the rustic and the sophisticated.

"The Age of Pottery and Porcelain"

If the output of the color-print masters was prodigious, it was easily matched by that of the potters. The Momoyama-period products also laid the foundations of their art, and throughout the Tokugawa period they produced a rich diversity of wares inspired by native and by many foreign examples which came into the country. So much so that the Tokugawa period is sometimes called by the Japanese "the age of pottery and porcelain." One Japanese critic has estimated that there were as many as ten thousand different kilns and individual potters.

During these two and a half centuries the craft, both technically and artistically, reached full maturity. The Japanese showed the same powers of adoption and development as they had in the centuries following the introduction of Buddhism, and as they were again to show in the change-over to Western methods in the nineteenth and twentieth centuries. A good example is the sloping-kiln technique. This is, in effect, a communal series of connecting kilns built up a hillside and fired simultaneously, a system which was brought over from Korea and is still used. The best craftsmen even now have first choice of position in the row of kilns. This technique resulted in a much greater productivity. The inventiveness of design, far outstripping the more conservative Chinese genius, found ample expression in ceramics. Eminent artists applied themselves to the craft in a manner which Western artists have only recently adopted. Clay was a means of expressing personality—a concept unknown to the Chinese. The works of potters known by name were prized highly. One of the most famous was the Kyoto potter Ninsei (active in the early Tokugawa period). Many of his works, which can be quite plain and undecorated, show a strong influence of lacquerwares in their designs and surface textures. Figure 168, his most famous piece, is a large jar with a design of cherry blossom on a mountainside. This is the highly decorated style for which he is best known. The mists and contours of the mountain are done in white and gold, the flowers in red and blue. The black background is particularly reminiscent of lacquer. The decoration is set off by the buff clay. The strong shape is said to have been inspired by southern Chinese wares imported during the Momoyama period.

The eclecticism of the Japanese artists in the choice of their material is a modern phenomenon, and gave their work a refreshing vitality. All material was one to their restless seeking. Once again the small communities centered around a feudal lord provided patronage for countless small craftsmen. Their position was far more honored and exalted than that of their unnamed counterparts in the great factories of China. One is struck by the difference from Chinese practice. No literati painter in China would demean himself by extending his art to embellish the crafts. Certainly the court painters of China would not have been in sympathy with the great lines of Japanese official painters like the Kanō and Tosa who were also hereditary craftsmen. As with modern Western practice

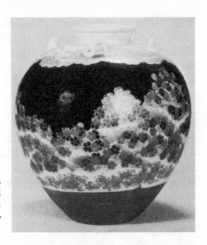

168. Glazed pottery jar with a design of Mt. Yoshino, by Ninsei (active early Tokugawa period). Height: 9 in. Seikadō Foundation, Tokyo.

—Picasso springs immediately to mind—painters, poets, calligraphers, potters, and metalworkers all tried their hands at other crafts.

The tea ceremony continued to create the demand without which the arts of the ceramic workers could never have blossomed. Its implements provided a wide range and ample scope for ceramic ideas —not only in the tea bowls themselves, but also in tea caddies, flower vases, incense burners and containers, rests for ladles and for jar covers, bowls for tea slops, ash containers, cake bowls and plates, plates for charcoal braziers, and other wine and food vessels. In fact any vessel which could serve a useful function in the ceremony was welcomed into the ceramic family and arrayed for admiration on the mats before the masters. If the ceremony needed a vessel there was a potter ready to give thought to producing a ware of fitness and beauty. The combination of implements was dictated only by experiment and taste. They were, for example, constantly changed according to the seasons of the year. Successful innovations were always applauded. The juxtaposition of the various pots was carefully thought out with a view to the harmony of the ensemble.

The appreciation of unusual wares and the love of variety created a fashion for preserving examples of the craft from China, Annam,

Siam. Chinese export wares of the Ming dynasty which reached Japan via the Pacific islands and even Dutch wares reaching the country through Nagasaki were very popular. All fitted into the tea room, were admired, and influenced the work of the native potters. The words *wabi* ("rustic tranquillity") and *shibui* ("sobriety") which were constantly on the lips of the tea devotees, reflect the Japanese admiration of restraint in their best ceramics. The "life" demanded of the best wares is an extension of the Japanese appreciation of individuality in all their art. It gives the work of the potters an inner warmth which cannot be claimed for the Chinese products, in which perfection and grandeur take its place. The downright eccentricity of some Japanese wares is but the extreme expression of this trend.

The irregularities which, at first sight, seem to be the result of faulty technique were often created on purpose and admired for the strength or vitality they impart. The knife cuts, thumb marks, squeezed sides, mottled or running glazes, irregular foot-rims, and lopsided shapes were felt to increase the interest of a vessel. These recur down the years, though the potters took care in the best pieces not to turn these "defects" into conscious affectations. "Beauty within simplicity" and "unobtrusive grace" were the ideals of the tea-ceremony wares.

It was, nevertheless, a vigorous age; the consummate skill and tranquil perfection found in the finest Chinese wares generally escaped the Japanese potter. Where the Chinese are assured and work steadily toward perfection, the Japanese are experimental and above all restless. These are qualities which Western art has led us to understand. Equally the Japanese are never the prisoners of their own techniques as were sometimes the Chinese, especially in later times. Thus in Japan the art never died as it did in nineteenth-century China. It is as alive and as progressive today as it was two hundred years ago.

Karatsu Ware

Some of the earlier kilns were mentioned in the chapter on the Momoyama period. Figure 169 shows a bowl from one of the Karatsu kilns in the southern island of Kyushu, a great ceramic center. It is a "Painted" Karatsu bowl of a typically Korean shape with a greenish brown glaze and decorated with two sprays of freely painted strokes in black. Being nearest to Korea, the influence of

Korean wares of the Yi dynasty (1392–1910) was even stronger here than on the mainland. The congealed glaze which reveals the body appeals strongly to the Japanese appreciation of contrasts. The design is in the best tradition of freehand decoration which goes back to Korean wares, and possibly even to *tz'u-chou* wares of Sung China. The Karatsu kilns produced a wide variety of wares (fig. 170) in addition to this type—plates with designs of fruit and flowers, Mishima-type wares with very small repeated inlaid designs in white.

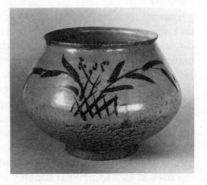

169. Bowl of Painted Karatsu ware. Tokugawa period. Greenish brown iron glaze. Height: 6½ in. Idemitsu Art Gallery, Tokyo.

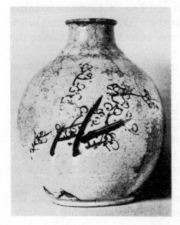

170. Jar of Painted Karatsu ware. Tokugawa period. Iron glaze. Height: 9¾ in. British Museum.

Sometimes brushmarks or comb scratches that sweep quickly across the glaze produce a design of great vitality and freedom. The brushmark effect was greatly admired and developed. Painting and scratching methods of decoration were often most cleverly combined. Thick, white glazes in imitation of Seto wares were sometimes used. These Karatsu wares have an infinite variety of shape and design combined with the simple strength demanded by the masters of the tea ceremony.

Porcelain

Pottery remained popular throughout the period but an important innovation during these centuries completely changed the direction of the craft. This was the discovery by the Japanese of the nature of the raw materials and the technique of porcelain manufacture, which had previously been unknown to them.

Japan, like Europe, admired the jewellike hardness and brilliance of Chinese porcelain, but its inventors had guarded the secrets of its manufacture very closely. Its introduction to Japan is a complex story. During the reign of the Chinese emperor Wan Li (1573–1619) porcelain was first exported to Japan in any quantity. Furthermore, during this period Japanese pirates infested the Chinese coast bringing back as loot somewhat rough polychrome wares and often provincial blue-and-white which served as models. Immigrants to Japan at the fall of the Ming dynasty in China brought information about enameling and Koreans, who had worked in Chinese factories and were brought back as a result of the second Japanese campaign in Korea, finally revealed the process of porcelain production to the Japanese.

The first kiln to produce porcelain in Japan was probably that of Tengudani, established in 1616 by Korean potters in the town of Arita. They introduced the important *noborigama*, or linked-chamber step kiln built up a hillside, which enabled the potters to achieve high temperatures and efficient firing. Thereafter, many Japanese pottery kilns quickly changed over to porcelain manufacture and a host of new factories began to produce it exclusively. The early wares resembled Karatsu products; then were added underglaze blue and finally a range of enamel colors. Again the variety is so great and the output so widely distributed among the many active kilns that only the broadest identification is possible.

Skillful copying of early wares by later potters adds to the problems of dating; the constant cross-fertilization of ideas between the various kilns adds to the confusion. Japanese experts themselves quite often frankly admit defeat in trying to establish the kiln which made a certain ware or the date when it was made. Soame Jenyns draws a parallel between the small Japanese kilns working for their patrons, the local lords, with the mid-eighteenth-century German courts each with its own porcelain factory and its own carefully guarded ceramic secrets.[18]

Kakiemon Ware

The most famous kilns were those belonging to the Arita group near Nagasaki in Kyushu. Korean-style wares had been made there since the early seventeenth century, but historians credit Kakiemon I (1596–1666) with the discovery of the technique of overglaze decoration toward the middle of the century. It proved impossible to keep secret the new techniques which spread rapidly to other kilns in the district. The Kakiemon family continued to work as potters throughout the period and is still active. The products of the various members of the family are extremely difficult to distinguish and they therefore can pass under the generic name of *kakiemonte*, or "in the style of Kakiemon."

The Arita Kakiemon wares are of milky white porcelain decorated in polychrome fashion with red, green, yellow, blue, and aubergine enamels, often enriched with gold. These inspired the

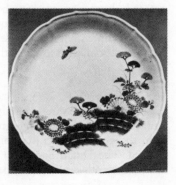

171. Lobed dish of Kakiemon-type Arita ware. Tokugawa period. Porcelain decorated in enamels and underglaze blue. Diameter: approx. 5 in. Collection of the late Soame Jenyns, England.

eighteenth-century potters of Meissen and Chelsea wares. Although modeled on Chinese wares of the K'ang-hsi period (1662–1722), the potters almost invariably show a decorative approach which can only be Japanese. The lobed dish in figure 171 is decorated in enamels and underglaze blue with a most sensitive design of a woven hedge with a profusion of flowers growing from behind it. A butterfly hovers above them adding to the lightness of the composition. This refined decoration is characteristically Japanese. The whole surface is treated as a single unit—an approach inherited from the Momoyama period and strongly influenced by textile design. The Chinese in their finest ceramics may show a more perfect technique but their designs often give the impression of having been constantly repeated. Japanese ceramics made for the home market have an air of being individual works of art, each one the result of as much thought as a painting. When a Chinese potter made a set the pieces were generally identical, whereas in a Japanese set each individual piece often has some small variation—it may be a different bunch of flowers, a butterfly in a different position, or a design reversed. The respective craftsmen seem to have been conscious of their public. A Chinese vase is made to be admired on its pedestal; a Japanese, to be studied in loving hands. The Chinese connoisseur expects his potters to demonstrate their skill; the Japanese, to transmit their personalities.

Apart from the dislike of repeat designs and the tendency toward pictorial treatment, the effect produced by Japanese porcelain is softer and more lyrical than that of Chinese wares of the same period. The Japanese excel in the successful combination of naturalism and abstraction, weaving both into tasteful harmonies. In their way, the finest of these Kakiemon wares, more subtle in their charms than their contemporary Chinese famille-verte and incidentally much rarer, can hold their own with the best products of eighteenth-century China.

Imari Ware

The Kakiemon wares are only one of many groups made in the Arita district. Another large group are the Imari wares, so called from the port of Imari (ten miles from Arita) whence they were shipped. The Dutch East India Company brought many of these late-seventeenth-century porcelains to Europe where they were in

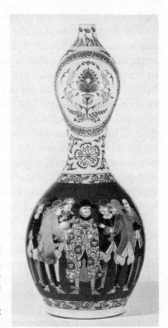

172. Vase with Dutchmen and foreign vessel. Imari ware from the Arita kilns. Tokugawa period. Porcelain with overglaze enamels. Height: 1 ft. 10 in. Cleveland Museum of Art, Gift of Ralph King.

great demand as decorations for palaces and large country houses. So great was their success in Europe that the Chinese copied them in order to share the lucrative market. Most of them are decorated in underglaze blue, iron-red, and gold, and many are little short of ceramic monstrosities.* They deserve the bad name they have among modern connoisseurs, but we should remember that they were made entirely to satisfy a European taste which the Japanese had shrewdly assessed. Even today the Japanese will send cheap, shoddy objects to Europe while keeping the finest things for their own more discerning market. But some of these Imari wares made for Europe and decorated with designs of Dutch ships and men have an interest and charm of their own (fig. 172).

* For a good account of the Japanese export trade see Soame Jenyns, *Japanese Porcelain* (London: Faber and Faber, 1965) which includes much of the pioneer work of T. Volker, for whose works see the Bibliography.

Nabeshima Porcelain and Hirado Blue-and-White

The most beautiful of the Arita wares is the Nabeshima porcelain made in an isolated site at Okawachi near Arita, an area which has remained from that time the most important ceramic-producing area in Japan. This particular kiln was established by the ruling family of Nabeshima in 1675 to supply its own house with porcelain of the very highest quality. The secrets were closely guarded and few pieces were sold outside the family, though some made prestigious gifts. The finest period of the kiln was the second half of the eighteenth century and the beginning of the nineteenth. Every care was taken to make these plates and dishes the ultimate of refinement and perfection. Any imperfect pieces were smashed and the fragments buried. Blue-and-white and celadon wares were produced here but the most typical variety, for which it is justly famous, is colored ware (fig. 173). Here again the decorative approach with its fondness for novel floral and geometric motifs is essentially Japanese, and strongly influenced by the very original textile designs of the period, as well as by lacquerwares which they replaced for table use. The potters of Nabeshima were certainly inspired by the elegance and technical accomplishment of Chinese porcelains of the Yung-chêng and Ch'ien-lung period (1722–96), but the Japanese colors are more diffused, the designs bolder and less mechanical. Most have a typical comb design on the foot. The scale of design is always broader and more sweeping than in the Kakiemon wares. Their soft, "milky" pastel shades on a pure white, ultra-refined body seem almost luminous.

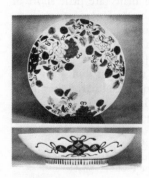

173. Plate of Nabeshima porcelain. Tokugawa period. Blue, red, and green glaze on white background. Height: 2 in.; diameter: 6¾ in. Collection of the late W. Cohn, England.

The Hirado kiln, also situated near Arita, flourished 1712–1843. This kiln is famous for its blue-and-white wares which at their simplest come remarkably close to the Chinese. The pure whiteness of the glaze gives them an added perfection. At times the potters of this kiln tried their hands at complicated forms which show one of the less attractive Japanese characteristics—an inability to maintain exercise of a mastered technique in simple terms.

Kutani Ware

Porcelain manufacture was not restricted to the island of Kyushu alone. In eastern Japan on the mainland, a kiln was established in the seventeenth century at a village called Kutani in Kaga province far from the porcelain manufacturing center of Arita. There is much controversy about this ware but it flourished for only about fifty years, so the original output was relatively small; it enjoyed a short but prolific revival in the nineteenth century and we do not know why it stopped production. It is sometimes difficult to distinguish between the Ko Kutani ("Old" Kutani) wares and Arita wares made in Kutani style. The Old Kutani enameled porcelain from this site has a character all its own. Its strong design and heavy grandeur of color are not found either in Nabeshima or Kakiemon wares. Indeed drawing, design, and color in this early Kutani ware are all of unequalled power; the calligraphic brushwork, the eloquent broken lines and empty spaces help make it one of the most exciting of all porcelains. Old Kutani wares were made in many styles; pieces are found in Chinese style, in pure Japanese style, and in combinations of the two. A ewer in the Victoria and Albert Museum (fig. 174) shows the typical freedom of brushwork, sweeping design, and originality which give these wares their life and their appeal. The sturdy shape bridges the gap between the conscious roughness of the pottery tea-ceremony wares and the suave perfection of the technically accomplished porcelains of the late eighteenth and early nineteenth centuries. The rhythm, as powerful as any seen in Ming colored enamels, is not gained at the expense of heaviness. The confident shapes and incisive brushwork remind one of much early European porcelain. If the Japanese potter could not always produce the lightness of his Chinese inspiration, he never forgot the need to satisfy the tactile sense which is so important to the Japanese ceramic lover.

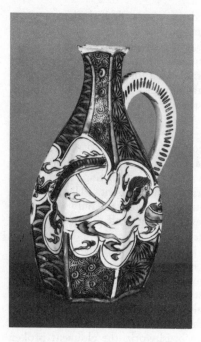

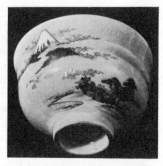

174. Ewer of Ko ("Old") Kutani porcelain. Tokugawa period. Purple, green, yellow, and red on white. Height: 8 in. Victoria and Albert Museum, London.

175. Bowl of Satsuma ware. Late Tokugawa period. Colored enamels on buff-colored glaze. Museum of Eastern Art, Oxford.

Satsuma Ware

No account of the Tokugawa wares, however brief, can avoid mentioning Satsuma. *Satsuma* is a generic name for Jōsa, Maeshima, Tateno, and Ryūmonji wares. Most Japanese wares brought by the public into the oriental departments of museums are late-nineteenth-century specimens of this type with ornate decorations in every possible color over a creamy crackled glaze. Often, alack, their only admirable qualities are a remarkable dexterity of design and execution. The earlier pieces mostly copied Korean pottery in plain colors with amber, black, or white decoration. The tea caddies with black over white glaze, most of which were made in the Tateno kilns, are highly prized. In later times fine pottery was enameled over the glaze. Before the wares became too rococo Satsuma produced some fine pieces with delicate but brilliant designs on lustrous crackled glazes of great depth (fig. 175).

Metalwork

The metalwork crafts shared the prosperity of the ceramic industry. A wide variety of objects from cast vessels and figures to iron kettles have decorations ranging from the most restrained to the most flamboyant. One sees the understanding of material, care in manufacture, and attention to detail—the norms of Japanese craftsmen in this period—as much in the sturdy reticence of the tea-ceremony iron implements as in the extravagant gold inlay of the sword-guards. *Tsuba* manufacture especially attracted the finest metalworkers and absorbed their energies. The long lists of schools and masters can here only be represented by six which show some aspects of the diverse work of the period. They by no means cover the whole range of work produced in the medium.

Figure 176(*a*) is a typical iron guard with gold inlay. The inlay of delicately worked clematis flowers covers both faces and the slightly raised border and edge. The gold itself is in two slightly different tones to give added life and variety. The inlay itself is of the flat type (*hira-zōgan*) in which the iron background is cut to take the inlay with a slight undercutting to hold it in place. The whole surface is then rubbed flat. This *tsuba* is probably an early example of the type dating from the eighteenth century. The advance in technique on the Momoyama guards is very noticeable. The workers in this period seem to delight in overcoming technical difficulties. As in the prints, every technical challenge was met and overcome.

Figure 176(*b*) is a brass guard of the *sentoku* variety which has gained an attractive chrome-yellow effect from a pickling process. It illustrates the characteristic Japanese use of figures, here applied in high relief and in various metals to produce a pictorial effect (*iro-e*). On one side of the guard (not illustrated) is a gnarled pine tree, part of which creeps over to the reverse side, and under this branch are two seated figures. They represent the legendary Takeshi-no-uchi-no-Sukune, an aged minister of the warrior-empress Jingū (second to third century A.D.), receiving from a kneeling demon, the servant of the sea god, the two "tide-ruling" gems. The pine tree is engraved with a special tool which the craftsmen invented to produce in metal the effect of brushwork. It is signed Kigōdō Naoyoshi and is probably late-eighteenth-century work of the Nara Toshinaga school. The design and workmanship are bold and confident; the various techniques are skillfully combined. No pictorial or sculp-

tural effect was too difficult for simulation in these miniature frames of metal.

Figure 176(c) belongs to a group of miscellaneous iron guards decorated with gold inlay in a unique Japanese technique. This was developed to create in metal the impression of wash-drawing. The *nunome*, or "cloth texture," method was used to inlay floral branches which surround *kiri* ("paulownia") badges. The branches spread freely over the edges in a manner typical of the late Japanese decorative sense. The background and design are by this means completely integrated. It is signed by an unrecorded artist, Hakuman Nobutoshi, whose name is repeated in a double-gourd-shaped seal. This is an example of what the Japanese call "presentation work." Such jewellike guards were used by the daimyos as presents for shogunal officials and became popular as gifts between friends. They reflect the finesse of taste in the period and the high standards demanded of the craftsmen.

Figure 176(d) is a simpler, less ostentatious guard which appealed to the *shibui* side of Japanese taste. It is an iron guard pierced in such a way that the modeling is almost in the round. The design of two blades of rice in the ear skillfully surrounds the central area within a narrow border. It seems that there was no space, however awkwardly shaped, that the Japanese could not turn to decorative use. The *tsuba* is signed "Myōchin Yoshihisa, resident in Echizen." The Myōchin school is one of the most famous. Its founders were originally armorers and the family took the name Myōchin in 1150. As *tsuba* makers they were eminent from the sixteenth century onward and some members of the family worked as sword fitters for the shoguns. Their innovations were only surpassed by the number of other craftsmen who incorporated their ideas. The school was widely dispersed; the branch which made this particular guard worked in Echizen province until well into the nineteenth century, and all its followers signed themselves Yoshihisa. This example was probably made in the early nineteenth century.

Figures 176(e) and 176(f) show the climax of technique and sensibility in *tsuba* manufacture. Both are made of *shakudō*, the alloy of copper and gold, and the backgrounds are punched with the minute *nanako* ("fish roe") dots. The guard shown in figure 176(e) has a plain edge richly gilt and decorated in bold *iro-e* work almost in the round. Two quail are shown below sprays of various autumn

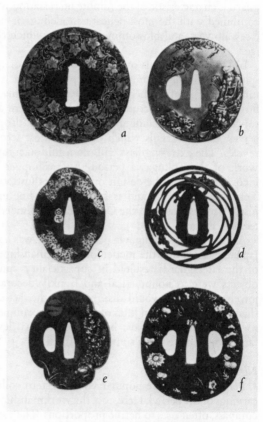

176. Six sword guards in a variety of techniques (see text). Tokugawa period. Approx. one-half actual size. Museum of Eastern Art, Oxford.

plants. The moon, partly clouded over, is in silver inlay with the *nanako* punching continued over its surface. The signature is that of Mokuiensai Ishiguro who died in 1838. The school to which he belonged was founded by Ishiguro Masatsune (1746–1820) and had a large following until the mid-nineteenth century, its products being particularly popular with the samurai. The decoration of this guard is characteristic of the minute incrustation work on soft metals combined with the most delicate modeling of birds, fish, insects, trees, flowers, and blossoming hedges in which this school specialized.

In 176(f) the edge is overlapped by a mass of leaves in relief inspired by various autumn plants depicted on each face: chrysanthemum, aster, gentian, begonia, lespedeza, patrinia, and eularia. The flowers are richly encrusted in gold, with here and there a subtle touch of silver—including even tiny silver drops of dew on the leaves, minute details which only the most scrupulous inspection reveals. The extra-vigilant will often find such rewards in the craftwork of the Tokugawa period. A grasshopper and a cricket are incorporated into the design on the side illustrated. It is signed by Terumasa (1704–72) and is an unusually fine example from this justly famous master of the Ōmori school founded in the early eighteenth century.

After the mid-Tokugawa period, armor was less in use and some Japanese claim that the meticulous workmanship and minute detail of the later guards resulted in superficiality and triviality. These objects were as nonpractical and frankly decorative as a piece of jewelry. Nobody would disagree with the fact that they have lost the powerful, practical lines of the earlier examples. Without doing so they could never have been raised to that level of beauty and fantasy which we see in so many of them.

Netsuke

Perhaps even more popular with Western collectors are the tiny carvings of the period. Here, too, the workmanship, despite its minute compass, often rises to heroic proportions. The vast reserve of sculptural talent which disappeared from the service of the temples after the Kamakura period dispersed itself in the design and manufacture of such objects as *netsuke*. These are small objects of many shapes used as buttons to prevent the end of a cord from slipping out of the

obi, or belt. At the end of the cord hung such things as *inrō* (seal boxes) or portable smoking and writing implements. Like the *tsuba* they were made in the thousands and represent an output of unrivaled quality and quantity.

The origins of *netsuke* are obscure but they are said to have been made first in the fifteenth century. No examples from this early period exist and even sixteenth-century specimens are extremely rare. The introduction of the habit of smoking by the Portuguese after 1542 increased the use of accessories hanging from the belt and hence also the need for *netsuke*. *Inrō* with *netsuke* to match became popular and many famous craftsmen like Kōetsu (see p. 243) turned their skill to making them. Many of the oldest *netsuke* are small objects of foreign origin which the Japanese adapted to the purpose, and it is said that Hideyoshi brought some of these back from his campaigns on the mainland. Once accepted in Japan, the production of *netsuke* shared the enthusiasm of the other crafts. The names of 2,700 makers of the seventeenth to nineteenth century are recorded. The main centers of the craft were in Tokyo, Kyoto, and Nagoya but many smaller areas throughout Japan also produced them.

The carvers generally, but by no means exclusively, used wood and ivory for their carvings. They also experimented with every possible material which came to their hands—horn, coral, tortoiseshell, mother-of-pearl, lacquer, pottery, marble, obsidian, and, of course, the various base and precious metals. All the decorative techniques found on metalwork and lacquerwork were adapted for the purpose and the choice of subjects was equally wide. Humans and animals form the largest group but landscapes, seals of Chinese form, curiosities such as telescopes, sundials, pistols, whistles, and firefly cages are also frequently found. An amusing group of "trick" *netsuke* provided the carvers with a further opportunity to display their ingenuity. Some of these are human figures weighted in such a way that when knocked over they always return to an upright position; others have revolving eyes or protruding tongues. They carved chestnuts with worms which move, wasp nests with movable grubs, buds with movable seeds, and cunning reversible masks which look like faces whichever way up they are held.

The shape most frequently found is that of the *manjū* or Japanese bun, known in the West as "the Japanese button." Masks modeled on those used in Nō plays were popular subjects from the seventeenth

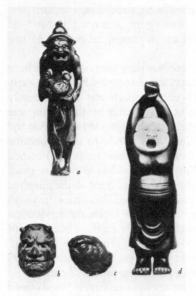

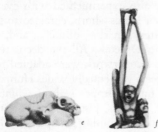

177. Six *netsuke*. *a*, "Dutchman Holding a Fighting Cock." Unsigned. Probably seventeenth century. Wood. Height: 4 in. *b*, "*Oni* (Devil) Mask." Unsigned. Ca. 1800. Wood and glass. Height: 1½ in. *c*, "Fish," by Masanao (active 1800–30). Wood. Height: 1½ in. *d*, "Okame Yawning," by Hidemasa. Eighteenth century. Wood and ivory. Height: 5¼ in. *e*, "Bull and Calf," by Tomotada (active 1750–1800). Ivory. Length: 2½ in. *f*, "Ashinaga Yawning and Tenagu Sleeping," by Chikamasa. Middle nineteenth century. Ivory. Height: 3¼ in. All pieces are in the British Museum.

century onward, their most famous carver being Deme Ieiman of the mid-eighteenth century, a descendant of a famous school of mask carvers. The *kagami-buta* type, in which a decorative metal disc is set in a circular frame of ivory or wood, gave the metal-workers an opportunity to participate in the production of *netsuke*, and such eminent schools as the Myōchin made them.

The six *netsuke* illustrated here give only a glimpse of the infinite variety found in these masterpieces of lilliputian art. Figure 177(*a*), "Dutchman Holding a Fighting Cock" is an unsigned work in wood. It probably comes from a Kyoto workshop of the seventeenth century. A number of such surviving figures, not all of which are so unflattering to the Westerner, provide an amusing sidelight on the pleasures of the Dutch in Japan and on the Japanese view of the strange "barbarians." The *oni*, or "devil," mask in figure 177(*b*) is also of wood but with glass eyes. Such devils often appear in Japanese art and are usually represented with a square head, two horns, sharp teeth, and malignant eyes surmounted by bushy eye-brows. This unsigned specimen was probably made about 1800. Figure 177(*c*), a skillfully modeled, plump fish, is signed "Masanao," who worked about 1800–30 in Kyoto. He is one of the most famous names in *netsuke* carving; his originality and fine carving influenced many successors and imitators.

Figure 177(*d*), "Okame Yawning," is a combination of wood and ivory possibly by the eighteenth-century master Hidemasa of Osaka. Okame's full name is Ama-no-Uzume-no-Mikoto. She is the goddess of mirth who, by a lewd dance, helped persuade the sun goddess Amaterasu to come out of the cave into which she had fled, so depriving the world of light. She is usually shown laughing, and her jovial figure, often scantily clad, is a popular *netsuke* motif. Hidemasa's designs are always distinguished by simple lines and powerful modeling.

Tomotada (active 1750–1800), who carved the bull and calf in figure 177(*e*), was, with Masanao and Yoshinaga, one of the three great masters of the eighteenth century. His work has much in common with that of Masanao but he worked quite independently of him. This animal group, made about 1800, is most typical of his carvings, and the composition was much imitated by later craftsmen. Many very sensitively carved animals are represented in *netsuke* and they are always a delight to handle.

The *netsuke* illustrated in figure 177(*f*) is a more grotesque ivory group, "Ashinaga Yawning and Tenagu Sleeping," by Chikamasa, who worked from about 1830 into the Meiji period which began in 1868. His school is famous for its groups of animals and humans. The two mythical figures in the carving were said to have lived on the coast of China. The long-armed Tenagu was supposed to have caught fish while perched on the back of Ashinaga, who could wade deep into the sea on his long legs. These few *netsuke* show just a few of the many sources to which the Japanese turned for fitting subjects for these tiny works.

In Conclusion

It is not altogether unfitting to end this short survey of Japanese art with the *netsuke* of the nineteenth century. It opened with the Jōmon figurines of two thousand years before. The spirits which inspired the arts of Jōmon and Tokugawa times differed completely but it is not too farfetched to see the same hand at work in both of them. Certain characteristics persist in an art of unusual continuity— through the earliest portraiture of the *haniwa*, the idealism of Nara, the mysticism of Heian, and the realism of Kamakura. With the *netsuke*, the Japanese carvers seem to have turned full circle, summing up as they did so the abilities of nearly two millennia.

By 1868, a combination of internal and external pressures had forced Japan out of her self-imposed seclusion and the ensuing contacts with the West brought a flood of European art, itself then entering a very stimulating revolutionary phase. In the turmoil this created, a number of distinguished and original native painters tried, often successfully, to preserve and develop their own *bunjin* styles. Others studied in Paris and on their return either copied French styles or attempted the most difficult of all syntheses, that of Eastern and Western manners. Interesting and vigorous though it was, we are not yet in a position to assess their work.

The second half of this century may well see a reassessment and revival of traditional styles of painting in Japan. It is one of the functions of the artist to make us see things with new eyes; in this the Eastern modes, whose powers of adaption are unquestionable, have much to offer us in the West. A revival is already evident in new Japanese styles of calligraphy which are constantly appearing. Calligraphy is an essentially Eastern art not easily dominated by

foreign influences, and from calligraphy to painting is but a short step. In the course of this study we have seen Japanese artists repeatedly absorbing influences from China, which after a century or so they have made entirely their own. We may well see them do the same with the powerful influences from the West.

NOTES

INTRODUCTION

1. Laurence Binyon, *Painting in the Far East: An Introduction to the History of Pictorial Art in Asia, Especially China and Japan*, 3rd ed. rev. (London: Edward Arnold, 1923), p. 8.

CHAPTER 1: Japanese Art to the Sixth Century

1. Sir George B. Sansom, *Japan: A Short Cultural History*, rev. ed. (London: Cresset Press, 1946), p. 46.
2. J. Edward Kidder, Jr., *The Birth of Japanese Art* (London: George Allen and Unwin, 1965), p. 8.
3. Roy Andrew Miller, *Japanese Ceramics* (Tokyo: Toto Shuppan, 1960), p. 18.
4. Kidder, *Birth of Japanese Art*, p. 8.
5. Ibid., p. 160.

CHAPTER 2: The Asuka or Suiko Period

1. René Grousset, *Le Japon* (Paris: Les Editions G. Crès, 1930), p. 14.
2. John M. Rosenfield and Shūjirō Shimada, *Traditions of Japanese Art: Selections from the Kimiko and John Powers Collection* (Cambridge, Mass.: Fogg Art Museum, 1970), p. 11.
3. Seiichi Mizuno, *Asuka Buddhist Art: Horyu-ji*, trans. Richard L. Gage (New York and Tokyo: John Weatherhill, 1974), p. 158.
4. Sherman E. Lee, *A History of Far Eastern Art* (Englewood Cliffs, N. J.: Prentice-Hall; New York: Harry N. Abrams, 1964), p. 151.
5. Yukio Yashiro, *2000 Years of Japanese Art*, ed. Peter C. Swann (New York: Harry N. Abrams, 1959), p. 50.
6. Ibid., p. 54.

CHAPTER 3: The Nara Period

1. Edwin O. Reischauer, *Japan: The Story of a Nation* (New York: Alfred A. Knopf, 1970), p. 20.
2. Lee, *History of Far Eastern Art*, p. 54.
3. Yashiro, *2000 Years of Japanese Art*, p. 63.
4. Tōichirō Naitō, *The Wall Paintings of Hōryūji*, trans. and ed. William Reynolds Beal Acker and Benjamin Rowland, Jr., American Council of Learned Societies, Studies in Chinese and Related Civilizations (Baltimore: Waverly Press, 1943), p. 33.
5. Fujio Koyama, "The Yüeh-chou Yao Celadons Excavated in Japan," *Artibus Asiae* 14 1/2 (1951):26–42.

CHAPTER 4: The Early Heian Period

1. Sansom, *Japan*, pp. 190–93.
2. Ibid., p. 226.
3. E. W. F. Tomlin, *Japan* (London: Thames and Hudson, 1973), p. 22.
4. Langdon Warner, *The Enduring Art of Japan* (Cambridge, Mass.: Harvard University Press, 1952), p. 28.
5. Sir Charles Eliot, *Japanese Buddhism* (London: Routledge and Kegan Paul, 1935), p. 239.
6. Edwin O. Reischauer, trans., *Ennin's Diary: The Record of A Pilgrimage to China in Search of the Law* (New York: Ronald Press, 1955).
7. Yashiro, *2000 Years of Japanese Art*, p. 80.
8. Benjamin Rowland, Jr., "Indian Images in Chinese Sculpture," *Artibus Asiae* 10/1 (1947):5–33.
9. Koyama, "Yüeh-chou Yao Celadons," pp. 26–42.

CHAPTER 5: The Late Heian or Fujiwara Period

1. Alexander C. Soper, "The Illustrative Method of the Tokugawa 'Genji' Pictures," *The Art Bulletin* 37, no. 1 (1955):3.
2. Sansom, *Japan*, p. 243.
3. Soper, "The Tokugawa 'Genji' Pictures," pp. 1–16.
4. Sherman E. Lee, *Japanese Decorative Style* (New York: Harper and Row, Icon Editions, 1972), pp. 27–28.
5. Harold P. Stern, *Birds, Beasts, Blossoms, and Bugs: The Nature of Japan* (New York: Harry N. Abrams, 1976), p. 24.

CHAPTER 6: The Kamakura Period

1. Sansom, *Japan*, p. 300.
2. Lee, *Japanese Decorative Style*, pp. 47–48.
3. Miyeko Murase, *Japanese Art: Selections from the Mary and Jackson Burke*

Collection (New York: Metropolitan Museum of Art, 1975), p. 11.

4. Langdon Warner, *The Craft of the Japanese Sculptor* (New York: Hacker Art Books, 1976), p. 12.

5. Rosenfield and Shimada, *Traditions of Japanese Art*, p. 90.

6. Kenneth Clark, *The Nude: A Study of Ideal Art* (London: John Murray, 1956), p. 127.

7. Stern: *Birds, Beasts, Blossoms, and Bugs*, p. 9.

8. Ibid., p. 16.

CHAPTER 7: The Ashikaga or Muromachi Period

1. Lee, *Japanese Decorative Style*, p. 47.

2. Yashiro, *2000 Years of Japanese Art*, p. 178.

3. E. Herbert Norman, "Andō Shōeki and the Anatomy of Japanese Feudalism," *The Asiatic Society of Japan*, 3rd ser. 2 (December, 1949):84–85.

4. Jean-Pierre Hauchecorne, "The Spirit of Zen," *This Is Japan 1956* (Tokyo: Asahi Shimbunsha, 1956):202–3.

CHAPTER 8: The Momoyama Period

1. Lee, *Japanese Decorative Style*, p. 8.

2. Basil Gray, "Western Influence in Japan," *Oriental Art*, n.s. 2, no. 4 (1956):128–37.

3. Soame Jenyns, *Japanese Pottery* (London: Faber and Faber, 1971), p. 147.

4. Ibid., p. 156.

5. T. Volker, "Japanese Export Lacquer," *Oriental Art*, n.s. 3, no. 2 (1957): 60.

CHAPTER 9: The Tokugawa or Edo Period

1. Edwin O. Reischauer, *The Japanese* (Cambridge, Mass.: Harvard University Press, Belknap Press, 1977), p. 213.

2. Edward G. Seidensticker, trans., *The Tale of Genji*, 2 vols. (New York: Alfred A. Knopf, 1976), 1:304.

3. Stephen Addis, *Nanga Painting*, Exhibition Catalogue (London: privately published, 1975), p. 5.

4. Osvald Sirén, *The Chinese on the Art of Painting: Translations and Comments* (New York: Schocken Books, 1963), p. 188.

5. James Cahill, *Scholar Painters of Japan: The Nanga School* (New York: The Asia Society, 1972), p. 71.

6. Rosenfield and Shimada, *Traditions of Japanese Art*, p. 259.

7. T. Volker, "Two Japanese Libri Amicorum," *Oriental Art*, n.s. 1, no. 3 (1955):111–14.

8. Lafcadio Hearn, "Feudal Integration," *Japan: An Attempt at Interpretation*

(Rutland, Vt. and Tokyo: Charles E. Tuttle, 1955), p. 356.

9. R. H. Van Gulik, *The Erotic Colour Prints of the Ming Period* (Japan: privately published, 1951) and David Chibbett, *The History of Japanese Printing and Book Illustration* (New York and Tokyo: Kodansha International, 1977), p. 35.

10. Takahashi Seiichiro, ed., *Kaigetsudō*, English text by Richard Lane (Rutland, Vt. and Tokyo: Charles E. Tuttle, 1959), pp. 19–21.

11. G. L. Anderson, ed., *Masterpieces of the Orient* (New York: Norton, 1977), p. 755.

12. Faubion Bowers in the *New York Times* on the occasion of a visit of an outstanding Kabuki troupe led by Ichikawa Enosuke II (21 August 1977).

13. Jack Hillier, *Suzuki Harunobu: An Exhibition of His Colour-Prints and Illustrated Books on the Occasion of the Bicentenary of His Death in 1770* (Philadelphia: Philadelphia Museum of Art, 1970), pp. 12–13.

14. Ibid., p. 16.

15. Chibbett, *History of Japanese Printing*, p. 188.

16. Ibid., p. 190.

17. Takahashi, *Kaigetsudō*, p. 29.

18. Soame Jenyns, *Japanese Porcelain* (London: Faber and Faber, 1965), p. 12.

BIBLIOGRAPHY

Akiyama, Terukazu. *Japanese Painting*. London: Macmillan, 1977.

Awakawa, Yasuichi. *Zen Painting*. Translated by John Bester. New York and Tokyo: Kodansha International, 1971.

Binyon, Laurance, and Sexton, J. J. O'Brien. *Japanese Colour Prints*. Revised edition edited by Basil Gray. London: Faber and Faber, 1960.

Bowers, Faubion. *Japanese Theatre*. 1952. Reprint. Rutland, Vt. and Tokyo: Charles E. Tuttle, 1974.

Cahill, James. *Scholar Painters of Japan: The Nanga School*. New York: Asia Society, 1972.

Chibbett, David. *The History of Japanese Printing and Book Illustration*. New York and Tokyo: Kodansha International, 1977.

Conzé, Edward. *Buddhism: Its Essence and Development*. 1951. Reprint. New York: Harper and Row, Harper Torchbooks, 1958.

Doi, Tsugiyoshi. *Momoyama Decorative Painting*. Translated by Edna B. Crawford. New York and Tokyo: John Weatherhill, 1977.

Drexler, Arthur. *The Architecture of Japan*. New York: Museum of Modern Art, 1955.

Fontein, Jan, and Hickman, Money L. *Zen Painting et Calligraphy*. Boston: New York Graphic Society, 1970.

Frédérick, Louis. *Japan: Art and Civilization*. London: Thames and Hudson, 1969.

Grilli, Elise. *The Art of the Japanese Screen*. New York and Tokyo: John Weatherhill, 1971.

Hasumi, Toshimitsu. *Zen in Japanese Art: A Way of Spiritual Experience*. New York: Philosophical Library, 1962.

Hillier, J. *The Japanese Print: A New Approach*. 1960. Reprint. Rutland, Vt. and Tokyo: Charles E. Tuttle, 1975.

Honey, William Bowyer. *The Ceramic Art of China and Other Countries of the Far East*. London: Faber and Faber, 1945.

Ienaga, Saburo. *Painting in the Yamato Style*. Translated by John M. Shields. New York and Tokyo: John Weatherhill, 1973.

Jenyns, Soame. *Japanese Pottery*. London: Faber and Faber, 1971.

Jonas, F. M. *Netsuké*. 1928. Reprint. Rutland, Vt. and Tokyo: Charles E. Tuttle, 1960.

Kato, Shuichi. *Form, Style, Tradition: Reflections on Japanese Art and Society*. Translated by John Bester. New York and Tokyo: Kodansha International, 1971.

Kidder, J. Edward, Jr. *Early Japanese Art: The Great Tombs and Treasures*. Princeton, N.J.: Van Nostrand, 1964.

Kondō, Ichitarō. *Japanese Genre Painting: The Lively Art of Renaissance Japan*. Translated by Roy Andrew Miller. Rutland, Vt. and Tokyo: Charles E. Tuttle, 1961.

Kuck, Loraine E. *The World of the Japanese Garden: From Chinese Origins to Modern Landscape Art*. New York and Tokyo: John Weatherhill, 1968.

Lane, Richard. *Masters of the Japanese Print*. London: Thames and Hudson, 1962.

Lee, Sherman E. *A History of Far Eastern Art*. Englewood Cliffs, N.J.: Prentice-Hall; New York: Harry N. Abrams, 1964.

―――. *Japanese Decorative Style*. New York: Harper and Row, Icon Editions, 1972.

Maraini, Fosco. *Meeting with Japan*. New York: Viking Press, 1960.

Meissner, Kurt. *Japanese Woodblock Prints in Miniature: The Genre of Surimono*. Rutland, Vt. and Tokyo: Charles E. Tuttle, 1970.

Michener, James A. *Japanese Prints: From the Early Masters to the Modern*. Rutland, Vt. and Tokyo: Charles E. Tuttle, 1959.

Minnich, Helen Benton, and Nomura, Shojiro. *Japanese Costume and the Makers of Its Elegant Tradition*. Rutland, Vt. and Tokyo: Charles E. Tuttle, 1963.

Mōri, Hisashi. *Japanese Portrait Sculpture*. Translated and adapted by W. Chië Ishibashi. New York and Tokyo: Kodansha International, 1977.

Munsterberg, Hugo. *The Folk Arts of Japan*. Rutland, Vt. and Tokyo: Charles E. Tuttle, 1958.

Murase, Miyeko. *Japanese Art: Selections from the Mary and Jackson Burke Collection*. New York: Metropolitan Museum of Art, 1975.

Noma, Seiroku. *The Arts of Japan*. Translated and adapted by John Rosen-

field (vol. 1) and Glenn Webb (vol. 2). First standard edition. New York and Tokyo: Kodansha International, 1978.

Okakura, Kakuzo. *The Ideals of the East with Special Reference to the Art of Japan.* 1904. Reprint. Rutland, Vt. and Tokyo: Charles E. Tuttle, 1970.

Okamoto, Yoshitomo. *The Namban Art of Japan.* Translated by Ronald K. Jones. New York and Tokyo: John Weatherhill, 1972.

Okudaira, Hideo. *Emaki: Japanese Picture Scrolls.* Rutland, Vt. and Tokyo: Charles E. Tuttle, 1962.

Paine, Robert Treat, and Soper, Alexander C. *The Art and Architecture of Japan.* Baltimore: Penguin Books, 1955.

Reischauer, Edwin O. *The Japanese.* Cambridge, Mass.: Harvard University Press, Belknap Press, 1977.

Roberts, Laurance P. *A Dictionary of Japanese Artists: Painting, Sculpture, Ceramics, Prints, Lacquer.* New York and Tokyo: John Weatherhill, 1976.

———. *Roberts' Guide to Japanese Museums.* New York and Tokyo: Kodansha International, 1978.

Rosenfield, John M. *Japanese Arts of the Heian Period.* New York: Asia Society, 1967.

———, and Shimada, Shūjirō. *Traditions of Japanese Art: Selections from the Kimiko and John Powers Collection.* Cambridge, Mass.: Fogg Art Museum, 1970.

Sansom, Sir George B. *Japan: A Short Cultural History.* Rev. ed. London: Cresset Press, 1946.

Sawa, Takaaki [Ryūken]. *Art in Japanese Esoteric Buddhism.* Translated by Richard L. Gage. New York and Tokyo: John Weatherhill, 1972.

Stern, Harold P. *Birds, Beasts, Blossoms, and Bugs: The Nature of Japan.* New York: Harry N. Abrams, 1976.

Tanaka, Ichimatsu. *Japanese Ink Painting: Shubun to Sesshu.* Translated by Bruce Darling. New York and Tokyo: John Weatherhill, 1972.

Volker, T. *Porcelain and the Dutch East India Company.* Leiden: E. J. Brill, 1954.

———. *The Japanese Porcelain Trade of the Dutch East India Company after 1683.* Leiden: E. J. Brill, 1959.

Warner, Langdon. *The Enduring Art of Japan.* Cambridge, Mass.: Harvard University Press, 1952.

Yashiro, Yukio. *2000 Years of Japanese Art.* Edited by Peter C. Swann. New York: Harry N. Abrams, 1959.

INDEX

Figure numbers are given in brackets